MUSIC
AS A MULTICULTURAL EXPERIENCE

Sixth Edition

Shelley Davis
University of Maryland

Kendall Hunt
publishing company

Picture Acknowledgments

Ali Akbar College, San Rafael: 124, 126, 127; Ernst Burger Collection, Munich: 95; Dover Publications Inc.: 23 (recorder, clarinet, oboe, English horn, Bagpipes), 28 (violin, harpsichord, piano), 30 (bass drum, xylophone), 185, 195, 223); Barbara Gibson:1, 19, 36, 41, 55, 69, 85, 103, 133, 152, 159, 177, 181, 193, 207, 219, 220, 231, 249, 253, 255, 257; Hamburger Kunsthalle: 164; Harvard University Press: 23 (flute, panpipes), 28 *rĕbab, sārangī,* Burmese harp), 3 (kettledrum, Javanese *gĕnder*), 195, 202; Harvard University Press illustrations are by Carmela Ciampa and Laszlo Meszoly. Reprinted by permission of the publisher from The New Harvard Dictionary of Music, edited by Don Michael Randel, Cambridge, Mass.: Harvard University Press, Copyright © 1986 by the President and Fellows of Harvard College; Hessische Landesbibliothek, Wiesbaden: 233; Historisches Museum, Vienna: 149, 151; Marc Hoffman: three Javanese shadowdrama puppets: 184 (Petruk), 293 (Kayon); International Piano Archives at Maryland, College Park: 243, 244; Leipzig, Museum für Geschichte der Stadt Leipzig: 111; The Library of Congress: 236; Magellan Geographix, Santa Barbara, CA: 121 (India, China, Russia), 183 (Indonesia), 221 (Africa), 242 (The Balkans); 143 (Europe), 144 (The Middle East), Mozart Museum, Salzburg: 95; Musée du Louvre, Paris: 162; *Musical Instruments of the World* (bantam): 186 (bonang); Music Division, New York Public Library, Lincoln Center: 112 (Handel); National Galleries of Scotland, Edinburgh: 163; National Gallery, Berlin: 165 (destroyed, 1945); Novosti Press Agency: 98; Schumannhaus, Bonn: 236; Tate Gallery, London: 179; James Gritz/Photonica; UBC Press: 171. Photos reprinted with permission of the publisher from Chinese Opera by Siu Wang-Ngai with Peter Lovrick, University of British Columbia Press © 1997. All rights reserved by the Publisher.

The lines from "darling! because my blood can sing," copyright, 1944, © 1972, 1991 by the Trustees for E. E. Cummings Trust, from *Complete Poems: 1904–1962* by E. E. Cummings, Edited by George J. Firmage. Reprinted by permission of Liveright Publishing Corporation.

The excerpt from "You, Andrew Marvell," *Collected Poems 1917–1982* by Archibald MacLeish. Copyright © 1985 by the Estate of Archibald MacLeish. Reprinted by permission of Houghton Mifflin Co. All rights reserved.

Contents

PART TWO
STYLE

PART THREE
GLOBAL PERSPECTIVES

Preface to Fourth Edition

After having presented and shared the ineffable beauties of music with undergraduates and non-majors for over a quarter of a century, the author has gained a revitalized perspective from the experience, particularly with regard to music-appreciation curricula. Today's society and our music students seem increasingly to feel a need for partaking in an ever-widening musical spectrum: European classics remain an expectation, but their interrelationships with (and opposition to) other styles are eagerly sought in today's world since for many of us, jazz, folk, international, popular, and other musical styles have become integral to our auditory experience.

This text addresses principally undergraduate non-music majors, and it draws from a variety of sources in selected Euro-American Western musical styles and non-Western musical traditions. At the chapters' conclusions, suggested bibliographies, discographies, and videocassettes allow for expansion of the material, if so desired. The emphasis remains on ideas even though specific pieces are studied, and the instructor is free to use whatever other examples may be preferred. A student who has worked with this text should be able to encounter a particular type of music, even on a first hearing, with a fair amount of open-mindedness and understanding.

The goal of this book was and is to widen our students' awareness of some of the many and diverse musical styles, genres, and customs available to them. For continuity, stylistic pairings that appeared reasonable and comparatively easy to grasp by non-majors were early on considered—Baroque affective music with the North Indian *rāg'* system, Mozart with Turkish Janissary music, Wagner with the concept of the *Gesamtkunstwerk*, Debussy with Indonesian *gamělan* music, Bartók with Central- and East-European ethnic folk music, African music with African-American music. These juxtapositions, while obviously not the only ones, were nonetheless convenient and plausible. Then, as a natural outgrowth of the original concept, the last part of the text was fashioned to explore various social aspects of music, particularly the undervalued roles of women as composers, patrons, performers, and teachers in the history of the Western Euro-American musical tradition. Owing to the global significance of both sub-Saharan African music and African-American music, the essays on them were almost inevitably divided into two separate chapters in order to facilitate closer examination.

The author thanks the University of Maryland, College Park, which awarded an innovative teaching grant to assist in the preparation of the original text, and, more recently, to Professor Richard Wexler of the School of Music for his invaluable advice and recommendations. My deep appreciation also goes to the administrators and staff of the University's various libraries, most notably those associated with the Michelle Smith Performing Arts Library—Dr. Bruce Wilson for granting access to the Luther Whiting Mason Collection, the source for the example of cipher notation appearing in Chapter 1: Torri, *Daitô gunka* (Tokyo: Dai Nihon Tosho, 1896); Bonnie Jo Dopp, Curator of Special Collections, for her many suggestions and in particular her contributions to Chapter 14; and Donald Manildi, Curator of the International Piano Archives at Maryland, for his advice and the access given the author to the extensive portrait collection in the Archives and permission granted to publish several of these portraits. I am most indebted to Ms. Elizabeth Walker, Librarian, and Ms. Sally Grant Branca, Archivist, at the Curtis Institute of Music in Philadelphia for graciously supplying material

regarding Isabelle Vengerova discussed in Chapter 14, "Women in Music." In this regard, thanks also to Professor Emeritus Joseph Resitz of Indiana University for his advice and insight into various aspects of Madame Vengerova's biography and students. My deep gratitude is extended to my students of the past, including Joan Michele Donati, Kimberly Ann Maney, Stephen J. Miles, and Robin Wildstein, as well as Dr. April Nash Greenan, Dr. Bliss Sheryl Little, and Dr. Lisa Urkevich for their many contributions and consistent encouragement, and, most recently, to Ms. Lucienne Pulliam for helping in preparing some of the musical examples and illustrations used in this edition. A friend, Chia-Pin Chang, kindly gave valuable information and recommendations for the discussion of Beijing Opera in Chapter 9, for which I am truly in his debt. I have been most fortunate to have had input from a succession of three remarkably gifted young scholars—Ann Riesbeck DiClemente, Chadwick Oliver Jenkins, and Jarl Olaf Hulbert—who, working closely with our students while teaching the appreciation courses, were able to ignite a widened interest in music among their non-majors and who inspired their undergraduate audiences to explore music from seemingly distant lands and an apparently remote past. In addition, Ms. DiClemente (who contributed some of the review questions at the ends of the chapters), Mr. Jenkins, and Mr. Hulbert have all been most helpful with invaluable suggestions regarding the present edition.

For Chapter 8 in the "Styles" part of the book, I thank the eminent C. P. E. Bach scholar and Professor Emeritus E. Eugene Helm, who took the time to write, in most elegant prose, the content on Mozart and Beethoven in the first instance. My admiration as well as special thanks are due Ms. Heather H. Austin, Acquisitions Editor for Kendall/Hunt Publishing Company, for her encouragement and professionalism as well as her diplomatic skills in sparking the inspiration for the current edition of this text. Finally, my heartfelt appreciation goes to a long-time friend, ethnomusicologist Dr. Karl Signell, a specialist in Turkish music, whose fertile imagination gave rise to the initial concept of the book and who subsequently provided both inspiration and substance for its ultimate realization.

Shelley Davis

Preface to Fifth Edition

With advice from talented young teachers who have devoted themselves to conveying their enthusiasm and love for music to our students, the author has redesigned *Music as a Multicultural Experience* and expanded its content with the addition of a chapter that deals specifically with music of the Middle East. In pursuing a streamlining of the format, the fifteen-chapter plan has been retained, and two former chapters, 2 (Notation) and 13 (Society), have been conflated into a new, introductory Chapter 1. The overall format is thus:

Introduction: *Context* (Chapter 1)
Part One: *Elements* (Chapters 2–6)
Part Two: *Style* (Chapters 7–11)
Part Three: *Global Perspectives* (Chapters 12–15)

This sequence begins with an introductory overview and expands in an ever-increasing, germinal progression, from the basic, individual elements of music to the manner in which these elements are applied and combined to profile specific styles from both the Western-European tradition and some selected repertories from other cultures. The final step in this broadening process resulted in exploring music from a series of wider-ranged points of view. In general terms, while the design of this new edition follows that of its predecessors, the aim has been to increase the over-all coverage without adding to the complexity and number of the text's chapters.

Heartfelt thanks are due Dr. Lisa Urkevich, musicologist and ethnomusicologist, for her invaluable expertise and gracious willingness to author a new Chapter 12, which is concerned with one of her several specialties, music of the Middle East. Dr. Urkevich has been able to present often profound and sometimes elusive concepts in a prose style that is direct and readily accessible. To Professor Robert Provine, internationally renowned scholar and true friend, I owe my deepest respect and special thanks for his continued encouragement and expertise, particularly with regard to all matters Far-Eastern. Special kudos are due Paul Michael Covey, who has contributed both time and effort to this text, most notably with regard to his virtuosity in handling electronic paraphernalia, and Frank Raymond Latino, who has instilled in our students a renewed zest for pursuing the various treasures in our world of music. To the students at the University of Maryland who have unselfishly supplied helpful comments at all steps along the way, I dedicate this book.

S. D.

Preface to the Sixth Edition

This edition builds on the same progression as the Fifth Edition: an introductory overview of music's place in society to analyses of music's basic elements (timbre, time, melody, texture and harmony, form) for Part One; various musical styles, East and West, for Part Two; and global perspectives for Part Three. After consultation with the various instructors who have used this text, and following their input, the author has made adjustments and additions, most especially regarding the questions at the conclusions of several of the chapters and the enhancement of the Glossary. This author again dedicates the book to his students at the University of Maryland.

Regarding the changes referred to above, Paul Michael Covey, the main instructor of our music-appreciation course at the University of Maryland, and his teaching assistant, Ms. Jennifer Kobuskie, have supplied much of the more invaluable information, and to both of these young scholars, the author wishes to express his deepest gratitude. As in the previous edition, Mr. Covey has been most helpful in supplying and enhancing visual aspects of the text. His dedication to the success of this book and willingness to give liberally of his valuable time are rare, his abilities in all things electronic truly awe-inspiring.

S. D.

1

SOCIETY

No human society lacks music. From the Ona people of Tierra del Fuego to the Eskimos of Point Barrow, from the suburbs of Grand Rapids, Michigan, and the farm communities of Nebraska to the barrios of Brooklyn, music is part of our lives.

Humans as social beings developed music, a complex system of communication, as one of many devices for telling fellow humans a state of mind. Important events demand music; imagine a wedding, a graduation, a funeral, a birthday without it. Music, like dance, expresses what words cannot. Our mood can instantly change via musical cues, as when we hear the organ or the shofar in a religious service. Like art, architecture, and dance, music provides a nonverbal mode of communication.

Music in Society

The many different meanings of music may be divided into three levels:

1. personal
2. cultural
3. universal

A couple hears "our song." They turn to gaze at each other, eyes misting over with fond memories. We all have a personal storehouse of specific musical pieces or perhaps just a special sound that has the power to unlock personal memories. Were you listening to a certain tune the day a new life came into your family or a life left it? Does a certain nursery song bring back memories of a younger sister? This personal level of meaning is unique to one or two persons or at most a small group.

At the cultural level, our mass response to a single musical stimulus reveals the bonds of our commonality. "We Shall Overcome" symbolized the 1960s civil rights struggle for millions. The entire nation of Israel and many Jews in the diaspora feel strong emotions on hearing "Hatiqvah," the Israeli national anthem, but the melody means nothing to an Uzbeki tribesman of Central Asia or a non-Jewish Louisiana alligator hunter. Beyond national boundaries, Beethoven's Fifth Symphony can reinforce bonds between the educated élite from New York to New Delhi, just as a current rock song may be the common currency of a growing international youth culture.

But all of these responses have limits. At the universal level, we are forced to speculate on incomplete evidence. To the best of our knowledge, all humanity has two fundamental responses to music, affective and kinetic. They are both different aspects of the same thing, the state of the mind/body and its expression of that state. The affective response is the internal emotional reaction the mind/body feels toward a meaningful music. The kinetic response expresses those feelings through dance, clapping, nodding, and toe-tapping. Even the rigidly attentive modern concertgoer will often unconsciously tap his or her program or toe in time to a catchy rhythm.

Of these three response levels—personal, cultural, and universal—the first is too specific and the last too abstract for our purposes. In this chapter, let us explore the symbolism and meaning of music mostly in a societal context. The most effective first step may be to pair music, one by one, with related forms of communication: ideas, drama, dance, and multiple arts. Music's meanings may thus be made clearer through these familiar contexts.

Ideas

Music is placed in the context of the impalpable through ideas: storytelling, music reflecting itself, song, and grand abstract principles.

Words alone tell a story in one way. Music without words can tell a story in a different way. Each of the non-verbal arts has its own means of communication, and each creates its own effects. Even today, the story of a prehistoric hunt recounted in wall paintings in a cave in Lescaux, France captures our imagination.

Any music that is meant to point to something outside itself is program music. Extreme examples attempt literally and specifically to paint in tones a picture or a story, hence the expression tone painting. The opposite of program music is "absolute" music, which is music without any extramusical association supplied by its composer.

Much of the symphonic repertory tells a story, as a glance at titles suggests:

Till Eulenspiegel's Merry Pranks, by R. Strauss (1894–95)
The Sea, by Debussy (1903–05)
Pacific 231 (the name of a train), by Honegger (1923)
Pastoral Symphony, by Beethoven (1808)

Subtitles given by the composers to individual movements or sections of these pieces are often even more explicit. Debussy captioned the movements of *The Sea* "From Dawn to Noon on the Sea," "Play of the Waves," and "Dialogue of the Wind and the Sea." Beethoven, although cautioning that he intended "expression of feeling rather than tone painting," was nevertheless literal in his storytelling; written indications for the *Pastoral* movements are "Awakening of Cheerful Feelings on Arrival in the Country," "Scene by the Brook," "Peasants' Merrymaking," "Storm," and "Shepherds' Hymn, Joy and Gratitude After the Storm."

Beethoven's first movement gives us a breath of fresh country air with a simple melody accompanied by a bagpipe-like drone.

The murmuring and rustling of soft instruments accompanies a melody that now flows in rivulets, now in broad streams in the "Brook" movement.

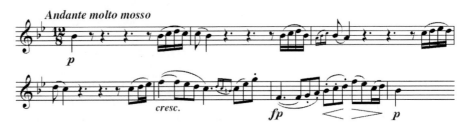

Two country dances depict merrymaking in the third movement, and the second dance's rhythms seem especially peasant-like.

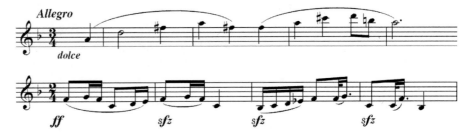

**program music
tone painting
absolute music**

 **Beethoven,
Pastoral Symphony**

In track **1,** the first movement gives us a breath of fresh country air, with the melody accompanied by bagpipe-like drone. In track **2,** the murmuring of soft instruments goes with a melody that flows in the "Brook" movement. The third movement occurs in tracks **3** and **4,** depicting two country dances, one lilting, the other peasant-like. Track **5** presents the famous "Storm" movement, with especially strong timpani accents portraying thunder and lightning flashes. In track **6,** a magnificent and often-heard finale returns to calm after a storm, reflecting a hymn-like serenity.

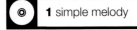 **1** simple melody

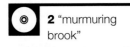 **2** "murmuring brook"

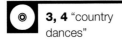 **3, 4** "country dances"

The angular melody of the fourth movement leaps in jagged lightning flashes,

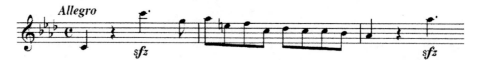

and the calm, simple hymn of the shepherds

paints a scene of gratitude and joy after the storm, in the last movement. The tone painting throughout this symphony varies in degrees of literalness, from horn-calls and bird calls being specific, to a general mood of calm or agitation being less so, to passages of purely musical interest. Some listeners prefer knowing as much as possible about the program attributed to a piece of music, while others think any and all programs hinder their enjoyment of the music itself.

In American folklore, the train has long stood as a vivid symbol for the yearning to get away. The midnight special and you-can-hear-the-whistle-blow images in many a folk song were highly suggestive. Often, the temptation to influence the music of a song by re-creating train sounds has proved irresistible. "Gospel Train," a song performed by the Little Wonders of Havre de Grace, Maryland, in a popular Black gospel (religious) style of the 1930s and 1940s, goes beyond imitating train whistles, bells, and engine noises when one of the vocalists imitates a harmonica imitating a train, cupping his hands over his mouth as though playing a harmonica.

Unlike the Little Wonders, French composer Arthur Honegger had no spiritual message; he wished only to make the symphony orchestra simulate a train ride. Honegger's *Pacific 231* (1923) begins with the slow, wheezing sounds of engine getting under way, attains the rapid, busy sounds of full speed midway in the piece, and brings the machine to a full stop at the end, with a final hiss of escaping steam wittily closing the piece. Composers and musicians in many cultures delight in imitations of these types. Whether the result is more akin to parlor games or high art depends on the composer's subtlety and sophistication. Beethoven's *Wellington's Victory* (1813) is direct in portraying the sounds of battle. George Crumb's *Music for a Summer Evening (Makrokosmos III),* for two amplified pianos and percussion, is more suggestive in simulating the quiet sounds of the night.

The symphony orchestra is not the only medium of tone painting. European vocal pieces of the 16th and 17th centuries sometimes imitate cuckoo calls and the cries of street vendors. Rain-forest people of Central America imitate the buzzings of bees in a honey-hunting song, and barnyard noises were a favorite device of Dixieland Jazz in the post-World War I period. On the surface, these examples of musical storytelling strike us as clever, and sometimes ingenious. More deeply, they show music's capacity to transform a mundane event into an artistic experience.

Quotation

Another direction music may point to outside of its immediate self is to another piece of music. Musical quotations, like rhetorical quotations, can be suggestive, satirical, or simple-minded. Old silent film scores strung together pieces from the well-known repertory: "Hearts and Flowers" for a romantic scene, say, and Rossini's Overture to his opera *William Tell* (1828) for a chase scene. In all European classical music, the melody probably quoted the most often is the Chant melody to the *Dies irae* (Day of Wrath). The text to the *Dies irae* is from the Mass for the Dead; the second verse begins with the words "Day of Wrath, day of dread;

Dies Irae quotations

calamity and misery. . . ." The chant melody alone has no intrinsic meaning were it not for this association with the Day of Judgment. Berlioz's *Symphonie fantastique* (1830), Liszt's *Totentanz* (1849, rev. 1854), and Rachmaninoff's *Rhapsody on a Theme of Paganini* (1934) are only a few of the many compositions that exploit the *Dies irae* melody with its association of death and damnation. A musical quotation used in this way is a kind of shorthand, taking advantage of an established connection with the outside world rather than creating a new one.

ridicule A playful or spiteful composer can take a swipe at another composer by a well-placed musical quotation. A harsh intent can be devastating. During the Second World War, the Seventh Symphony (1941) by Shostakovich, a Russian composer, attained a huge popularity in Europe and America owing to its representation of the heroic defense of Leningrad and by its parodying of a German march. The Hungarian composer Béla Bartók, himself a refugee from the war, was chagrined with the popularity of Shostakovich's symphony and parodied the parody. A short melody prominent in the first movement of the Shostakovich work:

is quoted two years later by Bartók in the fourth movement of his *Concerto for Orchestra* (1943), now transformed into circus music and greeted by mocking laughter and a loud Bronx cheer from the orchestra.

parody Where Bartók ridiculed by selected quotation in the 20th century, Mozart in 1787 composed a whole piece, the purpose of which was to poke fun at the musically challenged in his *Musical Joke* for string quartet and two horns. A musical quotation may take up a particular melody or an entire style, and even more. In 1920, the French composer Maurice Ravel completed an orchestral piece, *La Valse,* a profound parody not only of the waltz but also of an entire crumbling (Austrian) society and an era.

folk element In the early 19th century, Beethoven borrowed from another style, folk music, in some of the examples above from his *Pastoral* Symphony. The nationalistic composers of the 19th and 20th centuries have relied on extensive popular and folk borrowings, from Chopin (Polish) and Dvořák (Bohemian) to Bartók (Hungarian) and Stravinsky (Russian). More recent examples occur in the Peoples Republic of China, where folk arts carry a political message. Japanese traditional *Kabuki* opera may quote a famous instrumental classic from the *koto* zither repertoire, and the audience will recognize it immediately. A Turkish traditional *ney* (flute) player startles an Istanbul audience in the midst of a long improvisation by weaving the "Ode to Joy" theme from Beethoven's Ninth Symphony into an otherwise Near Eastern context. East borrowing from West is fair play turnabout; at least since Jean Jacques Rousseau (18th century), Europeans have been borrowing from the East.

The more knowledgeable listener is likely to recognize quotations. In literature, a thousand English pub (neighborhood bar) closings are recaptured for those who know, when T. S. Eliot quotes "Hurry up please, it's time" in his poem "The Waste Land." And in drama, every new James Bond film reawakens memories of all its predecessors in the series—and beyond, to the myth echoing down the centuries of

the clever, indestructible hero. The Bond films also spoof other films and sometimes include musical quotations as well, such as with the popular television commercial Marlboro Country theme for an Argentine *gaucho* cowboy scene in *Moonraker*. Every work of art is linked, whether by direct quotation or indirectly, to ever-widening circles of relationships with other works.

Words

words and music
interrelations

Of all music's associations with other arts, the one with words is the most important. After all, most of the world's music is song—music with words. Song collections, from the *Song of Songs* of the Bible to program notes for a pop music CD, often consist of only words. A song may be a story with a musical vehicle or a piece of beautiful music with added words. We all know of songs in which the lyrics are direct and simple, like the Arab layali in which the text "ya layl(i), ya 'ayni" (oh, night, oh, my beloved) is repeated over and over. In such instances, the musical setting and the singer's art reign supreme. Conversely, a mere vamping accompaniment or a monotonous melody is deliberately plain, to avoid distraction from the main interest, the message or the story, as in the Native American healer's chant or a vaudevillean's patter song. In Mendelssohn's oratorio *Elijah* (1846), the simplest melody sets off the importance of the words "Behold, God hath sent Elijah the prophet."

Occasionally, both poetry and music are of equal beauty and fit each other with such harmonious agreement that the wedding of the two arts is perfect. Schubert's *Erlking* (1815) is such a marvel; when interpreted by equally matched performing artists Dietrich Fischer-Dieskau and Gerald Moore, the artistic convergence is breathtaking. The song is also narrative, depicting by both voice and piano a terrifying ride in the night.

Professional epic singers in Korea are said to need the strength of several oxen. The performances last for hours and the recitation of the story requires in turn heroic declamation, song, heightened speech, and pantomime. This art, called *p'ansori,* is entirely programmatic.

Song has proven over the centuries to be an excellent means of eliciting an inflammatory or hortatory message. In protest song, words call out to overthrow the oppressor, to seek justice, to right wrongs. The music can be an effective cultural bonding agent when cast in the style most dear to the protestors. "Venga Jaleo," a song of the Republican side in the Spanish Civil War, asks for a machine gun in a popularized, quasi-flamenco style. Ray Charles, in the mainstream style of 1970s rhythm-and-blues, cries out for the "hungry little child" and asks "How can you find a job if there just ain't one?" in *Hey, Mister.* The music of *Hey, Mister* could have almost any text, protest or no, but here the message of the protest dominates the music.

Language, even when used poetically, is one of the most concrete modes of human communication. Music, no matter how programmatic, is an abstract means of expression. The complementary relationship between language and music may explain the affinity of one for the other and a seemingly universal need for song.

The Supernatural

Music in the prehistoric past probably began as an attempt to give super-natural utterances to important words and ritual occasions. Like poetry, drama, and dance, the art of music exerts a mysterious power. It can heal when we are sick, as does the Siberian shaman's ritual exorcism or, in theory at least, the piped-in

Muzak music in an American hospital ward. It heightens our religious fervor, as does the cantor's voice at Rosh Hoshanah or the voudun (voodoo) religious ceremony of Haiti. Profound, primordial human feelings are bound up in the mixture of music and the supernatural.

Winter Solstice ritual

The natural cycle of the seasons calls for supernatural observance. The New Year, or mid-winter solstice, is ritually important in many cultures. We burn a yule log and sing Auld Lang Syne in one culture. In Hungary, the Csángó people have preserved a pre-Christian winter ritual—a group of young people go from house to house, reciting magical verses to bring bountiful crops for the coming year:

> Good health! Good fortune! We've been sowing the fine clean corn in the wide fields, in rows of twelve, with twelve plows . . . Later, we returned to the field—with the master on his horse. And like a benediction from heaven, we received three measures of corn.

**Csángó ritual
patriotic purpose**

They use instruments of magical import to raise the words to supernatural purpose: clappers, metal bell, flute, horn, and an ancient drum that is rubbed, the "bull roarer." There is some similarity in the spiritual sustenance of this ritual for the Csángó people and the annual Fourth of July concert on the Mall in Washington, D.C. Patriotic speeches are made, the National Symphony plays "The Stars and Stripes Forever," the audience dances, and fireworks explode over a mass communion. One ritual celebrates the mysterious, supernatural fecundity of the earth, the other celebrates the deeply-felt, supernatural symbolism of a nation's social bond.

In advanced-industry cultures, spiritual beliefs usually are brought out through music only on special occasions. But among traditional Native North Americans, very little music is casual or nonreligious. Recognizing and respecting the spiritual forces in every facet of life are the primary reasons for music. In a Yaqui deer dance song for the Spring Equinox, the magical power of the words takes precedence over musical interest. The highly spiritual world view of the Native American creates a music of profound importance to his or her daily life, but this importance is not easy for an outsider to understand. In some tribes, a man's wealth is reckoned by the number of songs he "owns"; in other tribes, songs are *learned* in dreams. If the Non-Native American finds the *music* monotonous, it is probably because the transcendent meaning of the song is found in the words.

Supernatural music can also be elaborate and complex. Masses composed for the church by Haydn, Beethoven, Schubert, and Verdi are among the glories of European art music. Musicians of South India will tell you that every piece in the classical repertoire is, without exception, devoted to God. The Turkish *Mevlevi* brotherhood developed a music from the 16th to the 19th centuries, a music acknowledged to be the highest and most refined expression of Ottoman classical music. Whether plain or ornamental, music is a key ingredient in spiritual devotion. Can there be a church, temple, mosque, cult, medicine man, shaman, or faith-healer without music?

Music in the context of ideas we have considered above—tone painting, poetry, religion—serves as the intangible. Music also serves more tangible functions, as in its association with its sister arts, especially drama and dance.

Drama

cinema

Film is one of the most popular dramatic media in the world today. Nearly every film has background music. What function does this background music serve?

John Williams, composer of scores for *Star Wars*, *Close Encounters of the Third Kind*, and many other films, thinks of his art as complementary to the drama, not slavishly descriptive:

> In a film, music has the place of what novelists call hidden dialogue. The music is what *isn't* said. The actors are saying one thing, the locations another, and the music something else.

Listen to the music in the next film you see (especially recommended if the film is boring). Does a discord warn you that a seemingly harmless bystander is really a pod-person? Does a quotation from a popular piano concerto lend a high-class tone? Does a lush, romantic swelling in the orchestra betray the romantic swelling in the hero's heart?

radio

In the old radio shows such as *Captain Midnight, The Lone Ranger,* and *Sergeant Preston of the Yukon,* musical backgrounds and bridges were as essential to the dramatic mood as were the sound effects. Radio's audio-only nature makes it an ideal medium for maximum musical effectiveness in drama.

Silent films were incomplete without the music of a pianist or organist. The musical cliché of the trade was the classic villain's giveaway as much as the leering and the stroking of his mustache:

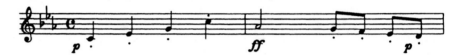

television

Television, in fact more popular worldwide than film, also offers opportunities for observing the interrelationship of the visual mode of communication and the aural, including music. Commercials differ from the drama by being more expensive, hence more concentrated. Music in a commercial therefore needs to be optimally effective. Recognition is virtue, as are symbolic associations and emotional punch. Ask a folk-music lover what he or she thinks of the appropriation of bluegrass music in commercials to lend them the authority of down-home, old-fashioned America. The recognition factor for themes and songs from television is surely higher than for any other music in modern American culture.

architecture

A rare but instructive context for music is that of architecture. There have been some singularly appropriate combinations of the two. At the end of the 16th century, the organist of St. Mark's Cathedral in Venice composed an unusual piece for opposing brass choirs. The organist, Giovanni Gabrieli, made use of the design of the cathedral, placing his instruments for best stereophonic effect. Centuries later, the French architect Le Corbusier was asked to conceive a mixed arts spectacle for the Brussels World's Fair in 1958. His protégé, the composer/architect Iannis Xenakis, executed for Le Corbusier a concrete pavilion designed so that all surfaces were hyperbolic or parabolic. Xenakis installed 400 speakers around the inner surfaces of the pavilion and played his tape composition *Concret P H* (1958) to express in music the roughness of the concrete texture and its coefficient of internal friction. The music, he said, was "lines of sound moving in complex paths from point to point in space, like needles darting from everywhere."

Dance

physical movement

If music originated in early humanity's desire to elevate words to another dimension, dance surely was at the very least close behind. The universal impulse to respond kinetically shows up in a baby's natural tendency to move to musical stimuli. Even before being able to walk, he/she dances. In the broadest sense, dance can include marching, sports, work, and musicians' gestures, especially those of singers and conductors.

art in time

Dance, like music, exists mainly in time and is therefore rhythmic. Dance "likes" music; silent dance is rare. Like music, dance also reaches basic human feelings of ancient origin. When we participate in a group doing the *hora* folk dance or the latest popular dance, we experience an exhilarating state of subsumption into the community. The individual disappears. In each culture or subculture, there is a music that is just right for dance. The more right the music, especially the rhythm, the more difficult it is to resist dancing. At a good rock concert, it would be impossible to prevent the patrons from dancing in the aisles. At Mardi Gras time in Rio de Janeiro, who could quietly stay indoors while the bands play in the streets and people dance all night?

Because dance involves a physical response in time, it is more closely linked to music than is drama. Dance and music are so close that they sometimes intermingle. In American tap dance or North Indian classical dance, *kathak* (COT-ock), the feet of the dancer beat out rhythms like instruments. In all dance, the silent rhythms of the limbs and torso are a quasi-musical element. In Ewe dance of West Africa, the counter-rhythms of the dancers' bodies are like additional layers of instruments in the ensemble. Though silent, their forcefulness matches that of the drums.

Balinese *legong*
Japanese *Echigo Jishi*

Professionalization of dance separates participants from passive spectators, as in ballet, pantomime, Korean court dance, Balinese *legong* (LAY-gong), and classical dance of South India based on the *Nātya-Sāstra* (NAT-ya SHAS'truh) of Bharata. The spectators may be better able to see and hear, but they are inhibited from their natural kinetic response to the music, except vicariously. The music in these genres is likewise performed by professionals. If such music is isolated from its dance context, it may lack logical continuity. Some composers recycle their dance music by stitching together a concert work, as is done with *Echigo Jishi* (EY-chee-go JEE-shee), a lion dance from the Japanese *Kabuki* theater, or as did Darius Milhaud, a 20th-century French composer, with his *La Création du monde*. If we have seen the original dance with the music, we are reminded of it in the concert version and replay it in our imagination.

The union of music and sports is ancient. Anatolian wrestling, Afghan polo, Thai boxing without music are as unthinkable as American college football without a band. Music is not mere decoration to these sports but integral to a multi-layered experience.

Trumpet-and-timpani fanfares have long heralded pageantry in the symbolism of European culture.

Synergism

Multiple arts tend towards synergism: the total effect exceeds the sum of individual parts. A rock concert mixes music with strobe lights, stage sets, grotesque masks, smoke and fog machines, and instrument-smashing pantomimes (to say nothing of song lyrics, the words) for audience approval, although the individual elements would be intolerably weak in isolation. Weak or not, the piling up of many arts into a single event sets music in a different light, compared to the purely musical event. European opera is usually created from a collaboration between a librettist and a composer. For *Don Giovanni,* the initial words were supplied by Lorenzo da Ponte and the music by Mozart. The final production, though, added to these arts those of costuming, staging, dance and makeup. A Javanese *Wayang* shadow play synthesizes the puppeteer's songs and those of a female soloist and a male chorus with a large *gamêlan* orchestra. Mythology of the ancient Javanese and of India permeates the puppet drama. Classical Javanese poetry is sung by the puppeteer. Dance, ethics, color, and shadow are all woven into the grand design.

*Gesamtkunstwerk*
music drama

The 19th-century German composer Richard Wagner could not accept the state of opera in his time. He believed that traditional opera artificially separated one art from another. Wagner's *Gesamtkunstwerk* strove to re-create the dramatic concept of a total art work in which all the elements would be integrated and each would then reinforce the impact of the others. His music dramas, such as the *Ring of the Nibelungs* cycle, attempted to fuse music, German mythology, poetry, costuming and staging, dance and even architecture and painting, into a seamless whole, a "music of the future." In this example, a single genius carried the day. (See the discussion of Wagner and the *Gesamtkunstwerk* in Chapter 9.) Other successful combinations of many arts had the good fortune to count on the happy collaboration of many geniuses. In the early 20th century, the Russian impresario Sergei Diaghilev rounded up the leading artists of the time for his various Parisian productions with the result that his Russian Ballet company, *Ballets Russes,* became one of the most brilliant artistic collaborations in Western history.

Asian musical theater, such as the Beijing Opera or the Javanese shadow-puppet drama, tends to combine many arts on equal footing: music, dance, acrobatics, pantomime, literature, and costuming. The Japanese *Kabuki* drama, a spectacular example of this principle, has appealed to Japan's merchant class since the 17th century. Entering the famous Kabuki-Za Theater in Tokyo, you will observe at least five arts, each a democratic complement to the others.

The arts communicate to us through our several senses: sight, hearing, and by extension, touch and kinetic sense. A complex but unified event confronts our cognitive senses and our memory on many levels at once. As an ideal, these marvelously complex confections of multiple arts show off music in such a way that our perspective of music itself and the other arts as well is enhanced.

Notation: A Means of Communication

Musical notation resembles speech notation (writing) because it preserves an aural communication. But there is also a spoken, "oral" notation for music. "Do-re-mi-do" is an example of oral musical notation. Thus, music, an aural communication, may be represented by (1) silent, visual symbols (notation), or by (2) spoken oral sounds. Speech is usually represented only by visual symbols (but for a crossover, see "talking instruments," Chapter 13).

abstract notation
and tablature notation

Visual music notations are ordinarily of two types: **abstract** and **tablature**. The five-line staff notation of Western classical music gives an abstract prescription of notes for the player to sound. By contrast, tablature notations tell the player directly which finger to place and where, as with guitar symbols in popular sheet music.

staff notation

Traditional Western staff notation has a long history. Greek and Hebrew speech recitation symbols from the distant past gradually developed into general symbols of melodic motion and inflection, called neumes (pronounced NOOMS).

/ ʌ ʌ ∿ ♩♩ ⸰⟋ ⟋⸫ ⸗

pitch identification clef

During the 11th century, efforts were made to give these symbols more accuracy by employing staff lines. Although pitches were not standardized (such as the 20th-century perception of a "440 A"), distance relationships between any two or more pitches could be more precisely determined by means of staff lines, so long as there was a starting point. For the starting point, a staff line in the 11th and 12th centuries was sometimes colored red to signify "F," or yellow to signify "C." Distance relationships with other pitches on the other lines could then be followed. A different contemporary practice, however, took hold: the letters F or C were placed on a line, for similar purposes. Later, the letter G was also used. G, F, and C are called "clefs" in modern usage. Pitches go from A to G in our alphabet.

Our modern clefs evolved from the original staff letters:

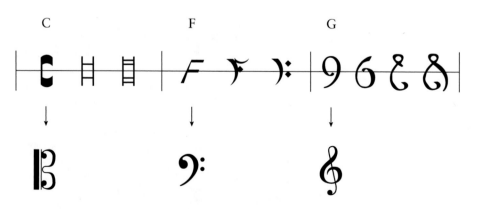

Traditional Staff Notation

staff

The placing of notes on a staff of five lines and four (or six) spaces indicates the relative pitches of those notes. Precise pitches are determined by the clef at the far left side of the staff:

G *or* TREBLE CLEF On 2nd line up, fixing that as Treble G

F *or* BASS CLEF On 2nd line down, fixing that as Bass F

C *or* ALTO CLEF On 3rd line, fixing that as Middle C

See Appendix I for details of pitches and durations (time-values).

Other Notations: A Sampling

guitar tablature

Guitar players sometimes use a symbol called "guitar tablature." A small diagram represents the strings of the guitar and shows which frets the player should press and which frets to omit. In jazz or popular music, the guitarist can produce the chord needed for that point in the music. If the composer wants a "B-flat major-7th" chord (B♭ M7; see Chapter 5), the score will show the symbol, or tablature, for that chord above the melody at that point:

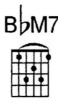

Even if not familiar with the "B♭ M7" chord, the guitarist can quickly see where to put the fingers.

Javanese *gamĕlan*

Javanese court *gamĕlan* notation likewise provides only a basic melody with a number assigned for each pitch (1, 2, 3, etc., similar to the Western *do, re, mi*) and a few outside clues as to the form a piece should take. The player of each instrument knows how to elaborate on that basic melody according to the instrument's role, much as the piano, bass, saxophone, and other jazz instrumentalists interpret their parts from a "fake sheet."

jazz "fake sheet"

Musical notations have always suited the particular music involved. A jazz "fake sheet" ("lead sheet") gives only the basic melody and letter names for the harmonies. (For a "7" chord, see Chapter 5.) The piano, the string bass, and the saxophone must each extrapolate from that notation to "realize" the different functions for each instrument:

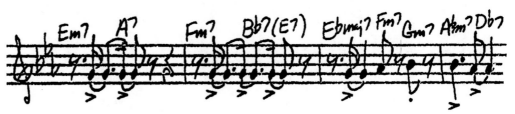

Moment's Notice, Coltrane

cipher notation

 A Japanese song notation uses numbers to denote scale degrees (see Chapter 4 and the Glossary), and numbers tend to speak a universal language. The melody of the song appears in numbers and is thus called **cipher** (number) **notation.** The Japanese characters under the numbers give the text of the song.

 The tune on the following page is an arrangement of an American piece; the arrangement dates from the Meiji (MAY-JEE) Period, occurring at the end of the 19th century when Japan was opening up to Western influences and, coincidentally, Western painters and poets were eagerly exploring and assimilating the art and ideas of the Far East. See if you can coordinate the cipher notation with the staff notation.

 Other notations are discussed elsewhere in the text, and the Western *solfège* syllables appear in Appendix III.

遠 征 の 夕

{ト 調 長 旋 法}

(四分二拍手)

```
3   3   2 . 1 | 6   6   1,  | 5   1   2 . 3 | 2 . 0 |
ケ  サ  タ  チ    イ  デ  シ     シ  ラ  ミ  子    子

3   3   2 . 1 | 6   6   1,  | 5   3   2 . 2 | 1 . 0 |
ハ  ル  バ  ル    コ  ト  ニ     ミ  カ  ヘ  レ    ベ

2 . 2   1   2 | 3 . 3   2,  | 5 . 5   6 . 6 | 5 . 0 |
カ  が  ヤ  ク    ユ  フ  ヒ     カ  ゲ  ハ  ゲ    シ

5 . 5   3   5 | 6 . 6   5,  | 3 . 3   2 . 1 | 2 . 0 |
ヤ  が  ノ  ル    フ  チ  ノ     カ  ン  ベ  ン    ニ

3   3   2 . 1 | 6   6   1,  | 5   3   2 . 2 | 1 . 0 ||
シ  ホ  カ  ゼ    ア  ラ  ク     ミ  ダ  レ  ツ    ツ
```

◎大東軍歌　花の卷　遠征の夕

KEY WORDS

Absolute music, cipher notation, note, program music, staff notation, synergism, tablature

SUGGESTED READING

Adorno, Theodor W. *Introduction to the Sociology of Music.* Trans. by E. B. Ashton. New York: Seabury Press, 1962. (A cornerstone of any investigation into the relationship between society and music. Though the writing sometimes appears didactic and one must sift through Adorno's customary prejudice against all forms of popular music, he also provides a substantial amount of material to discuss.)

Blacking, John. *How Musical is Man?* Seattle: University of Washington, 1973.

Boatwright, Howard. *Introduction to the Theory of Music.* New York: Norton, 1956.

Dahlhaus, Carl. *The Idea of Absolute Music.* Trans, by Roger Lustig. Chicago: University of Chicago Press, 1989. (Dahlhaus discusses the recent emphasis in music aesthetics on the "absolute," which implies more than simply instrumental music.)

Mellers, Wilfrid. *Music and Society.* New York: Roy Publishers, 1950. (Though somewhat dated, this book makes intriguing connections, particularly in the first chapter, that equate some aspects of music with belief in God and the feeling of oneness with the universe.)

Merriam, Alan P. *The Anthropology of Music.* Evanston: Northwestern University Press, 1964. (The classic text exploring the many ways in which several cultures use and conceptualize music.)

Meyer, Leonard B. *Emotion and Meaning in Music.* Chicago and London: University of Chicago Press, 1956. (This is a first-rate book by an excellent scholar sympathetic to music.)

Rastall, Richard. *The Notation of Western Music.* London, Melbourne and Toronto: J. M. Dent & Sons, 1983. (This book provides a clear summary of the development of notation in the Western tradition.)

Read, Gardner, *Music Notation: A Manual of Modern Practice*. Second Edition. New York: Taplinger Publishing Company, 1979.

"Universals" (special issue). *The World of Music: Intercultural Music Studies* 19/1–2, 1977; articles on notation in *The New Grove Dictionary of Music and Musicians* and *The New Harvard Dictionary of Music*

SUGGESTED LISTENING

Storytelling	*La mer* (The Sea), Debussy; *Symphony No. 6 in F Major*, Beethoven; *Till Eulenspiegels lustige Streiche* (Till Eulenspiegels's Merry Pranks), R. Strauss; *The Little Wonders*, Kaleidophone KS 801; *Pacific 231*, Honegger; *Wellington's Victory*, Beethoven; *Music for a Summer Evening (Makrokosmos III)*, George Crumb; "Thyrsis, Sleepest Thou," John Bennet; *Pygmies of the Ituri Forest*, Folkways; "Barnyard Blues," Original Dixieland Jazz Band; Original Radio Broadcasts: *The Lone Ranger, Sergeant Preston of the Yukon, The Shadow*; *Peter and the Wolf*, Prokofiev.
Quotation	"*Dies Irae*," Gregorian Chant, Archive ARC 3031; *Totentanz*, Liszt; *Symphonie fantastique*, Berlioz; *Rhapsody on a Theme of Paganini*, Rachmaninoff; *Symphony No. 7, "Leningrad,"* Shostakovich; *Concerto for Orchestra*, Bartók; *Ein musikalischer Spass* (A Musical Joke), Mozart; *The Theme Scene*, Henry Mancini, RCA 3052; *Unbegun Symphony*, P.D.Q. Bach.
Words	*Songs in the Key of Life*. Stevie Wonder; *Taqsīm and Layālī: Cairo Tradition*, Philips/UNESCO 6586 010; *Elijah*, Mendelssohn; *Erlkönig* (Erlking), Schubert; Pansori; *Korea's Epic Vocal Art*, Nonesuch H-72049; *Hey, Mister*, Ray Charles; *Qur'an* (Koran) from the Islamic Cultural Center, New York.
The Supernatural	Hungarian mid-winter ritual on *Musique populaire hongroise*, OCORA OCR 54; *Stars and Stripes Forever*, John Philip Sousa; *Songs of the Yuma, Cocopa, and Yaqui*, Library of Congress AFSL 24; *Turkey I: Music of the* Mevlevi, Bärenreiter/UNESCO 30L 2019.
Drama	*Star Wars*, John Williams.
Architecture	*Sonata pian'e forte*, Giovanni Gabrieli; *Concret P H*, Iannis Xenakis.
Dance	*Vyjayanthimala: Bharata Nātya, Dance Music*, EMI-Odeon SMOCE-2005; Kabuki: *Classical Theater of Japan*, available from Japanese consulate or embassy; *The Moor's Pavane*, Jose Limón dance company.
Sports Music	*Bugler's Dream* (Olympic fanfare), Leo Arnaud, *U.S.A.*, Angel S 36936; *Folk Music from West Java*, OCORA OCR 46.

HELPFUL VIEWING

Chunhyang. Videodisc. A Taehung Pictures production, prod. by Lee Tae Won, dir. by Im Kwŏn-t'aek, adapted for the screen by Im Myoung-kon (originally released as a motion picture in 2000, Letterbox Widescreen version). Part of the International Cinema series. Imprint: New Yorker Video: 82601, © 2001. [116 minutes]

Humor in Music (Young People's Concerts, 10 videos, 25 programs). Part of a videocassette (with *What is Melody?*). Script by Leonard Bernstein, originally broadcast on television on 28 February 1959 and recorded with the New York Philharmonic at Carnegie Hall. Prod. CBS Television Network; prod. and dir. by Roger Englander; Exec. Prod. Harry Kraut; dist. Leonard Bernstein Society. [60 minutes]

DVD: *Humor in Music*. Disc 2 of the 9-disc set, *Leonard Bernstein's Young People's Concerts*. ISBN: 0769715036. West Long Branch, NJ: KULTUR VIDEO: D1503, [2004].

"Sound, Music, and the Environment," *Exploring the World of Music*. Videocassette 1 (of 12). Fritz Weaver, narrator. Prod. Pacific Street Films and the Educational Film Center;

series prod. Steven Fischler, Joel Sucher. Prod./dir. Martin D. Toub. Imprint: Annenberg/CPB Project, © 1998. [32 minutes]

"The Transformative Power of Music," *Exploring the World of Music.* Videocassette 2 (of 12). As above. [30 minutes]

"Music and Memory," *Exploring the World of Music.* Videocassette 3 (of 12). As above. [30 minutes]

What Does Music Mean? (Young People's Concerts, with Leonard Bernstein and the New York Philharmonic, originally broadcast on 18 January 1958.) Videocassette (together with *What is Orchestration?*) [see Chapter 2] A CBS Television Network production. Imprint; Sony Classical, 1993. [60 minutes; *What is Orchestration?* 59 minutes]

DVD: *What Does Music Mean?* Disc 1 of the 9-disc set, *Leonard Bernstein's Young People's Concerts.* ISBN: 0769715036. West Long Branch, NJ: KULTUR VIDEO: D1503, [2004].

1
REVIEW SHEET

Short Answers

1. Name at least five arts that may be combined with music.

2. Specify the advantages and disadvantages of staff notation, tablature, and cipher notation.

Short Essays

1. Is music an "invention" of humanity?

2. What function(s) does music serve in society today?

2

TIMBRE

Every musical thought needs an instrumental or vocal medium for it to be realized in performance. The tone color, or "timbre," of the chosen instrument then becomes as important an ingredient in the musical confection as rhythm and melody. In some cultures, the option of choosing tone colors resides with the composer; listen to Beethoven's Fifth Symphony or Gershwin's *Rhapsody in Blue*. In other cultures, socially defined norms of sound quality are traditionally more restricted; listen to a Delta blues or a Swiss yodel.

heredity vs environment

Think of any timbre as the product of two factors, one inherent, the other cultural. The anthropological parallel is heredity and environment. A fertilized human ovum contains a genetic code that fixes the species, sex, size, body type, and many features of the adult-to-be. These fixed hereditary elements in the human are comparable to the physical construction of a musical instrument. Certain natural tendencies and limits seem obvious. But once born, a person is conditioned by the society into which he or she is cast. Moreover, the life history of each individual is unique. The instrumental equivalent of human environmental influences is the cultural and individual choices of timbre and playing or singing style from among the many possibilities. A child is born male or female, but male or female adult roles are culturally conditioned and individually chosen. A clarinet has a single reed, a cylindrical-conical bore, a set of keys, and range limits. Compare the various timbres achieved by a classical clarinetist playing a Mozart concerto to that of a New Orleans funeral band clarinetist, or a Greek gypsy clarinetist from Epirus. Inherent factors determine the underlying unity, the sound of the physical instrument, while cultural factors show us the surface variety.

Since we have been talking about comparisons of instruments with human development, let us begin our survey of instruments with the most human of all instruments, the voice.

The Voice

Music probably began as heightened speech, and song (music and words) is universal. The voice carries a special emotional meaning that no other instrument has. Your favorite singer, be it Luciano Pavarotti or Sarah Vaughan, satisfies some deep human need that instruments lack.

child

One recognizes a friend's speaking voice, even over the telephone, partly by its timbre (quality). Singing voices are categorized on the basis of timbre as male, female, and childlike. Listen to a children's choir. Clear and silvery, the timbre is pure. The angelic impression comes from a lack of adult male voices in the low range. The high voices of the immature boys sound cherubic. This timbre was so appealing that castration was practiced from the 16th through the 18th centuries on Italian boy singers with promising voices. A *castrato* singer had the voice of a boy and the lung power of a man. At the height of their popularity, the castrati were lionized like today's rock stars. The last of the castrati, Alessandro Moreschi, was recorded before he died early in the 20th century.

Normal adult singing voices in European choral music are often divided into four main ranges, two female and two male:

Soprano	**female**
Alto (Contralto)	**female**
Tenor	**male**
Bass	**male**

This vocal paradigm provides a model for choirs of instruments as well. Finer classification of ranges is necessary for operatic roles. The baritone range lies between the bass and tenor, the mezzo soprano between the alto and soprano.

falsetto

Again, culture can partially thwart inherent genetic tendencies. Through projecting his head tones rather than chest tones, a male *falsetto* can sing alto or soprano like the *castrati,* but without the same power and stamina. Listen to counter-tenor Brian Asawa, a Mongolian long song, or certain African-American gospel groups and pop singers.

types

Operatic voices are also classified by inherent qualities other than range. A dramatic soprano and a heroic tenor project power. A lyric soprano is lighter, more melodious. The coloratura soprano's agile voice has a good high range; the basso profundo plumbs the subterranean depths.

stereotypes

These inherent voice qualities determine the singer's type of stage role. The bass of the title role in Mussorgsky's *Boris Godunov* plays Tsar of All the Russias. The dusky mezzo-soprano quality of the title role of Bizet's *Carmen* seems perfect for a gypsy cigarette-factory temptress. In Beijing Opera, voice-types also reinforce dramatic role-types. The Chinese audience knows by voice the old man, old woman, female, and warrior roles. The young man, *xiao sheng* (H'SEE-OW SHUNG) in Beijing Opera is dramatically represented by a voice that abruptly changes registers from high to low and back again, portraying the adolescent male's cracking voice.

ranges

Each voice has different ranges, or *registers:* high, medium, and low. For each register, the voice exhibits a somewhat different timbre.

cultural expectations

Every culture conditions its members to expect and produce sounds that bind its people together. From a variety of humanly possible sounds, a timbre peculiar to each culture or sub-culture develops.

Sprechstimme, rap

The voice is used musically in many ways besides singing. Everyday speech itself provides a kind of music. It has rhythm and tonal inflection. Whispering has rhythm. Heightened speech moves closer to singing: the rhythms are more regular and relative pitches more exaggerated. Listen to a good political orator or a Shakespearean actor's heightened speech. Rap singing, *Sprechstimme,* and operatic recitative use stylized rhythms and quasi-pitches closer to song. A continuum of vocal timbres thus runs the gamut from whispering to song:

whispering

 speech

 oration

 Sprechstimme

 recitative, rap

 song

The natural singing voice is altered by mechanical means in some cultures. Stevie Wonder's voice synthesizer (an electronic device) and the huge masks of ancient Greek drama are both voice-transformers. (See "masks" in the *Encyclopedia Britannica.*) So is the kazoo-like device used in a funeral ritual of the Dan people in West Africa. In that ritual, the voice is disguised by singing into a hollow bird-bone with a spider's web membrane at the other end (like a kazoo). As the body and face are disguised by paint and masks, the voice also undergoes a dramatic transformation.

pesinden singers

The most common transformation of the voice happens when the individual voice blends with a mass of others, all singing the same melody in unison. Unison choral singing is a sound common to almost all musical cultures and in Western music is known to us through Gregorian chant. The singing in the Javanese court *gamĕlan* combines many techniques and qualities in a single piece: a solo female voice, the *pesinden,* contrasts with the unison male chorus, punctuated by cries of indeterminate pitch and sliding ornaments by individual men. Communal timbre often has the same strong effect on us as does communal dancing.

classification system

Although the voice has unique expressive and emotional qualities, humans invented tools (instruments) to extend the capabilities of their voices and bodies. The Euro-American classification system organizes instruments into four categories—strings, woodwinds, brass, and percussion—according to their function in the symphony orchestra. The system adopted by German musicologist Curt Sachs and Austrian ethnomusicologist E. M. von Hornbostel (1914), traceable to an ancient Sanskrit treatise, the *Nātya-Sāstra*, modifies the traditional orchestral categories and gives them Latin-Greek names:

the *Nātya-śāstra*

Aerophones	*flutes, reeds, brass*
Chordophones	*bowed, plucked, and struck strings*
Membranophones	*drums*
Idiophones	*self-sounding instruments (cymbals, woodblock, etc.)*

In 1940, Sachs added the category of Electrophones, instruments in which the vibrations are produced by electrical means. Many now accept another category, Nature (examples appear below under that subheading). Other systems of classification, such as those based on material, or social function, or status, are also possible, but a modified Sachs-Hornbostel method appears here since it has a widespread acceptance.

Aerophones

Some of the most ancient musical instruments of humanity are aerophones, or "wind" instruments. A type of flute was played in paleolithic times and trumpets were in use in neolithic times. Wind instruments are a natural extension of the human voice and are powered by the force of life—breath. We can divide wind instruments into three groups: flute, reeds, and trumpets (or "brass").

Flutes:

side-blown	European flute, piccolo
duct flute	recorder
rim-blown	*shakuhachi*, panpipes

European flute

Flutes come in several shapes and sizes, but most are long tubes. All flutes are sounded by the player blowing across an edge; the homemade version of this is the soda bottle you blow across the top. The English poet Shelley caught the essence of the European flute: "I nursed the plant, and on the . . . flute Played to it . . . Soft melodies" (1822). The European flute has many finger keys, its timbre velvety in the low register, brilliant in the upper. In jazz and popular orchestras, the flute is also used for its "soft melodies" and agility. The piccolo, a miniature version in a much higher range, is shrill and can cut through the sound of the entire orchestra or band.

recorder "whistle flute"

The recorder and its relatives are also flutes, but recorders have a duct that directs the breath to the sounding edge. The homemade version of this is the willow whistle. The modern flute is metal, but Renaissance and Baroque recorders are wooden. The mellow, warbling voice of the recorder was used at one time to teach pet birds to sing; thus, an Elizabethan madrigal invites a "sweet bird" to "tune to us . . . thy shrill recorder" (1603). A *consort*, or choir, of recorders, such as those played during the Renaissance, ranges from sopranino about the length of your hand, to bass, your seated height. Many Baroque compositions for "flute" were intended for the alto recorder, the *flauto dolce*, or "sweet flute."

rim-blown flute

You play the classical European flute by holding it horizontally (transversely) and blowing across the edge of the blowing hole on its side. You play a rim-blown flute holding it vertically or obliquely, blowing across an edge at its end. Rim-blown flutes are played in the Balkans, the Near East, and throughout Asia. With the rim-blown flute, you have good control over the pitch; the Japanese *shakuhachi* has only five holes but you adjust the airstream to get more than thirteen notes to the octave.

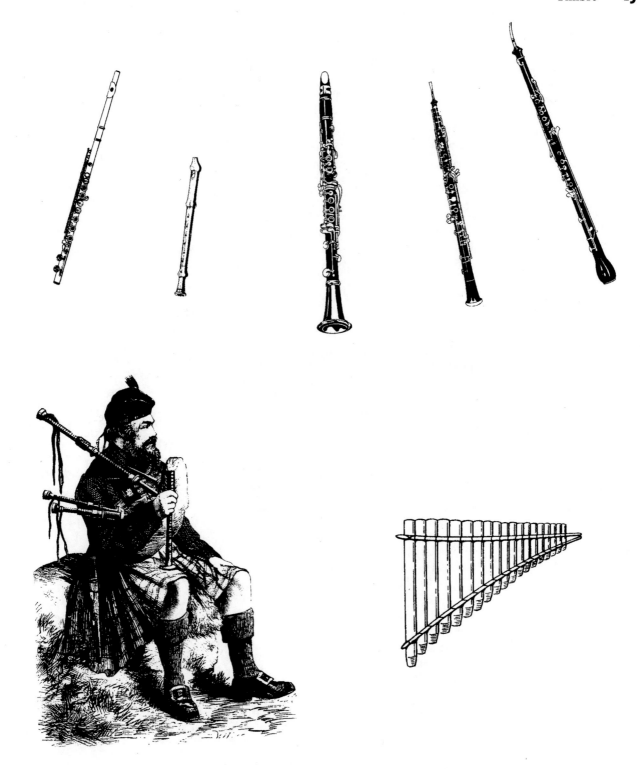

Aerophones: Flutes and Reeds

Top row, left to right: flute, recorder, clarinet, oboe, English horn.
Bottom row: bagpipe, panpipes.

7 Romanian panpies: "Doina"

Aerophones have subcategories of flutes, reeds, and brass. Flutes can be side-blown, duct, or rim-blown. Panpipes are vertical, rim-blown flutes with a gentle, airy timbre. They can be traced back to ancient China and Greece.

clarinet

saxophone

shawms

The **English horn** is neither English nor a horn. It is an alto (medium to low) register oboe, a double-reed aerophone with a soft nasal timbre.

8 English horn: "Swan of Tuonela"

bagpipes

trumpet

Take some vertical, rim-blown flutes, each of which sounds one note, bind them together like a raft, and you have a set of panpipes. Ancient China and Greece had panpipes, and they are still played today in Africa, Romania, and the Andes. Panpipes called *sicu* from the Andean region of Peru survive from pre-Columbian civilizations, as do many transverse flutes in that region.

Reeds:

single reed	clarinet, saxophone
double reed	oboe, English horn, bassoon
other reeds	bagpipes

Reeds are usually divided into two groups, single and double. The European clarinet, a single reed, is almost as agile as the flute. The different timbres of the clarinet's registers are so unlike one another that they have separate names. The low *chalumeau* (SHAL-oo-MOE) register is mysterious and barks a bit, the high clarinet (*clarion* or *clarino*) register is as bright as a small trumpet. In different cultures, the clarinet sound varies. Physical changes also modify the sound, as when the player selects a softer reed, covers the holes, or varies the attack.

The saxophone, also a single reed, has a body made of brass, its sound midway between reeds and the brasses. The sax is adaptable in wind bands and jazz band, since it blends with both woodwinds and brass. It comes in many sizes, the most common being alto and tenor.

Double-reeds include oboes, bassoons, some bagpipes, and Asian outdoor shawms. Today's orchestral oboe typically has a sweet, rich sound; as early as 1794, an author mentions its "tender accents." The English horn, an alto oboe, plays "tender accents" with a melancholy tinge (listen to Sibelius' *Swan of Tuonela*). But the Asian shawms, the still living ancestors of the oboe, are raucous, imposing, and even fearsome. Ideally suited to broadcasting music outdoors, the Asian shawm sounds the alarums of war, heralds with pomp the arrival of a ruler, and announces weddings in villages.

The drone of the bagpipe is its distinctive feature. One or more tones are held continuously against a melody, a quality that led Shakespeare to declare "As Melancholy as . . . a Louers Lute . . . or the Drone of a Lincolnshire Bagpipe." Besides Lincolnshire and Scotland, bagpipes are native to India and North Africa, Italy and Poland, and many other countries. Most bagpipe reeds are single. The homemade prototype is the balloon, the neck of which you stretch to make a primitive reed substitute. Nero is said to have been fond of playing the bagpipe. While Rome burned, Nero probably "skirled," not "fiddled." In Muslim-influenced countries, the drone-and-melody texture of the bagpipe is duplicated by two separate musicians. In India, one *shehnai* (sh'n-EYE; a kind of shawm) player performs the melody while his assistant holds a single note as a continuous drone.

The woodwinds of European classical music are the flutes and the reeds. Flute, oboe, clarinet, and bassoon are the main woodwinds of the orchestra. The woodwind quintet of chamber music adds the horn, a brass instrument that blends particularly well with the woodwinds.

Brass:

| metal | trumpet, horn, Tibetan trumpet |
| other | animal horns, conch shell, African ivory trumpet |

The homemade prototype of the reeds is the blade of grass; held taut between thumb knuckles of both hands, you blow to set it vibrating. The brass prototype is the conch shell; with lips held tightly together and pressed against a hole in the end of the shell, you blow hard. With brass instruments, the player's lips act as double reeds. The trumpet family includes the trumpet, horn, trombone, and tuba of the

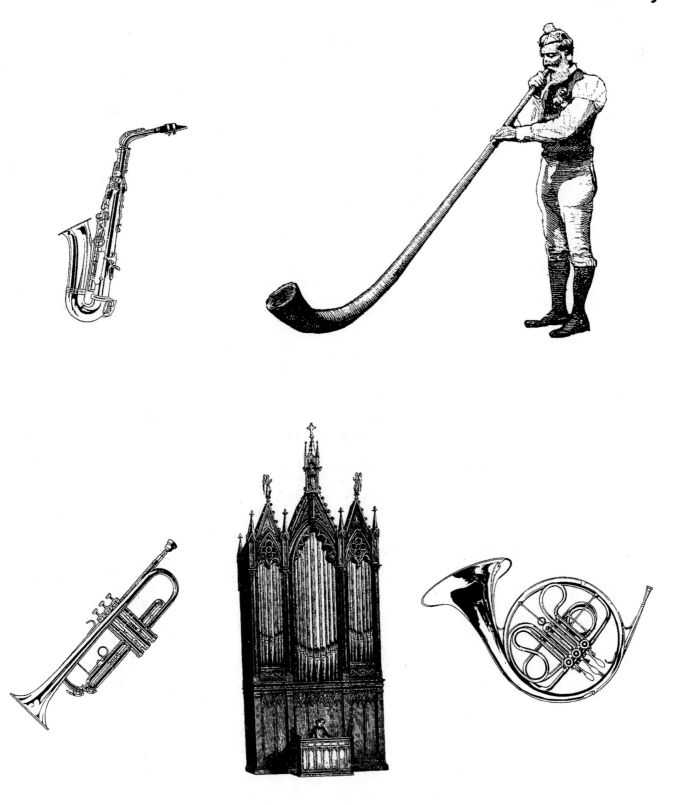

Aerophones: Reeds, Brass, Pipe Organ

Top row: alto saxophone, Alphorn.
Bottom row: trumpet, pipe organ, horn.

orchestra. In its long history, trumpet and (reed) shawms were used in warfare to transmit signals; trumpets were also important adjuncts to courtly life. Trumpets and kettledrums were reserved exclusively for nobility at one time; when Handel orchestrates "King of Kings, and Lord of Lords" ("Hallelujah Chorus" from *Messiah*), he brings out the trumpets and kettledrums. A 1901 gospel song asks "Where shall I go when the first trumpet sounds?" Modern trumpet-family instruments are metal, but elsewhere and at other times, wood, ivory, and shells have served. The trumpet proper and its near relative, the cornet, have been mainstays of jazz for most of its history, beginning with the legendary cornetist Buddy Bolden in the 1890s.

horn

The trumpet has military and regal history. The horn, a larger instrument of a different construction, originated in the hunt. In the music of Mozart's time, late-18th century, you often hear echoes of the ancient hunt traditions when horns are used.

Tibetan temple trumpet

The conch shell serves as a signalling device in the Pacific. It can be considered a trumpet because it is blown with taut lips, as are also the sixteen-foot-long Tibetan temple trumpets. The New Orleans wind bands, from which jazz developed around the turn of the 20th century, may have been inspired by African models. Ivory or wooden trumpet ensembles, with or without drums, are played in Western and Central Africa. In Asia, long, ornate metal trumpets, reaching the length of sixteen feet, sometimes have supernatural associations, their tone low and awesome as in a Lamaistic ritual of Tibet.

Pipe Organ

One wind instrument can sound like nearly any of the flute, reed, and brass types mentioned above—the pipe organ. The organ's keyboard mechanism takes air from a wind supply and feeds it to various pipes. Technically, the pipes are flutes and reeds, but the art of combining timbres and overtones on the organ has led to approximations of almost everything, from *vox humana* (human voice) to trumpet, from strings to bassoon. Until the advent of electronic synthesizers, the organ had long been unrivaled in power and variety of timbres.

Chordophones

 The **sārangī** is a bowed chordophone from North India that features a subset of strings (symphathetic strings) that resonate the sounds of the bowed settings. This produces a soft, shimmering echo-like timbre.

String instruments, or chordophones, are sounded by bowing, plucking, or striking a stretched string. The homemade prototype is a rubber band stretched between your fingers and plucked with the other hand. Strings are found in all parts of the world as fiddles, lutes, lyres, zithers, and harps.

Bowed:

violin, Javanese *rābab;* viola d'amore, Norwegian *hardanger* fiddle, North Indian *sārangī*

bowed chordophones

A sustained tone of a bowed instrument resembles the voice or a wind instrument more than do the short-lived tones of the plucked harp or the struck dulcimer. The bowed string choir in the modern orchestra of Europe consists of violins, violas, violoncellos ('cellos), and double basses. The double bass as a plucked string instrument is common in jazz and popular music.

violin

The violin, commonly referred to as "fiddle," has been an ensemble-section instrument, the workhorse of the classical orchestra, since the 18th century. As a vehicle for a virtuoso, it has been prominent since the mid-19th century. Because of its singing tone and virtuoso capabilities, the violin has also succeeded as a popular and nightclub instrument. Sherlock Holmes played the violin to contemplate, Gypsies in Eastern Europe play the violin to entertain, and the instrument has had a long-standing and special mystique for marginal musicians *(Fiddler on the Roof).*

Javanese *rābab*

Fiddles are played in most parts of the world. The Javanese *rābab* spike fiddle, with its shaft running through its body like a spike, is actually one of the most elegant-looking instruments in the world. It leads the court orchestra *(gamĕlan)* with its soft, plaintive pleadings.

sympathetic strings

Some bowed fiddles, such as the European *viola d'amore* of the Baroque and early Classic eras, have extra non-melody strings which are never bowed, but which resonate in sympathy with each note of the melody produced by the bowed strings. These sympathetic strings give a faint halo, a silvery shimmer to the tone quality, apparently considered conducive to amorous pursuits by the namers of this instrument. Chordophones with sympathetic strings occur in other cultures and in varied forms. The Norwegian *hardanger* (HAR-dang'r) has only four sympathetic strings, but the North Indian *sārangī* (seh-RAHN-gee [hard g]), may have as many as fifteen. You can hear sympathetic strings on the piano by silently pressing a chord and holding it while sharply sounding the same chord in another octave staccato.

 9 *sārangī* "Allah-hoo"

Plucked:

harpsichord (psaltery), harp, Japanese *koto,* guitar

plucked chordophones

The violin played *pizzicato* is no longer a bowed string but a plucked one. The only consistently plucked string in the classical orchestra is the harp, but popular and folk music also have the guitar, banjo, and washtub bass. The harpsichord, a keyboard string instrument popular from the 15th through the 18th centuries, plucks its strings with a quill mechanism. The harpsichord attack is softer than that of the piano, and its timbre is twangier, more silvery, and stringier. The harpsichord's qualities are well suited to the intimate atmosphere of the chamber music of those centuries, although venturesome rock musicians and film composers have also found its sometimes pungent timbre intriguing.

harpsichord

Burmese harp

Harps have enjoyed an ancient and universal appeal. They have been played by ancient Egyptian slave girls, modern Latin American folk musicians, European symphonic musicians, and Hungarian Gypsies. In the courts of the Burmese kings, the harp *(saùng-gauk)* was one of the most important chamber music instruments, suitable for both solo pieces and accompaniment to the voice.

♪ The **Japanese koto** is a plucked string instrument with a six-foot-long sounding board. Its strings are plucked with ivory picks, which produce a bright, percussive timbre.

A fascinating sound is produced by the Arabic 'ūd (al- 'ūd, from Arabic "the wood"), an unfretted piriform (pear-shaped or neck-bowled lute) member of the plucked chordophone family. Traditionally, the 'ūd, or oud, regarded as the "queen of instruments" in the Middle East, was to be plucked with an eagle feather or a pick made from a water buffalo's horn. The 'ūd and its smaller and higher pitched Turkish equivalent, the *ud* or *ut,* have almost forty related instrumental lute-types worldwide including the Western European lute, mandolin, and theorbo, and the Indian sitār. Ancient Southern Mesopotamian archetypes may date back about 5000 years, and the Arabic type was probably introduced to Western Europe in the early eighth century by the Arabs who established the Umayyad Caliphate of Al-Andalus in Spain and Portugal. The absence of frets allows for expressive microtonal inflections typical of some Arabic melodic types and occurred some time after the beginning of the twelfth century. The Arabic 'ūd includes equivalents in Syria, Iraq and Egypt, and the Turkish types include Greek and Persian versions. The 'ūd usually consists of eleven strings, ten or which are paired in courses of two, and the lowest string is single. Your example is a *taksim,* an instrumental improvisation performed on a Turkish instrument.

 10 koto "Chidori"

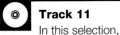 **Track 11**
In this selection, you will hear a *taksim,* an improvisation, on the Turkish ud (a smaller version of the Arabic type) by celebrated *ud* player Necati Çelik.

The Japanese *koto* is plucked with the fingers and has thirteen strings that run parallel to the instrument's six-foot-long, gently arched sound board. Because ivory picks are attached to the plucking fingers and the strings are tense, the sound is percussive and bright. The performer makes subtle tone changes by pulling the string sideways, or pressing down on the non-plucked side of the movable bridge.

guitar

The guitar has both a glorious past and a busy present, from Baroque chamber music and Spanish flamenco to bluegrass and rock. The acoustic (non-electric)

Chordophones

Top row: violin, Javanese *rābab,* North Indian *sārangī.*
Bottom row: harpsichord, Burmese harp, spinet piano.

guitar spread over the world in the 20th century; it is played in towns and cities of East and South Africa. Just as the basic characteristics of *koto* playing are determined by its long strings and movable bridges, the nature of guitar music is related to its construction: a resonant body, a long neck making many notes possible, and frets, or ridges, on the neck for distinct pitches.

Struck:

piano, clavichord, dulcimer, Persian *santur*

A few string instruments are neither bowed nor plucked, but struck. The sound is that of a percussive string. The piano, the clavichord, and hammered dulcimer are examples of struck strings.

piano

The modern piano with a full keyboard has eighty-eight keys, each attached to a series of levers that set into motion a felt-tipped hammer to strike the set of strings for the selected note. Listen to a performance by any good pianist and notice the fine gradations of tone color (timbre), dynamics (loud vs soft), and other expression possible on such a highly mechanized instrument. Artistry is needed to overcome the disadvantage of a machinery that isolates the player's body from direct contact with the strings. But the great advantage of the piano is the fingers' command over as many notes as can be touched. The fingers can scamper up and down the keys whose lowest pitches are below those of the string bass, and whose highest pitches are above those of the smallest woodwind of the orchestra. Or the ten digits can simultaneously strike great blocks of tones (chords).

clavichord

The clavichord, played from about the 14th through the 18th centuries, sounds like a small, faint piano, but its tone is sweeter, more metallic, and potentially more expressive. Its hushed voice is ideal for contemplative solo playing. Since the tangent mechanism that strikes the strings remains in contact while the note continues to sound, the performer has control over that sustained tone by varying the pressure and therefore the pitch, a feature that 18th-century composers greatly appreciated.

dulcimer

A dulcimer, technically speaking, is a struck zither (see the Glossary). Plucked zithers, such as the Appalachian dulcimer, may also have this name, but we cannot expect uniformity in names of instruments except in textbooks. Dulcimers may be thought of as a piano without the keys and levers. Its strings, usually metal, crisscross in parallel fashion over small bridges on the box, and each hand holds a long, light, flexible hammer with padded ends. The dulcimer apparently originated in an

santur

area of Central Asia and the Persian *santur* dulcimer is still the leading classical instrument of that country, now called Iran. A trapezoidal, flat box usually about the size of a serving tray, the instrument-type is found from Korea *(yanggŭm)* to Hungary *(cimbalom)*. Since the 1960s and 1970s, the Appalachian hammered dulcimer has attained prominence in folk-music revival in the United States.

Instruments that are struck are by definition percussion. Drums, bells, rattles, gongs, and xylophones are all percussion. So are pianos and dulcimers, thus belonging to two instrument groups, strings and percussion.

Membranophones

Membranophones are percussion instruments sounded by striking a stretched membrane: in other words, drums. Flicking your fingers against your cheeks is the prototypical membranophone. Other types include the kettledrum, or timpani, snare drum, bass drum, tambourine, and bongos. When a banjo player deliberately strikes the face of the banjo with the backs of his fingers, the banjo becomes a drum, a quasi-membranophone.

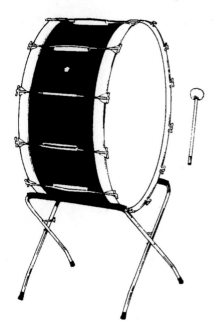

Membranophones

Top row: kettledrum, bass drum.
Bottom row: Idiophones: xylophone, Javanese *gender*.

Tuned Membranophones:

timpani, Indian *tablā*, Ugandan royal drums

timpani

Drums can be divided into two classes: those of definite pitch and those of indefinite pitch. The timpani are the only tuned drums in the symphony orchestra. Bongos are sometimes carefully tuned in sophisticated Latin bands. Definiteness of pitch is relative; some drummers might even be able to sing you the pitch of a bass drum, but the average listener would find it indefinite in pitch.

Indian *tablā*

The North Indian *tablā* are among the most finely tuned drums. "*Tablā*" refers to the pair of drums but is also the proper name of the player's right-hand drum, the tuned one. In a recording of Indian music, notice the timbre of hands and fingers, not sticks, striking skin membranes.

Fifteen tuned drums make up the royal drum ensemble of Ugandans in East Africa. Six drummers play the royal music, each one using several drums at one time.

Untuned:

snare drum, Eskimo frame drum, Chinese *pan ku*

Snare drum

The snare drum of the symphony orchestra, an untuned membranophone, has a raspy, incisive bite to its tone. That timbre comes from the metal or gut snare strings, which buzz every time the head is struck. Without them, the snare drum sounds like a tom-tom. This principle—embellishing the basic sound of an instrument by adding another sound—is also common to many African instruments, the voice-kazoo aerophone being one of them. The snare drum is shallow and has two tight heads, which give it a sharp, high tone. Composers often use it for a military effect.

frame drums

Frame drums are a common instrument type. You make one by stretching a single skin over a narrow hoop; it has only one head. The Spanish tambourine and the Arabic *daf* are frame drums with jingles (added sounds). The Eskimos play a large frame drum with no jingles. It has a handle and is played with a stick.

Chinese *pan ku*

Sometimes a drum does not sound like a drum. The leader of the Beijing Opera orchestra plays the *pan ku,* a membranophone. The tone quality of the *pan ku* is dry, cutting and wooden, and it is easily heard above the loud ensemble. Its construction explains that sound: the striking surface of the head is only the size of a doughnut. Underneath the rest of the skin, it is solid wood. The construction and sonic quality of the *pan ku* bring us to a significant point: the categories of musical instruments (membranophones) relate things by primary *sound-production method,* not necessarily the sound you hear.

Friction:

South African *ingungu*

friction drum

A friction drum is not struck; the original vibrations are generated by rubbing or pulling up and down with a stick or string fastened to the head. It sounds like animal grunts or perhaps a supernatural voice. All continents except Antarctica have friction drums.

Idiophones

Idiophones are percussion instruments whose bodies are naturally sonorous instruments. Sleigh bells, cymbals, rattles, and log drums are examples of idiophones. They can be struck, shaken, plucked, blown, or rubbed. Some are tuned, others have indefinite pitch.

Struck:

gong, woodblock

gongs

Gongs originated in Asia, as the cliché-ridden soundtrack of a television drama or film supposedly set in that part of the world reminds us. The orchestral gong is called

tam-tam. The player strikes it with a large soft beater, producing an extremely low, soft, but awesome and lingering roar. The tam-tam seldom speaks but commands attention whenever it does speak. The word "gong" comes from Java. In the Javanese court orchestra, the great gong sounds infrequently but at crucial junctures in the music. Southeast Asian orchestras are made up not only of different kinds and sizes of gongs but also of *gong-chimes,* which feature clear, bell-like sounds of bronze idiophones shaped like inverted kettles with knobs. The *kulintang* (COOL-in-tahng) ensemble of the southern Philippines has all these sonorities as well as a tall, single-headed drum.

Less common members of the orchestral percussion battery are the woodblock and cowbell, idiophones borrowed from popular music. In Leroy Anderson's *Syncopated Clock,* the dry, hollow sound of the wood block marks the "clock" part, and the metallic clank of the cowbell appears just before the end of the piece. At the end, a plastic whistle, an aerophone, is also to be played by a percussionist.

Plucked:

music box, African *mbira*

mbira

The European music box and the African *mbira,* or lamellaphone, are both tuned, plucked idiophones with a row of projecting tongues, one for each note. In the music box, a mechanical cylinder plucks the tongues. In the African mbira, the thumbs and forefingers of human hands pluck the tongues. Since both instruments usually use metal tongues, the timbres are similar. *Mbira* players in Zimbabwe, East Africa, are often accompanied by a net-rattle, a large gourd covered by a loose net embedded with cowrie shells. African slaves brought the net-rattle to the New World, and in modern Afro-Brazilian popular music, the instrument evolved into the *cabaça* (kah-BAHSS-ah), a metal, urbanized variant.

cannon

European composers of the late-19th century pushed the limits of orchestral expression to their utmost by searching out the most extraordinary percussion effects. Tchaikovsky's finale to his *1812 Overture* shows one extreme. His score calls for real churchbells (idiophones) and real cannons (struck idiophones?) together with most of the more normal percussion. In the 20th-century, Steve Reich composed for an ensemble of hand-clapping, a type of idiophone.

Tuned-struck:

church bells, xylophone, vibraphone

xylophone
vibraphone

Tuned idiophones in the orchestra are usually made of tuned slabs of wood or metal, arranged like a piano keyboard, as the xylophone and orchestra bells. Orchestral chimes are metal tubes that sound like church bells. The glockenspiel, a portable high-pitched version of the orchestra bells, adds glitter to the sound of a marching band. The symphonic xylophone, with its keys of wood in rows, has a loud, dry, wooden quality. Its piercing sounds can cut through the entire symphony orchestra. In his *Danse macabre* (1874), the French composer Camille Saint-Saëns uses the xylophone to create the aural illusion of rattling bones. At the opposite end of the world, a slightly different xylophone, the Javanese *gambang* has a gentle, scarcely audible sound. The gambang must blend in with the other soft-sounding instruments of the court orchestra, so it is struck with large, padded mallets. The vibraharp, or vibraphone, was invented in the U.S. and has had some acceptance in jazz and popular music. A metal "xylophone" or a metallophone, the vibraphone's soft, metallic sound also has a vibrato caused by motor-driven oscillators in each resonator. The orchestral celesta, a small piano-like keyboard instrument with its hammers hitting bells rather than strings, aims at a "heavenly" sound, or at least a light-hearted one, as in Tchaikovsky's "Dance of the Sugar-Plum Fairies."

The xylophone instrument-type is found over much of Africa, but it varies in construction and sound. In northwest Ghana, the Lobi people favor the xylophone

in their music and build their instruments with great care. The Lobi xylophone has keys of high-density tropical wood and a carefully tuned gourd resonator under each key. Each resonator has a side hole covered with a spider's web membrane that adds a slight buzz to the tone.

Electrophones

Technology in the 20th century led to a new class of instrument, electrophones. Traditional acoustical instruments became amplified and transformed everywhere, from Greek villages to African towns. Microphones and reverberation units (echo-producers), synthesizers, and electric guitars burgeoned with the rise of industry. Technology is certain to produce yet more.

electric guitar

The electric guitar, the most popular of all the electrophones, was first adopted commercially in the 1930s. The seemingly universal enthusiasm for the electric guitar comes from a combination of advantages: a blues and folk history as an acoustical instrument, a search for technological means to ever more varied timbres and ever louder dynamics (even feedback—electronic screech), and association with youth-rock culture.

musique concrète

A new step in the direction of electrophones occurred in the works of the *musique concrète* composers beginning in the late 1940s. No instruments or performers are needed. Or we might say that the creative artist/electronic technician is both composer and performer. This person works directly with electromagnetic tape or synthesizer; the only creative limits are the current state of the art, the artist's own knowledge and pocketbook, and the capacities of the audience. Ordinary, mundane sounds, or musical sounds, or synthesized sounds, can be sped up, slowed down, filtered, compressed, reversed, or whatever, to create a radically new kind of music, at first seeming only remotely related to previous music. The "found" sounds of *musique concrète* parallel philosophically the *objet trouvé* of modern art.

synthesizer

Synthesizers can re-create a familiar Bach composition in sonorities never dreamed of in prior centuries. Composers in popular and classical music today can explore the adventuresome potential of this wizardry in re-creating sounds of traditional instruments of the past (viola d'amore, for example) and present (piano, for example), but they also can create completely new sonic effects for the future. The composer also saves money by not paying for music copying, performer fees, and concert hall rentals.

Idiom Transfer

When as kids we took a tissue-paper-and-comb and imitated a bugle call on it, we were borrowing the idiom of the bugle. When Billie Holiday strives to emulate Satchmo, when an Afghan vocalist sounds exactly like the *rābab* lute, and when Bach re-creates with the orchestra shepherd's bagpipes in his Christmas Oratorio, these are also examples of transfers of idiom.

Transfer of idiom is a type of musical metaphor in which timbre and other idiosyncrasies of one instrument are imitated by another. Bobby McFerrin, a popular singer, built a professional career around remarkably realistic vocal imitations of drums, string bass, and other instruments. An old Scotswoman uses her voice to imitate the melody and articulation quirks of the Highland pipes. In Bali, a chorus of 250 men for the *ketchak* ritual use their voices in a strongly rhythmic fashion, copying the Balinese *gamĕlan* (GAH-meh-lahn) sound and texture. Several European keyboard instruments, such as organ and harpsichord, have stops that alter the timbre to mimic other instruments. Sometimes, a keyboard instrument, such as the harpsichord, also takes over the repertoire of the superseded instrument such as that of the lute. In Franz Schubert's "The Hurdy-Gurdy Man" from the song cycle *Winter Journey*

(1827), the piano part suggests in subtle manner the folk idiom of the hurdy-gurdy, or "wheel fiddle." The drone of the hurdy-gurdy, its phrases, and the half-frozen fingers of the lonely player are deftly portrayed in a clear yet subtle manner.

Mixed Timbres

The preceding survey emphasizes tone colors of single instruments. Much of the world's music, though, is performed in groups of heterogeneous instruments, in which the various colors of individual instruments may be combined to create complex timbre mixes.

The full European symphony orchestra may have more than 100 musicians. In most of the repertoire, all the families of instruments are represented (except electronic): aerophones, chordophones, membranophones, and idiophones. The multiple instruments in each string section usually play the same notes at the same time. But the wind and percussion instruments usually play separate parts. For the personnel of various orchestras, see the accompanying chart.

The Growth of the Symphony Orchestra, 18th to 20th Centuries

(excluding monster orchestras such as are found in Wagner's Ring Cycle; *see Chapter 9)*

Early Haydn
Symphony No. 12 (E Major) composed 1763 about 15 players
2 oboes, 2 horns, strings, (harpsichord and bassoon on the bass line)

Beethoven
Symphony No. 2 (D Major) published 1804 40–45 players
2 flutes, 2 oboes, 2 clarinets, 2 bassoons, 2 trumpets, 2 horns, 2 timpani, strings

Tchaikovsky
Symphony No.5 (E Minor) composed 1888 79–87 players
3 flutes, 2 oboes, 2 clarinets, 2 bassoons, 4 horns, 2 trumpets, 3 trombones, 1 tuba, 3 timpani (G,D,E), strings

Shostakovich
Symphony No. 5 (D Minor) composed 1938 80–90 players
1 piccolo, 2 flutes, 2 oboes, 2 clarinets, 1 piccolo clarinet (Eb), 1 contrabassoon, 2 bassoons, 4 horns, 3 trumpets, 3 trombones, 1 tuba, strings, timpani, snare drum, bass drum, triangle, cymbals, tam-tam, 2 harps, bells, xylophone, celesta, strings, piano

Large

Berlioz
Symphonie fantastique composed 1830 75–80 players
2 flutes (piccolo), 2 oboes (English horn), 2 clarinets, (1 Eb), 4 bassoons, 4 horns, 2 cornets, 2 trumpets, 3 trombones, 2 bass tubas, 12 1st violins, 11 2nd violins, 8 violas, 10 cellos, 8 double basses, 4 timpani, bass drum, cymbals, side drum, chimes

R. Strauss
Tone Poem, *Don Quixote* composed 1897 92–96 players
1 piccolo, 2 flutes, 2 oboes, 2 clarinets (Bb and Eb), bass clarinet, 1 English horn, 3 bassoons, 1 contra bassoon, 6 horns, 3 trumpets, 3 trombones, 1 tenor tuba, 1 bass tuba, 16 1st violins, 16 2nd violins, 12 violas, 10 cellos, 8 double basses, 1 harp, timpani, bass drum, side drum, glockenspiel, tambourine, cymbals, 1 wind machine

Modern orchestra (large American cities) 88–108 players
1 piccolo, 3 flutes, 3 oboes, 3 clarinets, 1 bass clarinet, 4–6 French horns, 1 English horn, 3 bassoons, 1 contrabassoon, 17 1st violins, 15 2nd violins, 11 violas, 10/11 cellos, 8 double basses, harps, 1 bass drum, 1 tenor drum, 4 trumpets, glockenspiel, celesta, xylophone, triangle, cymbals, 3 trombones (alternating on side), 1 tuba, timpani, piano

The figures run higher for state-supported theater/opera and broadcast orchestras.

The Indonesian court orchestra, the **gamĕlan,** features a variety of bronze gongs, chimes, and slabs that are struck by metal mallets that produce a bright, metallic timbre. These instruments are metallophones, which fall under the category of idiophones or self-sounding instruments.

◎ **12** Balinese *gamĕlan*

jug band
chamber ensemble

neo-folk ensembles

Beijing opera

The mixed sonorities of the full Javanese court *gamĕlan* may be compared with that of the symphony orchestra. There is a whole family of variously sized string instruments contributing to the European ensemble; the Javanese orchestra contains a whole family of gongs, ranging in pitch from the small, high *kĕmpul* (come-POOL) to the deep rumble of the great gong more than three feet in diameter and vibrating at about forty cycles per second. Although the main melodic burden is carried by metallophones (tuned metal bars, usually struck with a mallet), a good recording also clearly reveals a bowed chordophone and a membranophone. In soft passages, a flute is also heard. For a discussion of the Javanese *gamĕlan*, see Chapter 10. Compare the Balinese *gamĕlan* sound.

A rural Southern United States jug band plays traditional blues with a small ensemble. The melody now is played on a harmonica, a reed aerophone; the bass part is carried by the jug, a rim-blown aerophone; harmony and rhythm are filled in with the piano, a chordophone/struck idiophone; and a rhythmic fillip is added by the washboard, a scraped idiophone. In small ensembles, the individual parts are usually more distinct than with large orchestras. Like the jug band, Stravinsky's *The Soldier's Tale* (1918) employs a small chamber ensemble: narrator and dancers, violin and double bass, clarinet and bassoon, cornet and trombone, and percussion. It is more economical than a large ensemble, the effect is leaner and often cleaner.

Folk music everywhere is normally for solo voice or instrument, with small ensembles added from time to time. But neo-folk groups, organized for cosmopolitan taste and presented on the radio, records, and television, usually prefer massive sonorities similar to those of the symphony orchestra. The Bulgarian National Folk Ensemble shows how the orchestrator uses shepherd's flutes, bagpipes, and lutes of traditional Bulgarian village music with violins and other symphonic instruments to invent a new national Bulgarian sound.

The chamber-music sonority of the Beijing (*Jingjü*) opera shifts from full and noisy to light and transparent when the singer has an aria. As in European opera, the voice is of main interest, so only the supporting fiddle plays the melody behind the voice as the plucked lute quietly reinforces the fiddle and the *pan ku* drum lightly keeps the tempo alive. Only when the voice stops do the clangorous cymbals and gong return. The principle of lightening the instrumentation to allow the soloist to be heard is common to many genres, East and West.

During much of jazz's history, economics and esthetics have kept the size of the ensembles small, with combos rarely exceeding a quintet. But for the decades of the 1930s and 1940s, the big band sound of the Swing Era was popular. One of the geniuses of the big band was Duke Ellington. A typical Ellington arrangement might begin with a solo piano introduction, followed by contrasts of the massed saxophone section in alternation with the brass section. Opposition of reed and brass choirs is typical of the swing bands.

Nature

nightingale
wolves, whales

More and more people believe that music may be found outside human creation. If violins and slit drums are the instruments of yesterday, and synthesizers are the instruments of today, perhaps Nature will give us the music of tomorrow. People who live close to nature—farmers, herdsmen, hermits—certainly have a more intimate appreciation of natural sounds than do city dwellers. Even so, a certain nostalgia for a lost past lingers in the urban asphalt. In 1924, the Italian composer Ottorino Respighi composed the symphonic poem *The Pines of Rome*, in which a recording of a live nightingale "performs" with manmade orchestral instruments; the voices of the natural world are savored as a nostalgic reminder of the dim past by today's cosmopolite. In Japan, a recording of frog calls features such artists as "Rhacophorus schlegelii," and tiny insect "virtuosos" also have their own record.

Humpback Whale
Drawing by Barbara L. Gibson

In the U.S.A., Robert Redford narrates a National Geographic record of wolf howls and Capitol Records finds *Songs of the Humpback Whale* marketable. Nature is making a comeback.

John Cage, a musical philosopher of the 20th century, asserted that "music" is all around us every moment of our waking hours. We need only tune into it: "There is no such thing as an empty space or an empty time. There is always something to see, something to hear." Even in the silence of the anechoic chamber, you will hear the sound of your own heart beating.

KEY WORDS

Aerophone, chordophone, idiophone, metallophone, membranophone, woodwinds, brasswinds, strings, percussion, orchestra, *gamělan*, electrophone, *musique concrète*, synthesizer

SUGGESTED READING

Kartomi, Margaret J. *On Concepts and Classifications of Musical Instruments.* Chicago: University of Chicago Press, 1990. (Kartomi shows that each culture classifies music in ways that reflect its aesthetic sensibilities.)

Marcuse, Sybil. *A Survey of Musical Instruments.* New York: Harper & Row, 1975.

Munrow, David. *Musical Instruments of the Middle Ages and Renaissance.* London: Oxford University Press, 1976.

Musical Instruments of the World. New York: Sterling Publishing Co., Inc., 1997.

Reck, David. *Music of the Whole Earth.* New York: Scribners, 1977.

Sachs, Curt. *The History of Musical Instruments.* New York: Norton, 1940. (The main classification system discussed in this text is the Sachs-Hornbostel system.)

SUGGESTED LISTENING

Aerophones	Tibetan trumpets. *Musique rituelle tibétaine:* 1. "Cérémonie offrande." PlayaSound
Chordophones	Burmese harp, *Mahagitá:* 1. "In Praise of the Burmese Harp." Smithsonian Folkways CD 40492 <http://www.folkways.si.edu>
Idiophones	Javanese gamĕlan. *Shadow Music of Java,* 3. "Patalon." Rounder CD 5060 <http://www.rounder.com>
	Balinese gamĕlan. *Golden Rain,* 1. "Hudjan Mas (Golden Rain)" Nonesuch 79716 <http://www.nonesuch.com>
	Zimbabwe mbira. *The Soul of Mbira,* 7. "Nyamaropa yeVana Vava Mushonga." Nonesuch Explorer Series CD 79704 <http://www.nonesuch.com>
Membranophones	Ugandan tuned drums. *Uganda 1:* "The tuned drum band 'Kyuma.'" International Library of African Music, MOA24 <http://ilam.ru.ac.za>
Nature	*Songs of the Humpback Whale.* BMG/Living Music.

HELPFUL VIEWING

"Timbre: The Color of Music," *Exploring the World of Music.* Videocassette 7 (of 12). Fritz Weaver, narrator. Prod. Pacific Street Films and the Educational Film Center; series prod. Steven Fischler, Joel Sucher. Prod./dir. Martin D. Toub. Imprint: Annenberg/CPB Project, ©1998. [30 minutes]

2
REVIEW SHEET

Short Answers

List five each of the following:
1. aerophones

2. chordophones

3. membranophones

4. idiophones

Short Essays

1. Cite at least one instrument in each of the categories "strings," "woodwinds," "brass," and "percussion" for which such a classification presents some difficulty.

2. Discuss the difference between the traditional classification of orchestral instruments and the Sachs-Hornbostel system.

3. Think of other ways of classifying musical instruments. Consider organic (bone, wood, horn, hair) vs. non-organic (metal, plastic, glass). Can you think of at least two instruments that are "non-organic"? Can you think of strengths and weaknesses in these classifications? In a social-functions classification, can you name at least two instruments typical of "popular" music and at least two typical of "classical" music?

3
TIME

Some arts combine time and space. Architecture seems to give about equal emphasis to both. In general, the performing arts such as music, dance, poetic recitation, and the cinema exist primarily in live time, clearly bounded by it. Visual and plastic arts such as painting and sculpture can, at least temporarily, exist "outside" of time. Inevitably, overlaps occur: paintings seem to change when viewed repeatedly as the meaning of a Rembrandt self-portrait grows with extended viewing, and the full power of a Beethoven symphony envelops us only after the final chord sounds. Yet each art retains its own relationship with time.

You could say that music is sound ordered in time. While poetry and music depend on sound for artistic expression, much of music's attraction results from its abstractness. Poetry uses a succession of words for allusive imagery and direct meaning. Music uses a succession of abstract sounds for outward manifestation and embodied meaning. To help us better understand music, the most logical place to start is with the basics of musical time: pulse, tempo, meter, and rhythm.

Pulse and Tempo

pulse (beat)

The temporal elements to which we respond most quickly are the pulse (beat) of a piece, and its tempo. When we hear a popular or classical composition on the radio, even if it is for the first time, we immediately respond to its beat and can tap it out. We sense when the beat is fast, slow, or moderate, even though these terms are relative and difficult to define. We often find it impossible not to express it in some way, as when we find ourselves tapping one of our feet or nodding in time with the music. The speed or rate of the pulse is the music's tempo. Uniform tempo has a steady succession of beats, and free time has an uneven distribution of beats.

Imagine a time–predictability continuum. At one extreme, an atomic clock at the National Institute of Standards and Technology in Boulder, Colorado loses perhaps a second every 3,000,000 years (if it lasts that long). That is predictability. At the other extreme, the random movements of electrons go helter-skelter in chaos on a TV screen tuned to an empty channel. Fill in the continuum with graded degrees of pulse predictability, using examples from the world around you. Eventually, as you are drawn to various aspects of music, you will find that even with its center tending to favor atomic clock predictability, music varies, from the Um-pah Um-pah repetition of a march to the relatively free movement of spoken dialogue in opera.

In classical West European music, the indications of the rate of the pulse are usually given in Italian and are referred to as *tempo markings*; among the more common designations are:

Prestissimo	Very quick	*Andantino*	Walking quickly
Presto	Quick	*Andante*	At a normal walking pace
Allegro	Fast (not as fast as Presto)	*Lento*	Slow
Allegro Moderato	Moderately fast	*Adagio*	Very slow
Allegretto	Reasonably fast	*Largo*	Broad, stately

Most music we hear has a steady beat, but the tempo can change gradually within a musical composition.

Ritardando means gradually becoming slower, accelerando means gradually becoming faster. A retard brakes the forward momentum of the music and prepares us for the end of a work or section. Retards are more numerous than accelerations. There is a clear parallel in rhetoric, where the slow-down and pause dramatize the end of a thought. By contrast, if the composer wishes to increase excitement at the conclusion, an acceleration is appropriate. In the selection you hear, what happens to the beat?

In some music, the tempo both accelerates and retards in a free manner within a short span. This elastic treatment of the beat is called **rubato,** from the Italian verb *rubare,* meaning "to steal from (the beat)." Tempo rubato, typical of epic-recitation traditions in the Balkans, Finland, and Russia, appears also in much standard "classical" music, including the rhapsodies of East European composers of the 19th and 20th centuries. The "spoken" quality of this music is also referred to as **parlando style.**

Meter and Rhythm

Groups of beats usually fall into patterns that emphasize one beat more than the others. Some groups have two beats, others have three, four, or more. The emphasis could be dynamics (relative loudness), duration (length), pitch, or timbre. If the emphasis comes from dynamics, the beat is called *accented,* indicated by the notational signs >, ^, or –.

There are no comparable signs or terms in Euro-American classical music for beat emphasis by pitch or timbre change. Although all types of emphasis often occur at the same time, when we speak of "accented" music, we usually mean the dynamics type.

(See "Dynamics" in Appendix V for an explanation of loudness markings in music and ranges of loudness in music history.)

Beat patterns group themselves into **meter,** a term borrowed from verse. Patterns of stressed syllables organize poetry in time, as with iambic pentameter: "So long as men can breathe, or eyes can see." Similarly, a recurrent pattern of stressed beats often helps organize music.

An orchestra conductor beats out these patterns with the baton, emphasizing the main beat with a downward motion, the downbeat. The upbeat is the conductor's action immediately preceding a downbeat. If we conduct something in two, in a duple meter, there are just two motions—a downbeat and an upbeat:

As you listen to the second movement of *Beethoven's Seventh Symphony,* conduct the music in a slow two.

Music conducted in three, in a triple meter, consists of a downbeat followed by a sideways motion to the right for the second beat and then an upbeat:

ritardando
accelerando
rubato
parlando style

 Tempo markings in music scores are general indications of tempo (rate of speed). *Accelerando* is a device that signifies a continuous acceleration of tempo for dramatic effect.

13 accelerando: "Oh, My God . . ."

meter
downbeat, upbeat
duple meter

Simple duple meter involves an accented downbeat and an unaccented upbeat, which is easily conducted with a downward motion followed by an upward one. In the long-short-short, long-long pattern, the short-short is simply a subdivision of the upbeat. Time signature: 2/4

14 duple meter: "Beeth. 7th, mvt. 2"

triple meter

 Simple triple meter involves an accented downbeat followed by two unaccented beats. Triple meter will always have a dance feeling to it. Count and conduct: ONE-two-three, ONE-two-three. Time signature: 3/4

15 triple meter: "Danube Waltz"

quadruple meter
primary accent
secondary accent

rhythm vs meter

A waltz is a well-known example of triple meter. As you conduct along with a Strauss waltz, notice how both pitch and dynamics combine to emphasize the main beat, and how the free tempo can accelerate to the point where it is easier to conduct in one rather than in three.

Of the other meters, quadruple time appears the most often. The conductor gives a clear downbeat, continues with a smaller motion to the left for the second beat, follows with a larger motion to the right for the third beat, and winds up on the fourth beat:

In quadruple meter, the first and third beats are stressed. The first, strongest beat is the primary accent, the third is the secondary accent; thus, quadruple meter may be considered an elaboration of duple meter. A fast quadruple meter is conducted in two.

In much of the music most familiar to us, meter implies a pattern of strong and weak beats that recurs until the end of the piece. In most of the musical selections we hear, composers find ways of adding variety to the basic pattern without destroying its framework. "Rhythm" provides the surface manifestation of any music, as opposed to the underlying structure of meter.

A composer may partially mask the meter by purposely suppressing a beat; in this situation, the meter, while still present (in our minds, at least), is not physically sounded. What is sounded thus forms a rhythmic variant of meter. In *America*, known as "God Save the Queen/King" in British context, the underlying meter is

but the surface rhythm of the passage is

Both the underlying meter and the surface rhythm coexist and interact on each other; what we hear physiologically and what we perceive psychologically are temporarily combined to produce an effect that goes beyond the individual meaning of each.

While listening to musical examples, find the beat, then group the beats together and conduct the music to yourself. Duple meter, sometimes appearing as 4/4 time, is the nearly universal meter of Rock, and you can find the downbeat by listening for the lowest note of the accompaniment, usually in the bass guitar, and applying the downbeat conducting motion to it. Marches are also in a type of duple (4/4) meter.

Simple vs. Compound Meter

simple meter
compound meter

Much Euro-American music has two kinds of beats: those subdivided in two, and those subdivided in three. Each simple beat subdivides in two; when simple beats are subsequently grouped together into metrical units, they form **simple meter.** By contrast, some beats are compounded by subdividing in three. When these triple-division beats are then grouped to form metrical patterns, the meter is **compound.** In compound meter, the basic beat is a dotted note, a note with a dot to the right of the notehead. The dot represents half the value of the note added to it. For example, ♩. has the value of three eighth-notes.

time signature
compound duple meter
compound triple meter

A "time signature" usually consists of two numbers, one above the other. In simple meters, the upper number tells how many beats are grouped in one measure; the lower number indicates the time-value of the basic beat. 2/4 means there are two beats per measure, each beat a quarter note. Meters with 2, 3, and 4 as the upper numbers are "simple" meters: 2/2 time is a simple duple meter, 3/4 time is simple triple, 4/4 (or "C") is simple quadruple. By contrast, a compound meter usually has 6, 9, or 12 as upper numbers. Conduct a compound meter as you would a simple meter; a compound duple meter, 2 × ♩. (= 6/8 time) gets two beats, a downbeat and an upbeat; a compound triple meter, 3 × ♩. (= 9/8 time), is conducted in three as if it were in 3/4 time.

 Compound meter involves the subdivision of the quarter note into eighth notes grouped in threes. Compound duple time signature: 6/8. In counting 1-2-3-4-5-6, a strong accent will be placed on the 1st beat and a slight accent on the 4th beat. This will suggest a duple meter (two groups of three beats each).

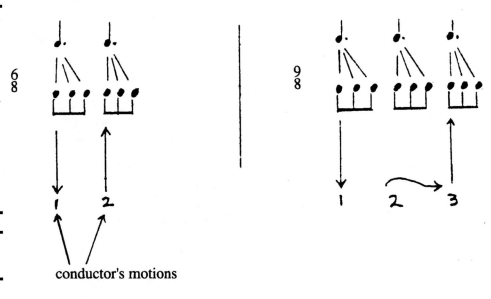

conductor's motions

◎ **16** compound duple: Beethoven

Listen to an excerpt from the last movement of Beethoven's Sixth Symphony and conduct the 6/8 time in a slow-moderate two. Then, listen to a selection in 9/8 time from J. S. Bach's Cantata 147, "Jesu, Joy of Man's Desiring," and conduct in a moderate three.

◎ **17** compound triple: Bach

 In **compound triple meter,** there are three groups of three beats each. In the time signature of 9/8, count 1-2-3-4-5-6-7-8-9 with accents on the 1st, 4th, and 7th beats.

A composer uses "triplets": for a triple subdivision of an undotted beat in simple meter. Triplets are used as exceptions: they appear when most of the beats subdivide in two.

Additive Meters

Sometimes we find a meter in which the basic beats, within any given measure, are uneven. This type characterizes much Balkan folk music. In Bulgarian dances, for example, although 2/4 is a favorite meter, patterns such as ♪♪. (5/16) and ♪. ♪♪ (7/16), and even more complex groupings (in 11/16 time), are also frequent. In these odd-numbered meters, some beats are longer than others, with values "added" to them. Additive meter thus signifies a grouping of unequal beats. Most of the usual additive meters consist of subdivisions by twos and threes.

5/4 meter

Additive beats appear in a 5/4 meter in "Mars, the Bringer of War," the first movement in Gustav Holst's orchestral suite, *The Planets* (1916). The listener can

Additive meter involves an uneven number of beats in each measure. In the time signature of 5/4, there is often an accent on the 1st and 4th beats of the five beats, or 3 + 2. Since most meter can be determined by either groups of 2 counts or 3 counts, this additive meter creates an imbalanced sense of 2 + 3 that can be a dramatic compositional device. it is also possible to have a 2 + 3 grouping of beats.

18 Holst *The Planets:* "Mars"

Syncopation borrows time from an accented beat and gives it to an unaccented beat. In ragtime music, the melody in the right hand of the pianist uses syncopation for a swing feeling against a straight march tempo in duple or quadruple time in the left hand. Syncopation can also apply to the entire suppression of a strong beat.

19 Joplin: "Easy Winners"

Hemiola involves setting of two beats against three. In this excerpt, listen for the compound duple time signature of 6/8 alternating with the simple triple 3/4 time signature.

20 Bernstein "America"

catch the 3+2 pattern most easily in the accompaniment of the first two measures. Dave Brubek's "Take Five" uses the same 3+2 pattern.

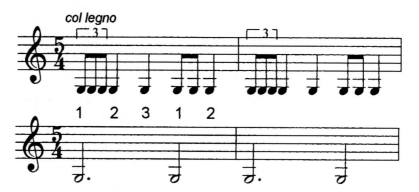

Syncopation

When the rhythm forces a temporary shift of stress, the opposition between metric beats and conflicting rhythmic emphasis results in syncopation.

Metrical music builds the expectation of a steady stream of beats with regularly recurring accents. In a waltz, we expect a ONE-two-three ONE-two-three triple-meter pattern. If suddenly the first beat is not played, we react to its absence with an involuntary movement of our bodies or nods of our heads. This absence of a strong beat is called "syncopation." In the waltz accompaniment, the first beat typically has a strong emphasis, so that when the UM-pah-pah, UM-pah-pah becomes—pah-pah,—pah-pah, the feeling caused by the lost beat is very strong. Syncopation also occurs with stressed weak beats (an upbeat, for instance) or weak parts of a beat.

Ragtime used to be called "syncopated music." While listening to a Scott Joplin selection, find the beat in the left-hand accompaniment and group the beats into a duple pattern as you conduct. The right-hand of the keyboard player will supply the syncopation, as in *The Easy Winners:*

Hemiola and Changing Meters

Some music has frequent metrical changes, implied by accents or actually written as different meters. Hemiola combines duple and triple meters. While a hemiola may be indicated by an actual change of the time signature, it often appears as an outside accent pattern superimposed on a basic, unchanging meter. Hemiola occurs when accents, real or implied, appear on every other note of three-note groups. In 6/8 time, the hemiola temporarily mutates into 3/4:

hemiola

In "America" from Leonard Bernstein's *West Side Story*, the basic metric pattern is 6/8 time, changed by hemiola to 3/4 time on the syllables "(A)-me-ri-ca":

Conduct the music in duple time until the syllables "[A]-me-ri-ca," where the beat changes to a slightly faster triple time. Further examples of hemiola, occurring in an especially subtle manner, appear in African drumming.

Rhythmic Cycles (Structured Pulse)

Rhythmic Modes

A rhythmic cycle organizes beats, as does a meter, but can be longer and more structural. Just as poets build rhythmic patterns into lines of a strophe in a poem, composers make rhythmic figures, repeat them, and through the repetition, build a larger musical unit. In music of Western Europe, examples occurred at least as early as the 13th century associated with the Notre Dame Cathedral in Paris. The Parisian composers used simple rhythmic modes (patterns) based on the equivalent of triple meter. Of the six modes, the most popular were the first and second, with the patterns ♩ ♪ and ♪ ♩ . The number of times each figure appears complete and without interruption was called ordo. The first mode, second ordo would be

Popular Greek bouzouki music uses cycles, too. The *Chiftetelli* rhythmic cycle is found in Greece, Turkey, and other Balkan countries.

which often appears in a variant such as

Turkish *Usûl*

Turkish classical music organizes beats and time into complex cycles, **usûls.** Turkish music students learn a song by simultaneously singing the melody and beating out the *usûl* pattern with a hand on each knee. The right knee signifies the *düm*

sound of the drum, the left knee signifies the *tek* sound. The simplest *usûl* is *Sofiyan* (2/4). One of the lengthier is **Zarbi Fetih,** an 88/4 unit (!). *Düm* sounds have stem up, *tek* are down:

Zarbi Fetih

Isorhythm

Like a rhythmic mode, isorhythm is a repeating pattern, but it tends to be more consistently melody-associated, especially in the non-Western repertories. Familiar, if somewhat free, examples of isorhythm occur in *The Star Spangled Banner* and *America (God Save the Queen)*. In some instances, a pattern of four measures is applied to a melody of eight or twelve or more measures. In *America*, the rhythmic pattern is relatively short, consisting of two measures. Isorhythmic patterns appear frequently in the folk music of some East European countries, particularly Hungary and Romania. Other examples occur in Native American music, such as that of the Arapaho people of the Great Plains.

Colotomic Music

timbre, pitch, time

colotomic cycle

Classical Javanese music organizes time into cycles that are punctuated not by dynamic accents but by pitch and tone color of specified instruments. Time-keeping **colotomic** instruments show how cycles, timbre, and musical structure are related. Patterns of pitch and timbre for establishing cycles also underline musical structure in Bali and Japan. In Javanese *gamĕlan* music, percussion instruments, especially gongs, have crucial parts. Colotomic structure, the repeating cycle of percussion patterns relating timbre and pitch to time, provides the key to understanding much East and Southeast Asian music. The large gong sound signals each cycle completion.

Polyrhythm

 Polyrhythm involves the simultaneous setting of one meter against a different meter. In this excerpt, the melody is in 12/16 time signature (compound quadruple) set against the accompaniment in simple duple 2/4.

21 Joplin *Pine Apple Rag*

Two or more different rhythms played simultaneously are called **polyrhythm.** In his *Pine Apple Rag*, Joplin emphasizes a 12/16 (♪ ♪ ♪ ♪) right-hand pattern against a steady 2/4 (♩ ♩ ♩ ♩) bass:

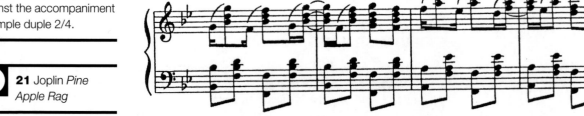

Some of the most impressive examples of polyrhythm come from African-derived music in the Caribbean Islands as well as from Africa.

Simultaneous Hemiola

In our previous discussion of meter, hemiola in a single melodic line, or *sequential* hemiola, was discussed. In *simultaneous* hemiola, three beats sound against two. (In "America" from *West Side Story*, three beats followed two.) The top part moves in 6/8 time (compound duple meter) and the bottom part is in 3/4 time (simple triple meter); in both parts, there is a steady stream of eighth-notes. Their accent patterns, however, conflict:

cross accents

The conflicting accents jump up and down, moving diagonally "across" the parts. This diagonal path of the accents, or **cross accents,** sets up syncopation, since the cross accents emphasize the weak part of a beat in one or more of the parts. African music provides some of the most complex and sophisticated patterns of cross accents.

Free Rhythm (Unmeasured Pulse)

Everyday speech is in free rhythm: "Hi! I'm Harriet Mobileup. I'm a junior partner in a prestigious law firm. What do you do?" Possibly because we associate clearly measured rhythm with poetry and music, it is often a novel experience to hear *non-metrical* poetry or music. Not surprisingly, much free rhythm has a flow and cadence that approximates speech.

parlando **rhythm**

Free rhythm and speechlike patterns appear in jazz and in African music. They also appear in improvised music of the Balkans, popular and classical, such as a bouzouki *taxim* at a Greek nightclub, a Romanian *doina*, or a flute *taksim* improvisation in the music of the *Mevlevi*, a Turkish Sufi Order. In Bulgarian village music, free rhythm occurs in a speechlike manner, often referred to as *parlando* (It., "speaking") style. Bartók imitates this style in the third movement of his *Music for Strings, Percussion and Celesta* (1936). (See Chapter 11.)

The Bulgarian *parlando* style stems from the epic tradition long popular throughout Europe and which continues in Yugoslavia, Finland, and Russia. The epic, a long narrative poem in the heroic tradition (such as *Beowulf*), is today particularly favored by Albanians, Croatians, Bulgarians, and Serbs. These epics continue for hours, and the singer accompanies himself on a *gusla*, a one-string fiddle. Many repetitions and short ornaments that resemble a brief quiver of the voice characterize the style, and the *gusla* often imitates these ornaments.

Improvised Rhythm

Musicians naturally tend towards rhythmic improvisation, since freedom from unchanging conventions, such as a metrical scheme, seems a natural inclination of the artistic spirit. Much improvised music arises from spontaneous embellishment of something already familiar. Often we hear free and new treatment of external rhythmic features, while harmony, melody and form remain comparatively unchanged.

Examples of rhythmic improvisation appear with the "ragging" of a tune. Early ragtime first caught the American fancy in the 1890s. Its strong emphasis on syncopation formed much of the basis for later jazz rhythms. Ragging a tune meant extemporaneously adding syncopation to other familiar music, such as marches and dances.

ragging a rag

A fascinating offshoot of this practice was the ragging of another, already composed, rag. Scott Joplin's famous *Maple Leaf Rag,* first published in 1899, was ragged later by Ferdinand "Jelly Roll" Morton. In his 1938 performance, Morton transformed the familiar rag into what became known as "New Orleans Style." This performance brings to mind two significant points. One is the importance of convention as an element in improvisation: the ragging of a tune makes necessary the adoption of ragtime-rhythm conventions. The other is the almost inevitable loss of some spontaneity when a disc is cut. While much of the spirit of improvisation may be retained in a good recording, it is really the "live" performance that captures the full spontaneity and excitement of a good improvisation.

Beginning about 1870, there arose in New Orleans a type of music that was later vitally important in the early development of jazz: marching bands made up of African-American players with instruments from Confederate Civil War bands. The instruments—the trumpet or cornet, clarinet, trombone, drums, sometimes even a piano—were performed in a different and unique style. Many labor and benevolent associations had their own bands; when a member died, the bands furnished funeral music both to and from the cemetery. On the way to the cemetery, the band usually played a spiritual song. On the way back the music was more lively, as the general public followed and danced while carrying colorful umbrellas. While the basic meter was that of a march in duple (or quadruple) time, the players characteristically improvised freely, particularly with the rhythm. This music has an exciting, free-for-all sound (see Chapter 15).

Indian *Tāla* (North Indian *Tāl, Tāl'*)

tāla (tāl)
vibhāga
mātrā
sam (sum)
khāli
āvarta
Tintāl

Drumming in India means improvisation. A ragtime piano player improvises rhythms against a composed piece. An Indian drummer improvises rhythms against a *tāla* rhythmic cycle.

Each *tāla* contains a repeating cycle of beats; each cycle statement has a pattern of beats, each of which is called *vibhāga*, corresponding to each of our main beats. The subdivision of each main beat is called *mātrā.* The North Indian *Tintāl (Teen Tāl)* has sixteen beats in four groups of four (we revisit *Tintāl* in Chapter 7):

	cycle to be repeated			
mātrā units	1 2 3 4	5 6 7 8	9 10 11 12	13 14 15 16
vibhāga units	S	X	O	X

As a listener, you can clap the *vibhāga* units, marked "S" or "X." The crucial beat, called *sam* or *sum*, is conventionally indicated by an "S." It is the beat upon which all the performers depend for a point of reference. The secondary strong beats are marked "X." Also a special feature of the North Indian beat patterns is the *khāli*, an "empty" or "open" beat, usually indicated by an "O." For the *khāli*, one turns out the hand, palm up.

The entire repeating cycle, *āvarta*, supplies the framework upon which the drummer improvises an intricate rhythmic superstructure, an essential test of skill. (Each *tāla* has its own particular rhythmic identity; in some of them, for example, the *vibhāga* may consist of three rather than two subdivisions.) Within any given *tāla*, when more than one player takes part in the music-making, they often compete to see how far each one can test the meter without the other faltering. The drummer tries to throw the other performers off by introducing increasingly sophisticated and complicated variants of rhythmic play.

With the sophisticated treatment of the Indian *tāla,* we have arrived at one of the subtlest uses of rhythm in the world of music. In the next chapter, we study melody; with rhythm, melody is one of the two most essential elements in music.

KEY WORDS

Rhythm, pulse, tempo, meter, simple meter, compound meter, additive meter, rhythmic mode, isorhythm, polyrhythm, simultaneous hemiola, cross accents, syncopation, *vibhāga, mātrā, sam (sum), khāli*

SUGGESTED READING

Kostka, Stefan and Dorothy Payne. *Tonal Harmony with an Introduction to Twentieth-Century Music.* 2nd ed. New York: McGraw-Hill, 1989. (Chapter 2)

LaRue, Jan. *Guidelines for Style Analysis.* 2nd ed. Warren, MI: Harmonie Park Press, 1992. Chapter 5, "Rhythm" (pp. 88–114)

Raymond, George Lansing, *Rhythm and Harmony in Poetry and Music.* New York: G. P. Putnam's Sons, 1909. (Chapter 2 discusses rhythm as it appears in nature.)

Robertson, Donald. *Tabla: A Rhythmic Introduction to Indian Music.* New York: Peer International Corporation, 1968.

Articles on polyrhythm, hemiola, rhythmic modes, meter, etc., in *The New Harvard Dictionary of Music* and in *The New Grove Dictionary of Music and Musicians.*

SUGGESTED LISTENING

Additive rhythm: Dave Brubeck, "Take Five," any recording

HELPFUL VIEWING

Circles Cycles: Kathak Dance. Narrator Zakir Hussain. Prod./dir.Robert Gottlieb. Imprint: University of California (Berkeley) Extension Center Media, ©1989. [28 minutes]

"Rhythm," *Exploring the World of Music,* Videocassette 5 (of 12). (See Chapter 1 for further bibliographic reference.) [30 minutes]

3
REVIEW SHEET

Short Answers

1. Give two examples of compositions that use additive meter and for each, show how their main beats are grouped.

2. Specify the main differences between 3/4 time and 6/8 time.

Short Essays

1. Define syncopation and give at least two examples.

2. Compare simultaneous hemiola with polyrhythm. Can you specify any difference in their definitions?

3. Explain the concept of cross accents.

4

MELODY

Similes and metaphors in the English language testify to the cultural resonance of the word "melody." In painting, poetry, and in life itself, melody is a symbol of beauty:

> The rising sun was beginning to silver the leaves . . . a visible melody . . . like the song of early birds. (John Galt, 1830)

> A pretty girl is like a melody. (Irving Berlin, 1919)

A melody is a succession of pitches that makes sense musically, just as a sentence is a series of words that makes sense grammatically. The basic building block of melody is a tone, or pitch. Like the single pulse, the basic building block of rhythm, a tone in isolation has little, if any, musical meaning.

Every melody consists of two or more pitches. The distance between any two tones is the *interval* between those two tones.

Scale

major scale

 The **major scale** consists of a specific structure of two tetrachords (a tetrachord consists of two whole steps followed by a half-step) joined by a whole step. This excerpt features a descending (falling contour) major scale.

◎ **22** *Joy to the World*

The most common scale today in European music is the major scale. The opening notes of Lowell Mason's carol *Joy to the World,* based on Mason's tune, *Antioch,* lay out the major scale in a descending series of pitches:

1. Joy to the world! the Lord is come;

The intervals between the ascending scale degrees are whole steps, except between 3 and 4 *(mi-fa)* and between 7 and 8 *(ti-do)*. You can see this on a piano keyboard: there is no black key between the white keys *E–F* and the white keys *B–C*. If W equals a whole-step, a tone, and H equals a half-step, a semitone, the ascending major scale is then:

do	re	mi-fa	sol	la	ti-do
W	W	H	W	W	H

We are sensitive to small changes in a scale. If just one of the tones of the major scale, the third degree, is lowered, the scale is transformed from major to a form of minor and the mood of the melody changes. *We Three Kings* is a minor melody (two other tones, the sixth and seventh, are also different from major). Notice the amazing transformation when *We Three Kings* is changed to major:

We three kings of O - ri- ent are;

Intervals

An interval is the distance between two tones. When the tones are heard one after the other, the interval is **melodic.** When they are heard at the same time, the interval is **harmonic.**

melodic interval: harmonic interval:

The range is E-F-G. That's three steps, so the interval is a third.

For the minor scale, the solfège syllables begin on *la:*



la ti-do re mi-fa sol la

W H W W H W W



♪ A **blues scale** is the major scale with chromatic alterations of a lowered 3rd, 7th, and sometimes 5th degree of the scale. These altered tones, called blues notes, often give a melancholy edge to the otherwise happy, open feeling of the major scale.

The African-American **blues** has a special scale modified from major and minor. The main scale of a blues melody can be either major or minor, yet certain degrees of the scale are neither major nor minor, but a special inflection unique to the blues. The third degree is most often blue, ambiguous, in between major and minor, sliding or scooping. The blue tones, whether the third, fifth, or seventh, are vocal in origin, but they also have many instrumental imitations.

◎ **23** Bessie Smith "Poor Man's Blues"

Blue notes pervade almost all of American popular music, not only the blues.

The pentatonic, or five-note, scale, though somewhat less familiar than major, minor, and blues scales, appears frequently in folksong and, more recently, popular song. Stephen Foster's adaptation of *Camptown Races,* is pentatonic:

♪ A **pentatonic scale** consists of five tones, the intervallic structure varying by musical culture. In this excerpt, the five strings of the banjo or the groups of two and three black keys on the piano are represented.

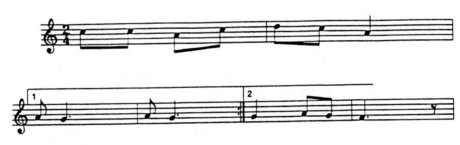

◎ **24** Gottschalk "The Banjo"

This type of pentatonic scale can be easily found on the piano by playing only the black keys. In the West, a pentatonic melody usually gives a simple and straightforward impression. In the high art cultures of Asia, pentatonic scales are ingeniously complex. Pentatonic scales are found everywhere, including all inhabited continents, and appear in a variety of forms:

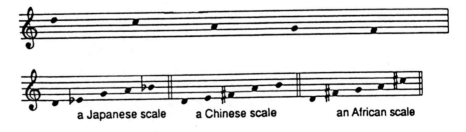



a Japanese scale **a Chinese scale** **an African scale**



♪ The **whole-tone scale,** consisting entirely of whole tones, sounds ethereal or transcendental. This is due to the absence of semi-tones (half-steps) and the harmonic tension they create.

The whole-tone scale favored by the French composer Claude Debussy and other composers of the 19th and early-20th centuries seems to be derived from Asian origins. Each interval of a whole-tone scale is the same size as all the others; this avoidance of differentiated intervals imparts a vagueness as to which note qualifies as the tonic, since there is no half-step *ti-do.*

◎ **25** Debussy "Voiles"

Track 26
A scale featuring two appearances of the augmented second, often referred to as "Hungarian-minor," typically creates that interval by raising the fourth and seventh degrees of the natural minor scale. The natural minor scale is the same as the Aeolian mode.

The very vagueness, the seeming weightlessness of the whole-tone scale, is the source of its charm. Also vague with regard to a tonic is a scale made up completely of half-steps (semitones). Such a scale of half-steps is called "chromatic." Music based on the chromatic scale is usually more strident-sounding than music based on the whole-tone scale.

Scales containing the interval of an augmented second, sometimes referred to as "Hungarian" and often by a variety of other names, though associated with the Roma, are common to the folk music not only of the Balkans but also, in various forms, to certain areas in the Near East. It is used by the 19th-century composer Camille Saint-Saëns to evoke the Biblical of the ancient Near East in his opera *Samson and Delilah*, in which the augmented second appears between the second and third steps of the scale, suggestive of the melody type *Hijaz* (see Chapter 12).

Augmented second scales

The "Near East-ern" scale
involves the sharpening of the 4th and 7th degrees of the Aeolian mode.

Human inventiveness has produced countless other scales, of seemingly infinite variety. Each scale identifies a culture or subculture; within any culture or subculture, it serves as a basis for remembering melodies (in Western music, think of the major scale and *Joy to the World*).

Mode

26 St.-Saëns "Bacchanale"

The word "mode" is related to the English word "mood," and many of the modes throughout the world, including those of medieval Europe, are often said to establish a specific mood. The North Indian mode *Bhairavī* represents melancholy and should be performed in the early morning before sunrise. The medieval church mode *Phrygian* is still heard in Spanish music with a *flamenco* (Arabic-gypsy) flavor.

Besides the extramusical associations of mood (or culture or place), a mode is usually bound by traditional rules of melodic progression. Yet the term "mode" is sometimes used interchangeably with "scale."

Aeolian mode

Major and minor modes are the most familiar to many modern listeners. For today's audiences, the major mode seems happy, and the minor mode, sad. Old ballads and airs preserve some other modes as well. *Greensleeves*, a famous old English tune referred to by Shakespeare, might be sung by one singer in the **Aeolian mode** (= minor scale):

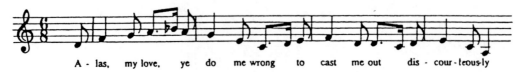

Dorian mode

Another singer might render it in a slightly different mode, **Dorian** (easily found by playing the D octave on the white keys of the piano). The difference between the two scales is only a change in one note (the sixth degree), but the mood is definitely altered:

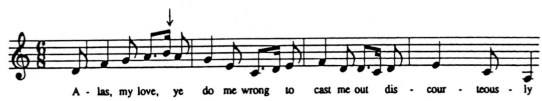

A - las, my love, ye do me wrong to cast me out dis - cour - teous - ly

Dorian mode

Mixolydian mode

Aeolian and Dorian modes date back to medieval chant, also called plainsong. A chant, *In Paradisum,* uses another mode, **Mixolydian.** You can play the Mixolydian scale on the piano using only the white keys, starting with G, the tonic. Mixolydian sounds like major except for the 7th degree of the scale, the F natural. Our major scale has a half-tone between ti and do; Mixolydian sounds different because it has a whole-tone interval just below the tonic:

In summary, modes can often be recognized simply by their distinctive scales. The older the music, the more likely that the wealth of melodic riches and extra-musical associations have been retained. For a listing of the "Church Modes," see Appendix III.

Disjunct vs. Conjunct Intervals

Just as the quality of sound from any instrument is related to the material used (such as wood or metal) and the manner of playing (such as bowed vs plucked), intervals, the stuff of which melodies are made, distinctly influence the quality of a melody. The opening section of Richard Strauss' *Also Sprach Zarathustra* (Thus Spake Zarathustra, 1896) sounds heroic and spacious, mostly because of the wide intervals of the theme announced first by the trumpets. The timpani solo echoes the intervals of the trumpet theme. In opposition to the trumpet theme, the orchestra replies with a melody of small intervals (an ascending major scale):

Melodies that move by relatively wide intervals, or "leaps," are called *disjunct.* By contrast, melodies that move in small intervals such as seconds or thirds, or by "scalar" motion, are called *conjunct.* Though there is a seemingly infinite number of melodies possible, each melody having its own pattern of intervals, one generalization may be made: melodies written for the voice tend to have more conjunct intervals than those written for instruments.

Contour

Pitch, scale, and mode can be considered the vocabulary of melody, but contour is the sentence. The shape, or contour, of a melody is what we remember, and the scale is the mental grid upon which that contour is laid. The mental grid (scale) and shape (contour) of the beginning melody of the second movement of Haydn's *Surprise* Symphony are:

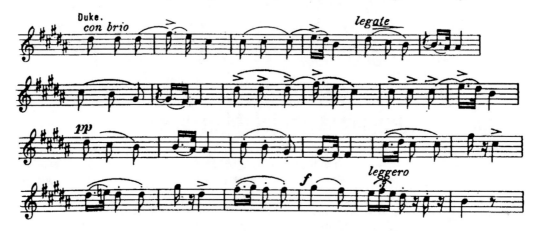

Like the skyline of Manhattan, recognition of familiar patterns is based on shape.

falling, rising contour

We can distinguish three basic over-all contours: falling, rising, and a combination of these two. A melody that begins on a high note and ends on a low note has a falling contour, for example, *Joy to the World.* No matter what twists and turns the melody may take, it is descending if the ultimate direction is from high to low. A falling contour is often intense at the outset on the high tone, gradually expending itself until the energy is dissipated on arrival at the lowest tone. The melodic contour of the ironic aria "La donna è mobile" ("Woman is Fickle") from Verdi's opera *Rigoletto* is a combination of falling, then rising movement:

A purely rising contour is less common, apparently since such a melody would rather quickly expend its sense of climax.

Some experiments show that we can distort the intervals, change the time values, even displace the octaves, and still keep enough of the contour to recognize the melodies. For example, change *Frère Jacques'* intervals to mostly half-steps:

Or convert the meter of "Colonel Bogey" from ₵ to 6/8:

Or introduce a Near Eastern scale into *Row, Row, Row Your Boat:*

Or displace octaves here in the "Ode to Joy" theme of Beethoven's Ninth Symphony:

These melodies are recognizable in spite of alterations, partly because of contour. Contour aids melodic recognition.

Melody Type

Throughout history and in different cultures, melodic formulas and ornaments have been used to establish the mood (or function) of a particular melody or recitation tone. These melody types have long histories and usually have an ancestral relationship to modern modal systems. The ancient Greek *nomos*, the Byzantine *echos*, the Javanese *paṭet*, the Arabic *maqām*, and the Indian *rāga* are all examples of melody type; so are street cries (a sidewalk merchant), the taunts of children ("Johnny got a spanking"), the chanting of psalms, and the pitch outline of a preacher's whole sermon.

Indian melodic composition is governed by the rules of the *rāga* (RAHG-ah) system (see Chapter 7). There are about fifty types in general use today, each recognizable by its distinctive features: contour, ornaments, stereotyped phrases, microtonal pitch inflections (intervals smaller than a semitone), and emphasis or avoidance of certain tones. With experience, the listener can begin to recognize a *rāga* by general feeling.

Stylistic Options

sequence

In constructing a melody, one works within the restrictions of a particular culture in the choice of scales and contours; these are part of his cultural identity and the audience's cultural identity. The composer also has, again within cultural limits, certain options in melody making. One optional device common to many cultures is the **sequence.** A short melodic fragment is repeated, each time beginning on a different

step of the scale, either ascending or, more often, descending. Some slight alterations usually take place during the sequence, but the contour remains almost exactly the same:

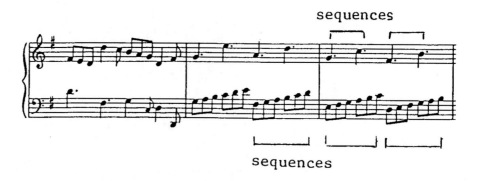

Sequence can temporarily mask a poverty of invention in the hands of a mediocre composer, but a master combines unity and variety through this device.

inversion

Another optional device used by composers is **inversion,** the repetition of a melody, upside-down, creating a contour similar to looking at a mountain and its reflection in a lake on a clear day. Inversion is more difficult to hear than sequence; the contour is preserved but in a more difficult-to-follow transformation. In a composition by J. S. Bach, we first become familiar with a melody through many repetitions. This helps us recognize its inversion later in the piece:

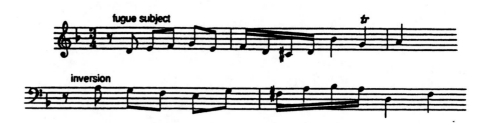

augmentation

Time values of a melody or theme can also be stretched or compressed. Stretching a melody, making it longer and slower, is called **augmentation** (referring to time values, not to be confused with augmented intervals referring to scale pitches). In Britten's *The Young Person's Guide to the Orchestra* (1946), the main theme is in minor and is introduced at a moderately fast tempo. Near the very end of the entire piece, Britten brings back the theme once more, this time in the major scale and in augmentation, approximately twice as slow as the original tempo:

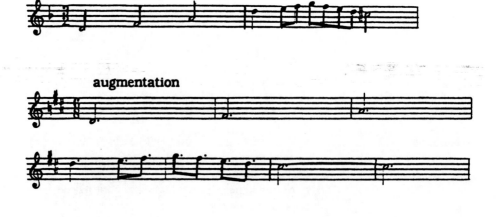

diminution The opposite of augmentation is **diminution,** the compression in time of a melody, making it shorter and faster. The main theme in Berlioz's *Symphonie fantastique* is a lyric, romantic melody for the violins and flute representing his Beloved. Later, after she rejects him, Berlioz paints a musical Witches' Sabbath in which she dances over his grave. Her melody is now in diminution and transforms into a grotesque clarinet solo.

These devices of sequence, inversion, augmentation, and diminution appear also in some other musics of the world, such as Javanese court *gamëlan* music. In music dramas, operas, plays with music, pantomimes, and related genres, melodic sequences are quite frequently used to represent a character on the stage.

motive A **motive** is the shortest melodic unit that is easily recognized and relatively complete in itself, like the ●●●— ("V for victory") opening of Beethoven's Fifth Symphony (1807/8):

A short phrase or motive, whether for stage works or not, has great potential for expansion, alteration, and development, both rhythmically and melodically. In jazz in the bebop era of the 1940s and 1950s, motivic development was central to the style: Listen to any solo by Charlie "Bird" Parker and try to follow its development through repetition and transformation of a brief melodic idea.

Modulation

tonic and dominant One significant melodic option, sometimes totally necessary in the music of some cultures, is modulation. One or more important tones act as reference points for orientation of the melody. The principal tone, the main referent, is the first tone of the scale, the **tonic** (see Appendix I). In European classical music, the **dominant,** which is the fifth degree of the scale, is the next most important tone, and the duality between these two poles is a kinetic source of European music's melodic interest.

In European classical music, modulation is the art of changing the tonal center, or tonic, from one pitch level to another, often but not necessarily always, the fifth degree (the "dominant" of the original scale). This most fundamental modulation can be learned by listening closely to and memorizing the shift from tonic to dominant in the beginning of Mozart's *Eine kleine Nachtmusik* (1787). The structure of the piece is based on this modulation. The first theme group is in the tonic key by

definition; Mozart then makes a transition to arrive at the dominant key and presents a contrasting theme in it, creating a binary opposition between the tonal centers G (tonic) and D (dominant) (this work is also discussed in Chapter 6):

modal change

The essence of modulation is a fresh, contrasting focal point for a melody. Modulation sometimes refers to a changing mode rather than a changing key center, as for example from C major to C minor. Both would have the same tonic but would have a different layout of scale degrees within the same octave. (For a brief review, compare the major/Ionian and minor/Aeolian modes in Appendix III.)

Melodic Improvisation

The most complex aspect of melodic construction is melodic improvisation, since almost by definition melody is composed spontaneously. Improvisation is the art of spontaneously performing the same melody differently every time. Improvising on a melody usually involves three methods: (1) adding notes (embellishment), (2) taking away notes (abstraction), or (3) altering notes. A composer-performer can also just make up or improvise a new melody.

During the New Orleans, or Dixieland, era of jazz (roughly 1900 to 1920), each instrumentalist would improvise a version of the given melody according to the nature of the instrument. The clarinet would busily run up and down the scale or arpeggiate, the trombone would punch out a slow-moving countermelody with typical slides and smears. The joyful freedom of these independent improvisations is what gives New Orleans jazz its essential character. Listen to anything by Louis Armstrong and this point is dramatically illustrated.

In European music of the Baroque period, particularly during the lifetime of J. S. Bach (1685–1750), both instrumentalist and vocalist were expected to improvise their own ornaments to a slow melody. In opera, the repeat of a slow aria was the signal for the singer to show off vocal technique with elaborate ornaments, the event to which the audience listened with awe and rapture. Today, the art of melodic improvisation in classical European music is almost lost to us, but performers sometimes read the ornaments added by a conscientious editor of the score. A few adventurous singers are reviving the unwritten art.

American popular musicians, especially those coming from African-American traditions, have kept alive the improvising ability. From Bessie Smith and Billie Holiday to Ray Charles and Al Jarreau, popular singers with improvisatory talents "compose" or re-compose as they sing.

Improvisation, whether in jazz, Baroque, or Indian music, satisfies basic musical and human needs. The constant interplay between the familiar and the unexpected represents an elementary dynamic of art. To witness another in the very act of formulating a communication never before heard is an experience that can never be replaced by plain repetition or recordings, no matter how perfect.

KEY WORDS

Scale, key, mode, modulation, tonic, inversion, augmentation, diminution, sequence

SUGGESTED READING

General

Dowling, W. Jay, and Dane L. Harwood. *Music Cognition.* San Diego: Academic Press, 1986. (This book discusses the perception of sound, consonance and dissonance, musical scales, melodic organization, musical attention and memory, rhythm, emotion and meaning, and various cultural aspects of music.)

Kingman, Daniel. *American Music: A Panorama.* New York: Schirmer, 1979.

Powers, Harold S. "Mode," *The New Grove Dictionary of Music and Musicians.* London: Macmillan, 1980, XII, 376–450.

Specialized

Hood, Mantle, and H. Susilo. *Music of the Venerable Dark Cloud: The Javanese* Gamelan Khjai Mendung. Los Angeles, UCLA Institute of Ethnomusicology, 1967.

Nketia, J. H. Kwabena. *The Music of Africa.* New York: Norton, 1974.

Tirro, Frank. *Jazz, a History.* New York: Norton, 1977.

SUGGESTED LISTENING

Scale	*Shadow Music of Java,* 3. Patalon. Rounder CD 5060; *SSI: Three Ragas,* 1. Chandranandan. AMMP CD9001; *Evil,* Evil, Chess/MCA; *Sophisticated Lady.* 14. Sophisticated Lady (Duke Ellington). RCA Victor 6641-2-RB
Mode	*Shadow Music of Java,* 3. Patalon. Rounder CD 5060; *SSI: Three Ragas,* 1. Chandranandan. AMMP CD9001
Improvisation	*Shadow Music of Java,* 3. Patalon. Rounder CD 5060; *SSI: Three Ragas,* 1. Chandranandan. AMMP CD9001: *Evil,* Evil, Chess/MCA: *Great Orig. Performances,* 3. Struttin' With Some Barbecue. Louisiana Red Hot

HELPFUL VIEWING

What is a Melody? (Young People's Concerts, 10 videos and 25 programs). Part of a videocassette (with *Humor in Music*). Script by Leonard Bernstein. Prod./dir. Roger Englander; exec. prod. Harry Kraut. Imprint: Sony Classical, 1993. [53 minutes]

DVD: *What Is Melody?* Disc 4 of the 9-disc set, *Leonard Bernstein's Young People's Concerts.* ISBN: 0769715036. West Long Branch, NJ: KULTUR VIDEO: D1503, [2004].

"Melody," *Exploring the World of Music.* Videocassette 6 (of 12). (See Chapter 1 for further bibliographic reference.) [30 minutes]

Raga. Videocassette. Prod./dir. Howard Worth, screenplay/assoc. prod. Nancy Bacal; imprint, Mystic Fire Video, c1991. [93 minutes]

4
REVIEW SHEET

Short Answers

1. Identify five different types of scales.

2. Identify at least four modes (by name).

3. Name three different types of melodic contours.

Short Essays

1. In music, what does "modulation" mean?

2. Can you imagine improvisation without melody? Explain your answer.

3. Describe the structure of a major scale.

4. Explain the difference between augmentation and diminution.

5

TEXTURE
AND HARMONY

In Chapter 4, we examined melody, a single voice. We now examine how multiple voices combine into counterpoint and harmony.

Various Types of Texture

"Texture" describes how and to what extent melodic lines are simultaneously combined, comparable to threads in a fabric. A single unaccompanied melodic line, as in Gregorian Chant, is called monophony. Monophony has purity and unity. An analogous fabric would have threads all the same color and texture.

More than one melodic line produces polyphony, a dramatically different texture from monophony. A Bach fugue is polyphonic. Polyphony has a rich and complex texture. An analogous fabric would have several colors and textures of which none predominates.

Heterophony uses different versions of the one melody at the same time, a texture between monophony and polyphony. Early New Orleans jazz is heterophonic. Heterophony has more unity than polyphony and more variety of texture than monophony. An analogous fabric would have variations on a pattern interwoven.

Homophony is melody with accompaniment. A Schubert song is homophonic. An analogous fabric would have a single image against a subordinate background.

Monophony

Monophonic texture involves one melody with no accompaniment. This can be one voice or a thousand voices if they are singing/playing the same melody in unison.

27 David Houston: "Amazing Grace"

If one person or a hundred sing the same melody, the music is monophonic.

monophony:

Monophony appears in music of all cultures. Serving a variety of functions, it characterizes ritualistic chant, from pentatonic Lummi paddling songs with drum accompaniment in Native American music to mystical praises of God in the Roman Catholic Service. In Medieval Europe, monophony occurred in Gregorian Chant, the music for the liturgy of the Roman Catholic Church. In such monophonic chant, a call-and-response interplay is typical, as it is in many musics of various regions and in much African ritual singing.

Heterophony

With untrained choruses, monophony may quickly (and unintentionally) become heterophony: two or more versions of the same melody occurring simultaneously. Yet, in many cultures, heterophony has attained so high a level of sophistication that it may itself be considered the end result of a long evolution.

heterophony:

Bahamian gospel songs are often heterophonic. Everyone keeps up with the tune in his or her own way, some speaking, others singing, often in different registers. For all the variations there is still a central musical line, but with an overall effect of freedom. The "edges" of the melody seem hazy. In many Bengali mystical songs the singer shares the melody with the *dotara,* a four-string instrument. The

idiomatic differences between the vocal line and the string-instrument line produce heterophony, since both otherwise simultaneously give the same melody. This type of heterophony is probably the most common among various cultures and the most easily perceived.

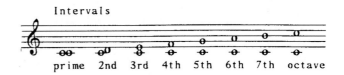

Polyphony: Parallel Motion

polyphony

When people sing the same melody at different pitch levels, other than the octave, the result is parallel-motion polyphony (people always sing in octaves, the women taking the higher register, the men the lower):

parallel motion: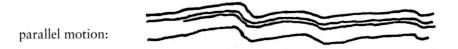

This type of texture appears often in folk music, but also in early Western European music. The intervals most frequent in parallel motion are thirds, fourths, and fifths:

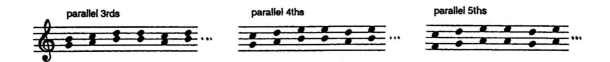

parallel 3rds and 6ths

 "Singing harmony" usually means singing in parallel thirds or sixths. Parallel thirds are common. In the wealth of African polyphony, parallel thirds and sixths are dominant in tribal music of the Congo and Guinea Coast. They also occur in tribal music from the Caucasus, and in Polish, Czech, Slovak, Italian, and German folk songs. In the Western Hemisphere, thirds appear in Puerto Rican folk songs, often over a guitar accompaniment. In Medieval art music, parallel thirds and sixths appear most often in music from the British Isles, dating at least from the 13th and 14th centuries.

parallel 4ths and 5ths

 Possibly even more universal are parallel fourths and fifths, occurring in music from Iceland (with ancient Scandinavian roots) and from Ukraine. They also appear in folk music of Asia Minor, the music of East Africa, and the art music of Medieval Europe.

parallel 2nds and 7ths

 Parallel seconds and sevenths are rarer on the world scene. Striking examples of parallel seconds occur in Balkan folk music and, in the Baltic region, the Lithuanian *sutartiné*, a type of song in which one voice imitates the melody of another. The interval of the second, which Western Europeans generally consider harsh sounding and difficult to sing, apparently causes few problems for folk singers of Eastern Europe. For example, parallel seconds such as

occur in folk songs on the Croatian island of Krk. (With a friend, sing a slow, easy tune like *My Country, 'Tis of Thee* in parallel seconds.)

Since about 1890, parallel chords have appeared anew in European art music, especially in that of French composer Achille Claude Debussy (see Chapter 10). Possibly influenced by the parallel fourths and fifths in Chinese mouth-organ *(shêng)* music, Debussy found this technique an attractive alternative to traditional harmony. This process, called "parallelism," had also been found in popular music and has long been the property of jazz, such as Duke Ellington's *Sophisticated Lady.*

parallelism, oblique motion

♪ Oblique motion involves a melody with contour set against a drone, a constant, unchanging tone. By its very composition, the bag pipes with chanter and drone exhibit oblique motion. A vocal version of oblique motion is termed *diaphony.*

Oblique Motion

When one part remains at fixed pitch while another part moves, we call the relationship "oblique motion":

oblique motion:

Bagpipes are well-known examples of oblique motion. One or more pipes hold a drone, or single fixed pitch, while a "chanter," or melody pipe, plays a tune. Estonian bagpipe drones are pitched a second above the keynote of the melody; conversely, the Irish Union (*Uilleann,* pronounced "ILL'n") pipes have many tunes built on the second degree of the chanter scale against a drone on the tonic. In East European folk music, when the chanter and drone parts are performed vocally and by woman, the term "diaphony" is used to describe the texture (see Chapter 14).

◎ 28 Uilleann pipes "The Brown Thorn"

Imitative Counterpoint

With Imitation, the same or a similar melody appears in various parts but with different points of entrance:

imitative counterpoint:

exact ("strict") imitation
canon and round

The concept of imitation in polyphony is associated with the term "counterpoint," which comes from the Latin *punctus contra punctum,* "point against point." The expression refers to a melodic series of notes heard against another melodic series of notes. When imitation is exact, we refer to the music as a *canon.* A special type of canon occurs when the leading voice, "*dux,*" begins again before the second voice, "*comes,*" finishes; the music continues on and on, as if moving in circles. Such a canon, like *Frère Jacques,* is referred to as a round or "*rota*" (wheel in Latin).

free imitation

Canons and rounds exemplify strict imitation. Free imitation, in which succeeding statements are similar, but not literal, is more common. Many examples appear in the organ fugues of J. S. Bach. Also, an involved interplay between the voice and violin characterizes a virtuosic South Indian musical genre known as *Kriti.* Towards the end, the singer, imitated by the violinist, improvises melodic and rhythmic variations, while the drummer maintains the *tāla* cycle. In music performed by the royal flutes of Uganda, the pulse is fast and some of the imitation takes place in the same register as the original statement, creating a busy, crowded texture.

Nonimitative Counterpoint

When two or more different melodies of similar importance occur simultaneously, we have nonimitative counterpoint:

nonimitative counterpoint:

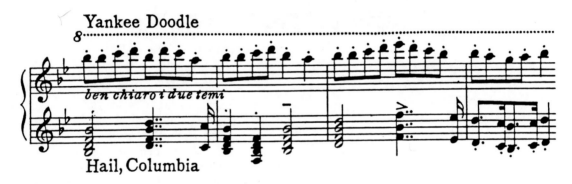

Traditional Euro-American music of the 18th, 19th, and early 20th centuries features many examples of nonimitative counterpoint. In the third movement of Bach's Cantata 79, *Gott, der Herr, ist Sonn' und Schild* (The Lord God is Our Light and Shield), a hymn sung by the choir contrasts with the horns, resulting in at least two clearly differentiated melodic ideas, each fully harmonized. In 1862, barely after the start of the Civil War, the American composer Louis Moreau Gottschalk completed his musical homage to the United States with a piano piece, *L'Union,* based on *The Star Spangled Banner, Yankee Doodle,* and *Hail Columbia,* the last two of which appear simultaneously at the conclusion.

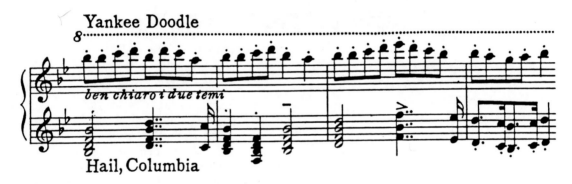

Homophonic texture involves a melody with accompaniment. In this excerpt, the melody is first heard in the upper strings set against an accompaniment of pizzicato lower strings. After the introduction of the theme, the solo piano presents the melody in the right hand and accompaniment in the left hand.

29 Mozart pno. conc. no. 21

Nonimitative polyphony also appears outside the Euro-American tradition, such as in African tribal music and Korean *Shinawi* (sheh-NAH-we) music. The Ba Benzele hunters of Central Africa perform a song before the departure of the hunters. One man repeats a yodelled figure and is soon joined by another man and a male chorus, while in the background, the women sing a countermelody.

Homophony

In homophony, one part dominates the others. Typically, a melody is supported by other parts, which function as accompaniment, as is in most traditional and popular songs. This type of homophony appears in the famous second movement of Mozart's 21st piano concerto:

chordal texture

Four-part harmonizations of hymn tunes form another type of homophony: texture in which all parts move nearly always at the same time, in fuller synchronization. Such a "homorhythmic" texture is also referred to as "chordal," most often heard in traditional settings of melodies such as *Old Hundredth:*

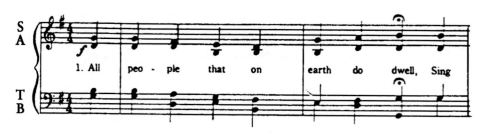

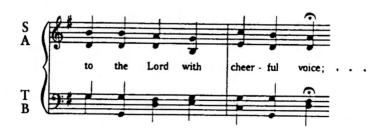

Harmony

two definitions of harmony

In many music theory discussions, "harmony" refers to simultaneous sounds in musical texture. If the melodic or "horizontal" elements correspond to the woof in a woven fabric, the harmonic or "vertical" elements correspond to the warp. In definitions of harmony, the term **chord** becomes important. A typical chord consists of three or more different pitches sounded at the same time. Beyond its reference to the vertical aspects of texture, "harmony" has also been used to describe *successions of chords,* vertical aspects of texture moving through time.

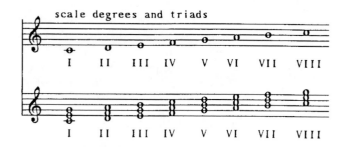

In general, there are three large families of chords: (1) those built on intervals of thirds, (2) those built on the intervals of seconds or fourths, and (3) those with added tones.

1. *Tertian Harmony.* Chords built on thirds are called "tertian." In traditional European music, by far the most frequently used chord is the **triad,** which results from two superposed thirds:

If you add a third above (or below) a triad, a "seventh" chord results; the number seven refers to the distance between the lowest note and the highest note of the chord:

If you add a third to a seventh chord, you get a ninth, chord:

If you continue adding more thirds, you get eleventh and then thirteenth chords. By the time you reach a fifteenth, you return to the lowest note of the triad at a higher octave and merely begin the process all over again. In traditional Western European music, triads dominated from the late 14th to the late 17th centuries, from which time sevenths became increasingly popular. In the 19th and 20th centuries, ninths prospered, as in the *Pavane for a Dead Princess* (1899) by French composer Maurice Ravel:

Much folk music around the world makes use of the third in polyphonic settings, in music from the Caucasus to the Congo. Occasionally these thirds combine to suggest triads.

2. *Cluster Chords and Quartal Harmony.* Another important group of chords includes those made up of seconds or of fourths. In harmony made up of seconds, the dense blending of fundamental pitches and their overtones tends to make us perceive the chords as noisy clusters rather than as combinations of distinct pitches, and the chords involved are often referred to as **cluster chords.** When they appear in a series, we refer to the succession of sounds as cluster harmony. By contrast, harmony built on intervals of fourths tends to have "open" sounds, more so even than triads. The harmony built on fourths is called **quartal.** Both types are grouped together because they occur far less frequently than chords built on thirds. The 20th-century composer Béla Bartók (see Chapter 11) used cluster chords and quartal harmony as well as a full complement of tertian harmonies.

3. *Added-Note Chords.* A third group of chords concerns harmonies such as triads with new pitches added to them. Among the harmonies that add pitches to the conventional triad is the "added-sixth" chord, known well in jazz:

In the preceding chord, the D is added above the triad on F. The chord is given its name "added sixth" since D is six scale degrees above F. Particularly in jazz improvisations, other notes besides sixths are often also added to tertian chords.

Other Harmonic Concepts

Broken Chords

broken chords

Sometimes a composer separates or "breaks" a chord into its individual pitches to extend its duration without directly repeating it. Such "broken" chords are typically tertian and frequently accompany a melodic line, whether performed on the African *mbira* thumb piano or in a 19th-century piano piece. Traditional triadic harmony is also the basis for broken chords in much bluegrass banjo music. The styles of broken harmony are often related closely to the performance requirements of particular instruments.

Cadences

authentic and plagal cadences

A harmonic cadence consists of two or more chords that function in a manner analogous to punctuation in writing. Occurring at the ends of phrases and larger musical units, cadences help shape the musical line, just as commas, semicolons, colons, question marks, exclamation points, and periods shape the structure of written sentences. The most important cadence in Classical European music is the authentic or V-I cadence: a tertian chord built on the fifth degree of the scale going to a tertian chord built on the first degree, as occurs at the conclusion of *The Star Spangled Banner* and most other classical works. The plagal or IV-I ("Amen") cadence appears somewhat less often, but a famous example occurs at the conclusion of the "Hallelujah" Chorus from Handel's *Messiah*.

 30 Beethoven 5th Symph. ending

♪ **An authentic cadence** is a harmonic progression from the dominant, the V chord, to the tonic, the I chord. The authentic cadence in this excerpt is the closing cadence of a four-movement work for orchestra, analogous to the period at the end of a long story.

 31 Handel "Hallelujah" ending

♪ **A plagal cadence** is a harmonic progression from the subdominant (IV chord) to the tonic (I chord). It is commonly known as the "Amen" cadence owing to its familiarity at the ending of Protestant hymns.

Rest and Motion

consonance
dissonance

In traditional Western music, some intervals have long been considered **consonant,** others **dissonant.** Consonance means stability and rest, dissonance means instability and motion.

The "one-ness" of sound of the octave is remarkable and recognized in many cultures. A group of men, women, and children, asked to sing a tune such as *America* "in the key of G," once given a unison G, will automatically start off in octaves, sometimes two or three apart. (Listen to the voices singing the National Anthem at a sports event.) This "one-ness" of sound (consonant), contrasts with the clashing of "dissonant" sounds. The strongest feelings of unity are with the unison, octave, and fifth. The strongest feelings of clash occur with seconds and sevenths in traditional Euro-American music.

The effects of rest and motion extend beyond simple intervals to chords and harmony. In a musical composition, the tonic chord gives the feeling of rest. Chords built on other degrees produce varying grades of movement. In a typical progression of V going to I, or of IV going to I, the impression is of motion going to rest.

The changes from rest to motion and back to rest give life to the music we hear and help sustain our interest in it. The motion-rest process can extend over an entire piece and not be limited to a single cadence. In many of the songs we learned in grade school, only several harmonies are used; these are usually the tonic (I) and the dominant (V), and sometimes the subdominant (IV). In the American traditional song *Clementine,* the harmony fluctuates between I (stability) and V (motion):

Twinkle, Twinkle, Little Star uses three chords: I, IV, and V. Movement is created by IV and V: V pushes strongly towards I, but IV has a weaker sense of motion, making its progression to I harmonically weaker:

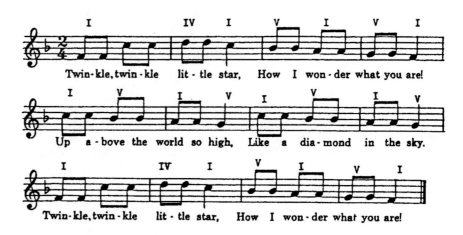

As *Twinkle, Twinkle, Little Star* shows, different harmonies have different strengths within a given piece. These varying strengths give shape to the body of a musical composition.

Tonality

tonality, key, tonic

Harmonic consonance and dissonance as well as cadences help project the impression of movement and arrival. When the authentic cadence appears at the conclusion, the music seems to have returned home. In traditional music, home is the tonic, the first degree of the scale. The terms "tonality" and "key" are synonymous and indicate the existence of a tonic, the tone around which the music orbits. If we say that a musical composition is in the key of "D," we mean that it will end, and often begin, with a harmony whose root (supporting pitch) is D.

Context

mouth organ harmony

Chinese and Japanese traditional music uses harmony as a vertical manifestation of the particular mode on which the melody is built. The harmonic structure is executed by mouth-organ (the Chinese *shêng* and the Japanese *shō*), and the main notes of the melody are always present from the pitches sustained on the mouth-organ. The harmony provides a pitch presently heard in the melody simultaneously with pitches already heard and pitches yet to be heard. Thus, there is a timeless quality in the treatment of harmony.

The *shō* in Japanese *gagaku* uses a vertical structure built on one of the tones from a specified modal system. Each chord is constructed in fifths. It is then compressed, by octave transpositions, into a chord made up of seconds, fourths, and fifths. For example, the chord known as *Gyo* is made up of five pitches, each a fifth apart:

but arranged as:

The harmonic structures are known collectively as *aitake*, and since the chords are performed on the *shō* mouth-organ, the harmonic practice is called *shō aitake*.

chord progressions

European music, from about 1350 to 1900, employed a relatively faster progression of harmonies. Most traditional Western music produces a series of chords in which each proceeds to the next in a continuous stream until the end of a movement. Such a goal-oriented, teleological series of chords produces a relatively kinetic style of harmony.

32 Chopin C-minor prelude

♪ This excerpt demonstrates a composition with a slow tempo yet with a fast harmonic rhythm. With each beat, the chord and the harmony changes. Listen for the alterations between minor and major harmonies.

In traditional Euro-American music, progressions lead naturally to the end of a phrase, usually marked with a cadence, the place where the singers in vocal pieces stop momentarily to take a breath if the piece is vocal. The ends of the phrases often coincide with the ends of lines in the text. Phrase endings in purely instrumental music are also shaped by cadences. A familiar example of chord progression occurs in the C-minor prelude for piano by the 19th-century Polish composer Frédéric Chopin:

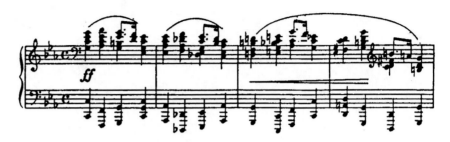

Sometimes a harmonic progression repeats over and over. In African music, a popular *mbira* (African thumb piano) chord sequence, one of several called *Nyamaropa,* consists of repeating patterns such as G-B-D, G-B-E, G-C-E, A-C-E (approximate pitches in Western notation):

"boogie-woogie" progression

blues progression

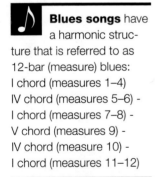

Blues songs have a harmonic structure that is referred to as 12-bar (measure) blues:
I chord (measures 1–4)
IV chord (measures 5–6) -
I chord (measures 7–8) -
V chord (measures 9) -
IV chord (measure 10) -
I chord (measures 11–12)

33 Bessie Smith "St. Louis Blues"

harmonic rhythm

Another similar repeating chord progression is the basic 12-measure **blues progression,** later adapted to a style of piano music especially popular in the 1930s called "boogie-woogie" and also used often during the early phases of rock music. While the blues progression may vary in length, occasionally substituting other chords, the standard 12-measure type is used almost exclusively in boogie-woogie and consists of chords built on the following scale degrees (one per measure):

I-I-I-I-IV-IV-I-I-V-IV-I-I

This 12-bar unit is then repeated throughout the entire piece. The repetition of the progression tends to give the total harmonic framework a contained motion, like the swinging movement of a pendulum:

I-I-I-I-IV-IV-I-I-V-IV-I-I I-I-I-I-IV-IV-I-I-V-IV-I-I - - -

Tempo

The rate at which chords change within a piece, usually referred to as **harmonic rhythm,** varies widely from one culture to another. In the *shō aitake* system of Japan, the harmony moves relatively slowly: the *shō* merely sustains the main pitches of the melody with harmonic clusters. As the mode changes, so do its main pitches, resulting in a new harmonic cluster for the *shō.* The chord series in African *mbira* patterns and in blues do progress forward initially, but since each progression is constantly repeated as a unit, the music projects the impression of contained motion. In much traditional European music, you find gradations of harmonic

tempo, from chords sustained through many measures to chords that change on every beat within a measure.

long-sustained chords (Japanese *shō aitake* system):

repeating chord pattern (African *mbira* thumb piano):

varied design of harmonic rhythm (European classical system):

Harmonic Improvisation

Conceptually, harmonic improvisation may be built on a vertical or a horizontal axis. On the vertical axis, we can add notes to preexistent chords, such as a third to a triad to form a seventh, or a second or sixth for cluster effect. Sometimes a completely different chord may be substituted for the original, taking for a point of reference a common note or some other conventional association. Substitute chords are, in a sense, ideas freely added to the general vertical axis. Along the horizontal axis, a contrapuntal line may freely combine with a given melody, forming a harmony with it and filling out the texture. Both processes, like other types of improvisation, generally adhere to some guidelines. While vertical vs horizontal approaches are isolated for conceptual clarity, in the real world of harmonic improvisation, many gradations between them exist.

vertical and horizontal improvisation

Vertical improvisation in the form of added-note chords crops up frequently in jazz, particularly piano music. Norwegian folk fiddlers improvise harmonies horizontally; there are usually two performers; the first plays the melody of a regional dance tune or other popular work, and the second improvises a counterpoint against it. Both together provide a flowing line of tertian harmony.

figured bass
basso continuo

The figured bass of the Baroque era (ca 1590 to mid-18th century) combines the horizontal and vertical approaches. During the later 16th century, the practice arose of supporting a vocal part with an independent bass line performed on instruments. One of the bass instruments, such as a large lute or a harpsichord, produced chords, indicated by numbers written above or below the bass line. The performer filled in the chords indicated by the numbers ("figures"):

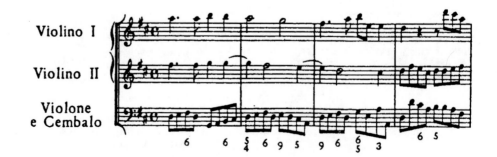

When extended throughout an entire piece, a figured bass was called a "thoroughbass" in English, a ***basso continuo*** in Italian. The figured bass was used in both instrumental and vocal ensembles, and it continued to be used until about 1800.

In Chapters 1 and 2, we studied how musical sounds are produced on instruments and how composers transmit those sounds to performers through notation. In Chapters 3, 4, and 5, we investigated the basic elements of music—rhythm, melody, and harmony. We will now explore how composers put these elements together to make musical forms.

KEY WORDS

Texture, monophony, heterophony, polyphony, imitative counterpoint, nonimitative counterpoint, homophony, homorhythm, chord, triad, seventh, ninth, broken chord, tonality, cadence, consonance, dissonance, harmonic tempo, figured bass, *basso continuo*

SUGGESTED READING

Berliner, Paul. *The Soul of* Mbira: *Music and Traditions of the Shona People of Zimbabwe.* Berkeley: University of California Press, 1978.

Garfias, Robert. *Music of a Thousand Autumns: The* Tōgaku *Style of Japanese Court Music.* Berkeley: University of California Press, 1975.

Kostka, Stefan and Dorothy Payne. *Tonal Harmony with an Introduction to Twentieth-Century Music.* 2nd ed. New York: McGraw-Hill, 1989.

LaRue, Jan. *Guidelines for Style Analysis.* 2nd ed. Warren, MI: Harmonie Park Press, 1992. Chapter 3, "Harmony" (pp. 39–68).

SUGGESTED LISTENING

Monophony	*SSI: Three Rāgas,* 1. Chandranandan. AMMP CD9001
Heterophony	*Shadow Music of Java,* 3. Patalon. Rounder CD 5060; *The Janissaries,* 4. Janissaries' Air. Auvidis/ETHNIC B6738; *Flute & koto du japon,* 4. Rokudan Nippon Columbia 100002; *Gagaku: Traditional Sound of Japan,* Etenraku. Nippon Columbia 28CF-2487; *Great Orig. Performances,* 3. Struttin' w/sm BBQ. Louisiana Red Hot
Parallelism	*Sophisticated Lady,* 14. Sophisticated Lady (Duke Ellington). RCA Victor 6641-2-RB; *Walter Gieseking Plays.* 5. Estampes: Pagodes. Vai Audio VAIA 1117
Oblique Motion	*Le Mystère des voix bulgares, vol. 2,* 1. The Flute Plays. Elektra EL 79201
Nonimitative	*Music of the Ba-Benzele Pygmies,* Return from the Hunt. Baerenreiter
Broken Chords	*The Soul of Mbira,* Nyamaropa. Elektra/Asylum H-72054
Blues Progression	*Evil,* Evil, Chess/MCA

HELPFUL VIEWING

"Harmony," *Exploring the World of Music.* Videocassette 9 (of 12). (See Chapter 1 for further bibliographic reference.) [30 minutes]

Red, White and Blue Grass. Videocassette (U-matic). Made by Elliott Erwitt for Time-Life Films. Imprint: Time-Life Multimedia, 1974. [27 minutes]

"Texture," *Exploring the World of Music.* Videocassette 8 (of 12). See Chapter 1 for further bibliographic reference.) [30 minutes]

5
REVIEW SHEET

Short Answers

1. List two types of imitative counterpoint.

2. What is "diaphony"?

3. What is a chord?

4. How many different pitches are there in a (complete) seventh chord?

5. Explain the four types of musical texture.

6. Explain parallel and oblique motion.

7. What is a cadence? What is the difference between an authentic cadence and a plagal cadence?

8. Describe the structure of 12-bar boogie-woogie progression.

6
FORM

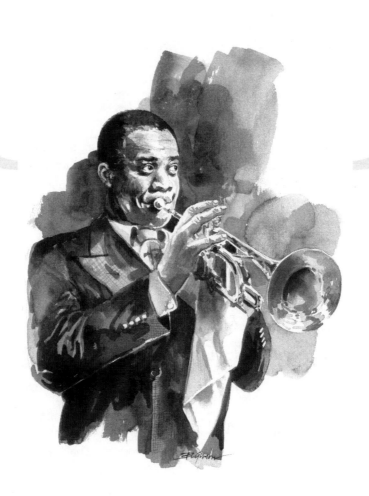

In the arts, "form" refers to the structure in which ideas that determine the total aesthetic experience are presented. In music, a succession of events occurs in time. In some respects, musical forms may be regarded as an extension of rhythm into a broad dimension. For example, a short repeating pattern may be considered primarily metrical. However, when a rhythmic pattern broadens into an extensive Turkish *usûl* or a colotomy stratum in a Balinese *gamělan*, its temporal aspects become increasingly formal.

Turkish *usûl* in 88/4 time:

entire piece:

metric pattern: o

entire piece: oo

In our discussion, form refers specifically to the way temporal events occur.

Closed Forms

Most traditional musical forms are "closed." They have a clearly stated close, built on a conventional cadence. The feeling of inevitability at the close grows from a process in which an expectation of the final cadence arises at some relatively early point in time. Cadences occur at places other than only the end of a composition; a coordinated system of cadences greatly enhances the effect of the final cadence. Many composers of art music search for a means of sustaining a feeling of goal-oriented movement, of "direction" in the unfolding musical line. An impression of musical trajectory emerges in "symmetrical" *(a b a)* forms with the return of earlier material at the close, establishing a scenario of statement, departure and return.

Modular Forms

There is a family of forms in which each design is complete in itself, but being short, has the capacity for further growth through literal or varied repetition. The forms in this family are **modular.** They are the simplest and most compact of forms.

A basic modular form, besides the simple statement *a,* is *a b,* as in *America* ("My Country, 'Tis of Thee"); *a* is six measures, *b* eight. As you sing it to yourself, conduct the music in three and count the measures as you go along.

A symmetrical design occurs with a restatement of *a* after *b.* A 15th-century example of *aba* form is a tune entitled *L'homme armé* ("The Armed Man"), so well-liked that it became a standard melody on which to base large polyphonic compositions for over a hundred years. The *b* section ends on a sustained note that directs our attention back to the restatement of *a,* much as an upbeat prepares us for a downbeat:

The armed man is to be feared; everywhere it has been proclaimed that everyone should arm himself with an iron coat of mail.

A frequent type in popular music is *aaba*, a variant of the symmetrical design of *L'homme armé*. With this form, the first *a* is usually an introductory statement of the main theme.

Sometimes a symmetrical form has sections complete in themselves: *b* projects the impression of complete close rather than immediately directing us back to *a*. This three-part form is called ternary. Since each section is complete in itself, ternary form is usually longer than the more continuous three-part structure exemplified in *L'homme armé*.

Since the Middle Ages, the structure *aab* has been popular in Europe, particularly in Germany, where it is still called "*Bar* form." *Bar* originally referred to a type of Medieval German poem of three or more stanzas, each with the structure *aab*. Chorales, the hymns of the Lutheran Church, employ *Bar* form. Most of J. S. Bach's sacred cantatas are based on the text and melody of a chorale, as for example Cantata 140, *Wachet auf, ruft uns die Stimme* (Awake, Call Out The Voices), written in 1731. The seventh and last movement of his cantata is based on the text *Gloria sei dir gesungen* (Glory Be Sung to Thee) and exemplifies *Bar* form, *a a* (lines 1–3, 4–6) *b* (lines 7–12):

ternary form

The **German *Bar* form,** aab, presents a melody which is repeated then followed by a contrasting melody. The origin of this structure dates back to German poetic structure in the Middle Ages. aab form is commonly found in Lutheran hymns.

34 Bach "Wachet auf"

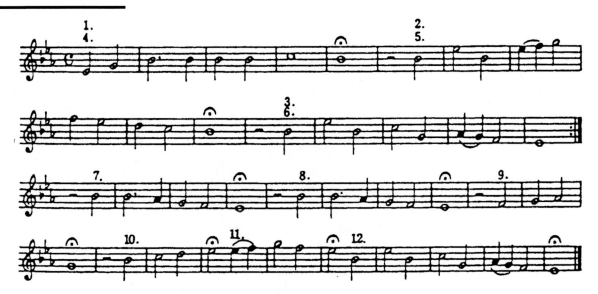

In European music especially, the *a* section often ends in a key other than I (the tonic), generally V (the dominant). Such change of key in *a* creates the need for a return to I in *b*, resulting in continuous form. The implied harmonic arch

themes: *a* *b*
 V ——→ V
keys: I↗ ↘I

binary form

produces a form known as **binary.** Many dances of the 18th century are binary. Both sections of a binary form usually repeat:

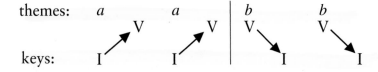

themes: *a* *a* | *b* *b*
 ↗V ↗V | V↘ V↘
keys: I I | I I

If *a* or its variant returns at the end of *b*, the form is *rounded*. Since the first *a* section modulates to a second key and the answering *ba'* modulates back to the tonic, the over-all structure becomes a **rounded-binary** form:

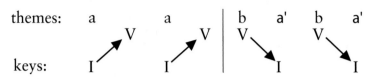

Strophe and Refrain Forms

In order to make a texted composition longer, composers often repeat a modular form for subsequent stanzas of text. When the stanzas have the same general structure and length, the musical module need be written only once, for the first stanza of the text. Such a process results in **strophic** form. If the music module consists of the form *aaba*, the strophic result would be *aaba, aaba, aaba*, for three stanzas. The module may be made up of any number of different musical units, and sometimes none repeats another: *abcde*. If the work is strophic, the module will be repeated as a whole: *abcde, abcde*. In texted music, strophic form is possible if the same number of syllables appear in each stanza. Strophic forms occur in the songs of East European countries such as Hungary and Romania. Though the number of accented syllables in each line of the poetry may vary, so long as the total number of syllables for each complete stanza of a poem stays constant, strophic form is possible. Characteristic of Euro-American folk song, strophic forms are often heard in purely instrumental arrangements, usually as dances that repeat until the dancers are tired.

Most refrain structures in Europe and America employ strophic form. The concept of the refrain is more widespread than that of the simple (Euro-American) strophe and probably has most of its origins in call-and-response chant. In the Euro-American repertory, the refrain's association with the strophe results in a broad variety of verse-and-refrain structures. For example, in some version of *The Two Sisters,* an English ballad, the refrain interpolates with the lines of the verse: lines 1 and 3 are freely texted, lines 2 and 4 recur as refrains. The musical structure is built up from the module *a B c D* (capital letters = refrain statements). The music module repeats as a unit, as a strophic structure: *a B c D, a B c D:*

music module:	a B c D	a B c D	a B c D
lines of text:	1–4	5 2 6 4	7 2 8 4

Each verse-and-refrain structure follows its own logic. Typically, refrains are relatively short. In some traditional songs, however, the verse and refrains are of the same length. In such instances, both may be set to the same musical module, as in the five-stanza song, *Clementine:*

music module:	abcd	ABCD	abcd	ABCD	——
lines of text:	1–4	5–8	9–12	5–8	——

An expansion occurs when the verse and refrain have different music but together form a module that then repeats as a strophe: *a b c d* (verse), *E F G H* (refrain) = one musical strophe, *a b c d E F G H* = a second musical strophe.

Refrain forms are not restricted to vocal music. A Turkish orchestral piece in "*Peshrev*" form consists of free-sounding passages (each called *hane*) alternating with refrains (each called *teslim*). This is the kind of music that may have been heard during the 18th century in a concert in the courtyard of a sultan. Throughout Europe, rondos became the vogue for the last movements of concertos and some symphonies during the 1770s. In the rondo the "refrain" is seldom the same on its reappearances and often is shortened or otherwise varied. The non-refrain sections

are called episodes. It is customary to employ *A* for refrain statements and other capital letters (*B, C, D, . . .*) for episodes. A favorite two-episode form was *A B A C A*.

Even freer refrain-like statements can link a chain of separate movements. In his piano piece *Pictures at an Exhibition,* written in 1874, Russian composer Modest Mussorgsky musically portrays an exhibition of paintings in a series of short movements. The movements are joined by a "promenade" theme that represents the composer walking from one painting to the next. As the mood of Mussorgsky changes, so does the mood of the promenade theme, as illustrated in its first several statements:

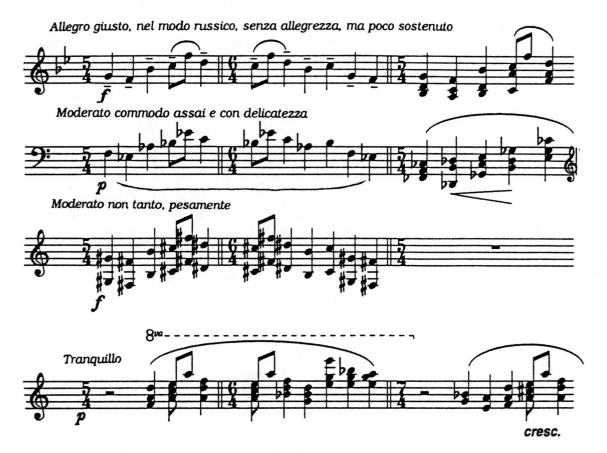

Theme and Variation

The wealth of variation styles found among different peoples probably reflects a universal yearning for artistic freedom. There are two types of variation: simultaneous and successive. Simultaneous variation occurs in heterophony (see Chapters 5 and 10); in successive variation, formal aspects are realized.

Successive-variation types are as rich in musical variety as in geographic spread. Seemingly all shades of spontaneity and complexity may be found, from the melodic variation in the instrumental sections of Burmese harp songs and the improvised variations of women's dances in the Congo to the solo instrumental variations of the Korean *sanjo,* the Japanese *koto danmono,* and the various rhythmic and melodic elaborations of Indian *tāla-rāga* systems.

There exist many gradations of spontaneity in the performance of the variations—Asian and African types are often more improvisational than those of traditional European music—but there are also many different stylistic approaches to the concept itself.

Some variations build from a melody or a rhythmic pattern, others from a harmonic progression or instrumental timbres. The possibilities are so numerous that codification seems difficult. There is, however an approach that proves helpful: relative length.

**continuous variations
ground basses**

 In this example of **continuous varia- tions,** an ostinato (repeated pattern) of 8 notes sets the harmonic foundation for the melody. With every ostinato cycle, the melody is embellished and more voices are added, resulting in a set of continuous 28 variations. See if you can count how many occur in this excerpt.

35 Pachelbel "Canon"

Short patterns, by their very brevity, tend to run one into the next and be perceived as part of a continuous line. In these continuous variations, the repeating pattern often occurs as a bass part or a bass-related harmonic progression on which the variations are built. As a result, continuous variations are often referred to as being built on "ground basses" or simply "grounds."

In Baroque music, bass lines often provide a basis for variation, such as Pachelbel's well-known *Canon for Three Violins and Continuo in D*, which has a repeating bass line with an implied, repeating harmonic progression:

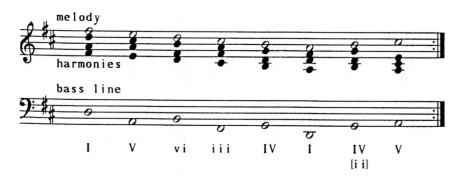

Continuous variations occur in J. S. Bach's famous Chaconne *(Ciacona)* for solo violin (ca 1720). The underlying harmonic framework controls the over-all form. In the Bach Chaconne, the theme consists of a four-measure harmonic progression:

repeating harmonic progressions

sectional variations

Modern applications of the continuous-variation principle on a repeating harmonic progression occur in many Rock songs, such as *Earth Angel* by The Penguins (1954). A series of broken chords forms the basis for variations in much *mbira* music, especially of the East African Shona.

Many longer themes are complete, independent melodies, especially in the Western repertory. The variations tend to be sectional, each variation a complete and self-sufficient statement by itself. This variation form is found in both classical and popular music and as typical of an English bagpiper performing *Oh, Dear, What Can The Matter Be* as of Count Basie playing *Teddy The Toad,* in which every verse of the tune serves as a separate variation.

Free-Strict Pairing

**Indian
ālāp and *gat***

The pairing of a slow, unmeasured prelude with a fast, measured piece is also a geographically widespread concept in musical forms. Examples include the Balkan *zurna* (oboe) prelude, improvised and unmeasured, followed by a metrical dance, the Japanese *netori,* an improvised and rhythmically free prelude followed by a composed piece, and the Javanese *gender* improvisation behind a spoken recitative of the *Dalang* puppeteer which is followed by the composed and measured *gending.* The free-strict grouping also occurs with the *ālāp* and *gat* of Indian music. A rhythmically free prelude, the *ālāp* gradually introduces the pitches and melodic traits of a particular *rāga.* Following this, the *gat,* referred to by Indian musicians as the "composition," consists of melodic variations improvised by the performer, who uses the *rāga* prepared by the *ālāp.* The *gat* is rhythmically structured by the cycle of a particular *tāla.*

recitative and aria

In traditional European music, free-strict combinations appear in opera since the late-17th century, with the pairing of recitative and aria. While most musical forms depend on repetition for points of reference and aesthetic logic, the requirements of drama more often support non-repetitive, straight-line continuity of plot. Early in the history of opera, it became standard to apportion most of the musical statements to the arias, that is, "airs" that reflect certain moods and feelings. To assure progression of the story, quasi-melodic and musically drier declamations, called recitatives, were used. While spoken dialogue replaced the recitative to further action in the popular operas of 18th-century England and Germany, the recitative-aria pairing was retained as one of the most familiar and traditional aspects of Italian opera, as in Handel's *Serse* (1738).

prelude, fantasy, toccata

In Baroque organ music, the free-strict combination occurs in the prelude-fugue pairing. Similar to the **prelude** but even freer in form and bolder in harmony as an introductory movement was the **fantasy**, whereas the **toccata** was specifically keyboard-oriented and more virtuosic. All three types of pairing found their highest mode of expression in the keyboard works of J. S. Bach.

Developmental Forms

European art music provides a family of forms in which themes develop in a broad structure. The number of developmental procedures are many, each genre the end product of a long history, often encompassing many other forms. In our brief discussion, we will isolate three characteristic genres: the fugue, often associated with music of the Baroque era; the sonata, often associated with music of the Classic era; and the symphonic poem, often associated with music of the Romantic era (19th century).

fugue:

subject
answer
exposition
episodes
stretto

The **fugue** presents a relatively free form built on the imitation of a theme called the subject. At the beginning, the subject enters separately in each voice-part, thereby establishing an imitative style. In the opening of Bach's fugues, statements on I usually alternate with those on V, less often some other scale degree. The statement not on I is an "answer"; if a statement begins on C, its answer comes in on G. The first presentation in all the voice-parts of the subjects and answers is called a fugue exposition. After the exposition, the fugue theme reappears from time to time in the texture. Places where the fugue theme is absent are called episodes. A typical fugue thus consists of subject statements alternating with episodes. Somewhere near the climax or conclusion of a fugue, the entries of the subject often overlap one another. This piling-up of entries is referred to as a stretto. Since the design of the fugue is so general, there has been occasional discussion as to whether a fugue is truly a "form" or merely a "style." The consensus is that it is a form.

monothematic form

Since fugues are typically based on one subject, they are considered monothematic. In more elaborate fugues the subject may appear backwards or upside-down, or in augmentation or diminution (see the discussion Stylistic Options in Chapter 4). A fugue modulates to different keys before returning to the tonic at the conclusion, but there is no prescribed plan for the number or types of keys visited.

fugato

Often compositions that are not fugues have sections within them written in the style of a fugue. These sections are referred to as fugatos or as written in fugal style.

countersubject

In the exposition of a fugue, the original voice with the subject will frequently continue with a counter-theme when the second voice enters with the subject. If the counter-theme reappears simultaneously with later statements of the subject, it is

♪ A form of imitative counterpoint (**polyphonic texture**), the fugue involves a melody presented in the tonic (I chord) that is answered by the same melody placed in the dominant (V chord). In this example of a four-voice fugue for organ, the melody is first presented in the soprano register, answered by the melody in the alto, then the melody in the tenor is answered by the melody in the bass (foot pedals on the organ).

36 Bach "Fugue in G Minor for Organ"

called a countersubject. A clear and well-known example of a countersubject appears in Bach's *Fugue in G Minor for Organ,* BWV 578 (1707). ("BWV 578" refers to the 578th work listed in the *Bach-Werke-Verzeichnis,* a thematic catalog of Bach's works.)

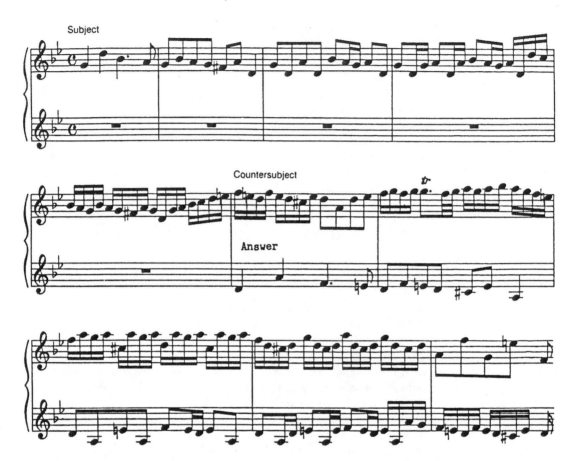

Sonatas are instrumental works usually involving one or two performers. Although sonatas date from the early 1600s and the term "sonata" goes back even further, the genre we know best today was an 18th- and 19th-century type. It consists of three or four separate movements and an over-all formal plan so successful that it soon appeared in other mediums and genres. For example, a quartet may be considered a sonata for four instruments, and a symphony as a sonata for full orchestra.

sonata form

What is generally meant by **"sonata form"** is not the sonata as a whole, but the form of its first movement. This first-movement plan is also called "sonata form" when applied to the first movement of other genres such as symphonies and quartets. The other movements of a four-movement sonata or symphony generally consist of a slow second movement, a dance movement in ternary form (two short movements strung together in the order Dance 1, Dance 2, return of Dance 1), and a final movement that is either a rondo or a sonata form.

exposition
development
recapitulation

Sonata form, with possible roots in the rounded-binary form of earlier dances, flowered in the late-18th century. It consists of an **exposition** (different from that of the fugue), a **development,** and a **recapitulation,** a modified restatement of the exposition:

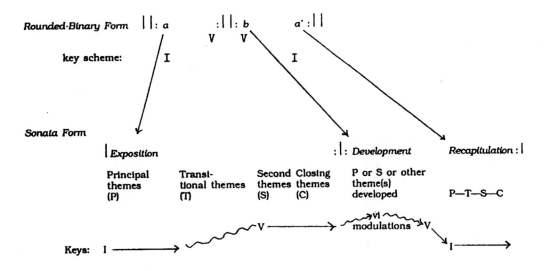

 Sonata form

involves the presentation of several melodic themes in three distinct sections. In the first section, the exposition, the principal theme is presented in the tonic, progresses to the dominant by the transitional theme, contrasted by the secondary theme which is followed by the closing or cadential theme. One or more of these four main themes is/are explored in the development section then restated in the recapitulation.

◎ **37** Mozart *Eine kleine Nachtmusik*

The **exposition** often has a plan, consisting of one or more themes in the principal key, one or more themes in the second key, and one or more cadence themes. Usually one or two themes from the exposition are elaborated in the development.

The **development,** the large central area of modulation in sonata form, grew out of the area that links the second key back to the first in binary form, and thematic elaboration became associated with this central area of modulation. In it, the composer usually isolated parts of an important theme from the exposition, then treated them sequentially and imitatively in different keys. Of the 18th-century composers of sonata form, Franz Joseph Haydn is celebrated for his elaborate development of thematic material. Yet the clearest examples of sonata form were composed by Haydn's younger contemporary, Wolfgang Amadé(us) Mozart.

During the summer of 1787, Mozart completed his *Eine kleine Nachtmusik* ("A Little Night Music," or late evening serenade), K. 525, today one of his best-known compositions. ("K" is used with the number that Ludwig Köchel, a 19th-century Mozart enthusiast, assigned to a Mozart composition.)

Like other popular music of the time, it was originally intended as a five-movement work with two minuets; unfortunately, the first minuet has been lost.

Though often referred to as a four-movement "serenade" for strings, its German title shows its lineage to the Italian "notturno" (night music) of the 18th century. This music was probably meant to be performed as chamber music with only one player for each written part.

The first movement is a clear sonata form with a relatively short development. The exposition has four main themes, one each for the *P, T, S,* and *C* sections. As you listen to this music, see if you can identify which of these themes appear(s) in the development. Why does Mozart choose the one(s) he does? (See also the discussion of Modulation in Chapter 4.)

PRINCIPAL THEME (P)

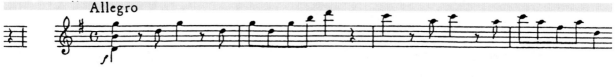

TRANSITIONAL THEME (T)

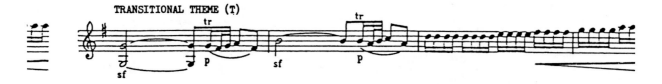

SECOND THEME (S)

CLOSING THEME (C)

symphonic poems
program music

Originally made popular by the renowned Hungarian piano virtuoso Franz Liszt (1811–86), **symphonic poems** began to appear with increasing frequency in the later 1840s and the 1850s. They were one-movement forms often associated (by the composer) with extramusical ideas such as a painting, a geographic location, or a literary work. Symphonic poems came to be the main source of what is called **program music.** The subjective feelings aroused in the composer from the extramusical source were to be musically conveyed to the listener. In reality, most symphonic poems do not need, and usually were not expected to require, an outside reference to be musically successful. Still, an outside reference tended to bring composer and audience member closer together psychologically.

Musically, the symphonic poem came about from a process of harmonic evolution. In the 19th century, harmony became increasingly complex, and key changes occurred with greater frequency. As the harmonic framework became broader and less predictable, composers began to adjust the other musical elements to compensate. Harmonic expansion was balanced by more emphasis on melodic unity: one or two melodic ideas constantly repeated, undergoing various degrees of change yet maintaining a basic identity that helped integrate the whole. The changes were less regimented than most theme-and-variation forms.

thematic
transformation

The principal building block in the integrative process was the motive, the shortest identifiable thematic unit in a musical composition. It is a brief statement, complete in itself even though generally employed to expand forms, like bricks on a façade. Usually, a motive has a melodic contour and rhythmic pattern that render it immediately identifiable, like the opening four notes in Beethoven's Fifth Symphony (three shorts and a long; see Chapter 4, "motive"). While melodic and rhythmic traits of the original motive were usually retained, the other elements—orchestration, harmony, register (general pitch level), dynamics, tempos—were often altered to fit the changing moods of the music itself. In a symphonic poem, the process of continuous motivic development is called thematic transformation.

Wolfgang Amadeus Mozart
Unfinished portrait by Joseph Lange, probably 1789.
(Mozart Museum, Salzburg)

Franz Liszt, Age 26, in a travelling coat.
By Josef Kriehuber, based on a drawing of 27 May, 1838.
(Ernst Burger Collection, Munich)

Open Forms

There are two types of "open form." One has no definite length and may be referred to as "never-ending." The other is clearly meant to stop but lacks a final cadence and thus is "anti-ending." Open forms tend to give the music a continuity that implies the infinite. They involve two philosophies: one, a natural expression of musical requirements, as with most examples from music outside the West-European classical tradition; the other, revolt against the standard closed forms of the Musical Establishment, as with most examples in Western music, including much Rock.

never-ending form in poetry

Open form occurs in other arts, especially 20th-century poetry. A poem that trails off in a never-ending diminuendo is "You, Andrew Marvell" (1930) by the American poet Archibald MacLeish. The central theme is the twilight of various nations, the spreading of night over glorious years past. The time is left open, be it a day, year, century, or era; the last of the nine stanzas reads:

> *Nor now the long light on the sea:*
>
> *And here face downward in the sun*
> *To feel how swift how secretly*
> *The shadow of the night comes on . . .*

anti-ending form in poetry

The greater shock effect of anti-ending forms, the revolt against the relative comfort of closed forms, can be found in poem "XL" from *1 × 1 [One Times One]* (1944) by the American poet e.e. cummings, which begins "darling! because my blood can sing." Though a motif recurs ("but if a look should april me"), there is a random quality to the poem, the last stanza of which reads:

> *but if a look should april me*
> *(though such as perfect hope can feel*
> *only despair completely strikes*
> *forests of mind, mountains of soul)*
> *quite at the hugest which of his who*
> *death is killed dead. Hills jump with brooks:*
> *trees tumble out of twigs and sticks;*

The semicolon directs us back into the poem, creating a circular, infinite effect.

never-ending form in music

Never-ending musical structures have become familiar to Euro-American audiences mainly through performances of Rock music, in which songs often have no formal ending and fade out at an arbitrarily chosen point, as in "Lucy in the Sky With Diamonds" from *Sgt Pepper's Lonely Hearts Club Band*. Though early performances of Rock with fade-outs were originally revolutionary, the fade-out process became so standard as to become convention, and once convention, it became natural. A totally natural type of implied continuity occurs in the dance music of the Ashanti, a tribe in Ghana. In this West African music, the dancers and musicians simply continue as long as they wish. Similar continuity exists in the *mbira* music of the Shona.

anti-ending form in music

Anti-ending forms are familiar to Euro-American audiences again through Rock music, as may be heard in the tongue-in-cheek song "Her Majesty" by the Beatles, in which iconoclasm reigns supreme. Anti-ending structures also occur in West European conservatory music, particularly of the 20th century. In 1909, the Austrian composer Arnold Schoenberg was experimenting with new types of forms as he abandoned the traditional idea of a single key center and branched out into new realms in which many keys were used as tonal centers in one composition. This was a period in which the expressionist style, with its many grim Freudian implications, was especially popular among painters in Germany and Austria. Schoenberg seems to have incorporated the highly emotional character of contem-

porary paintings into his music, and in the first movement of his *Five Pieces for Orchestra,* Opus 16, he conveys a feeling of deep anxiety. He later added the title "Premonitions" *("Vorgefühle")* to it. To help project the nightmarish formlessness of premonitions, Schönberg purposely avoided a cadence at the end.

Perhaps the ultimate revolt was a novel type of anti-ending structure "composed" in the 1950s by the American composer/philosopher John Cage. Its title *4′33″* indicates its length: a piano piece of four minutes and thirty-three seconds—of non-musical-performance. Cage expects us to listen to ambient sounds during that time frame: audience coughs, distant traffic, our heartbeats.

Selk'nam chant

A less familiar but truly remarkable example of anti-ending structure with a natural, non-revolt basis may be heard in a recording of Selk'nam (Ona) chants. The Selk'nam at one time inhabited the largest island of Tierra del Fuego, Argentina, directly south of the Straits of Magellan. In a fascinating recording of a chant sung by Lola Kiepja, the last surviving member of this Paleolithic tribe no longer in existence, we find music that is totally logogenic: the music is completely subordinated to the words, even more than the relationship between music and text in Sprechstimme or Italian-opera recitatives. Moreover, the Selk'nam chants may have been intoned without any accompaniment.

Compound Forms

The broadest music forms are compounded of a succession of individual movements. Compound forms find wide dispersion among many different cultures.

orchestral concerts recitals

symphony concerto

Perhaps the most familiar types of compound forms for Western audiences occur with formal orchestral concerts at places such as Lincoln Center or Carnegie Hall in New York, where a symphony, or a concerto involving a soloist, is presented. Each symphony or concerto often consists of more than one movement, and it is customary to withhold one's applause until the whole work has been completed. (Strict adherence to this audience protocol may be time-specific to the 20th–21st century: should one applaud at the wrong time, such enthusiasm [?] has traditionally elicited the strangest and most "superior" of looks from other audience members.) Sometimes one attends a concert for a single instrument, without an orchestra. At these events, the term "sonata" usually signifies a compound form. It is significant that the term "sonata" here differs from the expression "sonata form" discussed previously, the latter usually referring to a single movement within a sonata, most often the first movement (sometimes labeled "sonata-*Allegro*" form). If a singer appears in a recital, an equivalent compound form consisting of a group of songs is often referred to as a "cycle."

sonata

song cycle symphonic suite

Another concert-hall favorite with Euro-American audiences is the symphonic suite. The term "suite" applies here as in the expression "a suite of law offices." The symphonic suite generally consists of a series of dances taken from a previously written stage production. Since the more catchy numbers are usually abstracted from the original and grouped to form the suite, symphonic suites are often popular and frequently programmed. In European music, the symphonic suite has a venerable history, dating back to the second half of the 17th century. Not all suites are orchestral; some groups of dances may be written for small ensembles or for solo instruments, such as the various harpsichord suites or violin sonatas of the Baroque era (see Chapter 7).

smaller groups solo works

Tchaikovsky's *Nutcracker Suite*

The most familiar suites date from the 19th century, such as the one that was abstracted by the Russian composer Peter Ilich Tchaikovsky in 1892 from his ballet *The Nutcracker,* completed the year before, its libretto based on Alexandre Dumas' 1844 French adaptation of E.T.A. Hoffmann's popular 1816 Christmas tale *The Nutcracker and the Mouse King.* Tchaikovsky's orchestral concert version of *The Nutcracker* consists of a "miniature" overture, six dances, and a "final waltz." Its movements are very familiar to us mainly from their Christmas-time performances.

Peter Ilich Tchaikovsky

Receiving an honorary doctorate of music, Cambridge University, 1893.
(Novosti Press Agency)

Religious Services and Celebrations

Mevlevi Ayin

Chopi dance suite
Mozambique

Various liturgical types of compound forms exist and appear according to the nature of the service. A good example of such a compound form is the seven-movement *Mevlevi Ayin*. The *Mevlevi* are a Turkish mystical brotherhood and the *Ayin* is a well-organized ritual, and in that respect somewhat analogous to the Roman Catholic Mass. For a reference to extended and impressive large-scale dance suites involving many musicians and dancers, see the discussion in Chapter 13 regarding the Chopi people of Southern Mozambique, who use marimba-like instruments in an orchestra *(timbila)* to complement a series of dances.

Formal Improvisation

improvisation in form

improvisation of form

Conceptually, we may divide formal improvisation into two families: improvisation **in** form; improvisation **of** form.

Improvisation **in** form is common in much popular and classical instrumental music as well as in the art songs of various cultures. The cadenza in a piano concerto or opera aria is a specific section, the only one that calls for extended improvisation. In Turkish vocal music, the *gazel* in some respects corresponds to the cadenza. Like the aria cadenza, the *gazel* reveals the virtuoso technique of the singer in the best possible light, in a form such as *a-a-b-gazel-a*. The letters *a* and *b* stand for composed units, and the gazel is the section set aside for the singer to show off technique through improvisation. Improvisation **in** form sets aside a section in a form for improvisation.

Improvisation **of** form occurs less frequently. It ranges from the unintentional and relatively uncontrolled (an amateur opera troupe's orchestra scrambling after a vocal soloist who has had a memory lapse) to the intentional and controlled (improvisations of a Javanese *gamĕlan* following the signals of a puppeteer in a shadow play).

Improvisation of form takes place when a Javanese *gamĕlan* plays a single piece consisting of only two musical units, *a* and *b*. The first unit is repeated as many times as the leader wishes; then on his signal, the performers go on to the second unit: *a a a . . . b*. In this situation, the material within each unit remains fixed but the number of times a unit is heard is free: over-all the form is being improvised.

Wayang

The *Wayang*, a Javanese shadow-puppet play, is musically a compound form, made up of numerous separate pieces. The puppeteer *(Dalang)* signals the order, tempo, length, and number of repetitions for each performance. While the tunes themselves are standard, the treatment of each one depends on the fancy of the puppeteer. The over-all form is again flexible and highly variable from one performance to the next so that the *Dalang* can respond to the audience and current events.

Improvisation of form, then, refers to spontaneous changes (improvisation) of the order of modules or pieces; the performer improvises not melody, but the form itself.

Between the two conceptual extremes of a piece with a section set aside for improvisation, and a piece with over-all structural improvisation, there is a middle ground that encompasses music from many different lands: its use as preparation for an upcoming musical event, already alluded to in our discussion of free-strict pairings, such as the Indian *ālāp* and the Japanese *netori*.

Indeterminacy

When an entire structure is improvised (improvisation of form), the over-all form usually changes radically from one performance to the next. In the European repertory, the composer has traditionally sustained some residual control by retaining constants among internal musical elements, such as the use of ground basses or repeating harmonic progressions. During the late 1950s and the 60s, many American and European avant-garde composers expanded the concept of improvisation to include simultaneously the total form as well as most or all of the internal constants. As a result, the music they envisioned began to shed many of its traditional anchor points of reference. Some of the composers created compositions that transfer almost all formal options to the performer, while maintaining for themselves only the barest thread of "control." Some even crossed the line and transferred all compositional choices to the performer. The philosophy of the performer's "freedom"—non-control by the composer—is associated with the word *indeterminacy*.

Covering a wide range of possibilities, often employing structures suggesting anti-ending philosophies, composers of the 1960s did much to expand the traditional Western concept of form. In particular, the open structure in which each formal component is fixed, but the way it combines with the other components is random, has gained prominence. ("Using units *a, b, c, d, e, f*, perform them in any order desired; the piece ends when any unit is played for the third time.") Reminiscent somewhat of the improvisation of the Javanese *Wayang* shadow play and inspired directly by the constructions of the American sculptor Alexander Calder, it is sometimes referred to as "mobile" form.

Improvisation, though significant in Baroque music and in the cadenzas of Classic arias and concertos, as well as in the jazz of our era, was not exploited by most of the 19th-century composers, whose music has dominated the concert stage. The avant-garde composers of the post-World War II era reacted to this relative confinement exploring as many areas of compositional universality as possible.

We have now completed our survey of the various internal musical components: timbre, rhythm, melody, harmony, and form. In Part Two, we expand our approach and briefly explore some of the broader questions regarding music in its various styles in different social contexts.

KEY WORDS

Closed form, open form, compound form, modular form, strophic form, refrain form, rondo, developmental form, mobile form, indeterminacy

SUGGESTED READING

Berry, Wallace. *Form in Music.* Englewood Cliffs: Prentice-Hall, 1966.

——. *Structural Functions in Music.* Englewood Cliffs: Prentice-Hall, 1976.

Chapman, Anne. *Drama and Power in a Hunting Society: The Selk'nam of Tierra del Fuego.* Cambridge: Cambridge University Press, 1982.

Green, Douglass M. *Form in Tonal Music: An Introduction to Analysis.* 2nd ed. Fort Worth: Harcourt Brace Jovanovich College Publishers, 1979.

Langer, Susanne. *Feeling and Form.* London: Routledge & Paul, 1953.

LaRue, Jan. *Guidelines for Style Analysis.* 2nd ed. Warren, MI: Harmonie Park Press, 1992. Chapter 6, "Growth" (pp. 115–152).

Leichtentritt, Hugo. *Musical Form.* Cambridge, Mass.: Harvard University Press, 1951.

Meyer, Leonard B. *Music, the Arts and Ideas.* Chicago: University of Chicago Press, 1967.

Articles on "Form" and "Fugue" in *The New Harvard Dictionary of Music* and *The New Grove Dictionary of Music and Musicians.*

SUGGESTED LISTENING

aba Form	*Music of the Hundred Years' War* (Musica Reservata), Philips SAL 3722.
Verse-and-Refrain	*After the Ball* (Joan Morris), Nonesuch H-71304.
Open Form	Selk'nam (Ona) O *Chants of Tierra del Fuego, Argentina,* Folkways FE 4176 and 4179 (vol. II)

HELPFUL VIEWING

"Form: The Shape of Music," *Exploring the World of Music.* Videocassette 10 (of 12). (See Chapter 1 for further bibliographic reference.) [30 minutes]

What Makes Music Symphonic? (Young People's Concerts, 10 videos, 25 programs). Part of a videocassette (with *What is Classical Music?*). Script by Leonard Bernstein, originally broadcast on television on 13 December 1958 and recorded in Carnegie Hall. Prod. CBS Television Network; dist. Leonard Bernstein Society. [60 minutes]

DVD: What Makes Music Symphonic? Disc 2 of 9-disc set, *Leonard Bernstein's Young People's Concerts.* ISBN: 0769715036. West Long Branch, NJ: KULTUR VIDEO: D1503, [2004].

6
REVIEW SHEET

Short Essays

1. Explain binary, ternary, and rondo forms.

2. Explain verse and refrain.

3. Explain continuous variations.

4. Explain the concept of free-strict pairing using examples from Western and non-Western music.

5. Diagram the structure of a fugue and label its sections. Make references to its textures.

6. What is sonata form? Explain structure and concept.

7. What is a symphonic suite?

7

BAROQUE MUSIC
Bach and *Rāga*

The Baroque Era

Musically, the "Baroque" era extends from the late 16th to early 18th centuries. It was in the late-Baroque period that tonality and a modern approach to harmony first clearly emerged and that motoric repetitions of beats, familiar in Rock and other 20th-century musical styles, became characteristic. While Baroque music often elicits a positive response in the modern listener, "Baroque" was initially a pejorative, and as applied to music, a coming together of two meanings: the Italian *barocco,* meaning a far-fetched syllogism in logic; and the Portuguese *barroco,* meaning an odd-shaped pearl. During the early Classic period (1760s), it was used both ways, to describe music considered constrained and confused *(barocco),* and striving after effect *(barroco).* Its use reflected the age-old reaction against a parent generation's taste.

Baroque painters

To the art historian, Baroque usually brings to mind the sweep and color of a Rubens painting such as *La Kermesse* (Village Dance), the weightlessness of a 17th-century ceiling painting in a church or palace, and the glitter of a richly ornamented false façade on a Spanish cathedral. Despite the negative connotation of overt emotionalism occasionally associated with the term "Baroque," the era itself produced three of the greatest painters in Western history, only one of whom—the Flemish artist Peter Paul Rubens—could be referred to (only sometimes) as typically "Baroque." Rubens (1577–1640), a brilliant draftsman, combined the painterly qualities of a rich palette of colors and virtuosic technique with dynamic composition. His Spanish protégé Diego Velázquez (1593–1660) orchestrated all elements—color, line, mass, and original composition—with a brush style so vibrant yet subtle that it provided singular inspiration for painters in the 19th and 20th centuries. The Dutch painter Rembrandt van Rijn (1606–69) was able to imbue his subjects with a spiritual life that transcends the confines of the canvas and, in his drawings, like the great Chinese painters, imply the infinite by isolating or avoiding details.

While the glories of the high and late Renaissance were dominated in art by the Italian artists Leonardo, Michelangelo, and Raphael, the 17th century saw the creative flame pass mainly to Belgium, Spain, and the Netherlands. By contrast, in music the main artistic impetus had passed from Franco-Flemish musicians serving Italian courts to Italian composers. Italian genres such as opera, oratorio, cantata, sonata, concerto and even, in the next century, symphony, became generally accepted in Europe and the British Isles.

Baroque Style

Basso Continuo Textures

"thorough" bass
basso continuo

The outstanding notational characteristic of the period is the consistent use of the "thorough" bass, also known by its Italian designation *basso continuo,* often abbreviated to *continuo.* The *continuo* dominated art music to such an extent that the Baroque era itself has also been called the "thorough bass period." Various textures, *continuo*-derived, came into use during the 1600s. Of these, two stand out: a vocal line supported by the *continuo,* called "monody"; and two instrumental parts over the *continuo.* This last type, appearing in many early sonatas, is known as "trio-sonata" texture.

Andrea Pozzo (1642–1709). *Entrance of St. Ignatius into Paradise.* 1691–94. Ceiling fresco, S. Ignazio, Rome.

Pozzo was a leading exponent of illusionist ceiling decoration in Rome. Notice how all the architectural lines (actual and painted) converge on the center of the ceiling, where infinity (Heaven) appears to draw up the swirling masses and the viewer with an inexorable thrust.

Robert de Cotte (1656/7–1735). Interior of the Royal Chapel at Versailles (built 1699–1710).

Cotte, the brother-in-law of Hardouin-Mansart (the chief architect of Versailles), enjoyed an enviable international reputation of his own, supplying designs for edifices in Germany, Italy, Spain, and Switzerland, as well as France. The interior of the Royal Chapel, with its two-story elevation, fluted colonnade, and stunning play of light, provides a most remarkable example of the grandeur the French Baroque was able to attain.

Improvisation

The art of embellishing a melody or spontaneously composing a new melody in performance has virtually disappeared from Western classical music. It lives yet in many Asian cultures: Indian, Persian, Turkish, Arab, and Indonesian. A performer in these cultures is admired and judged by the quality of his or her improvisations. Similarly, most American Jazz musicians are judged primarily on their improvisatory facility, originality, and style. The basic process can take several forms. When Louis Armstrong takes "I Can't Give You Anything But Love, Baby," and works changes, rhythmic and melodic, on the original, the popular tune is recognizable yet different every time. And the cornet interpretation is different from the vocal one. But many jazz improvisations never state the original melody. Instead, the harmonic progression of the song is the basis for impromptu variation. Listen to any blues piece, for example. Recently, jazz musicians have burst traditional boundaries, leaving behind the original melody, harmony, and even rhythm. What remains is pure expression and emotion. Ornette Coleman and other jazz musicians often improvise freely, "composing" at the moment rather than basing their improvisation on previously composed material.

Improvisation

figured bass

Another significant style trait of the time was improvisation, which grew from an even older custom. Thus, *continuo* notation—the figured bass—institutionalized the improvisation of an accompaniment. In the European tradition of art music, more improvisation was expected of performers during the Baroque period than ever since, with the exception of some 20th-century music after World War II.

The Affective Style

An emphasis on overt expression was another fundamental stylistic aspect of Baroque music. One felt that music and poetry should impart specific "affects," positive or negative reactions to given stimuli. In a widely held belief inspired by ancient Greek philosophy, Baroque philosophers, scientists, and poets believed that certain vapors run continuously throughout the human body and that the way they combine at any specific moment determines a particular feeling, mood, or "affect," terms nearly synonymous. As the mixture of vapors change, so does the particular affect, which remains stable until external or internal stimuli bring about a new change in the balance. The equating of specific affects or moods with musical properties is not limited to Western music of the Baroque period, having numerous analogies in music from other cultures, particularly Asia.

The Doctrine of Affections

The era of Louis XIV, the "Sun King" (reigned 1643–1715), in which the aristocracy surrendered artistic and intellectual prerogative to absolute rulers, is often referred to as the period of "Absolutism." In philosophy and literature, the preoccupation was an objective methodology dominated by two strands, rationalism and empiricism, movements later combined into the fabric of the Enlightenment. A new emphasis on scientific discovery produced scientist-philosophers such as Sir Isaac Newton and Gottfried Wilhelm von Leibniz.

In line with the scientific method of inquiry pursued by the philosophers, Johann Mattheson, a famous late-Baroque theorist, sought to codify his musical observations into doctrines. By so doing he felt that he was raising the status of music to a more scientific level. In his discussion of the functions and expressive aspects of music, Mattheson classified the affects into general categories that, like scientific facts, could apply to particular situations.

Mood Music

Cultural conditioning specifies that certain categories of music generate predictable emotions. A lullaby soothes a tired baby, a march boosts patriotic fervor in wartime, piped-in music in a junior high school mitigates violence. Music hath charms. In musical systems using modes, mood is a common characteristic. Aristotle observed that each mode has its ethos: "Some modes make men sad and grave, like the Mixolydian."

A 17th-century Persian treatise reports that "In a gathering of sleek, pale-skinned men, the musician should play . . . soft, low-pitched modes such as *Iraq, Rast, Mukhalaf, Nihuft,* and kindred modes, from which listeners of this class, who have a natural freshness of mind, derive great gaiety and gladness, sharing in the pleasure that they bring." Indian classical music has an elaborate schema that associates each raga with a time of day, a mood, magical properties, and a deity.

The Javanese *wayang* shadow puppet drama lasts from sunset until dawn. The performance pieces for each of its three "acts" belong to the respective modes *Nem, Sanga,* and *Manyura.* From 8 P.M. until midnight, the mode of "youth," *Nem,* holds sway as opposing kingdoms of the drama and their bone of contention are introduced. *Sanga,* the mode of "maturity," reigns from midnight until 3 A.M., as the clowns pun, the story line entangles itself, and minor skirmishes erupt. In the final section, from 3 A.M. until daybreak, the decisive battles are fought and the victory dance of the good side is celebrated to the strains of *Manyura,* the mode of "old age and wisdom."

The Doctrine of Affections is a broad concept that includes all aspects of music associated with feeling ("Hate is represented by repulsive and rough harmony and a similar melody"). For models, Mattheson drew upon the ancient fields of oratory and rhetoric, and terms from rhetoric were frequently applied to music. In the Doctrine of Affections, constructions specifically associated with rhetoric were referred to as the Doctrine of Figures, which dates from the early Baroque. A common device, "word painting," was only one aspect ("hypotyposis") of the Doctrine of Figures.

In Baroque music, composers generally established a particular affect (e.g., sorrow, joy) at the beginning of a movement and adhered to it for the remainder of the movement.

Style Consciousness and Transfer of Idiom

In the early Baroque, the rise of the solo singer coincided with the new emphasis on the affective style, and the singer conveyed the affect of the text by specific vocal and rhythmic devices that reinforced the style. The affective style, at first associated specifically with the voice, was imitated in violin music and then in music for other instruments. Eventually, different styles were exchanged among various mediums, resulting in what is called "transfer of idiom." (See Chapter 2.)

Baroque Genres

Monody and Early Opera

early opera

During the late Renaissance, musical intermezzos appeared as diversions between the acts of a spoken play. The plays were often based on ancient Greek pastoral subjects, and the intermezzos were usually on related themes. These musical pastorals became important antecedents of opera.

"Camerata"

In the late 1570s and 1580s, a group of Florentine intellectuals established opera as a new genre. With Vincenzo Galilei (c 1520–1591), the father of the famous astronomer, they met at the palace of their patron Count Bardi to discuss science, literature, and music. Since they met in Bardi's parlor chamber, one of

their group, the singer/composer Giulio Caccini later referred to them as the "*camerate*[a]." Galilei drew upon some of the latest research of the time regarding the performance of tragedies by Aeschylus and Euripides and disseminated its findings among his friends. In an attempt to recapture some of the effects and techniques of ancient Greek tragedy, composers and writers brought into vogue a new style in which the inflections of natural speech were heightened for dramatic effect.

monody

In the new style, a solo singer performed in a rhythmically free and expressive manner, accompanied only by a *continuo* group. It was felt that the sparse accompaniment of the *continuo* would support rather than interfere with the clarity of the text by the singer. Music performed in this "affective" manner by a solo singer and *basso continuo* was called "monody." The earliest operas resulted from the combination of the pastoral subject matter with the monodic style. These operas, first produced in Florence, were performed in a declamatory manner, relieved by more tuneful vocal chamber-music digressions and dances in the traditional Renaissance style. ("Chamber music" generally refers to small ensembles, with one performer for each written part.)

Monteverdi
La favola d'Orfeo

The first lasting opera, *La favola d'Orfeo* (The Story of Orpheus) by Claudio Monteverdi (1567–1643) to a libretto in pastoral style, was premiered at Mantua in 1607. In *Orfeo*, Monteverdi calls for an orchestra of about forty players, with instruments specified, and presents instrumental movements, dances, and choruses, as well as various types of monody for differing dramatic effects.

After Monteverdi's *Orfeo,* opera grew steadily throughout Italy, especially at Bologna, Rome (where clear-cut distinctions were made between arias, the musical portions, and recitatives, the declamatory portions) and Venice, where in 1637 the first public opera house, the Teatro San Cassio, opened its doors, a spiritual ancestor of Milano's La Scala and New York's Metropolitan. Like Roman opera, Venetian opera contained many spectacular stage effects. The most important composers in the Venetian school were Monteverdi, whose style evolved continuously, and Pier Francesco Caletto-Broni, known as Cavalli (1602–76).

Instrumental Music: Sonata and Concerto

meanings of "sonata," "cantata"

The Italian word *sonata* means "sounded" or "played" on an instrument, as opposed to *cantata,* music that is sung. By the later 1600s, the sonata of several movements, usually four to seven, became one of the most favored of instrumental genres.

There were two main types of Baroque sonata: the church sonata and the chamber sonata. In the first half of the 17th century, sonatas were apparently written interchangeably for both church and court, and the instrument most preferred in Baroque sonatas was the violin. By the later 1600s, distinctions between church and chamber sonatas became clearer, the more serious, artistic type being the church sonata.

church sonata
chamber sonata
Arcangelo Corelli

Presumably, church sonatas were performed during the "action" parts of the service, such as the Post-Communion, and the Elevation of the Host and Chalice. Their continuo part could be performed on an organ as well as an archlute or harpsichord. During the late Baroque, the church sonata often appeared as a four-movement form in a slow-fast-slow-fast order. At court, composers usually wrote dances for the musical pleasure and education of their patrons. Many early printed collections of "sonatas" also included dances. Eventually the dances became associated with the always present title "sonata," forming the basis of the Baroque "chamber" sonata. Like its stricter cousin, the suite, the late Baroque chamber sonata consisted of groups of individual dances of diverse character but all in the same key. An example of this type of composition is the Sonata in D Minor, Opus 4, No. 8 by the late-Baroque master Arcangelo Corelli (1653–1713). This chamber sonata consists of a Prelude, Allemande, and Sarabande. The practice of combining dances into a compound form is discussed in Chapter 6.

Opposing Sonorities

The contrast of many and few, or different families of instruments is remarkable in the concert music of the Javanese *gamĕlan* (see Chapter 10). These opposing sonorities come about not from the formal structure, but from optional variations in a piece causing changes in tempo and density of notes.

A fixed melody (say, "*Pangkur*") may begin in Tempo One. It moves along briskly, with struck bronze metallophones and gong-chimes prevailing in a clanging, metallic sonority. The soft instruments sit this out. A drum signal now causes the melody pulse to slow down to Tempo Two, about twice as slow. Dynamics drop to mezzoforte, softer instruments can now be heard occasionally, and the texture has expanded enough so that there is room for embellishment of the melody. Yet another shift to Tempo Three causes a dramatic change in sonority. Now the clangorous bronzes are almost inaudible and the soft instruments dominate: female vocalist (*pesinden* singer), bamboo flute, fiddle, and xylophone. The texture becomes polyphonic, the scale microtonal. The lapse in time from one tone to the next of the original melody has so expanded that it is difficult for the novice to follow, and the embellishment commands attention.

In repeating the original *Pangkur* melody over and over, the orchestra, at the command of the drummer, can shift through three, four, or five different stages, each with its own appropriate tempo/density/sonority.

The Late-Baroque Concerto

the meaning of "concerto"

"Concerto" is derived from an Italian verb that means to work together in harmony, a meaning that prevailed in the early 1600s. It was associated with various ensembles, especially sacred compositions that blended voices and instruments. Sometime, during the 17th century, however, "concerto" acquired another meaning, probably through confusion, from a Latin verb (concertare) that means to contest. Actually, since what we hear results from a combination of clear, individual components, any distinction between the two meanings disappears. During the second half of the 17th century, "concerto" gradually became distinct from "sonata" and "sinfonia," the last-named becoming associated with instrumental overtures and interludes in operas and cantatas, and later, in the Classic era, the name for symphonies.

concerto grosso opposing sonorities

In performances at church and court, instrumentalists were often divided into groups, a small one consisting of the best players selected from the larger one. The small group was referred to as *solo, principale* or *concertino,* and the large group was called *tutti* (all), *ripieno* (full), or *concerto.* The grand concerto of the late Baroque, or *concerto grosso,* was primarily an interplay of a trio-sonata solo group with the full tutti. In the early concertos, two treble instruments (usually violins) and *basso continuo,* as the solo group, often proceed as if performing a trio sonata. Playing the same or similar music, the tutti appears, particularly at cadences, then drops out, creating an alternation of heavy and light sonorities. Some composers wrote only the solo parts, as if for a trio sonata, and indicated by shorthand signs when the tuttis should enter and drop out. Corelli, however, the most famous composer of concerti grossi, had the parts issued separately in the publications of his concertos. Listen to Corelli's Opus 6 *concerti grossi,* for example.

Antonio Vivaldi

After Corelli, the next phase in concerto evolution included the solo concerto (one solo instrument and orchestra), the standardization of a three-movement form (fast-slow-fast), and the "modulating ritornello" structure for the fast movements. Antonio Vivaldi (1678–1741) was a leading composer of the solo concerto. Born in Venice, Vivaldi became affiliated in 1704 with a foundling hospital for girls, the Conservatorio dell'Ospedale della Pietà, where he was appointed violin teacher in 1709 and director of the orchestra in 1716. Performances were given at the Church of the Pietà, and the musical skills of the girls were often highly praised by visitors. Vivaldi wrote many of his concertos for performances by the Conservatory orchestra. Besides hundreds of concertos for a variety of solo instruments, he also wrote about fifty operas and many sacred choral works.

Vivaldi wrote concertos for violins, oboes, trumpets, guitars, and other instruments, in different styles, from solo concerto to concerto grosso. In them, the "modulating ritornello" plan is well developed. "Ritornello" usually referred to

recurring instrumental statements in a vocal work, but it also applied to tutti returns in a concerto. The concerto ritornellos occur in different keys, making them distinct from true refrain forms.

As developed by Vivaldi, ritornellos form a ground plan over which the solo instrument soars with virtuosic figuration or contrasting thematic material. The ritornellos pass through a series of keys; at least one is in a contrasting mode, either major or minor. In many concertos, the modulation occurs in the solo part, the tutti then stating the ritornello in the new key. For an example, listen to the last movement of Vivaldi's violin concerto, Opus 3, No. 6, from a set of twelve concertos entitled *L'estro armonico* (The Harmonic Fancy).

The Apotheosis of Baroque Instrumental and Vocal Styles: Bach and Handel

Johann Sebastian Bach

During the late Baroque in the German states, a career as Chapel-master at a court composing instrumental music and possibly an occasional opera was ideal. Failing that, a career as town Cantor, a music director for a town's churches, was the most acceptable alternative. Both careers offered reasonable security, limited prestige, and modest pay since the Chapel-master and Cantor were functionaries of middling rank. Lower in social standing and pay was the Church Organist. Yet, all three careers could be considered glamour positions for a musician in a generally provincial society that equated the highest level of artistic accomplishment with craft, and craft with mundane skills.

Bach:

Arnstadt
Mühlhausen
Weimar
Cöthen
Leipzig

Johann Sebastian Bach (1685–1750) was the greatest member of a renowned Thuringian family of musicians. During the 1600s and 1700s, so many of this family obtained posts as Organists, Chapel-masters, and Cantors that at Eisenach, Bach's birthplace, it became customary to refer to town musicians as "the Bachs." As a very young child, Bach was taught violin by his father. Orphaned at the age of ten, he moved in with an older brother, Johann Christoph, with whom he studied keyboard. Bach became Church Organist at Arnstadt in 1704, at Mühlhausen in 1707, and from 1708 to 1717, was in the service of the devout Duke at Saxe-Weimar. During the Arnstadt and Weimar periods, Bach wrote the majority of his organ works. From 1717 to 1723, Bach was Chapel-master and Director of Chamber Music for Prince

Johann Sebastian Bach

Painting by Elias Gottlieb Haussmann, 1746.
Leipzig, Museum für Geschichte der Stadt Leipzig

Leopold of Anhalt-Cöthen. In his "Cöthen period," Bach wrote many instrumental works. Then, from 1723, Bach obtained his final post: Cantor at the Thomasschule at Leipzig, directing music at the Thomas and Nicholas Churches. It was at Leipzig that Bach wrote most of his cantatas, as well as several famous instrumental pieces including the "Goldberg" Variations, *The Art of the Fugue,* and the *Musical Offering.*

Even by Baroque standards, Bach's ability to improvise was outstanding. At 32, he had achieved an awesome reputation: a scheduled contest between him and a French keyboard player under consideration for the court post at Dresden was canceled when the latter, choosing discretion as the better part of valor, unceremoniously left town early the same morning. Thirty years later, as guest at the Court of Frederick the Great, Bach amazed the Court with his ability to play "unpremeditated" music, including a fugue on an unlikely, chromatic subject supplied by the King, himself a competent composer and flutist. Bach subsequently wrote several imitative pieces on this subject as well as a flute trio in the same key and dedicated the group as a "Musical Offering" to the King.

George Frideric Handel

Handel:

Hamburg
London
Rinaldo

The most successful exception to the Organist/Cantor/Chapel-master orbit of German composers is George Frideric Handel, born Georg Friederich Händel (Hendel) at Halle in Saxony in 1685. He studied the fundamentals of music in Germany, gained experience composing for the local opera in Hamburg, and made an artistically and financially successful trip to Italy (c 1707–1710). In 1710, Handel became Chapel-master to the Elector of Hanover and the same year received an invitation to compose an opera for performance at London. Handel's opera *Rinaldo,* produced at London in 1711, was such a resounding success that he returned there the following year on a leave of absence, never to return to his post at Hanover. As luck or fate would have it, in 1714, the Elector of Hanover succeeded to the English throne as George I. If he ever had been displeased with Handel's truancy, George did not show it for long, and Handel always remained a favorite with the Hanover Kings. Handel remained in England, became a naturalized British subject, making and losing one and possibly two large fortunes composing, producing, and directing Italian opera and English oratorio in London. Despite a modest annual grant from the Crown, most of the time Handel was economically independent. From about 1729 on, he composed the music, hired the hall, engaged and paid the singers and players, and even sold the tickets from his own home. He died in 1759.

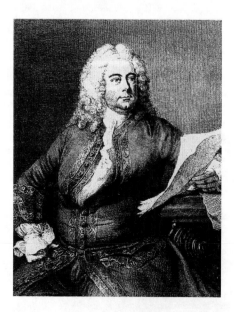

George Frideric Handel
Engraving by William Bromley, after a portrait
by Thomas Hudson.
Photo courtesy New York Public
Library Music Division

Bach's Orchestral Music

The French Overture

Bach:
instrumental music

In the Baroque period, an orchestral suite often began with a *French Overture*. The overtures preceding the great operas and ballets of Jean Baptiste Lully (1632–87) at the Court of Louis XIV were patterned on an older model from Venetian opera, consisting of a slow section followed by a fast one. In the late 1600s, there arose the practice of abstracting the overture and adjoining it to the principal dances from its opera or ballet for separate performance, in the style of the 19th-century symphonic suite.

As perfected by Lully, leader of the well-known string band at the Court of Louis XIV, the French overture itself, without the dances, had a widely imitated style. The first part of the overture, stately and slow, was characterized by dotted rhythms. The second part was faster, flowing, and often imitative. By Bach's time, the overture usually ended with a brief return to the opening slow part with dotted rhythms. This overture style became immensely popular for opening movements in various mediums and genres. Suites (particularly for orchestra) preceded by a movement in French-overture style were sometimes referred to simply as "overtures," though not part of a stage production.

The Overture in D Major, BWV 1068
(probably at Leipzig between 1729 and 1731)

Overture, BWV 1068

Of Bach's four surviving orchestral suites, the most familiar is the Third Overture, in D Major. It is scored for three trumpets, timpani, two oboes, strings, and continuo. The work begins with the characteristic slow tempo and dotted rhythms; after the first part repeats, a lively fugal part follows. Since both parts are repeated and the first part ends on the dominant (in which key the fugal part begins), this overture is in binary form *aabb*.

It is the following movement, "Air," that has made this suite famous. Written for strings alone and in binary dance form, it consists of a graceful melody in the first-violin part, like a vocal aria from an opera, over a walking bass line:

♪ The **Baroque orchestral suite** is a set of separate dance-related movements each with its own tempo, meter, and character. This excerpt illustrates the Baroque style of improvisation and embellishment of a melody.

38 Bach "Air"

In the next movement, Bach combines two Gavottes. (A gavotte is an old and graceful French dance with a duple beat and a series of four-measure phrases, each beginning and ending in the middle of a measure.) Despite present-day custom, it is probable that they are to be performed as written, without the return of Gavotte I after Gavotte II, since no indication for such a return appears. The remaining movements consist of a Bourrée, a lively dance from Auvergne with a duple beat like the Gavotte but beginning on a shorter upbeat; and a texturally uncomplicated Gigue, a lively dance, of Italian origin, in a compound meter.

Among Bach's other orchestral works are the six famous Brandenburg Concertos, sent with a letter of dedication to the Margrave of Brandenburg in 1721 but written much earlier, Nos. 1, 3, and 6 even dating back to the Weimar years. These are mostly in the old *concerto grosso* tradition.

Handel's Organ Concertos

Handel: instrumental music

Even though the keyboard did not become a favored solo instrument until the late-18th century (the violin still being preferred), Bach and Handel contributed significantly to its early use in concertos. Bach's concertos, some of which were arrangements of concertos originally for other instruments, were written mainly for harpsichord (several early arrangements, based on works by other composers, are for organ) and are stylistically akin to the Vivaldi three-movement type. Handel, in about 1735, began writing concertos for organ and orchestra (oboes and strings) as entertainments between the main parts of his oratorios. These concertos, many of them adaptations of other Handel works, proved enormously popular. Handel's concertos are reminiscent of Corelli's sonatas and concertos, many even following the old slow-fast-slow-fast sequence of church-sonata movements.

The Baroque Organ

The organ reached the stellar point in its venerable history during the Baroque era, when national schools of organ building, first emerging in the 16th century, became distinct. Perhaps the most impressive achievements in organ building were in the German and Netherlands school, in which each organ had two or more manual keyboards as well as the pedal keyboard, plus the availability of a wide variety of tone-color combinations. In England, most of the organs lacked a pedal keyboard but often had a wider manual range, while most Italian organs, frequently with only a single keyboard, sometimes had pedal boards permanently coupled to the manual. In France, organ building reached its zenith in the early 18th century, with famous builders such as Andreas Silbermann, brother of the noted South German builder Gottfried Silbermann. Yet, the pedals did not quite attain the independent development of those in the German school.

By using various "stops," knobs that mechanically admit or shut out whole sets or "registers" of pipes, the organist had many different combinations of timbres from which to choose. (Stops were being developed by the 15th century.) A register is an entire set of pipes controlled by one stop, "register" and "stop" thus being synonymous; many Baroque organs had over 70 stops. With a "mutation" stop, pitches corresponding to overtones or the fundamental pitch are added, creating artificially stressed harmonics. (The higher frequencies, still too soft to be heard as separate pitches, help create different timbre approximations.) Unison "ranks" and mutation "ranks" can be combined, creating even more timbres. (A rank is a complete set of pipes *of the same type;* a register consists of one or more ranks.) Stops of various kinds, "reeds," "strings," and combinations, gave the Baroque organist a panorama of tone colors not available to other performers. In addition, there were stops that added lower and higher octaves to pitches. The manual range of the unison pitch was represented by the reference "eight-foot," for 8′, stop. Stops for lower octaves, such as 16′, and higher octaves, such as 4′, greatly expanded the range and over-all sonic power of this royal instrument. The manual range of Bach's organs, without the added stops, was usually

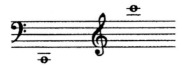

and the pedal range

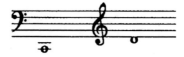

The compass of the English organ of Handel's time without the added octave stops, was customarily

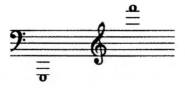

Handel's organ concertos are outstanding for their brilliance, especially since the organ was then as now associated closely with the more sober style of church music. Pedal keyboards on organs were apparently not yet common in England, where the Italian type of organ was in vogue, and Handel's organ music appears mainly on two staves, for the hand keyboards (manuals).

The Concerto in F Major, Opus 4, No. 4

Organ Concerto, Opus 4, No. 4

The opening ritornello is humorous; a solitary low F in the organ part is sounded, and then the tutti theme begins on the third beat of a movement in 4/4 time, sounding as if it were a half-measure late:

In traditional Baroque fashion, the theme is performed in unison by all the instruments. The solo organ then plays the theme and breaks into many fast runs, punctuated by tutti statements at the cadences. For much the remainder of the movement the organ has runs in sixteenth notes, and the tuttis reassert the ritornello theme in different keys.

The Andante, in *aba'* form, is an expressive movement in B-flat major, in which the soloist dominates, beginning alone with the main theme. A brief Adagio movement appears before the finale, as in a Corelli sonata. The finale is a brilliant fugal Allegro. The subject begins with the oboes and organ (right hand) and the answer appears in the violins and organ (left hand):

Throughout the entire movement, the tuttis are associated with the fugue subject, and the solo sections later have (episodic) thematic material independent of it.

Bach's Sacred Vocal Music

The St. Thomas School

Bach: vocal music

As Cantor at Leipzig, Bach was the official director of the town's music and senior music master of St. Thomas, the principal church, as well as the St. Thomas School, the municipal town school. In the St. Thomas School, he was third in rank among the academic leadership. Bach's work was principally connected with supplying musical compositions and performances for the two large churches, St. Thomas' and St. Nicholas'. He had less direct contact with two other churches in the St. Thomas Parish, the New Church and St. Peter's. Bach was also leader of the Collegium Musicum, involving the extracurricular music activity of the University students and may occasionally have prepared music for performance at St. Paul's, the University church, although most of the Collegium concerts took place in Zimmermann's Coffee House, a favorite Leipzig establishment for such entertainments. Bach was also the senior Latin instructor of the St. Thomas School students, who were expected to speak Latin even in their leisure time. Much of the Leipzig liturgy was in Latin.

The Leipzig Service

Leipzig service
chorale
chorale prelude

The service at Leipzig was based on Martin Luther's "German Mass and the Arrangement of the Service of God" published at Wittenberg in 1526, in which Luther retained the ritual of the Communion as the core of public worship. The Service was known as the Principal Service of God ("Hauptgottesdienst"). Some music-associated movements of the Roman Catholic Mass were retained with texts invariable from one service to the next. The texts of other musical portions of the service changed according to the specific reading from the Gospel or Epistle appropriate to the particular day in the Church Year. The Congregational hymns, called chorales (*Chorals* in German), were usually based on simple tunes, sometimes of popular origin.

Most of the services at Leipzig began between six and seven in the morning and lasted until noon. The cantata, based on the Sermon for the day, was performed at about 7:30, after the intoning of the Gospel by the Minister. The Sermon itself was given from 8:00 to 9:00. Before the later part of the service, centered on the Communion, either a chorale or part of a cantata was performed. At numerous times in the service, chorales were sung, sometimes preceded by a free organ piece based on a chorale melody and called "chorale prelude," which functioned to set the spiritual tone (affect) of its chorale.

Bach's Cantatas

sacred cantata
"concerto"

At Leipzig, Bach directed performances of cantatas for Sundays and Holy Days. During the 1600s, the Lutheran cantata had evolved in part from chorales and other pieces performed after the celebrant's intoning of the Gospel. Following an old practice, Bach used the title "Concerto" for most of his sacred cantatas, the title denoting a sacred work that combines vocal and instrumental parts. About 200 sacred cantatas by Bach have survived, most written by 1729.

Bach also wrote secular cantatas, a genre he called "Dramma per musica," for events such as coronations, birthdays, celebrations in honor of a university professor (!), and weddings. One cantata even honors coffee, a new 18th-century craze. About twenty-one of the secular cantatas presently survive intact. Bach's secular cantatas featured memorable tunes but had relatively few choruses and did not include chorales or chorale-related movements.

A sacred cantata by Bach often consists of six or seven movements (the secular cantatas typically have several more movements), beginning with a chorus, sometimes based on a chorale, and ending with a harmonized chorale. The other movements are mainly arias and recitatives, mostly to new texts, the addition of which became standard around 1700. (The chorale tunes and texts were much older.) The librettos were newly written by the composer or a contemporary or were taken from standard published sources. They are a mixture of diverse literary elements unified by the nature of the chorale, itself based on the sermon for a particular day in the Church Year. When earlier movements are based on the text and the melody of the chorale, the cantata is called a "chorale cantata."

Gott, der Herr, ist Sonn' und Schild, BWV 79

Bach's 79th Cantata

Bach's 79th Cantata was probably written in 1725 for the Reformation Festival, early in his tenure at Leipzig. The Reformation Festival was like the celebration of earthly victories in the cause of national religion, and the cantata as a whole has a martial character. In six movements, it is scored for soprano, alto, and bass soloists, chorus, two horns, timpani, two flutes, two oboes, strings, and continuo. The pivotal movements are the first (a rousing chorus) and third (a chorale movement). The second movement is an aria, the fourth and fifth movements a recitative followed by an aria, and the sixth a brief concluding chorale.

The opening chorus, *Gott, der Herr, ist Sonn' und Schild*, is based on a German translation of Psalm 84, Verse 12:

> *For the Lord God is a sun and shield;*
> *The Lord giveth grace and glory;*
> *No good thing will He withhold from them who are upright.*

This chorus has a polyphonic texture in which imitative and nonimitative counterpoint are combined. There are three principal musical ideas: (a) a fanfare melody in the horns supported by pounding timpani; (b) a march theme in the oboes and strings; (c) a fugue subject:

The form consists of an instrumental introduction followed by a chorus with three sections corresponding to a *Statement, Development,* and *Summation.* The third movement, based on the chorale, *Nun danket alle Gott* (Now thank we all our God), is for full chorus and orchestra; the text is from a hymn by Martin Rinkart (1636) and the melody is by Johann Crüger (1647):

Nun dan--- ket Al---- le Gott

Bach's musical setting of the chorale is in the standard *aab Bar* form. This music clearly demonstrates nonimitative counterpoint (see Chapter 5). The soprano, altos and tenors sing the chorale, doubled by instruments; against this, the horns and timpani present an almost literal version of the fanfare theme (a) from the opening movement. The horns play continuously throughout, having only three short rests: this movement is one of the most difficult in the entire modern horn repertory.

Handel's Vocal Music: The Operas

Handel's operas
Serious Italian operas of the kind Handel wrote consisted of three acts, each containing numerous scenes. The librettos often stressed the noble and compassionate character of a figure from Roman history (the Emperor Titus) or mythology (Jason [and the Golden Fleece]), the heroes often allegorically representative of contemporary sponsors among the nobility. Dramatic action was carried forth in the recitatives, a combination of melody and declamation, while musical aspects—what the partisans really came to hear—were represented in the arias, Italian for "airs." A scene would consist of a recitative setting up a particular passion or *affect* followed by an aria expressing that particular passion or *affect.*

da capo aria
In Baroque music each aria was limited to one affect. Each leading singer therefore had to have many different arias in order to express a dramatically convincing

 The **Baroque vocal genres** of opera and oratorio feature the free-strict pairing of *recitative* and *aria,* and the art of improvisation with melodic embellishment. Listen for the melismatic ornamentation of the melody with many notes per syllable of text.

variety of moods. There were general rules followed as to the number and nature of arias for each singer, and it was not permitted for two singers to have the same type of aria in succession. The form of the aria was almost always *aba'*, called "da capo" ("from the head [beginning]"). The *b* section would be in a different key and often have a new theme, but similar motives and the same affect were retained from the *a* section. At the end of the *b* section, there usually was a sign or the expression "dal segno" ("to the sign"), given to the singer to return back to the sign in the *a* section. It was expected that the performer then "improvise" ornamentation for the second *a* statement and thus show off the highest level of his or her art. Some singers made carefully prepared "improvisations" beforehand or at least followed a tried-and-true formula. The ornamented returns in da capo arias created an enormous excitement in the audience, especially when a singer performed long passages on a single breath. At late revivals of his operas, Handel seems to have cut out the repeat of the *a* sections, probably because some of his singers could not perform the elaborations. Because the *b* sections usually ended in a key other than that of the aria, they too were left out.

Handel and the English Oratorio

**oratorios:
background**

For a while, Handel did well financially with opera productions for the Royal Academy. In 1727, the same year he became a naturalized British subject, Handel was saddened by the death of his champion, George I. But Handel never lost royal favor and was chosen to write four anthems for the coronation of George II. Unfortunately, financial problems with opera were becoming acute, and a change in public taste was reflected in the popularity of *The Beggar's Opera,* by John Gay (libretto) and John Christopher Pepusch (music), a spoken play with lightweight tunes produced in 1728. *The Beggar's Opera* poked fun at many English conventions, especially those of traditional (Handelian) opera. By the end of the 1728 season, the Royal Academy lacked funds, and most of the leading singers were back in Europe.

**Handel's losing
opera ventures**

In 1729, Handel formed his own opera company and brought in new singers from Europe. In 1733, the Prince of Wales, eager to oppose the King (a Handel admirer), grouped together with some members of the nobility to form a rival opera company called "The Nobility Opera." They leased Handel's favorite stage, the King's Theatre at the Haymarket, and seized upon the services of the leading singer-stars, including the greatest of the castrati, the legendary Farinelli. Traditional opera was, however, a dying cause, and by 1737, their resources were drained.

***Esther
Acis and Galatea***

In 1733, some rivals had taken two earlier Handel works, *Esther,* an English stage setting of the biblical story, and *Acis and Galatea,* a pastoral opera also in English, and profitably produced them: there were no copyrights to protect composers. Handel himself then revised these two works and re-produced them. The concept of presenting large works in English appealed to Handel—but as oratorio, not opera. Henceforth, Handel became increasingly occupied with writing oratorios, and at the end of the 1741 season he abandoned opera as oratorios became increasingly popular, especially among merchants and middle-class professionals. While opera had catered to the aristocracy, Handel's oratorios achieved a wider success through the support of the middle classes.

Handelian oratorio

The Handelian oratorio is a large work in English with important choral movements and typically based on an Old Testament subject such as *Israel in Egypt* (1738) and *Samson* (1734). Conceived as a type of entertainment with no required staging, the oratorios were eventually written to be performed during Lent. They are longer and more narrative than Bach cantatas, but operatic elements such as recitatives are kept short, and the airs only occasionally adhere to the da capo design. It is in the choruses where some of Handel's most inspired writing occurs, as in the "Hallelujah" Chorus from *Messiah* (1742), in which relatively fast changes in texture result from units first heard separately then, immediately, in combination. With the textural variety, novel effects sometimes take place;

"Hallelujah" Chorus

note how at "King of Kings, and Lord of Lords" long-held pitches transferred to the top of the texture appear over chordal hammer strokes of "Hallelujah" and produce unusual inverted-pedal effects:

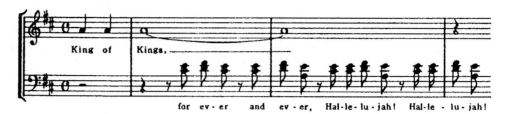

Messiah

When Handel received the libretto to *Messiah* in 1741, he was in the midst of the most difficult years of his career, as the continual decline of Italian opera had left him depressed and financially impoverished. At this time, the Lord Lieutenant of Ireland invited Handel to come to Dublin and direct a series of concerts featuring his own music. Working furiously from his secluded bachelor rooms at Hanover Square, Handel completed *Messiah* in only twenty-four days!

The libretto was supplied by Charles Jennens, a wealthy man with literary aspiration who probably did not write all of it. An associate of Handel's since 1725, Jennens had contributed the libretto to *Saul* in 1735. Writer and composer had an uneasy relationship at best, Jennens often criticizing Handel's work until success was imminent, whereupon Jennens would enthusiastically stand abreast his "colleague."

unique libretto

Messiah is unique in that it is concerned with the life of Jesus. The libretto is a skillful blend of both Old Testament (especially the prophecies of Isaiah and the Psalms) and New Testament (especially the Pauline letters). Unlike the conventional Handelian oratorio, which consisted of a newly written text with occasional biblical quotation, the words for *Messiah* are taken entirely from Scripture. The first part deals with Advent and Christmas, while the second and third parts portray the Passion with a more contemplative view than found in other works such as Bach's *Passion according to St. Matthew.* Part I consists of the prophecy and realization of God's plan to redeem humankind through the coming of the Messiah; Part II concerns the redemption of humankind through the sacrifice of Jesus; and Part III celebrates the final overcoming of death. The three parts have been referred to as "The Promise," "The Redemption," and "Hymn of Thanksgiving." Since the oratorio spans the entire life of Jesus, portions of *Messiah* may be used throughout the Ecclesiastical Year from Advent to Trinity, and sections have frequently been extracted for performance on different occasions. Moreover, since the first advertisement of *Messiah* had declared that it was "For the Relief of the Prisoners in the several Gaols, and for the Support of Mercer's Hospital in Stephen's Street, and of the Charitable Infirmary at the Inns Quay," *Messiah* was from its first performance associated with charity and fund-raising, an important component of its enduring success.

Part I: The Promise
Part II: The Redemption
Part III: Hymn of Thanksgiving

Handel's vocal style

A good example of Handel's vocal style directly follows the French-style overture. The "accompanied" (*accompagnato*) recitative for tenor soloist and strings, "Comfort ye my people," sets the affect of the radiant tenor aria, "Ev'ry valley shall be exalted." (Accompanied recitatives, in which singers are accompanied by various orchestral instruments, tend to be more song-like than "dry" [*secco*] recitatives, in which singers are supported by only *continuo* instruments.) In the aria, listen for word painting when the pitch descends on "low," and for rising melodic lines in the melismas (long vocalizations) on "ex-ALT-ed," which convincingly enhance the virtuosic effect.

39 Handel
"Ev'ry valley shall
be exalted"

legacies of Bach and Handel

With Bach and Handel, the Baroque era ended brilliantly. Bach, cerebral and traditional, wove separate strands from French, Italian, and German styles into an artistically unified musical fabric, basically instrumental and richly polyphonic. Handel's approach was outward, largely vocal, and relatively homophonic. Both

have achieved the enduring respect of later West-European composers. Bach was admired by Mozart and Beethoven in the Classic era, Mendelssohn, Chopin, Liszt, and Brahms (among others) in the Romantic era, and just about all composers in the main line of 20th-century music. Handel was one of Beethoven's favorite composers, and Handel's oratorios have strongly influenced the choral styles of Haydn in the Classic period, Mendelssohn in the Romantic, and virtually the entire school of English composers of vocal music in the late-19th and early 20th centuries.

India

Hindustani and Karnatic musicians

In Asia, musical genres that we could call "classical" are found in many nations, including Japan, Korea, Java, and India. The word "classical" often refers to music of the ruling classes. It is usually self-conscious music, that is, music with a theory and a history. Professional performers, the skilled few who perform for the unskilled many, are also an attribute of classical music. These characteristics, elitism, self-consciousness, and professionalism, apply to the music discussed in this part of the chapter. In these ways they are like the European classical music of "the three Bs," Bach, Beethoven, and Brahms.

Traditional classical musicians of India divide the subcontinent into two classical dialects, North and South. North Indian music is called Hindustani and South Indian *Karnatic* (Carnatic, Karnatak). (See the map.) While the structure and elements of these two dialects are similar, a North Indian musician ordinarily would not be conversant with South Indian music and vice versa, even though some intermingling has taken place. Ravi Shankar, a North Indian musician, will attempt Karnatic modes; and Subbulakshmi, a South Indian vocalist, occasionally tries out Hindustani songs. This chapter explores Hindustani music, but much of what is said here can apply generally to Karnatic music.

North India

The Hindustani region includes present-day North India and Pakistan. Historically, Muslim rulers of the medieval period left a strong imprint on this area; musically, we can attribute many of the instruments, the secular love songs, and the leisurely paced, mystical improvisations to this influence.

Music Making

European musical genius created a dynamic harmony, a wealth of orchestra colors, and grand architectonic forms. African musical genius created multilayered rhythmic ensembles, unrivaled in textural complexity. American Rock perfected a commodity that appeals to a targeted consumer audience by combining stage craft, public relations, socially appealing lyrics, and high decibel sound levels. Like the art music of Medieval Europe, Indian music, North and South, has expressed its genius in two linear dimensions: melody and rhythm. The intricate and expressive system for creating a single beautiful melodic line is called *rāga*. An equally sophisticated system, called *tāla*, creates single rhythmic lines, among the most complex in the world today. In North India, these terms are often pronounced and referred to as *"rāg"* and *"tāl."* Though our discussion will focus largely on North Indian performance, for easier identification the more familiar terms *rāga* and *tāla* will be used.

To these fundamental elements of melody and rhythm, a third element is usually present in Indian classical music: the drone. The typical ensemble for a North Indian concert is of small chamber-music size, often three musicians or fewer. The melody line follows the rules of a *rāga* system and is realized by the voice or one of the solo instruments such as the *sitār* or *sārod*. The rhythmic line follows the rules of a *tāla* system and is realized usually by the *tablā* (drum). A few more musicians, in the roles of alternate soloists, accompanists, or additional drones, may be added.

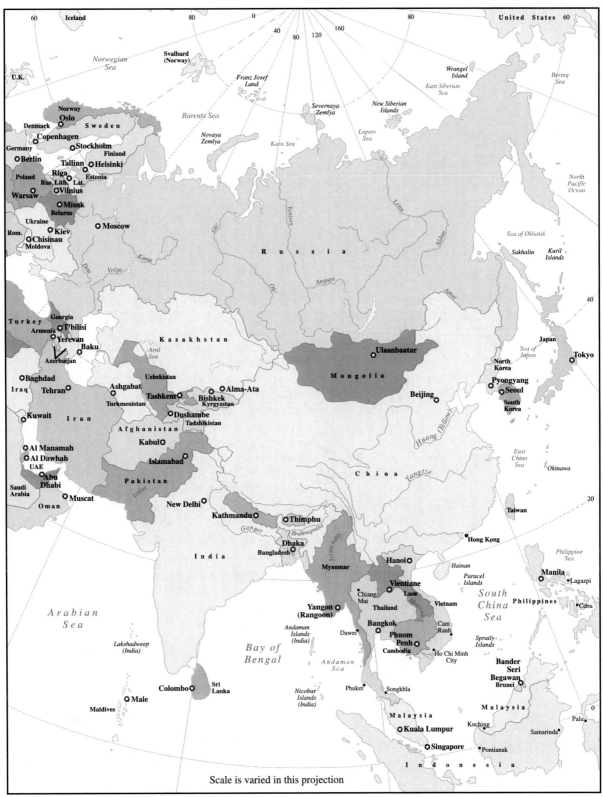

Scale is varied in this projection

© Magellan GeographixSMSanta Barbara CA www.maps.com

A single singer might accompany himself with just the drone of the *tānpūra*, a long-necked lute (South Indian *tāmbūra*), if no drummer is available.

The essentials of an Indian classical performance, then, are for example:

Principle	Element	Instrument
rāga	melody	*sitār*
tāla	rhythm	*tablā*
drone	drone	*tānpūra*

With symphony concerts, European and American audiences have become accustomed to hearing music in large halls such as Boston's Independence Hall, Amsterdam's Concertgebouw, and Moscow's Hall of Nations. While the great artists of Indian music do, on occasion, perform in such halls abroad and at similar ones at home (outdoor concerts on a huge scale are also popular in India), the essence of Indian classical music is intimate, the ideal setting a private home, like chamber music in Vienna during the late-18th and early 19th centuries. Friends gather on the appointed evening. Refreshments are offered the guests, including the performers. When the mood of those present mellows sufficiently, the musicians tune up and almost imperceptibly ease into performing roles.

The soloist (*sitār* player, vocalist) maintains eye contact with individual members of the audience, looking for a response. When an effective ornament, phrase, or interpretation of the *rāga* pleases, a listener usually nods his or her head appreciatively. The constant communication between performer and listener, taken together with the sensuous and enticing ornaments of North Indian music, leads one to compare this kind of music making to a personal conversation.

A typical concert, whether public or private, opens with an exploration in free rhythm of a chosen melodic mode *(rāga)* by the soloist, accompanied by the drone instrument. When the soloist brings the improvisation to an end, the drummer gets prepared to enter. On the heels of the improvisation, the soloist immediately launches into a composed piece, at which point the drummer joins in. A complete program might consist of two or three such *rāgas* and a few light classical encores to finish the evening. If at a home, the entire audience and performers might be served a light repast.

Rāga

Rāga system

Indian melodic composition is governed by the rules of the *rāga* (RAHG-ah) system. There are about fifty *rāga*-types in general use today, each recognizable by its distinctive features: contour, ornaments, stereotyped phrases, microtonal pitch inflections (intervals smaller than a semitone), and emphasis or avoidance of certain tones. With experience, the listener can begin to recognize a *rāga* by general feeling or intuition rather than analysis.

A *rāga* has a typical scale, a set of characteristic intervals. Most scales have seven tones, some six or five. Compare these scales of four commonly played *rāgas*:

Bhairavī:	C	Db	Eb	Fb	Gb	A	B
Todī:	C	Db	Eb	F#	G	Ab	B
Mālkosh:	C		Eb	F		Ab	Bb
Kalyān:	C	D	E	F#	G	A	B

The "tonic" or *sa,* is almost always the same tone, written C in the scales above.

After scale, contour best identifies a *rāga*. The following contours would suffice to define a few *rāgas* minimally. The performer elaborates on the contours when realizing it:

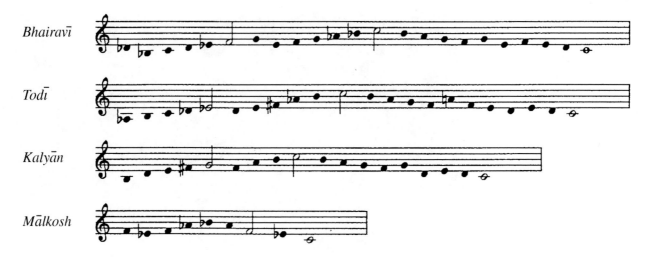

Bhairavī

Todī

Kalyān

Mālkosh

Two *rāga*-types may share the same fundamental scale, but differ in their respective contours. Thus, while the rules and terms mentioned here hold true in general, each musical situation is different, especially so in Indian music. In India they say, "Nothing is fixed—but some things are fixed."

Rāga also sometimes refers to a section of a concert program in which the performers improvise and play compositions in a given mode.

Rāga and Mood

mood/mode

In Chapter 4 (Melody), we saw that a major mode seems to give a happy effect for today's Western listener, and a minor mode a sad effect. Music in Renaissance Europe had a richer palette of modes, and their effects were more varied than happy or sad. The Dorian mode "has the liveliest melody of all, arouses the somnolent, refreshes the sad and disturbed," but Phrygian "moves to choler and biliousness . . . loud words, hideous battles, and bold deeds suit this [tone]," wrote Hermann Finck in mid-16th century. A mode has particular meaning for the listener steeped in that culture, just as a college fight song or a national anthem arouses strong feelings mostly in listeners loyal to that college or that country.

"choler . . . hideous battles"

Like medieval and Renaissance European music, music of India emphasizes melody. Indian music has hundreds of modes, each expressing a distinctive mood. "*Ranjayati iti Rāgah* (That which colors the mind is a rāga)." Like the Baroque era Doctrine of the Affections, each *rāga* plumbs the depths and complexities of a single emotion. Each *rāga* (mode) also associates with a time of day. *Lalit* is an early morning devotional *rāga*, *Sārang* has a cooling effect on a hot summer afternoon, and *Nāta*, a night *rāga*, portrays the heroism of a female warrior. Indian paintings and literature reinforce detailed *rāga* extramusical associations.

Ali Akbar Khan

"*Ustad*" is a title for a master musician in North India, Ustad Ali Akbar Khan is considered to be the most accomplished, most creative, and most profound of living Hindustani instrumentalists. Since 1955, he has been performing in America, as well as in India and Europe. He heads the Ali Akbar Colleges of Music, one in Calcutta and the other in San Rafael, California.

Ustad Khan's instrument is the *sārod* (see photo). He performs on a compact disc (*SS1: Three Rāgas*, CD AMMP 9001, signature series, Vol. 1) accompanied by Mahapurush Misra playing the *tablā*.

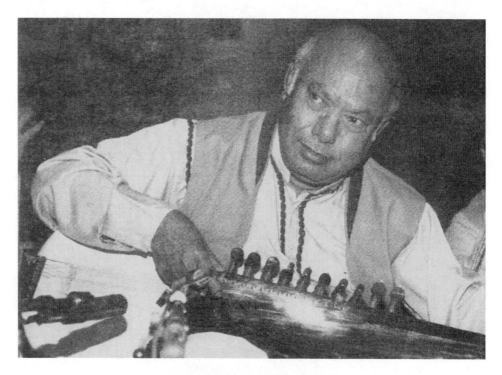

Ustad Ali Akbar Khan Sahib
Photo: Craig Kolb & Judith Bang-Kolb

On the recording, he first explores *Chandranandan*, a *rāga* he created, whose atmosphere "is of looking out into the universe on a full moon night." The name of the *rāga* means "the playing of the full moon." A *rāga* is usually introduced by a free rhythm *ālāp* or improvisation, the alap sometimes lasting an hour or more. But Ustad Khan introduces *rāga Chandranandan* with the briefest of phrases, less than one minute in total length (we warned earlier that the system is flexible). He gets immediately into the variations on the composed melody, the *gat*, and the drummer joins him.

For over twenty minutes, Ustad Khan and his partner improvise variations on a short melody.

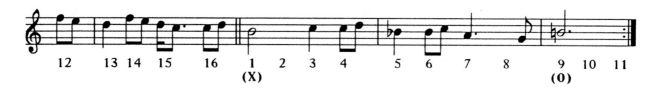

Ali Akbar Khan "Rāga" Chandranandan"

The variations are by turns joyful, meditative, plaintive, mathematical, and virtuosic. Periodically, the unadorned melody returns as a refrain. Ustad Khan uses many variation techniques already familiar to those listeners acquainted with jazz and European classical music: sequence, rhythmic alteration, development of short motives (riffs), and substitution of melody notes. Louis Armstrong fans will have little difficulty adapting to these techniques of variation.

Tāla

Tintāl

Indian rhythmic organization is governed by the rules of the *tāla (tāl)* system. Every composition is in a specific *tāla,* a patterned rhythmic cycle of a fixed number of beats. Along with *rāga,* it is one of the two main form-building principles of Indian music. See the *tāla* discussion at the conclusion of Chapter 3.

The most common *tāla* is *Tintāl.* (See also Chapter 3.) When *Tintāl* is performed in a slow tempo, it is sixteen beats long, divided into four groups of four beats. The strong point, *sam,* in the cycle of *Tintāl* is on one (x); the weak or empty point, *khāli,* is on nine (o). The weak point of a cycle is indicated to the listener by the absence of the low-sounding left-hand drum. The *Tintāl* cycle here is countable as four times four in the beginning variations. Count with a tap of the right hand each of the four main pulses, the first one *(sam)* with an audible slap (X), the second (* on 5) and fourth (* on 13) silently tapping, and the third *(khāli)* with the palm up to mark the empty beat (o and 9). The four subdivisions (.) you count with the thumb against each of the fingers, starting with the little finger:

```
1  2  3  4   5  6  7  8   9  10 11 12   13 14 15 16
X  •  •  •   *  •  •  •   O  •  •  •    *  •  •  •
(Slap)      (Tap)        (Palm up)     (Tap)
```

As the tempo becomes too fast to count the subdivisions, just mark the four main beats: X * O *.

Tihai

Keeping the *tāla* heightens the listener's perception of the structural need of the *sam,* the focal point of the cycle. The rhythmic resolution on the *sam* after considerable tension is built by the complex cross-rhythms (sometimes in dialogue between the *sārod* and *tablā*) provides a release. In a lively concert, a master artist will try to trick his accompanist into losing the *sam.* To emphasize the return to the *sam* even more, the musician brings into play a cadential device easily recognizable to the initiated: a three-fold figure called *tihai* ("tee-high"). It is simply a short rhythmic motive stated three times, ending exactly on the *sam.* Early in the variations the *tablā* player makes a short and simple tihai cadence:

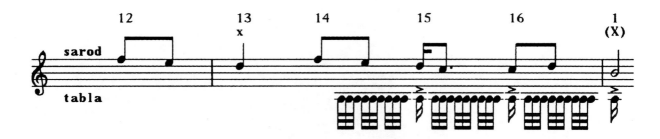

Audiences delight in giving a resounding slap of the hand on the knee in time with the resolution of the *tihai* cadence if it is long and complicated. At the very end of the variations, the final cadence must have a special finality, so a triple *tihai* cadence may be used (it is in this recording). In that case, the tihai is so constructed that the third statement of the motive does not end on the *sam.* Instead the whole tihai is repeated twice, nine statements of the motive in all, finally ending miraculously on the ultimate *sam.*

At the grand finale to *Chandranandan*, the *tablā* stops, the sarod lingers hauntingly over one short phrase in free rhythm in a subdued, expended tempo, and at last only the eternal drone prevails.

The second *rāga* presents a concert of a different nature. It is an *ālāp* improvisation of about twenty minutes' length. There is no *tablā*. Ustad Khan explores the *rāg Gauri Manjari* in the usual progression of stages, from free pulse (*ālāp* proper), to fixed pulse *(jor)*, to rapid pulse *(jhala)*.

Just as "Ustad," the equivalent of the Italian "Maestro," signifies a great master or teacher, "Pandit" (Pundit), meaning scholar or teacher, is used to show profound respect for its bearer, especially with regard to Indian classical musicians. In our CD selection, *Over the Moon* (Navras NRCD 0154), you hear *sārod* player Pandit Rajeev Taranath and *tablā* player Pandit Anindo Chatterjee in a widely acclaimed live rendition at London of Ustad Ali Akbar Khan's *Chandranandan rāga*. This performance demonstrates the remarkable identity of performer as re-creator. Just as the lines separating performer and composer in Baroque music were indistinct (Johann Sebastian Bach was well-known among contemporaries for his ability to extemporize), Indian musicians are cherished for their ability to create anew on the given. Pandit Taranath's improvisatory *ālāp* lasts for over twenty minutes, as it extends into a section in moderate tempo with a pulse felt in some phrases (the *jor*). With the arrival of the *gat* and the *tablā*, you will immediately be able to recognize Ustad Khan's *rāga* melody, here sounded a fourth lower. Pandit Taranath demonstrates his originality both in the varied appearances of the *gat* and the improvisations between its repetitions. The work intensifies with a second *gat*, the *Drut Gat*, taken at a faster tempo; the result is a three-part superstructure (one *ālāp* and two *gats*) that extends to over fifty-five minutes. A rousing climax, capped by a brilliant *tihai*, concludes this remarkable performance and elicits a most enthusiastic response from the audience.

In Hindustani music, many centuries of artistic development have nurtured a highly sophisticated interaction between a single melodic line and a single rhythmic line. A *raga* brings to life a commonly agreed upon set of rules each time it is re-created. Likewise, a *tāla*, though a cycle of a fixed number of beats, patterns of timbres, and strong and weak poles, truly lives only by means of the drummer's interpretation and improvisation. Both artistic processes balance elaborate rules with personal freedom, the expected with the new, the familiar with the eternal.

Chandranandan
in live performance

◉ **Tracks 40-4**
In this live concert, you hear the performers' free interpretation of Ustad Khan's *rāga Chandranandan*, in which (1) the *ālāp* is lengthened, and adds (2) a *jor;* Then comes (3), the entry of the *tablā* with the arrival of the *gat*. (4 and 5) A second *gat*, appearing in a faster tempo, is added by the performers, resulting in a concert that extends to almost an hour.

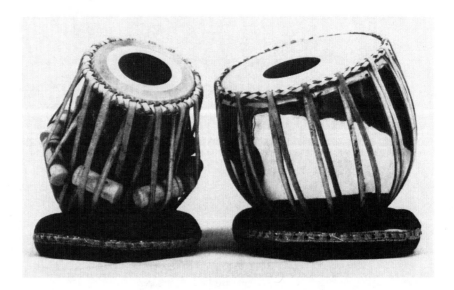

Tablā
Photo: Steve Brock for Ali Akbar College

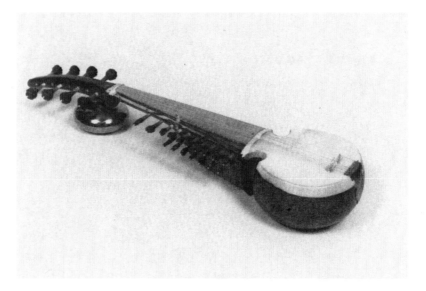

Sārod

Photo: Steve Brock for Ali Akbar College

Sārod

The Sārod is a fretless lute with a wide fingerboard covered with smooth metal that facilitates moving the fingers on the strings, producing graceful sliding ornaments and microtonal pitch changes endemic to much Indian music. There are 4 melody strings, a set of drone strings parallel to them, and underneath and parallel to those and run along the neck, 11 or 12 sympathetic strings tuned to the particular *rāga.* Like the American banjo, the bridge rests on the face of skin; the player's right hand plucks the strings with a plectrum made of thick coconut shell, accounting for the percussive, "metallic" sound when compared to the sitar. A round metal vestigial "resonator" is attached to the back of the neck, but its effect is more visual than aural.

Tablā

The **Tablā** is the main instrument of Hindustani classical music, consisting of a pair of drums played with the hands. The player's right-handed drum is made of wood and has a large black spot in the center of the head and has a high tone of definite pitch. The player strikes the right-handed drum with his fingers often very rapidly; with his left hand, the heel of the hand is used, and the tempo tends to be slower. Each hand is used in many different ways to obtain a great variety of timbres.

KEY WORDS

Affect, Baroque, *basso continuo, camerata,* opera, sonata, church sonata, chamber sonata, trio-sonata texture, concerto, *concerto grosso,* fugue, suite, French overture, cantata, oratorio, *sārod, sitār, tablā, rāga, tāla, tāmburā*

SUGGESTED READING

Bach and Handel

Abraham, Gerald. *The New Oxford History of Music, vol. 6: Concert Music 1630–1750.* London: Oxford University Press, 1985.

Arnold, Denis and Nigel Fortune (eds.) *The Monteverdi Companion.* New York: Norton, 1972.

Boyd, Malcolm. *Bach.* New York: Schirmer Books, 1997.

David, Hans T. and Arthur Mendel (eds.). *The Bach Reader,* rev. ed. New York: Norton, 1966.

Lang, Paul Henry. *George Frideric Handel.* New York: Norton, 1966.

Larsen, Jens Peter. *Handel's* Messiah, *Origins, Composition, Sources.* 2nd ed. New York: Norton, 1972.

Lewis, Anthony and Nigel Fortune (eds.). *The New Oxford History of Music, vol. 5: Opera and Church Music 1630–1750.* London: Oxford University Press, 1975.

Pincherle, Marc. *Corelli: His Life, His Works.* Tr. Hubert E. M. Russell: New York: Norton, 1956.

———. *Vivaldi.* New York: Norton, 1962.

India

Jairazbhoy, Nasir Ali. *The Rāgs of North Indian Music: Their Structure and Evolution.* Middletown: Wesleyan University Press, 1971.

Kaufmann, Walter. "India," *Harvard Dictionary of Music.* 2nd ed., 406–11.

———. *The Rāgas of North India.* Bloomington: Indiana University Press, 1968.

Krishnaswamy, S. *Musical Instruments of India,* rep. ed. (Delhi, 1965). Boston: Crescendo, 1970.

Neuman, Daniel M. *The Life of Music in North India: The Organization of an Artistic Tradition.* Detroit: Wayne State University Press, 1980. (This work provides a good perspective from the standpoint of the student.)

Wade, Bonnie C. *Music in India: The Classical Traditions.* Englewood Cliffs: Prentice-Hall, 1979.

SUGGESTED LISTENING

Ali Akbar Khan	*Ali Akbar Khan, Master Musician of India,* CD AMMP 9001, Signature Series, Vol. 1.
Bach	*Overture (No. 3) in D Major, BWV 1068;* Cantata 79, *Gott der Herr, ist Sonn und Schild, BWV 79.*
Corelli	*Sonata in D Minor, Opus 4, No. 8; Concerto Grosso in G Minor, Opus 6, No. 8.*
Handel	*Concerto in F Major, Opus 4, No. 4; Messiah.*
Rajeev Taranath and Anindo Chatterjee	*Over the Moon* Navras NRCD 0154
Vivaldi	*Concerto in A Minor, Opus 3, No. 6* (from *L'Estro armonico*).

HELPFUL VIEWING

Bach and Handel

Bach-Mozart. Videocassette 1 (spine number "36") of a four-cassette box entitled Great Composers, from the complete seven-program BBC TV series. Series Exec. Prod. Krišs Rusmanis, prod./dir. Francesca Kemp. Imprint: BBC, NVC Arts, Atlantic-Warner Music Vision 20511-3, © 1997. [Bach episode, 59 minutes] The Bach episode has also been released as a Kultur DVD, spine number D4119, © 2006 by WEA International Inc, a Warner Music Group company. [59 minutes]

Johann Sebastian Bach (the Famous Composers series, 1834). Written, prod., and dir. by Malcolm Hossick, dist. KULTUR International films. Imprint: © SCAN Productions, 1996. [35 minutes]

George Frideric Handel: Honour, Profit, and Pleasure. (Biographies in Music series). Prod. Simon Callow; dir. Anna Ambrose. Imprint: Films for the Humanities, © 1987. [70 minutes]

The Sound of the Carceri. (Yo-Yo Ma, Inspired by Bach series). Prod. Niv Fichman; dir./ed. Francois Girard (concept, Yo-Yo Ma; comp. Graphic design, Pedro Pires; photography, Alain Dostie); Imprint: Bullfrog Films, © 1997. [55 minutes]

India

Classical Music of North India (Washington Films series). Videocassette (U-matic), issued by the University of Washington Archives of Ethnic Music and Dance. Imprint: University of Washington Press, 1971. [33 minutes]

Hindustani Slide: Indian Classical Guitar. Vestapol Productions, dir. Abhjit Dasgupta. Vestapol Productions; dist. Rounder Records, © 1995. [81 minutes]

Rāga. (Music and Society series). Script, co-production, Bernard Queenan; dir. Deben Bhattacharya; Imprint: Audio-Forum, © 1992. [27 minutes]

Shahnai. Tom Evens. Imprint: Original Music, [1981]. [34 minutes]

7
REVIEW SHEET

Short Answers

1. List four aspects of Baroque style.

2. Compare Bach's style with that of Handel. How many differences can you specify?

3. What are the three main elements of Hindustani classical music? What instrument would be used for each of these three elements?

Short Essays

1. Discuss some characteristics of Baroque music that would make it especially attractive to a Western audience "untrained" in music.

2. Discuss some general similarities between Baroque music (of Western Europe) and the music of North India.

8
CLASSICISM
Mozart and the *Mehter*

High Classicism: Haydn and Mozart

We often call music of the late-18th and early 19th centuries "Classic" in recognition of the elegant coordination of its various elements. Despite the characteristic repose of its music, however, the second half of the 18th century was a time of political unrest and profound social change, of waning aristocracy and waxing bourgeoisie. The period saw the Seven Years' War (1756–63), the American War of Independence (1775–83), the French Revolution (1787–99), and Napoleon proclaimed First Consul (1799). The Industrial Revolution, with power-driven machines replacing hand-tools, was in its infancy but growing rapidly, as the early factory and oppression of the proletariat loomed. Collective thinking was changing from preoccupation with the natural sciences to greater concern for achieving social justice. Many writers, against what they viewed as suppression of knowledge by the Church, imagined that all objective fact could be ascertained. This era was witness to the climax of the Enlightenment and the last phase of the Age of Reason.

The Encyclopedists

The quest for clarity of form by Classic composers reflects a spiritual kinship to the philosophical tenets of late-18th-century writers in their search for social order. In France, three of the leading figures in the Enlightenment were Voltaire (François-Marie Arouet, 1694–1778), a skeptic and champion of social reform; Jean Jacques Rousseau (1712–78), a naturalist; and Denis Diderot (1713–84), co-editor of the twenty-eight volume *Encyclopédie* (1751–72; supplement and index, 1776–80). Diderot's life mission was to gather all (!) knowledge of the arts and sciences into an encyclopedia to be read, in its entirety, by every subscriber. Many of the Encyclopedists, referred to as *philosophes,* in particular Voltaire, Montesquieu (1689–1755), and Diderot, drew on the systematic approach to inquiry of British writers, especially John Locke (1632–1704), who, in his *Essay Concerning Human Understanding* (1689), had contended that the human mind is a blank slate, a "tabula rasa," upon which the facts of human experience are written in the formation of knowledge, and that only matter affects our five senses. Standing apart from the other Encyclopedists, Rousseau argued for a return to nature and the supremacy of feeling over reason. Rousseau's views later made him particularly attractive to writers of the Romantic movement. Himself a composer of vocal music, Rousseau preferred the clarity, melody, and expressive elements of Italian opera to the elegant, ornamental, and often instrumental French style.

Early Classic Trends

The artwork associated with gilt-edged paintings in palaces during the era of Louis XV (1715–74) reflects the opulence of the Counter-Reformation. Called *rococo,* from *"rocaille,"* it denotes a style of scroll ornamentation based on the graceful curves of shells and waterworn rocks. Baroque revels in unending ornament. *Rococo* reduces Baroque grandeur and elaboration to a style that is graceful but apparently somewhat shallow. The stylistic ideal was referred to as "galant," best exemplified in the *fête galante* paintings of Jean-Antoine Watteau (1684–1721) and some of his followers, depicting members of court frolicking in gardens and parks. In a later style more akin to the ideal of high-Classic music, the paintings of Jean-Baptiste-Siméon Chardin (1699–1779) emphasize balanced designs and the elegant coordination of stylistic details. In music, "galant" is now associated with all early Classic trends at theater and court after mid-century, as opposed to the more polyphonic style of church music.

Jean-Baptiste-Siméon Chardin (1699–1779)
Pipe and Jug, date unknown (1730?)

Chardin's paintings provided inspiration for many later generations, including 20th-century painters in the Cubist and Abstract Expressionist schools. His emphases on balanced design, on the elegant coordination of stylistic elements (line, shape, and scumbled color), and on unadorned substance and simplicity over frivolous detail anticipate by analogy the aesthetic later embraced by composers of high and late Classicism.

Among the galant styles were (1) a sentimental and expressive *(empfindsamer)* trend found in the keyboard music of Carl Philipp Emanuel Bach (1714–1788) at Berlin; (2) a dramatic trend in symphonic music of the late 1760s and 1770s, now often referred to as *"Sturm und Drang"* ("Storm and Stress"), the title of a play (1776) about the American Revolution by Maximilian Klinger (1752–1831).

The publishing of music mushroomed during the second half of the 18th century, and an abundance of sonatas and arrangements for keyboard and small ensembles began to glut the market. Intended primarily for amateurs, much of the published music was tuneful, ingratiating, and not overly complicated. The piano became a status symbol for those who could afford it, and children of the rising middle classes, to be considered well-bred, were expected to possess some musical ability.

Classic Style Classic music grew from a mixture of styles from many geographical areas, especially Austria, the German territories, Bohemia, Italy, and France (Paris). Its origins reach back to the early years of the century. At its full blossoming and associated with the music of Franz Joseph Haydn and Wolfgang Amadeus Mozart, classic style has as its basis graceful melodies supported by clear harmonies and tonality. (Baptized "Theophilius," Mozart preferred the Latin version "Amadeus" but often abbreviated it to Amadé or Amadè, or used the German version, Gottlieb.) "Sonata form," used in most of the important instrumental music of the time, also relies on the clarity of harmony and tonality. Unlike Baroque music, Classic music stresses contrasting moods, or *affects,* within a single movement or work. Lastly, Classic style is essentially the elegant coordination of diverse musical elements: simple, folklike melodies appear in sonata-form movements with involved thematic development; basic harmonies (I, IV, V) appear with sophisticated patterns of harmonic rhythm; and the prevailing tonal style sometimes has Eastern elements such as "Turkish Janissary" music and augmented-second scales.

Haydn: Freedom and Innovation

Haydn at Esterháza Franz Joseph Haydn (1732–1809), born in Rohrau, a town in Eastern Austria near the Hungarian border, began as a choirboy in Vienna, had an uncertain future when his voice changed, gathered funds in whatever musical manner he could, taught himself music theory, and by 1759, by teaching the right pupils and studying with the right masters, attained the position of music director at the court of Count Morzin, a

Bohemian nobleman. In 1761, Haydn began service at the court of Prince Paul Anton Esterházy, head of a wealthy and influential Hungarian family. For much the remainder of his life, Haydn served the Esterházys—Paul Anton till 1762, Nikolaus "the Magnificent" till 1790, Anton till 1794, and Nikolaus II from 1794 on. Haydn remained at Esterháza, the family palace in Hungary, for twenty-four years, from 1766 to 1790, at which time his reputation and Prince Anton's disinterest in music allowed him to move to his own home in Vienna. Haydn added to his fame with two extremely successful London visits, 1791–92, and 1794–95. By the end of his career, Haydn was the most respected of all living European composers, on both sides of the Atlantic. Some of his scores were prized possessions of Thomas Jefferson.

Haydn's music

Haydn was a prolific composer. In addition to his vocal works, Haydn wrote about 104 symphonies, more than sixty string quartets (a favorite and texturally balanced chamber-music genre consisting of 2 violins, 1 viola, and 1 cello), many concertos, sonatas, trios, and other small-ensemble genres, and, like Beethoven, he made numerous arrangements of British folk songs. Most of the later symphonies, written before the London visits, were intended for the Esterházy orchestra of about nineteen players. By contrast, an orchestra for the London concerts could number more than sixty players, according to newspaper announcements of that time.

Haydn in England

"London" ("Salomon") Symphonies

One December morning in 1790, the German-born violinist and impresario Johann Peter Salomon unexpectedly appeared in Haydn's Vienna home and proclaimed: "I am Salomon from London and have come to fetch you to England!" So began the saga of Haydn's historic and successful London concerts. For these concerts, Haydn, referred to by British journalists as "the Shakespeare of Music," wrote many outstanding works, including his last twelve symphonies. For the 1791–92 visit, Haydn wrote Symphonies 93–98 and for the 1794–95 visit, Symphonies 99–104.

Unlike the restricted, expert and aristocratic audiences at Esterháza, Haydn's audiences at London consisted of a social and economic mixture of both the general public and connoisseurs. And, in contrast to the larger cities in Continental Europe, musical events at London were reviewed by critics writing for newspapers, and Haydn received an unprecedented amount of positive critical acclaim in the press.

Symphony No. 100 in G Major, "Military"

"Military" Symphony

The première of Haydn's Symphony, No. 100, took place at the Hanover Square Rooms on March 31st, 1794, with Salomon directing the strings and Haydn at the keyboard. From its first performance on, this work enjoyed a huge success with both the general public and the reviewers in the press, and it soon became Haydn's single most famous and beloved symphony.

For his later symphonies, Haydn typically wrote slow introductions that create a mood of expectancy, often with unresolved final cadences. In the "Military" Symphony, there is a timpani roll at the cadence, heightening the feeling of anticipation. In his treatment of sonata form (see Chapter 6), Haydn frequently used procedures that could be considered outlandish for other composers, but not for him. The Exposition begins with a long, playful theme performed in an extremely high register by a solo flute (accompanied by two oboes):

Though Haydn generally favored the melodic use of woodwinds in his later symphonies, the length and lightness of the theme are unusual. More "oddities" occur. Rather than employing a new theme ("S") for the dominant key (D major), Haydn repeats the principal ("P") theme in the new key. He seems to revel in the unexpected: there is an unexpected turn to the minor mode, and then, suddenly, a contrasting, tuneful theme concludes the Exposition:

The contrasting theme occurs not as an "S" theme in the "usual" manner but as a closing theme. The effect of all this is an Exposition that seems unpremeditated, almost improvised.

In the Development, Haydn continues the closing theme rather than following the "usual" procedure and referring back to an earlier theme for elaboration. The effect is of one idea leading to the next in a seemingly unplanned manner. A feeling of temporary asymmetry results from the foreshortened Recapitulation: there is no need to restate the "S" theme in the tonic, since it would then be identical to the "P" theme. In order to bring a satisfying closure to the entire movement, Haydn provides us with a long coda, an added conclusion that again features a dramatic

The Early Symphony

Haydn, since the late 19th-century often referred to as "the father of the symphony," helped establish the symphony as one of the most enduring genres in Western orchestral music. Classic symphonies had some origins in the late-Baroque concertos, and in three-movement overtures to early 18th-century Neapolitan operas. The Italian name for overture is *sinfonia,* and the three movements generally appeared in the order fast-slow-fast. By the 1730s, opera symphonies were sometimes performed separately and became virtually indistinguishable from concert symphonies. After about 1775, symphonies began to have a standard four-movement sequence: fast first movement, slow second movement, dance movement (usually Minuet and Trio), and fast fourth movement ("Finale").

but brief change of key. Haydn's use of an extended coda anticipates a formal device later associated with Beethoven.

second movement
"Turkish" instruments

It is the second movement, a relatively fast-paced *Allegretto* march, that brought to this symphony its unparalleled and immediate popularity: "Encore! encore! encore! resounded from every seat" wrote the reviewer in the *Morning Chronicle* after the second performance of the Symphony on May 5th. Actually, this movement was a revised version from an earlier work, a "Concerto for the King of Naples" featuring two odd, hurdy-gurdylike instruments called *lire organizzate.* It is also this movement that gave the entire symphony its nickname "Military," the direct result of its use of "Turkish" instruments: bass drum, triangle, and cymbals.

The *Allegretto* begins serenely with a repeating theme in *alla breve* time (two half-notes per measure). In measure 57, about one-third into the movement, the mood changes abruptly as the quiet march becomes a battle march, with a shift to the minor mode, loud dynamics, and the use for the first time in the symphony of the "Turkish" instruments. To complete the picture, Haydn quotes a familiar fanfare with a solo trumpet. The dramatic and sudden appearance of the "Turkish" instruments inevitably suggested to the audience the program of a heroic march to battle: "It is the advancing to the battle; and the march of men, the sounding of the charge, the thundering of the onset, the clash of arms . . ." wrote the music critic. Haydn immediately made an arrangement of this *Allegretto* for military band.

third and fourth
movements

The third movement, a moderately paced "Menuet," has a straightforward ternary design: Menuet 1 + Menuet 2, called "Trio" because of its thinner texture, + Menuet 1, again. The Menuet and Trio are each in a simplified rather than true rounded-binary form *(aba),* since their opening *a* sections cadence on I (the tonic) rather than on V (the dominant). (See Chapter 6.) The relative simplicity of this *Menuet* makes it unusual, since Haydn in most of his other minuet movements typically provides some of his most innovative and original musical devices such as offbeat accents and colorful harmonies, and rustic or comic effects such as imitations of bagpipe drones and folklike scales. (Bagpipes were often used at popular events, such as country fairs, and provided accompaniment for dancing bears and other such entertainments.) Excitement returns in the fourth movement, a rondo marked *Presto.* This final movement or "Finale," begins with a group of refrain-and-episode statements and continues with an extended central area of modulation. Then, soon after the refrain theme reappears in the tonic, the "Turkish" instruments suddenly appear again and announce a triumphant climax to the entire symphony: apparently, the march to battle in the second movement brought victory in the Finale.

Haydn's Vocal Music

Masses

At Esterháza, there were two theaters, one for opera, the other for marionette performances. It was there that Haydn wrote nearly all of his operas and music for puppets, as well as most of his arias and songs. Several hundreds of the songs are arrangements of Scottish and Irish folk tunes made in connection with the London visits. But Haydn excelled in writing sacred vocal music, including Masses, twelve of which survive. In his Masses, scored for solo vocal quartet, chorus, and symphony orchestra, Haydn combined traditional polyphonic elements with newer elements of symphony style and sonata form.

oratorios

Two of Haydn's most impressive larger choral works are the late oratorios, *The Creation* (1798) and *The Seasons* (1801). While in England, Haydn had attended the Handel Festival at Westminster Abbey in 1791 and was deeply moved by the beauty and power of Handel's oratorios. Haydn's profundity is nowhere more in evidence than in *The Creation*. The text, based on Milton's *Paradise Lost*, was prepared in German by Baron van Swieten, an admirer of Bach and Handel. The orchestra was large for the time (3 flutes, 2 oboes, 2 clarinets, 2 bassoons, a contrabassoon, 2 horns, 2 trumpets, 3 trombones, kettle drums, and strings), and Haydn made full use of the added timbres. In the opening, "The Depiction of Chaos," bassoon arpeggios in the accompaniment and an expressive clarinet melody anticipate sounds associated with composers of a newer generation, especially Beethoven.

Invention is a hallmark of Haydn's style. Referring to his earlier years at the Esterházy palace, Haydn explained: "My Prince was pleased with all my work. . . . I was cut off from the world, there was no one around to mislead me, and I was thus forced to become original." Breaking new ground, Haydn was able to combine the new symphonic language with traditional polyphonic techniques, integrating popular elements into his art music, breathing a spirit of life and immediacy in everything he wrote.

Mozart: Grace and Balance

Salzburg and Vienna

Wolfgang Amadé Mozart (1756–91) was a musical superstar as a child. At six, he began tours of Europe that left listeners stunned by his precocious talents. Guided by his father, Leopold, a violinist in the Archbishop's orchestra at Salzburg, Wolfgang overwhelmed audiences throughout the German territories, as well as in Belgium, France, England, and Holland, all before he was ten. Most of Mozart's subsequent tours were to Italy, where he became preoccupied with opera. In 1777, while at Mannheim, which boasted the finest orchestra in Europe, Mozart met many fine musicians. In 1781, Mozart obtained leave from the Archbishop of Salzburg for a Munich performance of his opera, *Idomeneo, King of Crete,* and moved to Vienna, breaking ties with the Archbishop. In 1782, he married Constanze Weber. For six years, Mozart was comparatively successful and obtained the post of Imperial Chamber Musician at the Court of Emperor Joseph II. Preferring to freelance as a teacher, composer, and performer at musically active Vienna, Mozart passed up appointments at less cosmopolitan courts; unfortunately, he ultimately incurred severe financial hardships. In 1791, Mozart's last year, his newly completed German opera, *The Magic Flute,* became tremendously successful, and the outlook seemed brighter, but he died at the age of thirty-five before he could gain any financial relief.

Mozart's compositions

Despite his tragically short life, Mozart composed a considerable amount of music, covering a wide range of genres, including Masses, symphonies, various types of chamber music, and lighter works such as divertimentos, sonatas, songs, and miscellaneous dances. But it is in his concertos, symphonies, and especially his operas where Mozart's genius shines most brilliantly. Two traits of Mozart's style reflect his love for opera: beautiful melodies, many essentially in vocal style even when written for instruments, and a preference for contrasting themes that sound as if they represent contrasting affects in a vocal ensemble.

Style

Classic style

One formula for a new style in music: First, the forerunners whose rejection of the old is stimulating, but often short-sighted; their promotion of the new may be astonishing, but it is often also crude. They are generally condemned to the second rank because in rejecting the old they are rejecting part of themselves. Not enough

is left to develop and refine the raw new ideas. Then comes the second generation; having been detached from the old style, they are able to see it in clearer perspective. They combine old and new in a personal synthesis without following aesthetic dogma, and more of them will be composers of the first rank.

**first generation
pre-classicists**

The history of music gives us many examples of this formula for a new style, but perhaps none has as much importance as two generations of composers in the 18th century, the first flourishing mainly in the middle of the century, the second mainly in its second half. The first generation, that of the Mannheim School, J. S. Bach's sons, and other groups generally termed "Preclassical," had the task of dismantling the gigantic edifice of polyphony left by J. S. Bach's generation, mainly by substituting simple chords and singable tunes for richly interwoven lines of melody, and by putting long stretches of the same harmony in place of harmonies that changed on every beat.

**second generation
High Classicists**

The second generation was epitomized by Mozart. In his music, he did not have to be a destroyer; the essence of his genius was his ability to use both old and new, to be of the Enlightenment and yet rise far above the shallowness of the generation just before him. He accomplished this through a remarkable balance of all elements.

Timbre

Mozart and timbre

In Western music, Mozart occupies an intermediate position in the history of tone color. Before him, the tradition of specifying which instrument was to play which note was still fairly new; as late as 1749–50, J. S. Bach had deliberately written his monumental Art of Fugue without specifying instrumentation. After Mozart came, eventually, the deluge: instrumentation became a preoccupation of 19th-century composers. Mozart, product of a century that celebrated nature as a new discovery, listened to tone color with the aim of glorifying the natural and the idiosyncratic aspects of an instrument or voice. His treatment of the clarinet, a new instrument whose tone color always charmed him, illustrates this principle. Listen, for example, to the honor he accords the clarinet in his great Clarinet Quintet.

Rhythm and Melody

simplification of melody

What was the rhythmic-melodic problem that J. S. Bach's generation left for later 18th-century composers? Bach's magnificent strands of unbroken melody, his continuous expansion of a single rhythmically homogenous motive, was too much for the more prosaic Age of Enlightenment. "How can we sing such stuff?" said the popularizers like Voltaire. "Let's break it down into simple tunes with suitable accompaniment," said the *philosophes* like Rousseau.

**multiple affects:
C. P. E. Bach and Mozart**

Mozart's Classic melody generally divides itself into easily divisible phrases and repeats itself here and there but it also offers within a single movement a rhythmic differentiation and a contrast of affects previously unknown. The old Baroque "Doctrine of Affections" had required that a single "affect" pervade an entire movement. To make a change of affect, it was necessary to begin a new movement. In J. S. Bach's works, the sixteenth note could be the basic rhythm of an entire movement. In Mozart's works, long notes, middle-sized notes, and small notes make up the basic rhythm of a single movement or section. Between J. S. Bach and Mozart, C. P. E. Bach, son of J. S. and perhaps the most important of the Preclassic composers, practiced this same diversity of note-size, but there was a fascinating difference in the ways he and Mozart went about it: C. P. E. Bach crammed as many different note-values as he could into the smallest possible space, often at the expense of clear phrases and balancing repetitions, while Mozart uti-

"period structure"

lized this same variety of note-values on a broader musical plan of "period structure" through clear repetitions, phrases, and contrasts of moods. With C. P. E.

Bach, it was a long ribbon of rhythmically diversified, non-repeating melody, with phrase endings and breathing places generally papered over; with Mozart it was a series of clearly phrased and balanced melodies, with each successive melody founded on a different set of rhythmic values.

Polyphony and Harmony

treatment of counterpoint: J. S. Bach and Mozart

When the 18th-century rage for simplification came in the middle third of the century, it struck with such vehemence that the primary feature of traditionally complex counterpoint was swept away. To Frederick the Great's haughty court flutist J. J. Quantz, counterpoint was but "music for the eyes." Later, Mozart calmly and magnificently reinstated counterpoint, but with a difference: whereas J. S. Bach's counterpoint had been strict, Mozart's was *free*. Bach's magnificent counterpoint is introspective, profound, Baroque; Mozart's magnificent counterpoint is extroverted, accessible, Classic.

Form

classic "sonata form"

Sonata form reached its perfection in the Classic style of the late-18th century. Listen for the well-delineated sections of exposition, featuring principal, transitional, secondary and closing themes.

45 Mozart *Symphony no. 40,* 1st movement

What held a movement of music together in the 18th century? In J. S. Bach's time, primarily two ingredients: the ordered progression away from the home-base harmony (tonic) to the next most important harmony (dominant) and back to home base again, and the continuous expansion of the opening measures throughout the piece without departing from the character and mood (affect) of those opening measures. In Mozart's time, the second of these ingredients was discarded; a single movement could evoke more than one affect. Mozart's generation limited the affects of most movements to two, subjecting them to the organizing and balancing influence of Classicism, primarily by linking one affect to the tonic and the other to the dominant. It was the tonic-dominant opposition (or a similar opposition when a movement was in a minor key) that ruled the formal outline of a movement most often. The slowly developing vehicle through which tonic-dominant opposition became the main force in Mozart's musical form has become known (and, as Haydn has shown us, there is no one rigidly fixed type) as *sonata form,* in which (a) the two harmonies (really called *tonalities* when writ large) are introduced separately, each with or without its own affect, and each on such a broad plane that its tonality is pounded leisurely and, in Mozart's case, artfully, into the listener's consciousness; (b) there is a freer section in which the discipline of the two tonalities is abandoned in favor of a succession of different tonalities, usually using the ideas presented under (a); and (c) there is a return to the first procedure, a varied repetition of what we first heard, but this time with everything engineered so that it is all in the tonic. In other words, tonalities are presented in clear contrast to each other at first; then they and several others mix it up together; then they become reconciled. It is a bit like a novel, where opposing characters are introduced (Exposition), come into conflict (Development), and are reconciled in one way or another (Recapitulation). The first movement of Mozart's *Symphony No. 40 in G Minor,* K. 550, presents a clear and relatively balanced and symmetrical design, especially when compared to that of Haydn's "Military" Symphony.

Haydn and Mozart comparison

Haydn and Mozart represent two different facets of Classic style. Haydn is musically innovative and relatively unpredictable; he emphasizes surprise effects, weak-beat accents, sometimes "uneven" phrases (such as 3-bar groups), seizing our attention with plunges into the unexpected before eventual resolution. By contrast, Mozart combines all musical ideas into a coordinated, smooth-edged whole, emphasizing more regular phrasing, comparatively balanced formal designs, and a consistently maintained "thread" (his father referred to it in Italian as *"il filo"*). Haydn reveals the inner freedom of Classic style, Mozart its outer symmetry. Despite differences of stylistic approach, Haydn and Mozart admired each other's

contributions. In 1785, Haydn wrote to Mozart's father: "As God is my witness and as an honest man, I tell you that your son is the greatest composer known to me personally or by name. He has taste, and, what's more, the profoundest knowledge of composition." And it is reported that Mozart, often harsh in assessing other composers, said of Haydn: "There is no one who can do it all—to joke and to terrify, to evoke both laughter and profound feeling, and all equally well—except Joseph Haydn."

Mozart and the *Mehter*

"Turkish" music

Mozart's opera *The Abduction from the Seraglio,* first performed in 1782, brought an Eastern morsel to the Viennese stage: the Turkish harem (seraglio), a place where a Turkish ruler traditionally isolates his many wives. Mozart portrayed the Turks as seemingly threatening, actually harmless, and certainly delightful. What strange apparel, what fascinating music, what unheard-of customs, all observable from the comfort of a seat at the Vienna opera!

And what a change from almost exactly a hundred years earlier (1683), when Vienna was not kidding about the Turks, when it fought for its life in the famous Turkish Siege! In 1683, the Turkish Empire made the last of its many attempts—going back to the 16th century—to conquer Vienna, the seat of the Hapsburg Empire. (Turkish cannonballs are still embedded in the walls of castles around Vienna.) But the Turks were finally driven off, never to return. In the ensuing century, as the time of Mozart's birth approached, things Turkish gradually took on the character of a delicious imported delicacy rather than a heathen menace. Mozart and his contemporaries adopted Turkish instruments as additions to the orchestra. They even added what they thought or pretended were Turkish melodies and rhythms to their music, as in the famous "Rondo *alla Turca*" of Mozart's *Piano Sonata in A Major*, K. 300i, written at Paris in 1778.

Janizary influence
Yeniçeri bands

Mozart's finales to his A-major piano sonata, K. 300i, and violin concerto, K. 219, and similar "Turkish" works by Haydn and Beethoven, were inspired directly or indirectly by the music of the Janizary (*Yeniçeri*; pronounced "yenny-cherry") bands of the Sultan's bodyguards. In Turkish, the Janizary band is called *mehter* (pronounced mehh-tair).

In the hands of a lesser composer, a novelty like the importation of Turkishness into European style could easily be the whole point of a work; hundreds of mostly forgotten pieces were churned out in the 18th and 19th centuries for no reason other than to exploit some trendy fashion. But in the best works, the Classic

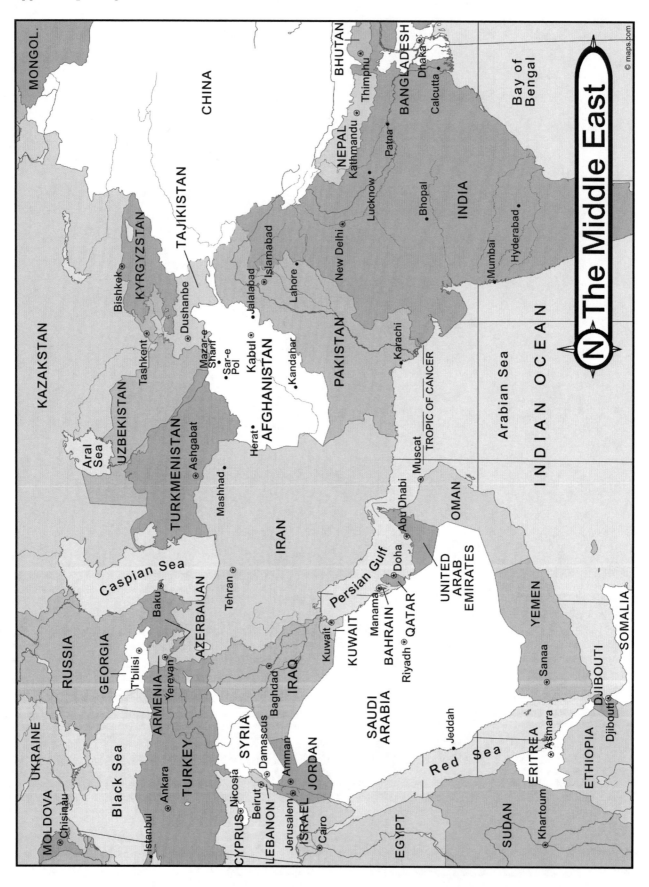

Opera in the Classic Era

In the 18th century, public opera increasingly replaced court-funded opera. The Baroque, formalized, three-act *opera seria* lost ground to the Classic, more flexible two- or four-act *opera buffa,* which had additional ensembles, greater interaction of characters, and a relative loosening of form. *Opera buffa* began as comic interludes between the acts of *opera seria* but around mid-century acquired sentimental and more serious traits. It was less allegorical than *opera seria,* not restricted to pseudo-history or mythology for subject matter, and the male lead was no longer a male soprano or alto *(castrato). Opera seria,* though old-fashioned, continued through the 18th century, but its rigid alternation of recitatives with solo arias limited the composer's freedom to develop onstage action. The most important composer of *opera seria* during the early Classic era was Christoph Willibald Gluck (1714–87). His often-cited reforms consisted mainly of attempting to heighten dramatic action by simplifying stage machinery and lessening abuses by singers, whose custom it was to lengthen arias by adding cadenzas and other elaborations.

Ever since his success with *Mithridates, King of Pontus* at Milan at age fourteen, Mozart was smitten with the challenge and potential of opera. Mozart's best-known stage works consist of three *buffa* operas, all on librettos by Lorenzo da Ponte *(The Marriage of Figaro, Don Giovanni, Così fan tutte)* two *Singspiele (The Abduction from the Seraglio, The Magic Flute),* and one *opera seria (Idomeneo, King of Crete).*

The Abduction from the Seraglio

♪ The influence of **Turkish style** in late 18th-century Europe is evident in the inclusion of the bass drum, cymbals, triangle and rhythms supposedly reminiscent of the Turkish military band, the *mehter.*

 46 Turkish music "Janizary Chorus"

balance of all elements overcame such one-sidedness. And in Mozart, above all other composers, any depiction of the dramatic or the unusual or the humorous, is subsumed into his larger conception of exquisitely weighted form and profoundest meaning.

Paradoxically, and this paradox is the essence of Mozart's Classicism, such depictions are not weakened by this control but are strengthened and given permanence.

Mozart's operas, undoubtedly the greatest examples of that genre in the Classic era, extend his abstract ideals of form and expression into the realm of human experience. As if his instrumental music were not enough to assure his immortality, he happened to be a musical dramatist of the first order, one whose conceptions rested upon a deep understanding of humankind's strengths and foibles. The plot of *The Abduction from the Seraglio* in itself, aside from the appeal of its Turkishness, hardly affords a clue as to the true worth of the opera: Konstanze is the beloved of the nobleman Belmonte; Blonde is Konstanze's maid and the girlfriend of the peasant Pedrillo; Pedrillo is Belmonte's servant. Konstanze, Blonde, and Pedrillo have been carried off by pirates to a Turkish harem. Belmonte, through many an intricate maneuver and comic confrontation, and with Pedrillo's help, makes his way into the harem and outwits the Pasha's overseer, Osmin. The rescue of the ladies—who have been resolutely faithful to their sweethearts—nearly succeeds, but is found out at the last minute. Nevertheless, the Pasha is magnanimous and releases the two couples anyway. What makes this opera an enduring part of the repertory—along with its "Turkish" themes in the overture, its chorus of Janizaries in the first act, palace guards, slaves, women of the harem—is the fact that its magnificent music is designed to illuminate the innermost feelings of comic characters in particular and human beings in general, in a way that neither words alone nor instrumental music alone can.

The Abduction has the additional distinction of standing virtually at the beginning of the history of native German opera. "Opera" in the 18th century meant opera in Italian everywhere, almost to the exclusion of other languages, even in Germany and Austria. Only with the gradual establishment of the *Singspiel,* a German play with music, in the second half of the 18th century, did the German desire for intelligibility outweigh the German infatuation with Italian singing. And only with *The Abduction* did this play-with-music truly metamorphose into a genre

commonly called opera—albeit with the persistence of dialogue that is spoken rather than sung, and showing Mozart's continuing attachment to Italian vocal production. After this there is a real history of real German opera. How curious that such a signal event came about as part of a fad for Turkishness!

mehter

Many another composer fell under the spell of Turkish music along with Mozart, Haydn, and Beethoven. A comparison of style and instruments might be helpful in understanding some important permanent results of such East-West cultural exchanges. The *mehter* was closely associated with the body-guards of the Sultan at the Sublime Porte in Ottoman times, and this affiliation caused it to be regarded with almost religious veneration by the Turks. On the battlefield, the Turkish soldiers responded not only to the flags and standards of their religion and ruler but also to the awesome sound of the *mehter* band. Each band numbered as many as one hundred players, and each regiment had a band.

instruments:
zil
kös

Many types of instruments were used in the ensemble. The characteristic sound of the *mehter* owes much to the unique brilliance of the *zil* (cymbals). The most impressive instrument in the band to the eye and the ear was the *kös* (keuss; giant timpani). Mounted in pairs of differing sizes (differing pitches) on camelback or even elephantback, the massed sound of these huge instruments gave heart to Islamic troops and terrified the enemy.

davul

The more lively rhythmic activity in the *mehter* band came from the *davul* (dah-ool; bass drum). The *davul* player marked the larger rhythmic beats with a heavy wooden drumstick in his right hand, keeping up a smaller running figure with a light switch in his left hand. The *davul* is a basic instrument in almost all Turkish folk music today.

nakkare
zurna
boru

The *nakkare* (nahk-kah-ray; small timpani) is a pair of drums easily held on the arm while playing with both hands. They are paired high-low, like the *kös*, but are easily portable. Complex polyrhythmic patterns often result from the interaction of the *kös, davul,* and *nakkare,* not unlike the percussion effects of our modern marching bands. These more powerful percussion, when used in full force, all but drown out the melodic instruments which include the *zurna* (zoor-nah; shawm), reinforced by the *boru* (boe-roo; trumpet).

çevgân

The percussion instrument Turks call *çevgân* (chev-gyahn; Turkish crescent) became known in Europe as "crescent," "Jingling Johnny," *chapeau chinois,* and *Schellenbaum.* Shaking it up-and-down, a light jingling effect is made, something like sleighbells. Descended from the Central Asian shaman's staff, it probably evolved into the bells of the modern marching band. It seems related also to the conductor's staff of the late 18th and early 19th centuries.

Of the many percussion instruments borrowed by the West from the Turks, the bass drum, cymbals, and crescent have remained virtually unchanged. By contrast, the timpani, snare drum, and triangle were considerably modified when compared to the Turkish models. An entire group of percussion instruments, the bass drum, snare drum, triangle, cymbals, bells and tambourine, more or less followed the same historical route. Asian in origin, they first gained favor among musicians of beggars and minstrels of the Middle Ages, crept into the ranks of military music that, especially of Turkey, served occasionally in the Late Baroque orchestra and were finally admitted to "legitimate" standing by the Classical composers. The rage for Janizary music of the late-18th century played an immediate role in their wide acceptance.

Europeanizing the Turkish band

The Turkish example of a highly organized "band" of wind and percussion instruments was not lost on West Europeans. Asian percussion instruments had crept into Europe via Spain and the Crusades, but it was during the reign of Louis XIV that "oboe bands" were introduced. The idea apparently came from the shawm *(zurna)* and drum *(davul)* bands of the Turkish Janizaries, successful in France, then England in the 17th century. It was at the beginning of the 18th century, however, that the full impact of the Janizary music made itself felt. The

Ottoman armies, with the unsuccessful second siege of Vienna in 1683, had passed their peak. In 1720, as a peacetime gesture, the Sultan sent a full *mehter* band to the Polish court. Other countries requested the same. First Russia, then Prussia, and, by the 1770s, most European courts had their own authentic Turkish bands.

"Turkish" rhythm

is a popular "Turkish" rhythmic stereotype used by Beethoven in his "Turkish March" from *The Ruins of Athens* (1812). Mozart, with this same underlying pattern, had created a more sophisticated "Rondo alla Turca" for the finale to his *Piano Sonata in A Major*, K. 300i. The left hand spins out the persistent rhythm similar to a stick-and-switch rhythm on the *davul*, leaving the right free to indulge in more fanciful flights of "Eastern" melodies.

The orchestral *Janitscharenmusik* developed into a stereotype by 1780. The bass drum, cymbals, triangle, and sometimes snare drum combination were noisy, and each instrument had its particular function in the ensemble, both features similar to the percussion ensemble of the *mehter,* although the European version was on a more primitive level. In Haydn's *Symphony No. 100 in G Major*, the "Military," the noisy interruptions in the *Allegretto* movement employ standard *"alla Turca"* effects: the heavy beats emphasized by the large stick on the bass drum in tandem with the cymbals, the small stick and triangle "trotting" along. The triangle also rings alarums and occasionally has small solos. The Turkish mania in European music faded in the early 19th century, but the legacy of the percussion instruments in the orchestra was permanent. The ghost of the *mehter* lives on in the Western orchestra, in opera, and in band music.

Mozart's representations of "Turkish" music, like those of Beethoven (discussed below) and other Western composers of the time, were charming, artistic, amusing, edifying—but not too accurate. Yet such adventures in foreignness did help bring about the eventual realization that the rest of the world's music deserves to be studied on its own terms. And, of course, the best of this "Turkish" music continues to thrive around the world, like "Turkish delight" candy, Turkish carpets, Turkish baths, and Turkish coffee.

Late Classicism: Beethoven

The span of Beethoven's life, 1770 to 1827, ran parallel to some of the most significant political and philosophical events of the modern era. Beethoven was six years old when the United States won its independence and nineteen when the storming of the Bastille ushered in the French Revolution and the ensuing Reign of Terror. He reached the height of his powers during the Napoleonic era, and he wrote the transcendental music of his late years at the beginning of the period following the Congress of Vienna.

Aufklärung

The German Enlightenment ("*Aufklärung*") arrived at its last phase during Beethoven's formative years. The German philosopher, Immanuel Kant (1724–1804), in a quest for the universal, went beyond the materialism of Locke and some of the French *philosophes* and drew upon the writings of Rousseau who, in *Émile* (1762), had argued that though reason may be against God and immortality, feeling is overwhelmingly in their favor. In his *Critique of Pure Reason* (1781), Kant recognized both the validity and the limitations of reason based on sensory stimuli and empirical dedication and synthesized these apparently opposing concepts while postulating the transcendence of sensory experience.

Goethe

In literature, Johann Wolfgang von Goethe (1749–1832), by nature a Classicist, through his uncanny ability to conceptualize the artist's feelings, strongly

influenced the younger generation of writers and artists throughout the Western world. Goethe's universalism, perhaps an outgrowth of the Rococo's infatuation with Asian literature and art, is reflected in works such as *Westöstlicher Divan* (West-Easterly Divan) of 1819, a collection of poems in which Persian, Greek, Hindu, Chinese, and Hebrew imageries are interspersed.

neoclassicism

In painting, sculpture, and architecture, the Napoleonic years were characterized by the clarity and sobriety of neoclassicism. The artists most in favor were the painter Jacques Louis David (1748–1825) and the sculptor Antonio Canova (1757–1822), both preoccupied with ancient Roman themes. In architecture, most of Europe had experienced a new zest for antiquity with the renewed excavations of Herculaneum and Pompeii begun in 1738 and 1748. On the upswing throughout Europe, neoclassicism since mid-century had dominated over other styles in England. In France, it reached its high point during and after the First Consulship of Napoleon (1799), and in the United States, the most well-known buildings influenced by neoclassicism are those of Thomas Jefferson, who helped design the University of Virginia at Charlottesville.

Beethoven and Universalism

In the 1790s, when Ludwig van Beethoven was in his twenties, he was already recognized as an irresistible musical force. Two centuries later, his music is still heard constantly. Beethoven's creations and his personality have been the objects of unceasing interest from ever-changing points of view. After his death in 1827 (10,000 people are said to have attended his funeral), his image grew to heroic proportions. Composers throughout the Romantic era and much of the 20th century, including Wagner and Bartók, have felt compelled to come to terms with his legacy.

first period
Bonn

The rather small city of Bonn, where Beethoven was born in 1770, was the seat of an Electoral court. Beethoven's father was a tenor singer at court, and young Ludwig was able to hear professional performances and study the piano, organ, violin, and viola with competent musicians. His father's ambition was to turn Ludwig—a piano prodigy and composer by the age of eight—into another Mozart, to be exhibited around Europe. But his father was an alcoholic, and Ludwig had to take over support of the family at eighteen. Beethoven's formal education was sadly incomplete. He had friends among the nobility, especially the von Breuning family, Count Waldstein, and the Elector himself. These aristocrats saw in Ludwig a talent worthy of support. They sent him off to Vienna in 1792; in a going-away book presented to him, Count Waldstein wrote: "Through constant industry you shall receive *Mozart's spirit from Haydn's hands.*"

Haydn, then at the height of his fame and between his famous visits to London, did indeed take on Beethoven as a pupil for about a year. The lessons were only moderately successful; the pupil was a bit too much of what Haydn called a "grand mogul." But Beethoven rapidly conquered Vienna's aristocracy, especially with his piano playing and improvisations.

Vienna

Vienna was still the imperial city that had been built up rapidly after the final defeat of the invading Turks in the preceding century. By the time of Beethoven's arrival, the city contained over 200 opulent palaces, owned by an assortment of royalty whose names have been preserved largely by their association with Haydn, Mozart, and Beethoven, among them the Archduke Rudolph, Beethoven's most loyal patron. By 1800, the Viennese nobility were generally aware that an exceptional artist had come into their midst, and Beethoven's aristocratic admirers saw to it that his material needs were met. Publishers in several countries were already competing for Beethoven's compositions.

deafness

Then, in 1801, Beethoven wrote confidentially to a friend back home in Bonn: "I have to tell you that my life is a misery. For almost two years I have avoided

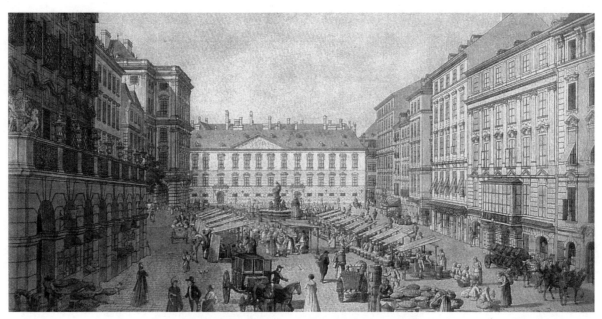

Beethoven's Vienna (early 19th century)

almost all social gatherings, because it is impossible for me to say to people, I am deaf." By the following year he had essentially given up hope that his hearing would ever improve.

Plunging ever deeper into lonely solitude—that was Beethoven's situation in 1802, the end of his "first period." By then, he had assimilated the Viennese style of Mozartian grace and Haydnesque wit. He had also begun to stretch that style in highly individual directions with such works as the *Sonate pathétique* for piano and the first two symphonies, through extremes of tempo and dynamics and expansions of formal design.

middle period

Beethoven then wrote to his friend in Bonn: "I will take Fate by the throat; it shall not wholly overcome me." He then entered upon his "middle" period, producing the works that today form the core of the Beethoven repertory. From 1803 to about 1812, he developed the symphony into a category that would thereafter become the standard for the genre. He finished his last symphony in 1824; it is No. 9. Haydn had written over 100 symphonies, Mozart nearly 50. As much as these works are loved, they are altogether different from Beethoven's symphonies. With Beethoven it was a matter of lengthy experiment, of sketches continuously altered or rejected, while all aspects of the external world—meals, pupils, servants, living quarters—were neglected.

Eroica **Symphony**

Sometimes a person in the arts can temporarily attract attention merely by being outrageous. There is much in Beethoven's music, particularly the symphonies, that a contemporary might call "outrageous." No. 3, the *Eroica* (1803), is a case in point. (The "hero" to whom Beethoven originally dedicated the symphony was Napoleon; but, when Beethoven learned that Napoleon had declared himself Emperor, he scratched the name "Bonaparte" off the title page and renamed the work *Sinfonia eroica*.) The first movement is "outrageously" long, longer than any other such movement previously composed. Early on, we are confronted with an "outrageous" stretch of off-beat accents on a dissonant harmony, again pounded into the listener's ears in the Development, more than an "outrageous" hundred bars longer than the Exposition. When the Recapitulation finally begins, one of the horns announces the return four bars "too early." And when the Recapitulation comes to an end, would it be satisfactory to call it quits at that point? Hardly. Beethoven appends a Coda almost as long as the Exposition, including further development, obviously to counterbalance the panoramic Development itself.

The "Heiligenstadt Testament" (1802)

In the so-called "Heiligenstadt Testament," a document addressed to his brothers and intended for reading after his death, Beethoven wrote, in part:

"Oh, how harshly have I been repulsed by the doubly sad experience of my bad hearing, and yet it was impossible for me to say to men speak louder, shout, for I am deaf. Ah, how could I possibly admit an infirmity in the one sense which should have been more perfect in me than in others, a sense which I once possessed in highest perfection. . . .

"Oh, I cannot do it; therefore forgive me when you see me draw back when I would gladly mingle with you. . . . I must live like an exile; if I approach near to people a hot terror seizes upon me . . . what a humiliation when one stood beside me and heard a flute in the distance and I heard nothing, or someone heard the shepherd singing and again I heard nothing. Such incidents brought me to the verge of despair, but little more and I would have put an end to my life—only art it was that withheld me. . . ."

expansions of Classic design

Beethoven's "outrageous" expansions of Classic design, however, were controlled formally. Within the realm of fully functional tonality—that system of 24 major and minor keys—Beethoven was able to visualize, as few others could, the relative weights of tonalities projected over long musical distances, much in the same way an architect balances the size and shape of one section of a building against another. This metaphor applies to Beethoven's other symphonies as well: in No. 4, the displacement of accents in the Scherzo to the point of disorientation, with the displacement nevertheless made a part of an over-all formal balance; in No. 5, the astounding thematic unity of all four movements and the *Finale* that defines the word "triumphant" for all time; in No. 6, the feeling of solace and uplift that accompanies the "programmatic" depiction of country life but that also follows deeper principles of abstract formal organization; in No. 7, the logical manipulation of tonality in the marching theme of the slow movement.

"Rasumovsky" Quartets

Fidelio

All this from a composer who became completely deaf by 1818. How do you compose if you can't hear? All musicians can conjure up melodies and harmonies silently, but few can construct massive scores of great complexity purely from imagination. As he struggled with those inner voices, Beethoven attempted to represent all the musical genres common to his era. The three string quartets of Opus 59, composed in 1806 and nicknamed "Rasumovsky" after their dedicatee, are, like the symphonies, drastic expansions of their genre. His opera, *Fidelio*, composed in 1805–6, is based on the rescue-from-tyranny theme of French revolutionary opera. Characteristically, the composer had to revise it repeatedly before it attained success in 1814. Beethoven's sets of variations, in several media, are a special case. Few composers escaped the rigid four-bar phraseology of the themes they chose. Beethoven is a notable exception, particularly in the last movement of the Ninth Symphony.

piano concertos
violin concerto

Closely allied to the symphonies are five piano concertos, all paradigms of inspiration belonging to the "early" (through 1802) and "middle" (through 1814) periods, and a Violin Concerto, Opus 61 (1806), that occupies the highest niche in the repertory. The 32 piano sonatas span a wide territory, from Classic formality and public brilliance in the first two periods to introspection in the third (post 1814) period, and provide the foundation of solo piano literature. Some of their nicknames are familiar: *Pathétique, Moonlight,* and *Appassionata.*

third period
Ninth Symphony
Missa Solemnis
late quartets

From about 1812 to 1815 Beethoven's production was hampered by ill health, financial difficulties, and family problems. But once again he "took Fate by the throat." The *Missa Solemnis* of 1823 cost Beethoven perhaps the greatest effort of his career. And if one can say that there is one most important group

The Imperial Court Theater by the Kärntnertor in Vienna. The première of Beethoven's Ninth Symphony took place here on Friday, May 7, 1824.

of Beethoven's compositions, that honor goes to the late string quartets, which occupied him exclusively in the last 2½ years of his life. These remarkable works, sometimes referred to as "abstract" owing to their denial of precedent and their new formal designs, seem to be essentially the result of artistic intuition.

The Ninth Symphony

Schiller's Ode
An die Freude

Into Beethoven's silent world in 1824 came his last symphony, No. 9. This symphony redefined what is meant by the term for the Romantic era, especially for composers like Berlioz and Wagner. A symphony is supposed to be entirely instrumental, whereas the last movement of No. 9, enhancing an older practice in symphonic works by composers during the French Revolution, incorporates vocal soloists and a chorus. They sing Beethoven's adaptation of Friedrich Schiller's "Ode to Joy" (*An die Freude,* dating from 1785), to a melody-with-variations that has in our time come to epitomize the hopes of humanity, particularly at the end of historic events—the end of World War II for instance, the destruction of the Berlin Wall, or, most recently, the Recessional for Pope Benedict XVI's celebration of the Mass at Yankee Stadium. This movement begins with a raucous, shocking chord, followed by a chaotic outburst. The orchestra timidly suggests, through instrumental recitatives, the themes of the preceding three movements. But these themes are each rejected. Then there appears an orchestral proposal of the "joy" melody:

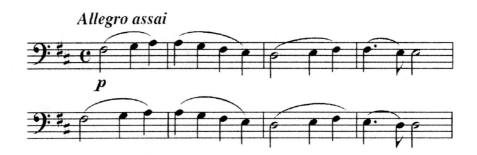

Drawing by Barbara L. Gibson

Noisy rejection again. At this point a bass singer suddenly stands up and sings words written by Beethoven himself. "O friends, not these sounds, but let us sing instead more pleasant and joyful ones." What follows is the "joy" theme with chorus and orchestra, singing Schiller's paean to joy, along with a set of variations on it that characteristically escape the limitations of predictable musical phraseology. These variations include complex fugues as well as a new theme and eventually a coda to end all codas, celebrating the "heaven-descended flame of joy." Earlier in the movement, at the end of the poem's third stanza, where "even the cherubs stand before God" *(vor Gott)*, the chorus and orchestra had been brought to fever pitch, the singers enunciating the words "vor Gott" with maximum effort. What does a composer do after a formal climax like this and there remain several stanzas to set before the movement ends? — Silence — then, *pianissimo*, from afar, at first barely audible, the "joy" theme approaches . . . but now as a Turkish march!

And here we return to Beethoven the architect, for only through an almost superhuman command of form could such a seemingly outlandish insertion succeed as part of the over-all plan. When the Ninth Symphony has ended after further climactic variations and the stupendous coda, the listener is left with a feeling of having experienced the sublime.

Goethe, the self-proclaimed Classicist, in his proto-Romantic "Storm and Stress" novella *The Sorrows of Young Werther* (1774), sparked the creative fires of young Romantic writers. In like manner Beethoven, born of a later generation, a child of the Enlightenment, provided through his music a seemingly infinite source of inspiration for Romantic composers. As reflected in Beethoven's life and music, artists must often confront two apparently opposing elements in their creative being: the desire for unity and order (Classicism), and a yearning after the infinite, the pursuit of the unattainable, the transcendence beyond traditional boundaries (Romanticism). As emphasis shifted from aristocratic patronage to open market, from court to salon, from desired universalism to creative individualism, Beethoven emerged as a guiding spirit at the dawn of a new age in music.

KEY WORDS

Classicism, Encyclopedists, rococo, galant, Age of Enlightenment, Janizary, *mehter, zil, kös, davul, nakkare, zurna, boru, çevgăn*

SUGGESTED READING

Haydn

Geiringer, Karl. *Haydn, A Creative Life in Music*. Berkeley: University of California Press, 1993.

Wyn Jones, David (ed.). *Haydn*. Oxford, New York: Oxford University Press, 2002.

Mozart

Einstein, Alfred. *Mozart: His Life, His Works*. New York: Norton, 1945.

Solomon, Maynard. *Mozart: A Life*. New York: HarperCollins Publishers, 1995.

Beethoven

Beethoven, Ludwig van. *Letters, Journals and Conversations*. Ed. and trans. Michael Hamburger. London: Thames and Hudson, 1951, rpt. 1996.

Cook, Nicholas. *Beethoven: Symphony No. 9*. Cambridge: Cambridge University Press, 1993.

Solomon, Maynard. *Beethoven*. 2nd rev. ed. New York: Schirmer Books; London: Prentice Hall International, 1998.

Turkish Influences

Signell, Karl. "Boomings, Jinglings, and Clangings: Turkish Influences in Western Music," *Music Educator's Journal* 54/9 (May 1968): 39–40.

The New Grove Dictionary of Music entries "Turkish music" and "Janizary"

General

Abraham, Gerald (ed.). *The New Oxford History of Music, vol. 8: The Age of Beethoven, 1790–1830*. London: Oxford University Press, 1982.

SUGGESTED LISTENING

Mozart	*Piano Sonata in A Major,* K. 300i; *The Abduction from the Seraglio,* K. 384; *Violin Concerto No. 5 in A Major,* K. 219.
Turkish	*The Janissaries* [Janizaries], 4. Janissaries' Air. Auvidis/ETHNIC B673
Beethoven	*The Ruins of Athens,* Opus 113 (incidental music to a play by August von Kotzebue); *Symphony No. 9 in D Minor,* Opus 125.
Haydn	*Symphony No. 100 in G Major* ("Military").

HELPFUL VIEWING

The Abduction from the Seraglio: Opera in Two Acts by Wolfgang Amadeus Mozart. Videodisc (DVD). New English libretto (with abridgments) by Kelly Rourke. Prod. Carla Hübner, dir. Joe Banno; musical dir. Carlos César Rodriguez. Cast: Jennifer Jellings, Tausha Torrez, David Brundage, Peter Burroughts, Ole Hass, and Daniel Ladmirault; recorded February 4, 2004 [a DVD + R]. (This is an abridged, two-act version of a three-act opera.) Imprint: The In Series Presents, © 2006 by WEA International Inc, a Warner Music Group company. [93 minutes]

Bach-Mozart. Videocassette 1 (spine number "36") of a four-cassette box entitled Great Composers, from the complete seven-program BBC TV series. Series Exec. Prod. Kriss Rusmanis, prod./dir. Francesca Kemp. Imprint: BBC, NVC Arts, Atlantic-Warner Music Vision 20511-3, © 1997. [Mozart episode, 59 minutes] The Mozart episode has also been released as a Kultur DVD, spine number D4118, © 2006 by WEA International Inc, a Warner Music Group company. [59 minutes]

Beethoven-Wagner. Videocassette 3 (spine number "72") of a four-cassette box entitled Great Composers, from the complete seven-program series BBC TV series. Series exec. Prod. Kriss Rusmanis. Imprint: BBC, NVC Arts, Atlantic-Warner Music Vision 20511-3, © 1977. [Wagner episode, 59 minutes]. The Beethoven episode has also been released as a Kultur DVD, spine number D4120, © 2006 by WEA International Inc, a Warner Music Group company. [59 minutes]

Haydn

Joseph Haydn: A Concise Biography and Musical Overview (the Famous Composers series, 1831). Written, prod., dir. Malcolm Hossick. Dist. KULTUR International Films. Imprint: SCAN Productions, 1995. [35 minutes]

Mozart

Bach-Mozart. Videocassette 1 (spine number "36") of a four-cassette box, *Great Composers,* from the complete seven-program BBC TV series. Series Exec. Prod. Kriš Rusmanis, prod./dir. Francesca Kemp. Imprint: BBC, NVC Arts, Atlantic-Warner Music Vision 20511-3, ©1997. [Mozart episode, 58 minutes]

Mozart (A&E Biography, AAE-14015). Exec. prod. Susan E. Leventhal, Michael Cascio; prod./dir. Molly Thompson, A&E dir. Bill Harris. ©1995 A&E Television Networks. [50 minutes]

Two Hundred Years of Mozart, 1791–1991. Host, Don North. Produced by Northstar Productions and Austria Wochenschau. Imprint: Educational Video Network, ©1991. [26 minutes]

Beethoven

Beethoven-Wagner. Videocassette 3 (spine number "72") of a four-cassette box entitled *Great Composers,* from the seven-program BBC TV series (see Bach-Mozart entry above) [Beethoven episode, 58 minutes]

Bernstein on Beethoven: A Celebration in Vienna. Written, narrated, cond., perf. by Leonard Bernstein (1970). Exec. prod. James Krayer, prod. Schuyler G. Chapin, Humphrey Burton; dir. Humphrey Burton. Dist. KULTUR International Films production. Imprint: Films for the Humanities, ©1992. [60 minutes]

DVD: *Bernstein on Beethoven: A Celebration in Vienna.* Prod. by Amberson Productions in association with the Columbia Broadcasting System and ORF. Exec prod.: James Krayer. Prod. by Schuyler G. Chapin, dir. Humphrey Burton, 1970. BERNSTEIN IN VIENNA: *Beethoven Piano Concerto No. 1.* Prod. by ORF in association with ZDF, Germany and Amberson Productions, dir. Arne Arnbom, 1970. A 2006 Kultur DVD, spine number D 2300; ISBN: 0-7697-8063-6. [125 minutes]

Ludwig van Beethoven: A Concise Biography and Musical Overview (the Famous Composers series, 1836). Written, prod., and dir. by Malcolm Hossick. Dist. KULTUR International Films. Imprint: SKAN Productions, ©1996. [35 minutes]

8
REVIEW SHEET

Short Answers

1. Name at least three standard orchestral instruments borrowed from the Turks.

2. Name at least two ways in which Turkish music influenced Western music.

3. Name three stylistic aspects of Classic music.

4. Identify at least two ways in which Classic music contrasts with late Baroque music.

Short Essay

1. Write three paragraphs comparing Mozart to Beethoven.

9

ROMANTICISM

Wagner, the *Gesamtkunstwerk*, and Beijing Opera

Most music familiar to a Western audience is from the 19th century. That century saw the rise and high point of a style called "Romantic," a word originally associated with heroic tales from the Middle Ages, such as the Arthurian Cycle of Romances and the Knights of the Round Table. Romantic artists stood for freedom. Freedom to express violent emotions, freedom of form, freedom to explore remote times and places and depths of the soul. Exalting in the spontaneous and unpremeditated, the Romantic sought the spiritual in nature rather than the material.

The Romantic Period

Congress of Vienna

Up until the 1848 uprisings that shook most of Europe, ferment in arts and ideas existed side by side with a veneer of political calm that followed the Napoleonic Wars. The leaders of the Congress of Vienna (1814–15), Metternich from Austria, Alexander I of Russia, Talleyrand from France, and Castlereagh from England, attempted to restore some of the pre-Revolution order, carving up Europe to accommodate the old ruling families. But the burgeoning Industrial Revolution, different class priorities, and extremely intense feelings of nationalism hastened the advent of profound social and political change.

nationalism

Predilection.
Individualism
Nationalism.
Emotionalism
Subjectivity

Nationalism was at the heart of 19th-century Romanticism. Reacting against foreign rule, people found a national identity in their cultural past. In the North German territories, the writer Johann Gottfried von Herder (1744–1803) had maintained that each nation has its own spirit of the people *(Volksgeist)* and pattern of growth. The inward turn was balanced and ultimately reinforced by a parallel growth in the spirit of universalism. Scholarly study of Eastern cultures had not begun until the reports of Jesuit missionaries, dispatched to China by Louis XIV, were published in the 18th century. During the Enlightenment, inquiry into Eastern philosophy and literature had gained strength, and in the 1760s, Herder himself paraphrased stories from Persian literature. He believed that poetry should be the universal expression of all people, not merely the intellectual élite. Asian poetry, the embodiment of this ideal, later became a significant source for Romanticism. The Western nationalist, by gaining a universalist's perspective, all the more cherished the timelessness and inner freshness of his or her own folk heritage. Somehow the folk arts seemed the only soul of nationhood.

Romanticism in Literature and Art

Romantic literature
England
Byron, Keats, Shelley

In both England and the German territories, many of the guidelines for Romantic literature were set before 1800, largely owing to the influence of the Frenchman Jean-Jacques Rousseau. In poetry and literature, Romantic rivulets of the later 1700s swelled to streams through the Napoleonic years, then thundered like waterfalls in England with Shelley, Keats, and Byron. The first generation of English Romantic poets, William Wordsworth, Samuel Coleridge, and others of the "Lake" School, reacted against the materialism of Locke, who had presented the famous analogy of the universe as a giant watchworks. In 1798, Wordsworth and Coleridge published the *Lyrical Ballads,* for which Coleridge wrote his "Rime of the Ancient Mariner." The Romantic love affair with the Gothic and the Middle Ages is exemplified in Sir Walter Scott's famous novel *Ivanhoe,* written in 1819, extolling medieval knighthood and heroic acts from deep in the English past.

Wordsworth
Coleridge

Germany
Jean Paul
E. T. A. Hoffmann
Wackenroder
Goethe

In the German territories, successive generations of authors from Wilhelm Heinrich Wackenroder and Ludwig Tieck to Jean Paul (Richter) and E. T. A. (Ernst Theodor Amadeus) Hoffmann carried the Romantic torch through the Napoleonic era. Wackenroder, who died in 1798 at the age of twenty-four, reflected the entire gamut of Romantic feeling in his *Confessions from the Heart of an Art-Loving*

Friar, published in 1796. One of the essays in the *Confessions,* with autobiographical overtones, is "The Strange Musical Life of the Musical Artist Joseph Berglinger." In it, Wackenroder portrays the conflict of artist with society and stresses the significance of emotion in the creative process, the importance of intuition over understanding, and the divine nature of creativity. In another essay, "Of Two Miraculous Languages [Art and Nature] and of Their Secret Power," Wackenroder asserts that one's understanding of God is awakened through artistic creations; that an understanding of God requires sentiment as well as intellect. In "The Ancient Painter Piero di Cosimo," he develops the theme of an artist so alienated from society that madness results, an idea reflected earlier in Goethe's *The Sorrows of Young Werther* (1774): "I have learned in my own way that all extraordinary men who have done great and impossible things have ever been decried by the world as drunk or insane."

painting in France, England, and Germany
Géricault
Delacroix

In painting, sweeping lines in the works of the French artists Théodore Géricault (1791–1824) and Eugène Delacroix (1798–1863) form a contrast to the balanced compositions of Classicists Jacques Louis David (1748–1825) and Jean Auguste Dominique Ingres (1780–1867). Color became an integral element of dramatic force, whether by its opulence in the paintings of Eastern subjects by Delacroix or by its tension-building understatement in Géricault's *Raft of the Medusa* (1819). English painters found fresh inspiration in nature. In his land-

Constable

scapes, John Constable (1776–1837) orchestrates the play of the sun's rays with tree shadows in a manner that anticipates Impressionism, while the seascapes of

Turner

William Turner (1775–1851) burst forth with color and movement that often leave literal treatment of the subject far behind. In Germany, a return to religion is

Friedrich
Runge

apparent through mystic symbolism in paintings by Caspar David Friedrich (1774–1840) and Philipp Otto Runge (1777–1810). Friedrich's landscapes often have a beautifully surrealistic quality.

Music in the Romantic Era

Many Romantics held music in high esteem; Walter Pater, a noted English critic, proposed that "all art aspires to the condition of music." Composers responded with a new appreciation of the other arts, upon which they drew freely for inspiration. Medieval legends, the writings of Shakespeare and Byron, and, in particular, Goethe's *Faust* all supplied literary inspiration. The composer that Romantics most admired was Beethoven, in whose music E.T.A. Hoffmann and others found Romantic traits, and Beethoven's influence became increasingly felt throughout the 19th century.

Romantic sonorities
chromatic melody
chromatic harmony

A mild interest in new sonorities in the Classic period became an obsession with the Romantics. Inventors created valves on horns and trumpets that allowed for a chromatic scale, a one-piece cast iron frame (rather than the earlier wooden frame) that permitted greater string tension on the piano, and new fingering mechanisms on woodwinds that afforded a wider range of pitches, dynamics, and timbres. Composers wrote for ever larger orchestras and a wider range of instruments. Moods became widely contrasting in the same composition, harmonies complex, forms less predictable. Chromatic scales that stress half-step motion found increasing favor as a basis for melodic and harmonic ideas. Sharps and flats, not part of the original key of a piece, were added to the melodic lines and melodic lines in the texture that use mainly semitones when they are combined result in chromatic harmony, and ambiguity of key center is characteristic of chromatic harmony. Composers in the 19th century stressed this ambivalence. They lengthened their works by extending their harmonies to distant keys before the eventual return home to the original tonic. Visually, a page of chromatic music looks dense and busy with its many accidentals—the flats, sharps, and naturals not in the key signature.

Ferdinand-Victor-Eugène Delacroix (1798–1863)
The Bark of Dante: Dante and Vergil in Hell (1822)

One of the supreme colorists of the 19th century, Delacroix often drew on the writings of Dante, Shakespeare, Goethe and Byron for inspiration. Delacroix's divisionist use of color (pigments adjacent on the canvas rather than mixed on the palette) and visible brushstrokes on a rugous surface anticipate many later trends in art, including Impressionism. In *The Bark of Dante,* Delacroix emphasized contrast: a spotlight on the foreground action and the distant fires in Hell in a generally dark and hazy context, the detachment of Vergil from the recoil of Dante and the contortions of the damned, and the unique red of Dante's hood and the bright oranges of the distant fires opposing the lights and darks of more neutral hues in the remainder of the painting.

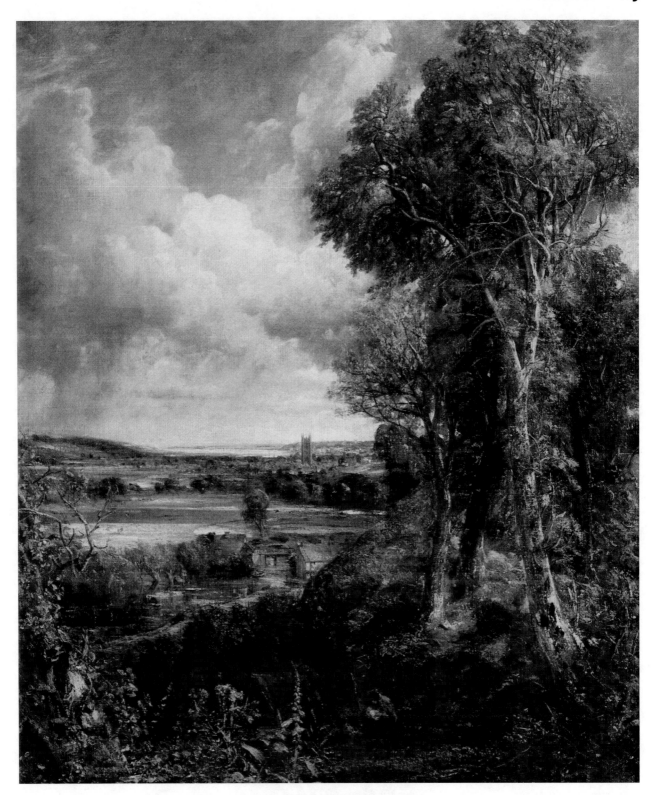

John Constable (1776–1837)
Landscape (Dedham Vale; 1828)

One of the greatest of British 19th-century landscape artists, Constable sought to capture natural effects in his paintings, including the shifting of light and shadow produced by cloud movement and changes in weather, the points of white and yellow created by sunlight reflected on leaves, and a spontaneous realism in his depiction of the outdoors. Constable's famous painting *The Hay Wain* (1821) was extremely popular among French artists, including Delacroix, and was exhibited in the Paris Salon of 1824, eliciting high praise among French critics.

Philipp Otto Runge (1777–1810)
The Hours of the Day: Morning (1808)

One of the leading (early) artists of the German Romantic School, Runge had a spiritual approach to art and nature. He perceived divinity as an omnipresent force, always renewed, and in the landscape, he sought to reveal a religious meaning in nature. In his versions of *Morning,* Runge attempted to present a new approach to Christian art, and in this particular group of paintings, he combined Christian and pagan features: at the top, three cherubs surround the Morning Star; below them, angels surround a white lily symbolizing virginal purity; the figure of Aurora advances towards us in front of the sun (her head is at the center of the composition); surrounded by cherubs and at the bottom center is a newly born baby, suggestive of the Christ Child in a Nativity scene. On a previous and prolonged visit to Denmark, Runge had studied Scandinavian epics and mythology and had subsequently incorporated many of their features in his painting. The mystical and symbolic aspects of his approach foreshadowed Wagner's aesthetic, especially the music dramas of the *Ring* cycle and *Parsifal.*

Caspar David Friedrich (1774–1840)
Monastery Graveyard in the Snow (1817–1819)

Friedrich, the leading representative of the German Romantic School, sought to reveal the spiritual significance of landscapes. Certain motifs recur in Friedrich's paintings: specific times of day (or night), seasonal changes, twisted limbs of oak trees in winter, Gothic ruins, crucifixes, and megalithic structures (dolmens and cromlechs). People are often portrayed as lonely figures, made insignificant by the forces of nature, and Friedrich's treatment of light frequently gives his paintings a brooding, melancholy, or dreamlike quality. In this wintry scene, a procession of monks accompanies a coffin past an open grave, through the portal of a Gothic ruin, and on to a distant altar with a crucifix and the possible promise of salvation. The mood is made stark by Friedrich's dramatic treatment of light and dark.

Program Music

program-music genres

Defined narrowly, "program music" is instrumental concert-hall music with an extra-musical association specified by the composer (see the discussions of program music in Chapter 1 and Chapter 6). While program music had existed in many forms previously, notably in the 18th century when many sonatas and symphonies had pastoral, hunt or battle associations, it did not become a dominant stylistic trend until the Romantic era. In Romantic music, the most prominent types of orchestral program music are: the programmatic concert overture; the symphonic poem, usually a single-movement work that emphasizes thematic transformation (see Chapter 6); "incidental" music accompanying and abstracted from a play; the program symphony, a multi-movement symphony with a story or other extra-musical association, such as Berlioz's *Symphonie fantastique* (1830; see Chapter 4); and the symphonic suite, such as Tchaikovsky's concert suite from his ballet *The Nutcracker* (1892; see Chapter 6).

Nationalism and Opera

German Principalities, Italy, France

Feelings of nationalism, growing rapidly since the Napoleonic years, came to a head by mid-century. In 1848, the same year the *Communist Manifesto* by Marx and Engels appeared, a series of uprisings spread throughout Europe, mainly in nations reacting against the conservative reapportionment of Europe by the rearguard faction at the Congress of Vienna. Street fighting broke out in Berlin and Munich, and political problems were not totally resolved until Bismarck's victories in the Franco-Prussian War, which ended in 1871 with the founding of a national and unified German state. In Italy, Mazzini, Cavour, and Garibaldi were among the leading figures in the *Risorgimento* ("Reawakening"), but it was not until 1870 that Italy became totally unified as a sovereign state. The 1848 unrest also affected Austria, where Metternich was driven out, and France, where Louis Philippe abdicated and the Second Republic was proclaimed with Louis Napoleon (Napoleon III) its President.

nationalistic opera

Composers, caught in the maelstrom of political change, found themselves increasingly occupied with communicating their nationalism through their art. The larger the audience, the more powerful the impact of their message, and the opera house became a place where the composer could express nationalistic sentiments to a large public. During the second half of the 19th century, three of the greatest opera composers were all ardent nationalists. Wagner, Mussorgsky, and Verdi each expressed his own philosophy through his art and found his own solution to the fundamental challenge posed by opera: how to combine drama, traditionally a continuous art, with music, traditionally a repetitive art.

German Romantic Opera

Singspiel roots

At the turn of the century, the principal form of German opera was *Singspiel*, consisting of Eastern-based and imaginative fairy tales, spoken dialogue, comic episodes, and simple tunes with immediate popular appeal. In the North, German writers, deeply involved with the new Romantic movement, yearned for a national identity. Retaining the popular aspects of the *Singspiel* and influenced by the new Romanticism from the North, a younger generation of opera composers mainly from the North added a profound tone of nationalism, an emphasis on nature, and references to specific real-life events. From this marriage, German Romantic Opera was born.

In German Romantic Opera, orchestra and chorus are crucial, the orchestra giving credibility to legendary and folkloristic elements, the chorus often representing a folk element for realism. A special feature, the dramatic scene grouping called *scena*, consisted of one or more arias freely combined with orchestrally accompanied recitative and spoken dialogue, all reinforcing dramatic continuity.

Wagner

Wagner's Early Operas

Die Feen

Das Liebesverbot Rienzi

After his first operatic endeavor *Die Feen* (*The Fairies*, early 1833), which followed the tradition of German Romantic Opera in the manner of the composer Carl Maria von Weber (1786–1826), Wagner (1813–83) again favored Weber in his two-act comic opera *Das Liebesverbot* (*The Ban on Love*, based on Shakespeare's *Measure for Measure*, 1835–36). Then in *Rienzi* (1838–40, based on a novel by E. Bulwer-Lytton), written during his first trip to Paris, Wagner changed to the style of Parisian Grand Opera, characterized by spectacle, semi-historical subject matter, intense emotionalism, and large crowd scenes. He then returned to German opera style and began evolving an individual approach, eventually achieving a stage philosophy of his own.

Der fliegende Holländer

Wagner's more mature operas began with *Der fliegende Holländer* (*The Flying Dutchman*, after Heine), written in German Romantic style produced at Dresden in 1843, the same year Wagner became director of the Dresden opera.

Tannhäuser
Lohengrin

Tannhäuser (1843–44) and *Lohengrin* (1846–48) are transitional. *Tannhäuser*, based on the medieval legend of a German knight and the theme of redemption, uses expressive recitative at several important points in the story for dramatic effect. *Lohengrin*, freely based on a medieval German romance, emphasizes symbolism and a *scena*-inspired continuity of action that is a forward-looking extension of German Romantic Opera.

decade of turmoil

For Wagner, the decade 1850 to 1860, a period of personal turmoil, was crucial. Wagner's revolutionary activities at Dresden resulted in a warrant for his arrest in 1849 and his exile until 1862. He took refuge in Switzerland, but domestic difficulties continued with his wife Minna. During this time, he received aid from Liszt, who directed the première of *Lohengrin* at Weimar in 1850. It was also at this time that Wagner aired his aesthetic views in *Artwork of the Future* (1849) and *Opera and Drama* (1850–51), developed his concepts of the total work of art—the *Gesamtkunstwerk*—and the music drama, and completed three, and began the fourth, of his seven music dramas.

Artwork of the Future
Opera and Drama

The Music Drama

Wagner felt that in the music drama, subject matter should be timeless and of relevance to all generations. For his librettos, which he always fashioned himself, he thus favored myth and legend. He also maintained that the words themselves should evoke emotions and chose a verse style with poetic forms and devices such as alliteration (*Stabreim*) to this end.

continuity and melodic declamation

In the music drama, Wagner stressed continuity of music as well as narrative and abandoned the traditional distinction between aria and recitative. This continuity, a logical outgrowth of the dramatic *scena* found in German Romantic Opera, was brought to a new and unique level by Wagner. He wrote vocal lines that heighten the inflections and rhythm of German verse in what has been called "melodic declamation"; other sections are more purely melodic, for situations highly charged emotionally.

Leitmotiv

– tells us what characters are thinking – psychological

The orchestra sustains the forward line. Wagner created rich combinations of sounds for new sonorities and expanded the size of the orchestra. He also developed a *Leitmotiv* system in which motives representing specific persons, ideas, or objects are transformed to fit changing situations in the narrative. Wagner's application of many motives for continuous dramatic narrative was original, even though representation by a specific motive was not new. With these motives, Wagner could recall the past, foretell the future, and bring to mind various happenings not directly on stage, thereby attaining added psychological dimension to the drama.

Freud

The *Ring* Cycle

Tristan und Isolde
Die Meistersinger
von Nürnberg
Parsifal
Völsunga Saga
Nibelungenlied

Wagner's music dramas consist of a cycle of four operas comprising *Der Ring des Nibelungen* (1853–74), as well as three separate works: *Tristan und Isolde* (1857–59), based on the Tristan and Yseult legend; *Die Meistersinger von Nürnberg* (1862–67); and *Parsifal* (1877–82), based partially on the medieval romance of Parzival. The *Ring* cycle freely interprets the *Völsunga Saga* (Story of the Volsungs), which is an Icelandic saga based on the *Nibelungenlied* (Song of the Nibelungs), a late-12th-century Germanic epic (regarding 5th-century Burgundians) replete with remote, mythological, and often arcane elements. Wagner's *Ring* cycle consists of four operas: *Das Rheingold*; (1853–54), *Die Walküre* (1854–55), *Siegfried* (1856–69), and *Götterdämmerung* (Twilight of the Gods, 1869–74). Actually, Wagner's poems were originally conceived during the late 1840s in reverse order, beginning with Siegfried's Death, then working back to Young Siegfried, then to earlier parts of the story.

the *Ring* cycle:
Das Rheingold
Die Walküre
Siegfried
Götterdämmerung

Like 'Star Wars'

Ring
synopsis

Following is a synopsis of Wagner's interpretation of the *Völsunga Saga:*

The gold of the Rhine, guarded by the Rhinemaidens, is stolen by Alberich, leader of the demonic Nibelheim dwarfs, after he learns that it confers boundless power on its possessor, who must however, renounce love forever. He fashions some of it into a ring. The gods Wotan and Loge steal the gold from Alberich, who pronounces a curse on it, and they give it to the giants Fafner and Fasolt in payment for building Valhalla, the Hall of Heroes in the castle Asgard. The hero Siegfried later takes the gold ring from the giant Fafner and gives it to his bride Brünnhilde, the former Valkyrie. At Brünnhilde's self-immolation on Siegfried's funeral pyre, and as Valhalla is engulfed, the ring is freed from its curse and returned to the Rhinemaidens.

Wagner and Chromatic Harmony

Tristan und Isolde

Tristan and chromatic
harmony

Wagner wrote *Tristan und Isolde* while deeply involved emotionally with Mathilde Wesendonck, the wife of a patron, its message apparently reflecting the theory of Arthur Schopenhauer's (1788–1860) that only death can terminate the power of the Will, here made manifest through an ill-fated love affair. Wagner felt that in *Tristan* he had finally mastered the art of transition. The action is slow moving, the stage darkly lit, and a heavy, foreboding atmosphere prevails. The intensely chromatic harmony begins with the first two measures of the Prelude:

The enigmatic quality and the harmonic ambiguity of these opening chords have been the subject of much theoretical discussion, dating back even to Wagner's day. Especially in the third (last) Act, Wagner postponed harmonic resolutions over long periods, and before the resolution does finally take place at the conclusion, tonal instability has prevailed. The final scene, the "Liebestod," is one of the most famous examples of chromatic harmony in the Western repertory. The opening chords of the Prelude, resolved differently and inconclusively earlier, finally return at the end for a convincing cadence. (See the asterisked chords.) The message: even death cannot prevent the consummation of love.

♪ **Act I, *Prelude***
At the opening, Wagner presents a now famous series of unresolved chords that remain unresolved in the Prelude and most of the opera.

Act III, *Conclusion*
With the "Liebestod," occurring at the end of the opera and providing a remarkable succession of unresolved harmonies, Wagner at the very end answers the enigmatic chords from the opening of the Prelude with a complete harmonic resolution for the final cadence.

47 and **48** Wagner, *Tristan und Isolde*

The *Gesamtkunstwerk*

In his *Opera and Drama,* Wagner wrote that

> The error in opera hitherto consisted in this, that a means of expression (the music) has been made an end, while the end itself (the drama) has been made the means.

A year earlier, in his *Artwork of the Future,* Wagner wrote that

> The *true* aim of art is . . . *all-embracing* . . . not the glorification of *this particular capacity,* but the glorification *in art of mankind in general.*

> The highest collective art work is the *drama.* . . .

> True drama can be conceived only as resulting from the *collective impulse of all the arts* to communicate in the most immediate way with a *collective public* . . . the aim of each individual art variety is fully attained only in the mutually understanding and understandable co-operation of all the art varieties.

composer as librettist

Schopenhauer

According to Wagner, the composer should write the libretto—Wagner had always written his own—and make all necessary directions regarding staging, performance, and everything else. (See the discussion under "Synergism" in Chapter 1.)

As time passed, Wagner appears to have changed his views somewhat, increasingly recognizing the primacy of music in opera. He became immersed in the philosophy of Arthur Schopenhauer who, in *The World as Will and Representation* (*Die Welt als Wille und Vorstellung,* 1818), had maintained that the Will is a universal force, that one's effort to achieve its ultimate satisfaction is a goal which cannot be attained and results in the tragedy of humankind's existence. Reason and philosophy merely increase the misery felt, but art, spontaneously conceived by the artist, exists independent of reason, and the creative artist transcends both reason and science. Art affords the means by which one may escape the suffering inherent in a world of the Will, allowing for a sense of the universal, and music is the only art that does not merely objectify ideas but directly reflects and embodies the Will itself: through it, the composer penetrates the deepest secrets of humankind's feeling and reveals the innermost essence of the universal. Schopenhauer supported the theory of absolute music and, regarding opera, felt that external ideas created by music are given visible form, that music must reign supreme, that a text should not interfere with its inner essence and meaning. Wagner endeavored to reconcile Schopenhauer's views with his own approach to drama. In the relationship of music and text, Wagner felt that music embodies feeling but cannot externally specify the object of the feeling. To Wagner, text and acting define the external message of the drama while music ideally sustains the internal meaning.

Later Occurrences of the *Gesamtkunstwerk* Ideal

Skryabin

Wagner strove to find a unity through simultaneous use of myth, dance, poetry, drama, and music. This concept of the *Gesamtkunstwerk* was expanded by the post-Romantic composer Alexander Skryabin (1872–1915), who viewed art as religion and religion as a concept of art. Skryabin proposed uniting all the arts and simultaneously exciting all the senses to a point where fusion occurs among not only the arts but also the senses. Impressions of the senses then meld with spiritual experience. Like the Russian mystic Symbolist poets, Skryabin believed that the artist, through the total art work, has the power to bring about the transmutation of the material to the spiritual.

the *Mysterium*

To Skryabin, the ultimate extension of the *Gesamtkunstwerk* was the "*Mysterium*," a "supreme final ecstasy." The *Mysterium*, occurring in an Indian temple constructed of columns of incense, would synthesize sound, color, odor, and movement. There would be no stage, no barrier between performer and spectator. Both artist and non-artist would attain the highest reality: pure spiritual being.

Prometheus

Skryabin never completed the *Mysterium*; he died at the early age of forty-three, having committed little of it to paper. He did, nevertheless, compose several pieces preliminary to the *Mysterium*. In his last orchestral work, *Prometheus* (1910), the concert hall is to be filled with colored lights corresponding to the musical sounds.

avant-garde art forms
rock-music videos
20th-century media

In the later 20th century, there was a rebirth of the *Gesamtkunstwerk* idea with the appearance of avant-garde art forms that combine multiple media with music to make a philosophic statement. Operatic creations such as *Einstein on the Beach* (1976) by Philip Glass (b. 1937) intermingle stage design, action, and non-narrative theater with musical elements such as minimalism and collage. These creations, often referred to as a type of "New Romanticism," went on to influence rock-music videos which today include music, words, costumes, lighting, stage sets, and often miniature dramas. Other art forms, such as films, dance, and television, frequently embrace numerous arts. Each, in its own way, is a *Gesamtkunstwerk*, a collective experience of the culture from which it arises.

Beijing Opera

Other societies also combine various arts. What is usually referred to in the West as "Beijing Opera" or "Beijing theater style," *JINGJÜ* (pronounced "JING-jue" as in French "rue"), currently the preferred transliteration (see the Glossary), is a relatively loud, exciting synthesis of numerous disciplines. *Jingjü* provides an art-form in which none of the components overshadows the others, as contrasted to, for example, the singer's art that dominates 18th-century Italian opera. (The crowds thronging the occasional appearance of a Chinese Pavarotti equivalent are the exception that proves the rule.) *Jingjü fuses, in an uncanny balance, acrobatics,* costuming, dance, elocution, pantomime, story-telling, and music. It emerged in the later eighteenth century, during the Qing dynasty (1644–1911/12), as four famous theater troupes from southern Anhui Province gathered at Beijing in 1790 for the birthday celebration of the Qianlong Emperor (1711–1799, r. 1736–95). In 1828, the Anhui performers gradually became joined with troupes from eastern Hubei Province, and the genre had fully blossomed by 1845. It sprouted from the confluence of several regional theater traditions and engendered an increased emphasis on instrumental accompaniment. The repertory consists of nearly 1,400 works, initially based mainly on historical stories and various types of political, military or civil struggles, the latter two having the deepest roots. Martial stories emphasize combat skills and acrobatics, and the civil types give more attention to personal and romantic relationships. From 1950 to 1985, there was a shift in the repertory toward contemporary life and events, but in more recent years, there has been an attempt to return to the older stories.

acrobatics, costuming, dance, elocution, mime, story-telling, music

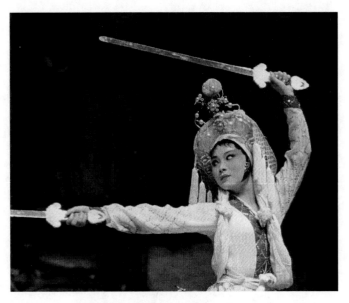

"White Snake" female warrior
Beijing Opera

costumes
colors

In *Jingjü*, the stage is typically a square platform viewed from all four, or three, of its sides and is divided by an embroidered curtain. The musicians are placed at the front of the stage. To compensate for the general absence of props, costumes and their colors are used to signal the rank of the characters portrayed: Emperors and their family members wear yellow robes, officials of lesser rank wear purple, all of the preceding typically with embroidered dragons. Others wear red to represent high virtue and blue for a somewhat lower rank. White signifies youth or old age, while brown or olive-green are worn specifically by the elderly, and black is used by the other actors.

facial coloring

Generically, *Sheng* ("shung") refers to a male lead role, *Dan* ("dahn") to a female role (female roles first appeared, unofficially, in the 1870s), *Jing* to a painted-face male role, one of special character, and *Chou* ("jow" as in "show") to a clown, often but not always a secondary role. In the Jing category of roles, face paint provides additional clues to the character involved; for example, scarlet for integrity, yellow for fierceness and rashness, white for treachery, black for strength and honesty, gold and silver for mystical and supernatural power (gods and demons).

The White Snake
female warrior type

The highly stylized, refined acting and pantomime of *Jingjü* are effectively expressed in the delicate hand gestures and head movements of the Green Snake, a female retainer in the drama The White Snake. Her flowing silk costume and white-and-red facial makeup reinforce the stereotyped "female warrior" voice quality of her arias. She also engages in stage battles with the enemies of her mistress; these battles involve elaborate tumbling, feinting, and acrobatic timing. The story line itself is typically one of conflicting loyalties, magic, and demons, with elements of Buddhism and pre-Buddhist lore mixed together.

In *Jingjü*, the music is used as accompaniment and falls into three categories: vocal arias; *qüpai* (fixed-tune, "chue-pie") instrumental melody types used to set up various contexts in the story; and percussion patterns that, similar to the *qüpai*, establish contexts, such as stage entrances, for which, alone, there are 48 types. *Jingjü* employs a small group of performers, consisting of a battery of drums, gongs, and cymbals with the addition of an oboe-like aerophone for generally louder scenes, while for other scenes, somewhat more melodic instruments, *viz.*,

jinghu,
 two-string fiddle

ruan, four-string lute

The *Gesamtkunstwerk*
 ideal:
A comparison

chordophones, including the *jinghu* ("jing-who"), and the *ruan* ("rwahn") are used. The *jinghu* is.a kind of high-pitched, two-string bamboo fiddle tuned according to regional tradition: A and D in northwestern Qinqiang ("shin-jiahng") opera for joyous stories in *Xipi* ("she-pea") style/modal system; and C and G in the south-central Hubei Province, for softer and lyrical stories in *Erhuang* ("are-hwang") style. The *ruan* is a round-bodied lute, coming in five sizes (and tunings), with four strings and twenty-four frets. Both *Xipi* and *Erhuang* styles use a two-beat per measure rhythm and have in common six tempos.

Like a modern rock concert or Western opera, in *Jingjü*, the music without the costumes, action, and spectacle gives us only a most limited impression of the total performance experience, the *Gesamtkunstwerk*. If we are unable to attend a performance, a video would be next best. If we wish to have an introduction and do not have a video, the music can suffice as a place to start.

With experience, the listener can savor the music beloved of traditional *jingjü* connoisseurs. One then learns to distinguish vocal styles for each stereotyped role; for example, the bearded baritone *lao-sheng*, perhaps a general; the young beardless falsetto *xiao-sheng*, ("h'see-ou-shung," "ou" as in "out") often a scholar-lover; the *qing-i* ("ching-ee") virtuous daughter; the *chou* clown.

In a sense, it may be argued that *Jingjü* comes even closer to realizing the Wagnerian ideal of true synergy than Wagner himself achieved in his music dramas, especially when considering the latter's earlier postulation that music should not dominate drama, that all diverse component parts had best interact on a mutually enhancing and, by implication, more approximately equal, basis for optimum result. Despite this goal, and irrespective of the indisputably effective staging, extensive use of traditional lore, and affective, alliterative poetry in his music dramas, Wagner ultimately tended to give music more intrinsic focus than that apportioned the other disciplines, an aspect he himself subsequently recognized and referred to as conveying the *internal* meaning of the narrative (see the *Gesamtkunstwerk* and Schopenhauer discussion above). Accepting as a given that Wagner's music dramas have justifiably become recognized as occupying a niche for themselves among the most respected canons in the Western-European repertory, the manifold aspects of theater employed in *Jingjü*, especially with regard to acrobatics, place it at a seemingly unique level of equipoise among the arts.

Other spectacular examples of the *Gesamtkunstwerk* principle include the Japanese *Kabuki* drama and the Javanese shadow-puppet play, *Wayang* (see "Synergism" in Chapter 1). Before the printing press, poetry and music were often combined in the same process. In a somewhat analogous fashion, the word "*ta*" among the Dan people of West Africa includes in a single concept what the separate English words "song," "dance," and "music" mean. Each culture and sub-culture has its own approach to combining the various arts, and, in many cultures, music is not the easily separable, discrete art form it has become in the traditional Western concert-hall repertory.

KEY WORDS

Program music, nationalism, German Romantic Opera, *Singspiel,* scena, music drama, *leitmotiv,* the *Ring* cycle, chromatic harmony, *Gesamtkunstwerk, Mysterium, Jingjü, jingh, ruan*

SUGGESTED READING

Wagner

Deathridge, John, and Carl Dalhaus. *The New Grove Wagner*. New York and London: Norton, 1984.

Stein, Jack M. *Wagner & the Synthesis of the Arts*. Westport, Connecticut: Greenwood Press, 1973 (© 1960).

Strunk, Oliver (ed.). *Source Readings in Music History,* rev. ed. Leo Treitler, ed. New York: Norton, 1998.

Walker, Alan. "Schopenhauer and Music," *The Piano Quarterly,* Number 144 (Winter 1988–89): 38–46.

Beijing Opera

Guy, Nancy. *Peking Opera and Politics in Taiwan.* Urbana: University of Illinois Press, © 2005.

Provine, Robert C., Yosihiko Tokumaru, and J. Lawrence Witzleben, eds. *East Asia, Japan, and Korea,* from *The Garland Encyclopedia of World Music* series. New York: Routledge, 2001.

Wichmann, Elizabeth. *Listening to Theatre: The Aural Dimension of Beijing Opera.* Honolulu: University of Hawaii Press, 1991.

SUGGESTED LISTENING

Wagner *Der Ring des Nibelungen; Tristan und Isolde.*

Beijing Opera *"The Swimming Dragon" China: Peking Opera. Playasound.*

HELPFUL VIEWING

Bawang bie ji (Farewell My Concubine) [video-recording], prod. by Hsu Feng, dir. by Zhen Kaige, screenplay by Lilian Lee and Lu Wei. Issued by Miramax Films in association with Maverick Picture Company and Tomson. Burbank CA: Miramax Home Entertainment, Distributed by Buena Vista Home Entertainment, [1999]. [172 minutes] [DVD]

Beethoven-Wagner. Videocassette 3 (spine number "72") of a four-cassette box entitled *Great Composers,* from the complete seven-program BBC-TV series. Series exec. prod. Kriss Rusmanis. Imprint: BBC, NVC Arts, Atlantic-Warner Music Vision 20511-3, © 1997. [Wagner episode, 59 minutes] The Wagner episode has also been released as a Kultur DVD, spine number D4122, © 2006 by WEA International Inc, a Warner Music Group company. [59 minutes]

A Chinese Cracker: The Making of the Peony Pavilion in Shanghai, New York, and Paris. Videodisc. An RM Associates production in association with SBS TV. Prod. and dir. by Chen Shi-Zheng, China and United States sequences dir. by Bill Shebar, narrated by Robert Powell. Imprint: Princeton, N.J.: Films for the Humanities & Sciences, © 2003. [53 minutes]

Wagner: Man and Musician. Videocassette (container title: *Richard Wagner: The Man and His Music).* Imprint: Films for the Humanities [1980s]. [45 minutes]

A "Ring" for Television. Prod. & dir. by Peter Weinberg, written by John Ardoin. A production of UNITEL in assoc. with WNET/Thirteen, George Grizzard. Camera, Fritz Beckhoff, Franz Knoll; exec. ed. Philippe Deriaz; host, Friedland Wagner. Imprint: UNITEL; Films for the Humanities [distributor], © 1983. [30 minutes]

An effective parody of the Wagnerian leitmotif, including several references to the *Ring* and *Tannhäuser,* is the famous Bugs Bunny cartoon featuring "Kill the Wabbit," contained in the collection, *Bugs Bunny's Overtures to Disaster* (available through Warner Brothers Home Video). "*A Chinese Cracker. . .* [53 minutes]"

9
REVIEW SHEET

Short Answers

1. List five stylistic traits of Romantic music (19th century).

Short Essays

1. Make a short comparison of Romantic and Classic music. Identify at least three traits for each.

2. Explain the term *Gesamtkunstwerk*.

3. Compare a Wagnerian music drama with a performance of *Jingjü*. Specify at least two ways they are alike and two ways they differ.

10
SYMBOLISTS AND IMPRESSIONISM
Debussy and the Gamĕlan

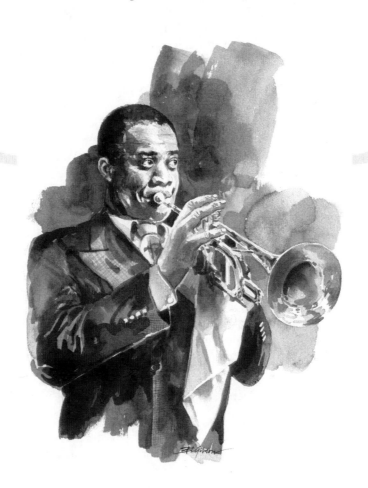

Debussy and the Symbolist Poets

"symbolistes"
"décadents"

Poe
Asian arts

Whistler

synaesthesia

Debussy's musical
philosophy

One of the most important composers of the later 19th century and early 20th century was a Frenchman, Achille-Claude Debussy (1862–1918). Even though Debussy is often referred to in terms of musical "Impressionism," his musical philosophy was closely associated with a group of French poets and dramatists initially labeled in derogatory fashion as *"symbolistes"* and *"décadents."* The Symbolist poets first came into prominence during the 1880s with Stéphane Mallarmé as their spiritual leader. The most famous Symbolists, all inspired by Charles Baudelaire, included Arthur Rimbaud and Paul Verlaine, as well as the Belgian dramatist Maurice Maeterlinck, who drew upon Asian mysticism, the imagery of Edgar Allan Poe, and the Wagnerian emphasis on affective poetic techniques. Their renewed fascination with Asian arts and culture had analogs with trends in art, notably with the French painters Edouard Manet (1832–1883) and Claude Monet (1840–1926) and especially the American James Abbott McNeill Whistler (1834–1903). Remarkably prophetic in his artistic approach, Whistler anticipated later trends regarding abstraction and a painting's inner harmony and gave many of his more abstract paintings alternative musical titles. The fascination that French writers had with the works of Poe was truly remarkable, and Poe's imagery, particularly of water, and the moods that his images evoked profoundly inspired the Symbolists. Wagner's use of assonance and alliteration for the purpose of arousing emotion in his listeners was another fundamental point of reference.

Symbolist poetry is suggestive and evocative rather than expository and descriptive. Words are used for the feelings and images they arouse rather than for their specific meanings. To the Symbolist, poetry, like music, is able to convey the essence of an idea through its abstract language, and the feelings aroused from this abstract language provide deeper artistic and spiritual insight than can any literal description. Again, like music, the sounds of the words are to be used for artistic effect; and, like the visual arts, the placing and spacing of words on a page become significant. Reaching deep down, images and thoughts sometimes pass below the level of the conscious into the subconscious, and, in this realm, the senses interpenetrate. One "hears" a color, "sees" a sound. This mixing of the senses, one aspect of *synaesthesia,* had many earlier precedents but did not flower fully until the reappearance of Asian influences during the second half of the 19th century. The Symbolists tended to view the unconscious as benign, Maeterlinck likening it to a vast and serene sea, the eternal source of all that is beautiful.

Debussy's kinship to the Symbolists went beyond his own poetic style and his settings of Symbolist poems, beyond even his artistic success with the opera *Pelléas et Mélisande* to the text of Maeterlinck's play, for Debussy's very own aesthetic was fundamentally related to that of the Symbolists. The language that he himself uses to describe music is often evocative in a Symbolist manner:

> Music, and music alone, has the power of evoking at will imaginary scenes—that real yet elusive world that gives birth in secret to the mystic poetry of the night and the thousand nameless sounds of leaves caressed by moonlight.

And after speaking against music that overtly describes nature (Beethoven's Sixth Symphony), Debussy then defends Beethoven:

> How much more profound an interpretation of the beauty of a landscape do we find in other passages by the great Master, because, rather than exact imitation, there is an emotional interpretation of that which is invisible in nature.

Here we have clues to Debussy's use of descriptive titles for his music as well as his approach to program music; rather than literal description, Debussy evokes moods based on subtle association and abstract suggestion.

James Abbott McNeill Whistler (1834–1903). Nocturne: Blue and Silver–Cremorne Lights (1872)

By stressing the inner harmony of a painting, the coordination of color, mass, shape and line in an aesthetically balanced design, and by downplaying the external details in a literal depiction of his subject matter, Whistler, an American painter domiciled in England, anticipated many later trends in art, including Abstract Expressionism. Whistler's emphasis on design reflects the strong influence of Japanese prints, and his restricted application of color (frequently one or two soft shades of Prussian blue or green, sometimes adorned with flecks of gold) often creates quiet and nostalgic moods. Whistler's use of a musical reference in his dual titles ("Nocturne," "Symphony," "Caprice," "Harmony," "Variations") has an analogue in Debussy's synaesthetic use of visual imagery in the titles of his musical compositions, such as *Estampes* ("Prints," or "Engravings") and *Feux d'artifice* ("Fireworks").

Debussy's Musical Style and Impressionism

Debussy's sources

In his desire to break away from the ponderous German tradition ("teutonic moonshine") of the recent musical past, Debussy looked elsewhere. For sources, he turned to the youthful musical language of the Russian nationalists Modest Mussorgsky (1839–81) and Aleksandr Borodin (1833–87) rather than to that of Wagner. From the distant past, he brought back archaic church modes; from the present, he created new effects with chromatic and whole-tone scales; from Indonesia and China, he was inspired by novel sonorities, fresh textural concepts and the pentatonic scale.

intuitive form

Debussy's rejection of tradition was extended to all the musical elements, including form. In both the second movement of his symphonic work *The Sea* (1905), a group of "Three Symphonic Sketches," and throughout his ballet *Jeux* (1913), an imaginary fantasy concerning a game of tennis, form seems to evolve intuitively, as one musical idea grows into the next, without any apparent preconceived plan. This intuitive approach, together with untraditional chord progressions often involving unresolved seventh and ninth chords, resulted in new problems at the initial, creative stages of composition, and Debussy was able to complete only a relatively small number of works.

soft dynamics

A most important aspect of Debussy's style was his preoccupation with sound itself. Just as the Symbolists were sensitive to the sounds of words, so was Debussy to the sounds of musical tones, especially with timbres in combination, one sound mass proceeding to the next. He preferred a moderate to very soft dynamic range (like Lennie Tristano and the Modern Jazz Quartet fifty years later) in which subtle shifts of texture and timbre could be hinted at, sometimes barely perceived. His interest also extended into the mysterious realm of non-sound; in a letter written in 1893, Debussy refers to the dramatic potential of silence as "perhaps the only means of throwing into relief the emotional value of the phrase." Thus, at the moment when Pelléas and Mélisande declare their love for each other in Act IV, Debussy chooses to reinforce the intense dramatic situation with silence in the orchestra:

Pagodes

In his piano compositions, Debussy was concerned with balancing different pitch and dynamic ranges and then blending them with special pedal effects much in the style of Chopin, whom he deeply admired.

Many subtle and characteristic combinations of sonorities are found in Debussy's *Estampes* (prints), a group of three piano pieces appearing in 1903. The title reflects some of the Symbolist philosophy of interrelating

 49 *"Pagodes, 'gong' "* At the very opening, Debussy imitates the sound of the large **gong,** commencing the colotomic cycle of a *gamĕlan* performance.

the aural and visual arts. In the first of these, *Pagodes* (Pagodas), Debussy makes much use of special pedal effects, resulting in a colorful combination of sonorities, and the open fifths, B and F-sharp, in the bass and then baritone regions at the opening, evoke the sounds of gongs:

 50 *"Pagodes, shêng' "* In a **pentatonic context,** Debussy uses a series of parallel fourths to imitate Chinese *shêng* music.

Throughout, Debussy employs a pentatonic scale *(F#-G#-B-C#-D#)* for its Eastern associations, and in one place there is a succession of parallel fourths and fifths reminiscent of Chinese *shêng* music:

 51 *"Pagodes, 'quiet delicacy' "* At the very end, Debussy uses different piano registers for the layered effect in a heterophonic texture reminiscent of a *gamĕlan* performance.

Towards the conclusion, Debussy uses the piano's wide range with long-held notes deep in the sonorous bass, melodic motion in the baritone-tenor region, and rippling passages in the treble part. All is to be played as quietly as possible, creating an effect of infinite delicacy:

Debussy's orchestration and "Impressionistic" style

Debussy was also deft in his handling of orchestral timbres. Favoring the melancholy sounds of woodwinds, pianissimo rolls and feathery strokes on percussion, muted brass and strings, and light sprays of harp glissandos, Debussy's art is one of subtle blends and shimmering tone combinations that disappear into the atmosphere. At the beginning of the third movement of *The Sea,* pianissimo timpani and drum rolls combine with distant rumbles in cellos and string basses, answered by a quiet and disappearing stroke on the tam-tam, with magical effect:

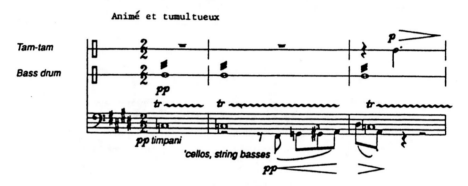

The subtle dynamics and mixed timbres (musically referred to as "tone colors") found in Debussy's orchestral renderings and the combination of graded sonorities with imaginative pedaling in his piano works almost naturally resulted in Debussy's musical style being associated with and equated with the soft edges and wide-ranging hues of Impressionist paintings. Debussy's sensitive handling of timbre and novel approach to harmonies, scales, and dynamics, often labeled as musical Impressionism, spawned an international trend among other composers, especially in the early part of the 20th century.

Indonesian Music

Debussy and Asian music

Debussy's fascination with Asian music dated at least from 1889, when he heard the Javanese *gamĕlan* at the Paris World's Fair and the instruments of the travelling theater from Cochin China. He was also present at the performance of the Balinese *gamĕlan* in the Paris Exhibition of 1900. Debussy's early love for subtle percussion effects may well have resulted from his contacts with the Javanese and Chinese ensembles. While it is not known whether he heard Chinese mouth-organ *(shêng)* music, Debussy doubtless studied music of a related nature and was influenced by it, particularly with regard to parallelism (successive chords in parallel motion), a revolutionary idea at that time in traditional Western harmony. It is quite possible that other harmonic techniques characteristic of Debussy's style, such as added-note chords (see *shō,* Chapter 5, Texture and Harmony), likewise had an Eastern derivation and were suggested by the cluster chords found in Asian music.

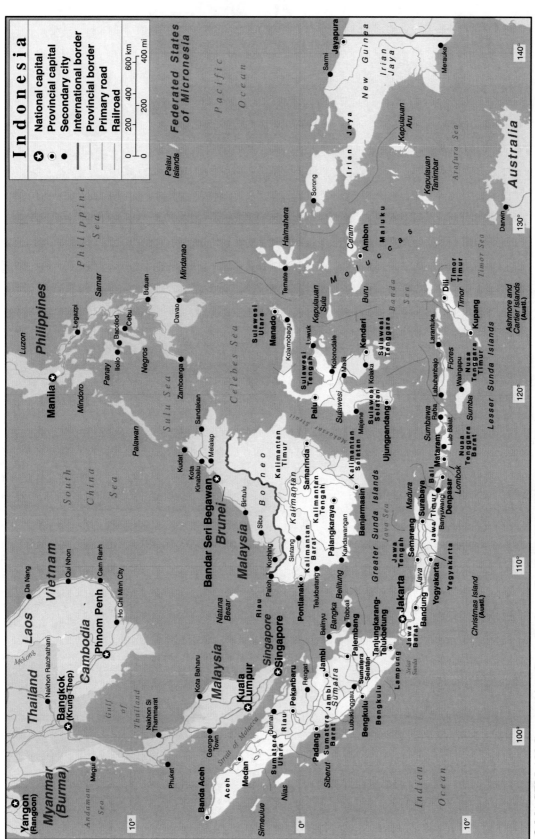

Map of Indonesia

© MAGELLAN Geographix℠Santa Barbara, CA (800) 929-4627 www.maps.com

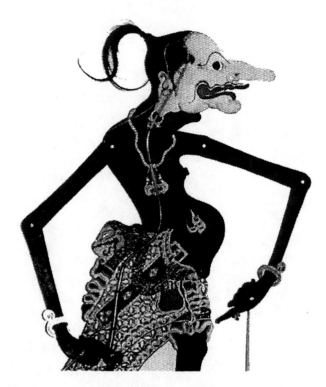

Petruk, a clown in the Javanese *Wayang* shadow drama

Java

Hindu and Islamic influences

The Indonesian island of Java is about three thousand miles to the southeast of India. A lush subtropical rainforest, Java has long supported a centralized civilization on its fertile volcanic soil. Traders and settlers from India, attracted to Java, eventually established a Hindu dynasty in central Java in the 7th century C.E.; the famous Buddhist monument at Borobudur in central Java was raised at the end of the 8th century. Indian temporal power and cultural influences continued for 800 years until, in the 16th century, the fabled last Hindu kingdom was toppled by the advent of Islam. In the next century, the Dutch colonized Indonesia and ruled it for over 300 years (1610–1942). While three centuries of European presence left hardly a perceptible mark on the arts of Indonesia, the more compatible Asian influences of Buddhist, Hindu, and Islamic civilizations blended with the mystical autochthonous Southeast Asian culture of the Javanese. The music of central Java contains elements derived from Indian, Arab, and Javanese sources.

court orchestra

One of the enduring cultural legacies of the last Hindu empire in Java is the music of the court orchestra, or *gamĕlan* (GAH-meh-lahn). A *gamĕlan* can be any sort of musical ensemble, but here the term refers to the classical orchestral tradition and repertoire centering on the royal courts of central Java, mainly Surakarta and Yogyakarta. A *gamĕlan* performance is an auspicious occasion. The anthropologist readily notes its use in marking significant social events: a rice harvest, a wedding, a birth, a circumcision party, or a funeral. On a personal level, we remember *gamĕlan* performances arranged to celebrate the arrival of an important person, the commemoration of Indonesian independence day, and the fond farewell party for a beloved friend.

gamĕlan instruments

Instruments of the orchestra are approached respectfully, and a good set of instruments is given a proper name, for example, "Sir Lake and Fountain." Most of the *gamĕlan* instruments are made of bronze: small and great gongs (*kĕmpul, gong agĕng;* "come-pool," "Ah-guhng"—"gong" is a word of Javanese origin); thick bronze slabs, or chimes, on wooden box resonators (*saron;* "Sah-rawn"); metallophones with thin bronze keys over tube resonators (*gĕnder;* "guhn-dair"); and sets of inverted "kettles" with knobs (*bonang, kĕnong, kĕtuk;* "bow-nahng, kuh-NAWNG, kuh-TOOK").

The bronze instruments, of Southeast Asian origin, form the main part of the *gamĕlan* but contrasting timbres, some of external origin, play crucial roles, in particular a slender and elegant *rābab* ("reh-bob"; spike fiddle of Muslim origin), zithers, a *siter* ("sit-air," related to the Indian *sitar*), a *gambang* ("gahm-bahng"; soft-sounding xylophone), a *gerongan* ("geh-rong-ahn"; male chorus), and a *pesinden* ("peh-SIN-den"; female vocal soloist).

A complete *gamĕlan* employs thirty to forty performers and uses seventy-five to eighty instruments (not all in continual use). Played in the so-called "strong style," the sonority is clangorous, martial, virile. In the "soft style," the *gamĕlan* exudes mystery, evokes sensuous timbres, suspends time.

the great gong

The awesome, deep rumble of the great gong begins and ends most *gamĕlan* compositions. The gong also marks the most important structural points in a piece. In Javanese society, age is respected; in the *gamĕlan* the eldest and most experienced musician plays the gong. The name of the orchestra is inscribed inside the gong, and before a formal performance, offerings of flowers, incense and fruit are made to the gong.

musical cycles

Like Indian classical music, Javanese *gamĕlan* music organizes time into cycles. The Indian *tāla* cycle has its counterpart in the Javanese *gongan* cycle. One *gongan* is the musical time that elapses between strokes of the great gong. The gongs and kettles in the *gamĕlan* of Java act as punctuating instruments, since their function is to make clear the beginnings, endings, and structurally important points in a musical "sentence," or gong cycle. The logic and inevitability of the punctuating cycle, once learned, give the listener a solid foothold and entry to *gamĕlan* music; its role can be compared to that of harmony in European symphonic music.

The instruments of the punctuating cycle are the great gong, the small gongs, the large kettles, and the small kettles. In the cyclical pattern of the punctuating instruments, there is a strong pole and a weak pole. The great gong, of course, is the strong pole; the weak pole is the omission of a small gong (see below). The similarity of this weak pole in the Javanese cycle is the *khāli*, or omitted left-hand drum in Hindustani music, which is probably related historically. (See Chapters 3 and 7.)

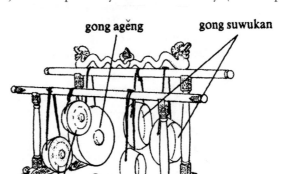

gong agĕng **gong suwukan**

kĕmpul

Set of gongs, from Javanese *gamĕlan*

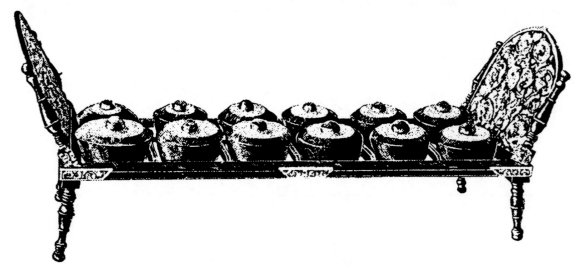

Bonang, from Javanese *gamělan*

ketawang form

Some *gamělan* forms have complex and irregular patterns, others are so long as to require years of practice to follow easily. But the form of a recorded example is short, easy to follow, and shows the general principles by which *gamělan* music is structured. The composition is in the form called *ketawang* and the title of the piece is *Puspowarno* (poos-puh-WAHR-no; "kinds of flowers"). This type of piece could be performed for the entrance of a Javanese prince into the reception hall.

The number of melody beats in one cycle of this piece is eight. The gong (G) sounds on eight; the small kettle (k) on one, three, five, and seven; the large kettle (K) on four; the small gong (g) on six; and the empty beat (–) on two:

k	–	k	K	k	g	k	G
1	2	3	4	5	6	7	8

(*Ketawang* structure)

A good practical way to learn this structure is to divide a group of people into four sections, each section for each punctuating instrument. First you rehearse, each section making appropriate sounds on cue: "tuk" for small kettle, "nong" for large kettle; "pul" for small gong, and "go-o-o-ong" for the great gong. When ready, you do it together with a recording.

**tuning systems
slendro and *pelog***

Javanese *gamělan* music has two completely different tuning systems. One system, *slendro,* is pentatonic (consisting of five tones). The *slendro* intervals are nearly equal, as are the intervals in the whole-tone scale of Debussy, except that the latter has six notes and therefore each interval is smaller. Since the notes of the Javanese scale fall mostly "in the cracks" between the notes of the piano, the pitches in the examples are only approximate. The intervals between pitches range from about a major second to about a minor third, as follows:

The other Javanese tuning system is called *pelog.* The intervals of *pelog* differ more widely. Whereas the *slendro* intervals are roughly equidistant, those of the seven-pitched *pelog* are often presented in a pentatonic pattern with uneven intervals (from a minor second to a major third), such as the following:

Every *gamělan* has its own tuning pattern; within acceptable tolerances of *slendro* and *pelog,* no two *gamělan*s are tuned the same. This is not the result of caprice or inaccuracy, but rather the desire for realizing personal taste, a goal that often tends to be suppressed in the rush towards uniformity in the modern world.

So-called vocal pitches, inflected by singers, fiddle *(rǎbab)* players, and flute *(suling)* players are microtonal variants of the basic pitches described previously and enhance the tonal spectrum by delightful contrasts with the fixed pitches of the bronze instruments. Slides and glides are especially effective when executed by singers and *rǎbab* players.

heterophonic texture

The texture of Javanese *gamělan* music is heterophonic. The melody is realized on three levels of relative movement: basic, punctuating, and elaborating. Instruments are characteristically limited to a specific category. The basic, or nuclear, melody *(balungan)* is played by the slab metallophones *(sarons)* and one large metallophone with resonators *(slěntěm).* The basic melody of *Puspowarno* as played by this group of instruments (shown together with cues for punctuating instruments for reference) is:

balungan

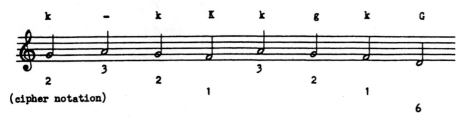

(cipher notation)

The basic melody moves along at a comfortable pace: the punctuating instruments are slower. The elaborating instruments play faster than the basic melody, in multiples of two, that is, twice as fast, four times as fast, eight times as fast, and so on. In simplified score, the relationship between the basic melody (middle staff), the punctuating instruments (bottom staff), and one elaborating instrument (top staff) would look like this:

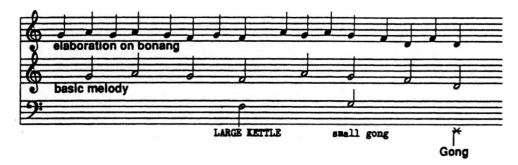

Each of the elaborating instruments has its own way of interpreting the melody. Special rhythmic and melodic freedom are the privilege and the pleasure of the female vocalist and the fiddle *(rǎbab)* player.

***buka* solo introduction**

Almost all *gamělan* compositions begin with a solo introduction, *buka,* on one of the elaborating instruments. The drum joins in near the end of the introduction: when the great gong sounds, the entire orchestra begins playing the melody, each instrument in its own way. Every composition ends with the great gong.

punctuation

Javanese musicians recognize forms on the basis of punctuating structure, and there are many forms besides the *ketawang* discussed earlier. The *gending* is the longest, and some from this group have a gong cycle up to as many as 120 beats.

Wayang
Dalang
paṭet

The *gamĕlan* performs for ceremonial occasions at the palace of the sultan, as well as for other auspicious occasions, mentioned earlier. But the truly outstanding social function, as when one's only daughter is getting married, calls for a shadow puppet play, *Wayang* (Wye-ahng), performed with *gamĕlan* accompaniment. The puppeteer, *Dalang* (DAH-lahng), is the spiritual and cultural descendant of ancient shamans. He brings to life a huge array of puppet characters numbering in the hundreds: demons and clowns, soldiers and kings, gods and servants. The puppeteer sings songs in ancient Javanese, manipulates the puppets, creates a voice for each character, tells jokes, and directs the orchestra. Performances usually last from sundown to cockcrow. Each stage of the *Wayang* has its appropriate mode, *paṭet* (PAH-tet), suitable for the ethos of the play at that hour. The correlation of melodic mode to time and affect is identical in principle to that of Hindustani music.

Hindustani vs Javanese styles

In comparing Hindustani and Javanese classical musics, we find that Javanese court *gamĕlan* music shares with Hindustani music certain fundamental concepts of melodic mode and rhythmic cycle. Both musics display a strong strain of mysticism and the relating of modes to the times of day. Yet the texture and the timbre of the Javanese music, with its sonorous bronze and delicate vocal shadings, could never be mistaken for Indian. And the Hindustani master's improvising dazzling drum accompaniments and constantly shifting melodic inventions are unique to the artists and culture of the Subcontinent.

KEY WORDS

Symbolism, Impressionism, *gamĕlan*, gong, *slendro, pelog, buka*

SUGGESTED READING

Debussy

Debussy, Claude. *Monsieur Croche, Anti-Dilettante,* in *Three Classics in the Esthetics of Music.* New York: Dover, 1962.

Lockspeiser, Edward. *Debussy.* 4th ed. New York: McGraw-Hill, 1972, © 1963.

Thompson, Oscar. *Debussy: Man and Artist.* New York: Dover Publications, Inc., 1937.

Java

Brandon, James R. (ed.). *On Thrones of Gold: Three Javanese Shadow Plays.* Cambridge, Massachusetts: Harvard University Press, 1970.

Lindsay, Jennifer. *Javanese Gamĕlan: Traditional Orchestra of Indonesia.* 2nd ed. Oxford: Oxford University Press, 1992. (This brief introduction to the subject includes many photographs and illustrations.)

Sorrell, Neil. *A Guide to the Gamĕlan.* London: Faber and Faber, 1990. (This provides a brief look at various issues concerning the *gamĕlan,* including its cultural setting, the instruments used, the rudiments of its musical style, and aspects of performance practice; the opening chapter compares Indonesian music with *gamĕlan*-inspired music of Debussy and other composers of the Western tradition and includes photographs of the instruments.)

SUGGESTED LISTENING

Debussy *Pagodes (Estampes,* No. 1), *La mer.*

Indonesia "Puspowarno," *Java: Court Gamĕlan,* Nonesuch 79719.

HELPFUL VIEWING

Debussy

Sorcerer of Sounds: The Story of Achille-Claude Debussy (Our Musical Heritage series). Videocassette(U-matic). A Twin City Area Educational Television Corp. prod. Dir. Suzanne O'Connell; writer Bert F. Cunnington; commentator, Arnold Walker. Imprint: Videorecord Corp. of America, [1970s]. [30 minutes]

The Turn of the Century (Music in Time series, part 14). Videocassette. Prod./dir. Derek Bailey; written by Derek Bailey; Polytel Film co-production. Cameras, Nick Hale [et al.]; film ed. Fiona Gillespie; voice of Denys Hawthorne; music consultant, William Mann. Imprint: Films for the Humanities, ©1982. [60 minutes]

Indonesia

Bali, Masterpiece of the Gods (National Geographic video, National Geographic Special), produced by the National Geographic Society and WQED Pittsburgh, written and produced by Miriam Birch, narrated by Richard Kiley. Dir. of photography, Mark Knobil; ed. Barry Nye; music, Jay Chattaway. Imprint: Time-Life Video, [1995], ©1990. [60 minutes]

Southeast Asia IV: Indonesia 1 (The JVC Video Anthology of World Music and Dance, vol. 9). Prod. ICHIKAWA Katsumori (JVC) (in collaboration with the National Museum of Ethnology [Osaka] and Smithsonian/Folkways Records. Dirs. NAKAGAWA Kunihiko (JVC) and ICHIHASHI Yuji (JVC). Imprint: JVC, Victor Co. of Japan production Company, Rounder Records distributor, 1988, 1990. [60 minutes]

Southeast Asia V: Indonesia 2 (The JVC Video Anthology of World Music and Dance, vol.10) (See the preceding entry.) [43 minutes]

10
REVIEW SHEET

Short Answers

1. Identify at least five new aspects of Debussy's musical style.

2. Which instrument is the most important in the Javanese court orchestra? Explain.

3. How does a *gamĕlan* composition usually begin? How does it end?

4. What is the texture of Javanese *gamĕlan* music and how is that texture created?

Short Essay

1. Specify at least two ways the music of Indonesia influenced Debussy. How many similarities can you identify?

11

THE 20th CENTURY
Bartók and Ethnic Folk Music

In 1900, *The Interpretation of Dreams,* Sigmund Freud's classic contribution to psychology was published and helped provide a nexus to the coming century. On December 17, 1903, Wilbur Wright was able to soar aloft over the sands of Kill Devil Hill near Kitty Hawk, North Carolina, for 59 seconds and 852 feet in the Wright Flyer, the first heavier-than-air machine to achieve sustained, piloted flight. Within two years, Albert Einstein presented his special theory of relativity, developed a decade later into the general theory of relativity. These events heralded an era in which the unknowns within mind and outer space were to be probed as never before. Great achievements were in the offing, but so were great irrationalities—two world wars, the atom bomb, the threat of global conflict. As technology improved and as the planet became ever smaller, humanity's accomplishments and failures were to become increasingly apparent to people in all areas and walks of life.

Crosscurrents in the Arts

Fauvists
Asian influences
African sculpture

At the turn of the 20th century, the dawn of a new era was also breaking in the Western arts. Certainly, the creative artist is affected, at least superficially, by external events. But changes occurring in the arts, especially painting and music, also came from deep within their own internal processes. In painting, artists such as the "Fauvists" found new inspiration in the Eastern styles of Persian and Indian miniatures, Japanese prints, and Chinese porcelains, as well as unsuspected vitality and power of the then recently discovered African sculpture. They no longer felt bound to reproduce an object's photographic likeness or to obey the laws of perspective and three-dimensional design that had been standard since the Renaissance. In music, traditional harmony, the basis of Classic form, had for many composers exhausted its potential. A generation of experimentation arose as the search for alternatives became intense. An artistic interchange grew between painter and composer, who were to become closer than ever before. In some instances, the mutual influence of artist and musician approached the basis of creation, as exemplified by the German "Blue Rider" Expressionists with the composer Arnold Schoenberg before World War I, and the Abstract Expressionists and then the Neo-Dadaists with the composer/philosopher John Cage after World War II.

Blue Rider

Cage

The New Music

With the arrival of the new century, Western music had transcended the confines—and security—of the tonal system. Functional harmony, which supported structure in traditional Western music, had evolved over hundreds of years, and its great period, ca. 1670–1900, is often thought of as containing the "Classics" (see Chapter 5, Texture and Harmony). In the early 1900s, harmony, melody, and rhythm became ever more free of traditional contexts, and ambiguities surrounding their functions brought about a crisis that affected the main stream of Western music. New concepts of harmony, rhythm, and melody dominated composers' thinking for at least half a century. There was also a new character of harmony: a vertical mass of sound with percussive function independent of its traditional use as a cog in the wheel of harmonic progression.

Composers stressed new aspects of sonority, as tone quality, dynamics, and instrumentation were vigorously reinvestigated. Whether with the monster orchestras of the early 1900s, the small ensembles favored after World War I, or the new electronic sounds of the post-World War II era, 20th-century composers found added musical interest in sound itself. The emphasis on sound became an important link that connected a wide variety of styles.

Schoenberg

Many 20th-century composers pursued a carefully planned approach to music. The Austrian composer Arnold Schoenberg (1874–1951) devised a widely adopted system of organizing compositions by means of arranging the twelve notes of the

Stravinsky

Kodály

chromatic scale in specific types of series. With the Russian composer Igor Stravinsky (1882–1971) and musical neoclassicism, attention was placed on an updated adapting of traditional classic elements. With the Hungarian composers Zoltán Kodály (1882–1967) and Béla Bartók, the emphasis was on scholarly investigation of folk music and the integration of folk idioms into their personal compositional styles.

Bartók

Eclecticism and Assimilation

An artistic colossus among composers during the first half of the 20th century, Béla Bartók was born in the Hungarian village of Nagyszentmiklós in 1881 and died at New York in 1945. He began as a pianist-composer in the Liszt tradition and later taught piano. Among Bartók's larger works are six string quartets, an opera, a ballet, *Music for Strings, Percussion, and Celesta*, three piano concertos, and a *Sonata for Two Pianos and Percussion*. He also wrote 153 teaching pieces of graded difficulty gathered into six books under the collective title *Mikrokosmos* (1926–37). The pieces

Bartók collecting songs from Slovak peasants in the village of Darázs, 1907

Rural Roma (Romani) musicians (1855)

A Countess playing together with a Roma ensemble (1860)

from *Mikrokosmos* are teaching aids of highest artistic quality. In his early years, he was strongly influenced by the styles of the late Romantics Johannes Brahms (1833–97), Liszt, Wagner, and Richard Strauss (1864–1949), whose *Also Sprach Zarathustra* (1896) he especially admired. Bartók also passed through a phase over which the shadow of Debussy was cast. Of overriding importance to Bartók, however, was the influence of Hungarian folk music.

assimilation of folk styles

Bartók's ambition was to assimilate many of the folk-song characteristics into his own personal composition style. Since he also used traditional "Western" forms such as sonata and fugue, he bridged a gap between pure nationalism and artistic internationalism. After World War I, Bartók's compositions became increasingly individualistic, evolving into a powerfully dissonant style that maintains balance between folk-song elements and classical techniques. Dismayed by the Nazi takeover of his beloved Hungary, Bartók came to America in 1940. His last works, including the *Concerto for Orchestra* (1943) and the Third Piano Concerto (1945) are written in a less dissonant style.

piano as percussion

Some of Bartók's most progressive ideas result from his fascination with new sounds and sonorities performed on traditional instruments. He occasionally treated the piano as a percussion instrument, making use of cluster chords:

He also experimented with new sound effects on string instruments, such as the sharp plucking of a string that makes it rebound on the fingerboard with a snap, indicated by the sign ɸ, or scratching softly on a large cymbal with the edge of a knife blade. He also was sensitive to the use of space as an element of form in several of his large ensemble works. Bartók loved the sounds of nature and often created special chirping and rustling effects, usually referred to as "night music."

modes and scales
Lydian mode and tritone

In reaction to the exclusive use of the major and minor scales, Bartók used many other modes, such as the Lydian and Mixolydian. He was particularly fond of the tritone (three whole steps, such as C to F#), strongly suggested by the Lydian mode, and often built broad tonal relationships in it, as in the *Music for Strings, Percussion, and Celesta*. Besides the pentatonic scale, he also employed the Roma(ni) or "Hungarian-minor" scale with its augmented seconds, as well as the whole-tone and chromatic scales (see Chapter 4). Harmonically, Bartók composed music based on seconds (Fourth String Quartet, 1928) and fourths (*Concerto for Orchestra*, 1943) as well as thirds.

arch form

Bartók's approach to standard Western forms was more individual than most. One design that he favored, arch form, is unusual for a compound structure. Based on the principle of symmetry, arch form in a single movement may be simply an *A B A* or *A B C B A* design, but Bartók also applied it to larger dimensions so that in a five-movement work (the Fourth and Fifth String Quartets or the *Concerto for Orchestra*), the first movement corresponds to the last and the second to the fourth, while the third movement functions as the keystone of the arch, sometimes itself in a symmetrical design *(A B A)*.

Music for Strings, Percussion, and Celesta (1936)

The four movements of *Music for Strings, Percussion, and Celesta* are internally related; the fugue theme of the first movement returns in each of the other three movements, creating an over-all organic unity. Space is an important element in this work, and Bartók specifies a seating arrangement whereby two groups of violins, violas, and cellos enclose two percussion groups (including the piano), double basses, and harp.

	Double Bass I	Double Bass II	
Violoncello I	Timpani	Bass Drum	Violoncello II
Viola I	Side Drums	Cymbals	Viola II
Violin II	Celesta	Xylophone	Violin IV
Violin I	Pianoforte	Harp	Violin III
	Conductor		

Throughout, Bartók uses intervals and space to clarify structure. Tritones appear prominently in all the movements, and the key centers chosen for them reveal an over-all tritone relationship: the first movement centers on A, the second movement on C, the third movement on F# (C and F# form a tritone), and the finale once again on A. The key of A is thus the fulcrum around which the tritone is balanced.

In the first movement, *Andante tranquillo,* the fugue subject grows out of the pitch *A:*

This **fugue's** subject expands continuously from the opening pitch "A" in a cellular manner and reappears in the later movements, uniting the entire work in an organic fashion.

52 1st mvt.: fugue subject

Subsequent entrances progress upwards by 5ths, *A-E-B-F#-C#-G#-(D#),* and fall downwards by 5ths, *A-D-G-C-F-Bb-Eb;* up and down entrances mostly alternate, creating an expanding key scheme. There are no episodes or countersubjects, and the texture fills out continuously.

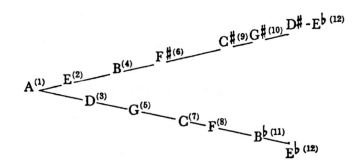

The climax comes with the arrival of *Eb,* two-thirds through the movement. When the bottom line reaches *Eb,* Bartók turns the texture upside down and shifts the *Eb* to the top. Immediately, a process of reversal, like an imploding galaxy, occurs. On single pitches, the *Eb* line precipitously falls by 4ths, *Eb-Bb-F-C.* On C, a temporary delay begins, as the fugue subject reappears, but inverted. Soon, entrances on *G-D-(A)* continue the reversal; concurrently, the original ascending line, now on the bottom, reappears with the inverted subject and rises by 4ths, *F#-B-E-(A).* As both lines approach pitch *A,* a diamond figure takes shape:

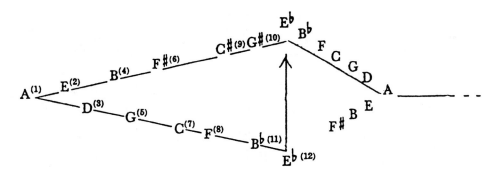

At pitch *A*, another delay takes place as the celesta (with its angelic sound) enters and the fugue subject appears simultaneously with its inversion in the violins. The process of implosion, however, cannot be reversed, and fragmented statements of the fugue subject and its inversion lead to a simultaneous statement of both when the texture closes in on unison *A*, the kernel from which everything began. This remarkable movement seems to fade into empty space, but it is subsequently reincarnated by transformed appearances of its subject in the three following movements.

53 2nd mvt.: piano as percussion

Bartók uses the piano as a percussion instrument in this movement, written as a quasi sonata form.

The second movement, *Allegro*, is the longest of the four, and it is in a free sonata form. There are several important themes in the Exposition, the first of which strongly emphasizes the tritone C–F#. Two of the Exposition's themes emphasize a playful character, reminiscent of jaunty folk dances. In the Development, the piano, used mainly as a percussion instrument, is prominent. Near the middle, a quiet *pizzicato* ("plucked") section in the strings foreshadows the main theme of the fourth movement. Near the end of the Development, the fugue subject from the first movement reappears, somewhat transformed. Thus, this movement, like the others, reflects a high degree of organic unity with the overall form.

For the third movement, *Adagio*, Bartók employs arch form: *A B C B A*. Between each section of the *A B C B A* arch form, a part of the first movement's fugue subject appears, clearly linking the form. This movement stresses novel sonorities. The opening sound, a repeating, high pitch on a xylophone contrasting to low answering rumbles on the timpani making pedal glissandos, was totally new when Bartók conceived it but has now become a classic, much imitated, juxtaposition. The viola theme that follows is written in rhythmically free parlando-rubato style, reflecting folk-song influences (see Chapter 3).

This movement is an arch form, *ABCBA*; in C, the **keystone** of the **arch,** Bartók uses **"night music,"** imitations of sounds heard at night in the outdoors. "Night Music" appears as arch keystones often in other works by Bartók.

The finale, *Allegro molto* ("very fast"), even more than the preceding two movements, reveals how thoroughly Bartók was able to assimilate folk-music characteristics into his personal style. This *Allegro molto* is a lively dance with many syncopations and is cast as a rondo with a design freer than most:

A B A C D E D' F G A.

The main themes are as follows:

54 3rd mvt.: "night music"

 This movement is a free rondo form: *ABA CDED'F G A.*

In Track **55,** you hear the *ABA* section, in which Bartók mixes both the Lydian and Mixolydian modes in a folk-like fashion and provides a sophisticated type of syncopated rhythm.

Track **56** presents the contrasting middle parts *CDED'F.*

Track **57** brings back the fugal cell from the opening movement in an expanded form *(G).*

55 finale: *ABA*

56 *C D E D' F*

57 *G*

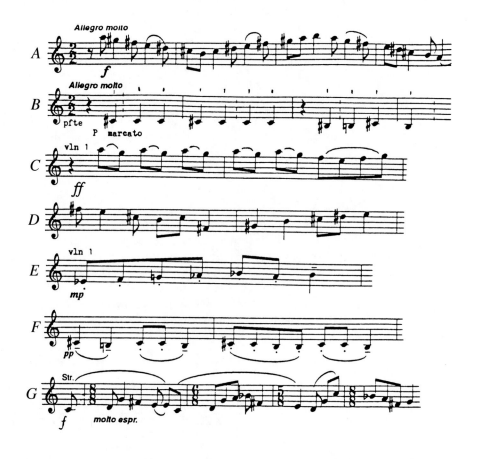

For the opening, Bartók rejects the traditional major scale in favor of more folk-like major-related modes. Though the music begins on the pitch A, Bartók limits the range to the B octave in the first three measures, producing the ascending scale B-C#-D#-E-F#-G#-A-B or *Mixolydian* mode (WWHWWHW) However, in measures 4 and 5, the lower range extends properly to A, producing the scale A-B-C#-D#-E-F#-G#-A or *Lydian* mode (WWWHWWH, see Appendix III, "Church" Modes). The apparent modal ambiguity strongly suggests a folk trait, since village music often retains a freedom that does not always allow for easy codification in traditional texts.

Rhythmically, Bartók combines a folk-like grouping of additive beats with a jauntier, more urbanized sense of syncopation. The rhythm suggests the additive beat pattern

(in 8/8 time), which brings to mind Bulgarian additive meters (see the discussion of additive meters in Chapter 3). Bartók, however, indicates the meter as 2/2 time, two half-notes per measure, thereby producing a syncopation on the second half-note:

Of the other sections, *C* and *F*, with their repeated-note patterns, and *E*, with its scale figure, all stressing conjunct motion and a rhythmic lilt, are especially folk-like. The fugue subject from the first movement returns in section *G*, appearing in a less chromatic version and with wider intervals.

The *Music for Strings, Percussion, and Celesta,* like other large-scale works by Bartók, reflects careful planning and a seemingly organic integration of East-European folk characteristics with traditional Western art-music elements, forms, and genres.

Bartók and Ethnic Music

Bartók and ethnomusicology

 Track **58,** a **Hungarian folk song,** illustrates the accented short-long pattern with the accented short on a strong beat, often called a "Scotch snap," typical of Hungarian folk music, as is also the pentatonic scale.

 58 "Scotch snap," Hungarian folk song

 Track **59** exemplifies additive meter in Bartók's folk-like "Bulgarian Dance." Additive meters are found in Russian and many East-European folk musics.

 59 Bartók "Bulgarian Dance"

Bartók began his ethnomusicological studies in 1904, and, in 1906, he and the Hungarian composer-music educator Zoltán Kodály began studying Hungarian folk-music, collecting literally thousands of melodies. Like many other composers of his generation, Bartók was a passionate nationalist. His approach to folk music was scholarly, and he went on field trips to gather his data. In searching for truly "Hungarian" music, he investigated what the peasants themselves sang rather than restricting himself to music of the Roma, considered representative of Hungarian music during the late-18th and 19th centuries. Bartók found that the oldest truly Hungarian songs had four-line verses (quatrains), each line of which has the same number of syllables and isometric phrases. While Kodály focused primarily on native Hungarian music, Bartók's searches extended to related folk styles throughout Central and Eastern Europe, including regions of Ukraine and the Balkan countries Serbia, Croatia, Bosnia, Bulgaria, Romania, and Turkey. He was also able to trace some aspects of East-European folk music to Arab sources from around Biskra in Algeria. Bartók's ethnomusicological publications attest to his scholarly and lifelong interest in these subjects.

As his style evolved, Bartók fruitfully drew upon folk elements. At first he made literal transcriptions of music heard in the field; only gradually did he assimilate the material into his own style, composing original music in the style of folk song or employing folk-song elements. Rhythmically, Bartók differentiated between a free, **parlando-rubato** style, like natural speech weak in metric feeling, and a structured, dance-like grouping of metric patterns which he referred to as

tempo giusto. The rhythmic motive ♪♪. , common in Hungarian folk song, appears frequently in Bartók's music. The short-long pattern, often called a "Scotch snap," and pentatonic scale and phrase repetitions a fifth lower, uncover the most ancient stratum of Hungarian music and surface in Bartók's music.

Bartók also made use of additive meters such as 2+2+3/4. Although these asymmetrical rhythms are often referred to as "Bulgarian," they are found in the folk dances of Romania, Russia, Greece, Turkey, and other similar cultures.

Hungarian Popular Music

In concerts of 19th-century music, we hear "Hungarian" works such as the *Hungarian Rhapsodies* of Franz Liszt and the *Hungarian Dances* of Johannes Brahms. ("Rhapsody" refers to a musical work that is relatively free in form and rhythm and that often has a spontaneous or improvisatory sound.) These genres are not to be confused with those based on true Hungarian folk music that we associate with Bartók and Kodály. In contrast to the later composers Liszt and Brahms had drawn mainly on music performed by the Roma in urban settings.

The Roma were nomadic people who came to the Western world from India. Much of the music the Roma of Liszt's time performed was apparently recently written by middle-class Hungarians. After the defeat of the Hungarian insurgents by Austrian and Russian forces in 1848, Hungarian (urban) refugees passed through various German states and brought with them mementos and customs from home. In music, there soon grew a veritable craze for "Gypsy" styles.

Some of the ornamentation and rhythmic figures we find in Liszt's Hungarian Rhapsodies doubtless accurately portray features of the more urbanized Roma

Cimbalom (hammered dulcimer)

"Hungarian-minor" scale

music of the time. In his "Hungarian" Rhapsodies, Liszt made frequent use of the "Hungarian-minor" scale, which emphasizes augmented seconds (see the Glossary). The scale is probably of Asian origin and transmitted throughout Europe by the Roma. At the beginning of his Eleventh Hungarian Rhapsody, Liszt makes the piano imitate the cimbalom, a large hammered dulcimer performed on by the Roma. In a somewhat different vein, one of his best-known works is his Second Hungarian Rhapsody, which he wrote in the manner of a *verbunkos*, originally danced by 18th-century Hungarian soldiers with swords and spears to help entice young men to join the army. It begins with a slow part called *lassú*, which is followed by fast part called *friss*. Besides the augmented seconds, all of Liszt's Hungarian Rhapsodies are in 2/4 or 4/4 meter and have some rhythmically free sections.

verbunkos

lassú
friss

In sum, there are two different types of musics, both referred to as "Hungarian." One, discussed and used by Bartók in the 20th century, is a truly indigenous statement of the peasant folk and of ancient origin. Since some interaction between the rural Hungarians and the Roma seems likely, we cannot assume a total separation of peasant from popular music of the Roma, and each has likely adopted some elements of the other's style.

The second type, espoused by Liszt and Brahms during the 19th century, is a more commercialized urban type made popular mainly by the Roma. By providing windows to the past, both genres are valuable as well as attractive.

In the Introduction, we explored music's various roles in society, and in Part One, we examined the basic components as the basis for understanding the various elements of musical style in Part Two. Now, in Part Three, we will take a more global view of music in broader contexts.

KEY WORDS

Lydian mode, "Scotch snap," arch form, Hungarian rhapsody, *verbunkos, lassú, friss,* cimbalom

SUGGESTED READING

Sárosi, Bálint. "Gypsy Musicians and Hungarian Peasant Music," *Yearbook of the International Folk Music Council* II (Urbana, 1970), 8–7.

Stevens, Halsey. *The Life and Music of Béla Bartók.* New York: Oxford University Press, 1964. (This book provides a brief but detailed account of the composer's life and a

useful overview of his output, including a thorough analysis of the quartets and the *Music for Strings, Percussion, and Celesta*.)

Gillies, Malcolm. *The Bartók Companion*. London: Faber and Faber, 1993. (This collection of articles covers various facets of Bartók's life, including his scholarly research.)

Articles on Bartók, Gypsy music, Hungarian dances, Hungarian Rhapsodies, and Hungary in *The New Harvard Dictionary of Music* and *New Grove Dictionary of Music and Musicians*.

SUGGESTED LISTENING

Bartók *Music for Strings, Percussion and Celesta.*

Folk Music *Folk Music of Hungary*. Recorded in Hungary Under the Supervision of Béla Bartók, Folkways FM 4000; *Zoltán Kodály/Béla Bartók: Hungarian Songs*. Angel 36334; *In the Shadow of the Mountain/Bulgarian Folk Music* (Bulgarian [additive meter]), Nonesuch [Explorer Series] H-72038; *A Harvest, a Shepherd, a Bride: Village Music of Bulgaria*. Nonesuch [Explorer Series] H-72034; *The Living Tradition: Music from Hungary* (gypsy and Hungarian peasant music), Argo ZFB 49 [stereo].

HELPFUL VIEWING

After the Storm: the American Exile of the Béla Bartók. Videocassette or DVD. A BBC TV/MTV Hungary coproduction in association with Portobello Productions and LA SEPT, dir. Donald Sturrock. Bartók's letters read by Bob Peck. Imprint: Princeton, N.J.: Films for the Humanities & Sciences, © 1989. [76 minutes]

The Fourth "B": The Story of Béla Bartók (Our Musical Heritage series). Prod. by Twin City Area Educational Television Corp.; dir. Suzanne O'Connell; writer, Bert F. Cunnington; commentator, Arnold Walker. Imprint: Videorecord Corp. of America, [1970] [30 minutes]

11
REVIEW SHEET

Short Answer

1. List at least two modes Bartók used, in addition to the major and minor modes.

Short Essays

1. Describe at least four features of Bartók's style related to previous European composition techniques.

2. Describe at least three features of Bartók's style which broke with previous European compositional techniques.

3. What are the characteristics of Eastern European musical elements of melody and rhythm?

12

THE MIDDLE EAST

Lisa Urkevich

The Far East

In music, art, and literature of Western-European culture, references to influences from the Middle East, Asia, and North Africa have a long and most distinguished history. They became prominent in the eighteenth century, increased in the last half of the nineteenth century, and stressed in the twentieth, especially after World War II. Preoccupation with the Far East (China) dating from the seventeenth century continued in porcelain and other decorative arts in the eighteenth century. In music, "Turkish" preoccupation resulted in the use of the Lydian mode in works such as Mozart's German opera, *The Abduction from the Seraglio* (Chapter 8).

Westöstlicher Divan

Delacroix in North Africa

In the nineteenth century, specific reference to Eastern models appeared in poetry, most notably in Goethe's *Westöstlicher Divan* of 1819, and in painting, as Eastern customs emerged in the sketches and watercolors Eugène Delacroix created during his 1832 visit to North Africa in which he depicted various cultural events and developed ideas regarding primary and secondary colors from shadows under a bright sun.

At mid-century, the Hungarian pianist Franz Liszt popularized the augmented second in his "Hungarian" Rhapsodies, which were transmitted Westward by the Roma (see Chapter 11).

Impressionist Monet
Symbolist Gauguin
Japanese prints

Debussy, Whistler
Ensembles from
Indonesia and China

Art from Japan became a seminal influence for colors and design with French Impressionist painter Claude Monet; colors and patterns with Symbolist painter Paul Gauguin; colors and design with Post-Impressionist Vincent van Gogh; and designs with transplanted proto-Abstractionist American artist James Abbott McNeill Whistler. All of these were influenced by Japanese woodblock-prints that had become known to Western artists since their first appearance in France during the 1860s. French composer Claude Debussy, who admired Whistler's works, was also fascinated with the pentatonic and whole–tone scales, subtle percussion effects, parallel chord progressions as well as the heterophonic textures of visiting ensembles from Indonesia and China, assimilating them into his own style (Chapter 10).

Thus far, we have surveyed music of several cultures, from both familiar Western and indigenous standpoints. Some broad and especially significant musical topics that have yet to be examined are those of the Middle East, and they provide a spectrum of diverse musical heritages. Western European composers have used pentatonic scales, heterophony, and augmented-second scales to create an "eastern" or "Asian" effect (Chapter 4). The association of the augmented-second interval, with a supposed Middle-East equivalent, is significant since it resembles (but does not duplicate) intervals in two maqāmāt (formulaic melody types), Nikriz and Hijaz (see below).

The Cradle of Civilization

The Middle East

The Middle East is the cradle of great civilizations and cultures, home of Mesopotamia's Fertile Crescent and the valley of the Nile river—all sites of some of the earliest known organized societies. The geographic sections of the Middle East span across the three continents of Africa, Europe, and Asia, with Arabic, Turkic, and Persian (Iranian) being the dominant language groups. Interpretations vary as to which countries encompass the Middle East, but it is commonly accepted that the area includes the nations of the Arabian Peninsula (Saudi Arabia, Kuwait, Bahrain, Qatar, United Arab Emirates, Oman, Yemen), the Levant (Syria, Lebanon, Jordan, the Palestinian Territories, and Israel), along with the major historical state-regions of Egypt, Iraq, Iran, and Turkey. The most populous countries are Turkey, Egypt, and Iran. See the map on page 144.

The Islamic World

Three monotheistic religions

Judaism, Christianity, and Islam, the three major monotheistic religions of the world, all originated in the Middle East. The followers of these religions all worship the same God, with the main difference being the understanding of when the revelations from God ceased to be communicated to Humankind. Judaism adheres to the Old Testament, Christianity adds the New Testament to the Old to unite as the Bible, and according to Muslim beliefs, Islam's holy book, the Quran, contains the last scripture, the final revelations of God.

The seventh century

Islam began to dominate today's Middle East in the seventh century. The Prophet Mohamed was born in 570 at Mecca (in present-day Saudi Arabia) and received his revelations in the early seventh century. Islam spread rapidly, reaching all of Arabia by 634, and by the late 600s it had become the main political force of the area. Eventually, Islam extended as far as central Asia in the east and into Spain in the west. The Quran, the holy book of Islam, is in Arabic and it is meant to be read and recited in Arabic. Thus Arabic was accepted as the mother tongue in many of these Middle Eastern areas. In other places, Arabic was primarily used as the written language of administration and scholarly work, similar to Latin in medieval Europe. Because of this spread of Arabic via Islam, there is often a common misconception that the entire region is culturally "Arab," but this is not the case. Turks, Persians, and non-Arab ethnic minorities have maintained a great deal of their early cultural distinctions. Over the centuries, however, many Arab peoples, have broken the links with their pre-Islamic past and identified more closely with an all-embracing but somewhat abstract Islamic Arab Nation rather than, for example, with ancient Mesopotamia or Pharaonic Egypt.

Views of Music in the Islamic Middle East

Islam had a profound influence on the development of music in the Middle East. From its advent, Islam viewed music suspiciously and classified it as one of the *malahi* (forbidden pleasures). The Quran does not directly contain anti-music statements, other than cautioning followers to avoid the kinds of music that lead to lewd or frivolous behavior. The apprehensive attitude toward music was actually developed by some theologians on the basis of the Hadith (Islamic traditions) and was eventually adopted by all four legal schools of Islam: Hanafi, Hanbali, Shāfi'ī, and Maliki.

Music in the Islamic World

In today's Islamic world—depending on the locale, cultural practices, or family belief systems—music might be enthusiastically embraced or completely forbidden. For devout Muslims, dance in general is viewed with great suspicion. Music is weighed according to its function and even to the instruments used. For instance, in central Arabia among Muslims of the strict Wahhabi sect, the more melodic the instrument, the more unacceptable it is. So, while a violin, an electronic keyboard, or an 'ūd (the lute of the region) would not be unheard of at the celebration of a moderate Middle Eastern family, such would be anathema to a devout Wahhabi Muslim who at best might permit mere hand-played frame drums to accompany a singer(s) at a feast or celebration. Of course, among strict Muslims, all such celebrations are gender segregated.

Music Makers: Muslim Professionals, Dilettantes, Ethnic Minorities

There are many professional performers who are ethnically of Arab, Turkish, and Persian (Iranian) heritage in the Middle East, and they can rise to prestigious fame and gain lofty social status. But the average musician, especially an instrumentalist, is held in low esteem. Sometimes musicians, no matter how successful, cannot find a suitable spouse, since no respecting family would let their daughter/son marry a musician. Professional musicians perform when ordered and therefore frequently are viewed like hired servants who entertain as their patrons instruct. Of course, it is believed that someone from a devout Muslim family should never actually become a professional musician him/herself, since it would bring shame on one's relatives. It is permissible, however, for a layperson (a non-professional) to partake in music making. For example, a gifted dilettante (who, as in 18th-century Europe, may be more skilled than even a professional) might be viewed with some respect as s/he plays what s/he chooses when s/he chooses and not for money. In any event, since professional musicians for the most part lack prestige in many Islamic sub-cultures, it is common for non-Muslims from minority groups to become involved in music-making. Christians, Jews, and descendents of African slaves are frequently found in professional Middle Eastern music circles, and in some places these non-Muslims or people of foreign heritage dominate the music scene.

Music Characteristics

Each Middle Eastern country has its own unique traditions, and there is great variety within individual lands and between music from different epochs. Such is understandable since the present-day artistic environment of the region has been enriched for centuries with elements from cultures with which the Islamic Empire came into contact through conquest. However, some traditional music threads can be seen throughout the Middle East, and one of the most significant is the reverence for the "word" in music.

Music and the *Word*

Music and the *Word* In the Middle East, especially in Arab countries, the *word* is of highest importance. According to Islam, around 610 the Prophet Mohammed received his first revelation from God through a voice, that of the Archangel Gabriel. Mohammed listened and was told to "recite." During and after the Prophet Mohammed's lifetime, these oral recitations were written down in the Quran—the name "quran" literally means "recitation." To this day not one dot has been changed in this holy book and foreign translations are never definitive, merely introductory. Thus, as Islam spread into Arab and non-Arab regions via the Quran, a respect for Arabic language was enforced. Consequently, as a matter of course, at the very core of Islamic societies is a seated admiration of the "word," especially in the Arabic language.

But even in pre-Islamic times, the word—that is, the way one speaks through poetry, prose, and the presentation of oral history—was of immense value. In the harsh, barren deserts of Arabia, there were no resources for the inhabitants to develop art forms like painting and sculpting, nor were there raw materials to create complex instruments like the piano. So, from the earliest times, desert dwellers exercised their mental muscles and manifested creativity through the way they presented or chose words. Indeed, part of the complexity of Arabic is that there are so many different word choices for actions or objects—one can choose from over 255

words for "camel" alone! Therefore, the word chosen and the way one phrases something is scrutinized and evaluated by the listener. In such a culture, formal speaking and spoken poetry and prose are held in the highest regard. And even today, as an extension of this, penmanship, calligraphy, and writing skills are important, as they show reverence to the word.

In such a culture, music is understandably considered foremost a tool to carry the word. The music is secondary to the text, as it is there to enhance the lyrics, not overwhelm them. In many Middle Eastern cultures, the term "music" itself means "song." For many people, music is an art form that must have words. Of course, there is highly stylized and complicated instrumental music, especially in Turkey, Iran, and Egypt, among other areas. But as a rule in the Middle East, particularly among the general public, music with good texts is truly what "music" is, and this takes precedence over instrumental music.

The Significance of Melody

Melody

Traditionally, there are no chords in Middle Eastern music—no playing three notes simultaneously with a basis of harmonic structure. Instead, there are intricate melodic lines of sound. Since the poem is the main art form of the Middle East, especially the Arab World, the melodies are viewed as devices that help present the text without obscuring it. These main melodies are constructed from melodic modes. Because melody is the focus in music, the texture is monophonic and heterophonic. In group performance, melodies are performed in unison or at the octave, but since each musician often embellishes according to the characteristics of his/her instrument, the result is a characteristic heterophony.

Heterophony

Improvisation and Intricacy

**Improvisations:
taqsim
 (instrument)
mawwâl (voice),
layālī (voice)**

♪ Listen to the free improvisatory Layālī in Maqām (mode) Bayati, by Ibrahim el-Haggar & Sami Nussair, Cairo (1991). From UNESCO AUVIDIS.

As with Middle Eastern art that often has a focus on geometric patterns, repetition, and intricacy, in Middle Eastern music, there is likewise a great appreciation for repetition with specialized detail. It is common to take a tune and pass it around the various members of an ensemble, each taking a turn performing it, and recreating the melody through stylized embellishment. This kind of improvisation of highly developed melodic and rhythmic lines is an important feature of Middle Eastern music. A melody can be altered melodically, rhythmically, through mode change, new timbres (sound colors), or through ornamentation. Another staple in the Arab world is a free improvisatory opening to a piece with no set tempo. When this is performed on an instrument it is called *taqsim*, and if a voice improvises, it is called *mawwâl* or *layālī*. These introductory improvisations introduce the melodic modes, the *maqāmāt*, and help set the mood for the audience.

The Primary Elements: Melody and Rhythm

Melodic Modes: Maqām, Makam, Dastgāh

**maqām
makam (Turkey)
dastgāh (Iran)**

A melodic mode is like a scale, but it has more detail. In Arabic, the word for melodic mode is "maqām," and in Turkey, it is spelled "makam." In Iran, the word "dastgāh" is used for melodic mode. While a scale is just a building block of melody, mode/maqām is closer to formal melody. So let's say, for example, that one is asked to write a simple melody based on a western major scale (*e.g.* do, re, mi, fa. . .). One would choose notes from the scale, usually end on the first/last scale degree, and could end up creating a tune like "Mary had a Little Lamb," for instance.

If one were asked to write a song in a Middle Eastern melodic mode, a maqām or dastgāh, there would be more rules to follow depending on the maqām one chooses to write within. For instance, there are certain pitches one would have to keep coming back to in the melody, and there would be certain rules about the way one moves to a note (*e.g.*, one might have to move through other notes beforehand); and there might be three- or four-note gestures that the composer must incorporate. The rules change depending on the mode within which one chooses to compose or improvise.

Another interesting characteristic of Middle Eastern melodic modes is the intervals within them that are not found in western tempered music. On the piano, there are white keys and black keys that represent whole steps and half steps. But in maqām and dastgāh, one might have to play 3/4 or 1/4 steps, or even intervals that do not subdivide equally. That is why it is impossible to play many maqāmāt (pl. of maqām) accurately on the piano. But one can play all maqāmāt on a violin, since the absence of frets permits the musician to slide his/her fingers freely in producing a variety of non-western pitches.

One of the most famous of the maqāmāt is Hijaz (Hejaz), named after the Hijaz west-coast region of today's Saudi Arabia. It contains pitches that approximate the western interval of an augmented second.

60 An example of the Hijaz Maqām played on the 'ūd.

Maqām Hijaz

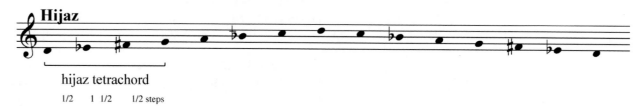

Hijaz

hijaz tetrachord

1/2 1 1/2 1/2 steps

♪ Listen to the great Egyptian singer Umm Kulthum (1904-75) sing Maqām Hijaz in the famous piece, "Ana Fi Intizarak" (I am waiting for you). Composed by Zakariya Ahmad with text by Mahmoud Biram Altounisi.

Rhythmic modes
iqa'ā (Arabic)
usûl (Turkish)
darb (Arabic,
used in Iran)

Rhythmic Modes: iqa'ā, usûl, darb

A rhythmic mode is an underlying rhythmic pattern found in Middle Eastern music. A rhythmic mode features stressed and non-stressed beats often played via designated low and high pitched sounds: low pitches are referred to as "düm" and high pitches as "tek." A hand drummer will often play closer to the center of the drum to get a lower "düm" sound, and closer to the rim for a "tek" sound. Middle Eastern rhythmic modes are similar to Indian tāla or Latin American dance modes, like the cha cha and rumba. In the Arab world, rhythmic modes are called "iqa'a," in Turkey, "usûl," and in Iran, "darb." A common rhythmic mode in the Arab World is the **SA'IDI**, which hails from southern Egypt. It comprises an 8-beat pattern as follows:

Düm	Tek	[rest]	Düm	Düm	[Rest]	Tek	[Rest]
1	2	3	4	5	6	7	8

Listen again to Umm Kulthum's "Ana Fi Intizarak" above. This has a sa'idi iqa'a, *i.e.*, a rhythmic mode.

Rhythmic modes have been important in the Middle East for centuries. Listen to this historical example from the Ottoman court of (c 1650–1700). (15. Dervis Mustafa (c 1650–1700): Nihavend Pesrev on Bezmara Ensemble-Turkey: Splendours of Topkapi CD, 1999.) In this Turkish example the melodic mode is "nihavend" which is similar to a western minor mode. The rhythmic mode, that is, the *usûl*, is "Aksak" which means "limping." There are several different Aksak usûl. The one here is in a seven-beat pattern and can be subdivided as 3 + 2 + 2, therefore, accents are on beats 1, 4, 6. This is religious Sufi music that was supposed to help induce trance for the Whirling Dervishes.

Tarab: A Music Aesthetic

Tarab is the "ecstasy" or "enchantment" that a musician is able to invoke in an audience. This is at the core of the musical aesthetic of the Arab World: performances are judged by tarab. Audience members regularly comment on their way home after hearing a singer or musician about the night's tarab and the quality of it. During the performance, listeners are expected to respond openly when they feel tarab—they cheer, they clap, they shout out words of praise to the performer. Of course, this incites other audience members to respond as well, and all of this group encouragement increasingly inspires the performer. Thus the musical evening is enhanced. To the general listener, tarab is largely ineffable—one just feels it without being able to pinpoint what it was about a performance that evoked tarab. But musically speaking, tarab is created from embellishment and stylized interpretation of the music. The performer may slow down, speed up, add certain note phrases or ornaments, change dynamics, insert tremolos, and so forth. Like a jazz singer who can manipulate a simple tune and turn it into a small masterpiece, the Arab tarab singer or musician can reinvent a composition on the spot and turn it into a tour de force.

The Instruments

The importance of the 'ūd

The takht ensemble

In Middle Eastern music, the most important melodic instrument is the lute, called *ūd* in Turkey and the Arab World and called '*ud* or *barbat* in Iran. (The size and tuning of an '*ūd* varies, depending on the region and the time period involved.) Some of the most important percussion instruments (membranophones) are goblet-shaped hand drums that go by various names such as *darabuka, doumbek, tablā,* or *darb* in Iran, among others.

The Takht (from Persian 'stand' or 'platform')

A takht is the traditional ensemble that formed the base group of Arab music in the late nineteenth and early twentieth centuries. The takht ensembles perform the Arab art or classical music of Egypt, Syria, and Lebanon and have become so popular that they are heard throughout the Arab World. A takht is a chamber group, meaning one person per instrument or part, as opposed to an orchestra, which can have many people playing the same type of instrument or musical part. A takht ensemble usually has four to five instruments (see below), but sometimes other instruments will be added, such as a double bass. The group also often has a small

chorus of four to five singers and a vocal soloist. The instrumental musicians will both sing and play.

The Takht Instruments

takht ensemble instruments:

'ūd (fretless lute),
nay (vertical flute),
qanun (plucked zither),
kamanja (violin),
riqq (tambourine)

'Ūd The *'ūd* (oud), is a short-necked lute with no frets ("ood"). The *'ūd* is the main melodic instrument of the Arab World. It is a large, pear-shaped ("piriform") lute with a short, fretless neck. It is associated with more urban, sophisticated music, especially since *'ūd* musicians require technical skill and some knowledge of maqāmāt. Moreover, the instrument is fragile and does not fare well in the desert climate of Bedouin. It dates back to the eighth century and has changed greatly over time with regard to size and strings. Today, Arab *'ūd*s normally have nine or eleven strings. This includes a single low bass string and four to five courses (a course is a pair of strings tuned to the same pitch). Arab *'ūd*s tend to be tuned in intervals of a 4th. There are no frets on an *'ūd* like one would find on a guitar, so the *'ūd* player can place his/her fingers anywhere on the neck and thereby produce the microtonal sounds needed to play maqāmāt.

♪ Listen to this example of takht, the Sharq Arabic Music Ensemble (with singing), performing "Muwashah Jallaman Qad Sawarak" [http://www.kmplimited.com/sharq/listen/].

Nay The *Nay*, is a vertical flute played with the side of the embouchure (mouth muscles). ("n-EYE").

Qanun A *Qanun* is a plucked zither ("q" pronounced like the "c" in "cough," "ca-NOON"). The Qanun was adapted and became the santur in Persia, which is a hammered zither like the piano.

Kamanja A *Kamanja* is the word used in the Arab world for a violin ("ka-MAN-zha").

Riqq A *Riqq* is a tambourine (pron. "rick" but with a rolled "r"). A riqq/tambourine might also be called a duff or tar, which are generic terms also used for "frame drum." The riqq player usually plays other percussion instruments, like the goblet-shaped drum know by many names, including *tablā* ("TAW-blah"), *doumbek, durbekki, darabukkah,* or a frame drum: a "tar."

KEY WORDS

darb, dastgāh, iqa'ā, kamanja, layāli, makam, maqām, Maqām Hijaz, mawwâl, nay (nai), qanun, riqq, sa'idi, tablā, takht, taqsim, tarab, 'ud, usûl

SUGGESTED READINGS

Davis, Ruth Frances. *Ma'luf: Reflections on the Arab Andalusian Music of Tunisia.* New York: Scarecrow, 2004.

During, Jean and Zia Mirabdolbaghi. *The Art of Persian Music.* Trans. from French and Persian by Manuchehr Anvar. Washington, DC: Mage, 1991.

Marcus, Scott. *Music in Egypt: Experiencing Music, Expressing Culture*. London: Oxford University Press, 2006.

Miller, Lloyd. *Music and Song in Persia: The Art of Avaz*. Salt Lake City: University of Utah Press, 1999.

Nooshin, Laudan. "The Processes of Creation and Recreation in Persian Classical Music." Ph.D. diss., University of London, 1996.

Popescu-Judetz, Eugenia. *Meanings in Turkish Musical Culture*. Istanbul, Turkey: Pan, 1996.

SUGGESTED LISTENING

Ibrahim el-Haggar & Sami Nussair. *Maqām [mode] Bayati*. Cairo: UNESCO AUVIDIS, 1991. (layāli.)

The Sharq Arabic Music Ensemble (with singing). *Muwashah Jallaman Qad Sawarak* (takht)[http://www.kmplimited.com/sharq/listen/]

HELPFUL VIEWING

Googoosh, Iran's Daughter. Produced, directed, and edited by Farhad Zamani. In English and Persian, with English subtitles. DVD. First Run Features FRF 911 283D. 2000. [158 minutes].

Umm Kulthum: A Voice Like Egypt. Written and directed by Michal Goldman. [Cairo]: Arab Film Distribution, 2006. [67 minutes].

12
REVIEW SHEET

Short Answers

1. Name and categorize five takht instruments.

2. Name two types of improvisation in music of the Middle East.

Short Essay

1. Identify and discuss at least two distinguishing characteristic aspects of Middle-Eastern music.

13
AFRICA

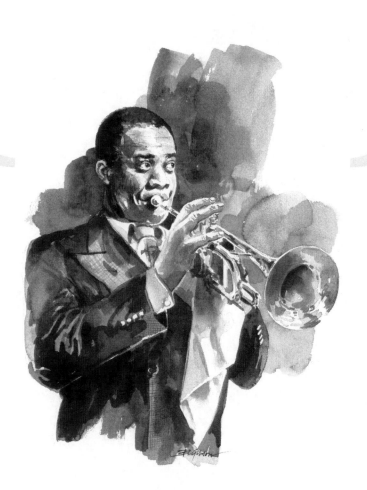

Africa effectively demonstrated its musical power in the 20th century. The world has adopted American ragtime, blues, jazz and rock styles—all permeated by African elements transmitted by the descendants of the slaves brought to the Western hemisphere. The rhythmic and expressive vitality of Africa blended with European structures and American spirit bringing forth musical styles of unequalled popular appeal around the globe.

Aside from its influence on popular music, traditional African music in all its dynamic complexity can itself be considered one of the major musical systems of the world. Nearly everyone knows of the rhythmic dynamism in African music, but how many music lovers recognize other important elements, such as the technique by which instruments talk, the tone qualities favored by Africans, and how musicians in an ensemble interact?

The vast continent of Africa covers an area larger than Europe and the United States combined. This chapter considers only Black Africa, that portion of the continent south of the Sahara. Some forty countries, numerous tribal and linguistic boundaries, and geographical conditions ranging from tropical rain forest to temperate climate in the south, all testify to the diversity of Africa.

From among the great variety of musical cultures represented in sub-Saharan Africa, five genres are discussed here: a talking drum of the Yoruba people in West Africa; a group song of the Benzele of Central Africa; an ancestor ritual with *mbira* "thumb piano" of the Shona people of Southeast Africa; a polyrhythmic drum ensemble of another Yoruba group; and an orchestral ensemble of Chopi *mbila* players, at Southeastern Coastal Africa.

Talking Drums

African "Talking" Drum

Drawing by Barbara L. Gibson

How can a drum talk? African drums, trumpets, slit logs, and other instruments have little in common with Morse Code or other sets of arbitrary symbols standing for language. In Morse Code, the assignment of a short tone for the letter "e" is neither related to the sound of the letter nor its meaning. African talking drums imitate human speech by reproducing its pitch and rhythm patterns.

The talking-instrument phenomenon occurs where tonal languages are spoken in Africa. As is the case with the Chinese spoken language and its close relatives, certain Bantu languages of Africa require the use of relative pitches as phoneme, or significant speech, sounds. Pitch change is as significant an element of speech as are vowels and consonants. In English, "trick" and "track" are two different words, but "soap opera" [high-low-low-high] and "soap opera" [low-high-high-low] are the same. Vowels and consonants cannot be reproduced on instruments but pitch patterns of speech can. Since speech utterances also have characteristic rhythmic patterns, the instrumental version of a sentence can "speak" the sentence using only pitch and rhythm. With talking instruments, pitch and rhythm can say sentences. The additional information of vowels and consonants is redundant.

A skilled drummer of the Yoruba people in Nigeria, West Africa, has available many proverbs, praise names for his chief, and other important persons, and other stereotyped messages. Contrary to popular belief, the drummer cannot literally communicate *ad hoc* statements such as "Please fetch for me the ballpoint pen in the left pocket of my safari jacket rolled up under the back seat of the Land Rover," although a resourceful drummer could get the main idea across. But a good drummer knows the right phrases to use for each social circumstance, can joke, chastise a dancer's poor performance, or correct a minor ensemble instrument. The master drummer holds a high status in traditional African society.

A favorite Yoruba instrument for talking is the hourglass-shaped pressure drum called *dundun*. The shape of the wooden body is hidden by the rows of rawhide lacing connecting the two heads. Holding the drum under his armpit, the

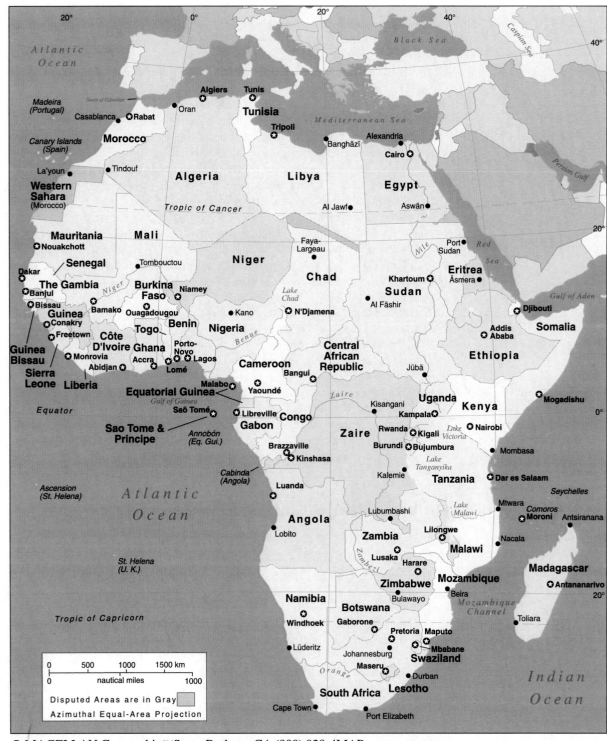

20° 0° 20° 40°

Atlantic Ocean

Black Sea *Caspian Sea*

40° 40°

Algiers Tunis

Strait of Gibraltar **Tunisia** *Mediterranean Sea*

Madeira (Portugal) Oran Tripoli Alexandria Banghāzī Cairo

Casablanca ⊕Rabat

Morocco

Canary Islands (Spain)

La'youn •Tindouf **Algeria** **Libya** **Egypt**

Western Sahara (Morocco)

Tropic of Cancer Al Jawf• Aswān• 20°

Mauritania **Mali** Faya-Largeau Port Sudan *Red Sea*

⊕Nouakchott **Niger** **Chad** Khartoum **Eritrea** Āsmera•

Dakar Tombouctou **Sudan** Djibouti⊕

Senegal **The Gambia** **Burkina** Niamey Al Fāshir *Gulf of Aden*

⊕Banjul *Niger* **Faso** Kano• N'Djamena Addis **Somalia**

⊕Bissau Bamako⊕ Ouagadougou⊕ *Benue* Ababa⊕

Guinea Conakry⊕ **Togo** **Benin** **Nigeria** **Central** **Ethiopia**

⊕Freetown **Côte** Porto- **African**

Guinea **D'Ivoire** **Ghana** Novo Lagos **Cameroon** **Republic** Jūbā•

Bissau ⊕Monrovia Accra⊕ ⊕Lomé Bangui Mogadishu⊕

Sierra Abidjan⊕ **Equatorial Guinea** Malabo⊕ Yaoundé• *Zaire* Kisangani• **Uganda** **Kenya**

Leone **Liberia** Saō Tomé• ⊕Libreville **Congo** Kampala⊕ 0°

Equator **Gabon** **Zaire** Rwanda ⊕Nairobi

Sao Tome & Principe Annobón (Eq. Gui.) ⊕Kigali *Lake Victoria*

Brazzaville⊕ Burundi ⊕Bujumbura

Cabinda (Angola) ⊕Kinshasa Mombasa•

Ascension (St. Helena) Luanda Kalemie• *Lake Tanganyika* **Tanzania** ⊕Dar es Salaam

Atlantic Ocean ⊕ Lubumbashi• *Lake Malawi* Mtwara• *Seychelles*

Lobito• **Angola** Lilongwe Comoros Antsiranana

St. Helena (U.K.) **Zambia** ⊕ ⊕Moroni Nacala•

Lusaka⊕ **Malawi**

Zambezi Harare **Madagascar**

Tropic of Capricorn **Zimbabwe** **Mozambique** Beira• Antananarivo⊕

Namibia Bulawayo• *Mozambique Channel* 20°

Botswana Toliara•

Windhoek⊕ Gaborone⊕ Pretoria Maputo

Lüderitz• ⊕ Mbabane **Swaziland**

0 500 1000 1500 km Johannesburg• Maseru **Mozambique**

0 1000 *Orange* Durban•

nautical miles **South Africa** **Lesotho** *Indian Ocean*

Disputed Areas are in Gray Cape Town• Port Elizabeth•

Azimuthal Equal-Area Projection

© MAGELLAN Geographix℠Santa Barbara, CA (800) 929-4MAP www.maps.com

drummer applies arm pressure to the laces to regulate the pitch. Tightening raises the pitch; loosening lowers it. Using high, low, and gliding pitches, the drummer reproduces sentence pitch patterns.

In addition, embellished sound, or "fuzz" tone, is an African timbre ideal. Examples of embellished sound in Western culture would be the snares on a drum, the membrane on a kazoo, or a mute on a trumpet.

The speaking drum of the *dundun* family is called *iya ilu* (YAH-loo) and has a set of small pellet bells attached around the rim of each head to sound each time the head is struck, an embellishment to the basic sound. If this embellishment were lacking, the listener would sorely miss it. Many African musical sounds are embellished.

iya ilu

Adesina Adayoti, master drummer of the Shango cult of Nigeria, performs the *iya ilu* talking drum in a recorded excerpt from a contemporary dance-drama by the Nigerian playwright-composer, Duro Ladipo. In one scene, a drummer on stage accompanies a powerful general named Timi of the court of the legendary king, Shango. As General Timi nears a town, his drummer calls out praises, repeating each spoken phrase on the drum: "Timi, with arrows of fire/Man greater than any man." Timi wants a good reception so he recites a charm directed at the townspeople. Each of his spoken phrases is also repeated by the drum:

Let the wind blow them all towards me
Let them all come rushing to me
We throw our net into the sea
It catches all the fish in the shallow waters

"Conversations"

61 Two master drummers engage in a fascinating drum dialogue.

A remarkable example of dialogue between drummers occurs in a performance by Malian virtuoso Kassoum Traoré who plays the *djembé* (a skin-covered, goblet-shaped hand drum) and noted Ghana *dundun* player Nii Ashitey Nsotse in a recording, *Bush Taxi from Bamako to Accra Suite* (Argile 09262). The title of the selection is most appropriately titled "Conversations."

Group Singing of the Ba-Benzele

The Ba-Benzele (BAH-ben-ZAY-leh; "Ba" is a plural prefix) people of Central Africa differ from their neighbors in physical appearance and culture. The Ba-Benzele are forest hunters of small physical size who are gatherers rather than farmers and who make their home in the darkness of the tropical rain forest. As nomads, they have hardly any use for elaborate material culture; with few instruments, their music has become highly developed, especially along vocal lines. Their way of life is free, peaceful, and respectful of the forest and the animals that they must kill in order to survive. The Ba-Benzele live in the region near the Sangha River, in the southwest of the Central African Republic. Benzele music is often densely polyphonic and assigns specific rhythms and textures to specific social occasions. (For a general discussion of polyphony and texture, see Chapter 5.)

Ba-Benzele "Rejoicing Song"

A successful hunt is a grand occasion for celebration among any hunting peoples, and the most festive Benzele singing rings out in the forest to welcome the hunters home. The "Rejoicing Song" celebrates such a successful hunt. Handclapping and struck machetes are the only percussion instruments, and a simple one-note flute is the only other instrument. The Benzele call the flute *hindewhu* (heen-de-hwoo) and play it alternating with the voice so as to make up one melody/rhythm:

The ancient appeal of this *hindewhu*/voice texture inspired Herbie Hancock to compose "Watermelon Man" for his *Headhunters* album.

In the "Rejoicing Song," at least twelve different parts, melodic and rhythmic, can be heard:

hindewhu #1, voice (2)

hindewhu #2, voice (2)

handclapping

machetes

men's chorus in parallel fourths (2)

male soloist

children's and women's chorus in parallel fourths (2)

female soloist

The yodeling of the male and female soloists, a technique common to other groups involving people of relatively small physical size, is similar to the *hindewhu*-voice line.

Mbira

linguaphone
lamellaphone

mbira dza vadzimu

What the Benzele *hindewhu* flute was to Herbie Hancock, the *mbira* ('m-BEER-uh) "thumb piano" was to "Earth, Wind, and Fire" and other African-American popular groups. One finds the *mbira* in Africa widely throughout the sub-Saharan region. Some of its many African names are: *kalimba, likembe* (lee-KEM-bay), *mbira, deze, zeze;* Europeans have variously called it *sansa, sanza, kaffir harp, thumb piano.* The

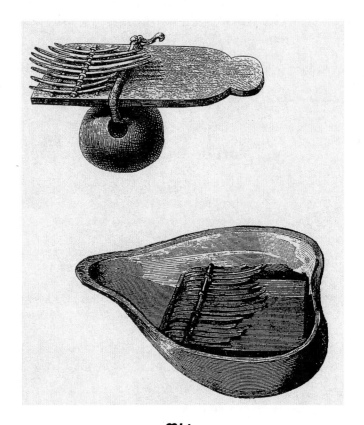

Mbiras
Dover Publications

mbira sound comes from the plucking of thin lamellae, or tongues, and is the best-known member of the plucked-idiophone *lamellaphone* or *linguaphone* family. This instrument-type is also found in the Caribbean and, in the late 19th century, was observed being played at Congo Square in New Orleans.

All of these instruments have in common a board on which is mounted a set of tongues or keys for plucking, often with a resonator box or shell. The European music box mechanism, operating on the same principles, may be related to the *mbira*.

The Shona people of Zimbabwe (formerly Rhodesia) are especially fond of *mbira* music and their instrument technology is probably the most advanced in Africa for this instrument type. One type of Shona mbira, the *mbira dza vadzimu* (JAH vah-JEE-moo; "mbira of the ancestors") plays a central role in spirit ritual.

The *mbira dza vadzimu* is the largest and most venerated of the various Shona *mbira* types. Its twenty-two keys are laid out in three rows, or manuals, two on the left and one on the right. The naked plucked sound of the metal tongues is clothed by the buzzing of bottle caps loosely attached to a piece of tin fastened at the lower edge of the sound-board—an embellished sound like the bells attached to the Yoruba talking drum. The soft plucked melodies are amplified by fixing the instrument inside a large calabash gourd resonator. The left thumb plucks the two left rows of keys, and the right thumb and forefinger pluck the single manual on the right.

In order to communicate with or placate an ancestral spirit, a Shona family stages a formal *bira* ceremony. The ceremony lasts all night and helps welcome the spirit of the deceased with dancing, singing, and *mbira* playing. If conditions are right, the spirit descends on one of the participants and takes possession of that person's body temporarily. Players of the *mbira dza vadzimu* supply the inspiration and energy for this communal act.

"Nyamaropa"

"Shona Ancestor Ritual," or *"Nyamaropa yekutanga"* (nyah-mah-ROPE-ah yeh-kuh-TAHN-gah), was recorded at a *bira* ceremony. Two instruments simultaneously play different variants of the same basic tune (see "heterophony," Ch. 5). One of the players sings an improvised melodic part. They are accompanied by a gourd rattle keeping the basic beat, handclapping, and dancers who "drum" the floor with their feet.

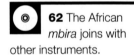

62 The African *mbira* joins with other instruments.

In the accompanying example, Track 61, on a CD titled *Legacies—Hagyományok* (Hungaroton Classic, HCD 31813), an *mbira*, cabaça, double cowbell, and marimba join in performing a colorful arrangement of Zimbabwe mbira music, providing a most attractive combination of timbres in the texture.

Yoruba Entertainment Music

As more Africans leave the traditional life of the villages and move to the cities, the functional role of music changes. In place of music for communicating with the spirit world or music to accompany life's major events, or work, we find entertainment music.

In the country of Benin, formerly Dahomey, a popular professional ensemble entertains urban folk on all sorts of occasions. The leader of the group plays the master drum. His large circular frame drum reproduces speech pitch patterns by his pressing the rim, thus altering the pitch. The ensemble includes five other musicians, including one who keeps the basic pulse (time line) on a gourd:

large frame drum (talking drum)

small frame drum

single-headed drum

calabash gourd (timeline)

5-key giant *mbira*

1-string fiddle

The sharp rhythms of the musician striking the large calabash with metal rings on his fingers keep the timeline. This particular timeline has a rhythm common to several African and African-influenced musics, such as those in Cameroon, the Caribbean, and Brazil:

We may hear this rhythm as five (♩ ♪♪) plus seven (♩ ♩ ♪♪) or perhaps as a constant implied pulse against which the three quarter-notes in the middle function as off-beats. A non-African probably cannot hear these rhythms the same way an African does, yet we can appreciate at an elemental level the rhythmic tension between the various instruments.

Each of the other instruments has its own role. The two other drums may never "talk," but they establish a rhythmic background by repeating their respective ostinato figures. The giant *mbira*, made with a large wooden box as resonator and slung around the player's neck, plays a simple line more rhythmic than melodic:

When we compare this *mbira* part to the rich tradition of the Shona described earlier, this West African type seems to represent a simplified musical style.

Near the end of the recording, an instrumental "visitor" from the Muslim world shows up: the fiddle. Elsewhere in the world a sustained-tone instrument, the fiddle here adopts a rhythmic role, in keeping with West African musical style.

Timbila

mbila
timbila

The Chopi villagers of the Inhambane region in southern coastal Mozambique in Southeastern Africa are widely acknowledged for their music and their large orchestras of wooden xylophones. (The Inhambane region is south as well as east of Zimbabwe.) Each of the instruments is called *mbila* and collectively referred to as *timbila*. The orchestras vary in size, the average being about ten instruments. The instruments come in different sizes—treble, alto, tenor, bass, and contrabass, but the tenor and treble types are seldom used these days. Under each wooden slab of the *mbila* there is a tubular resonant, and the instrument is the prototype of the marimba, which it resembles in both sound and construction. The *mbila* orchestras, the *timbila,* are found in virtually every large village and used in connection with dances called *Migodo* (singular *Ngodo*). The music, always newly conceived,

Migodo dances

is never written out and is based on a poem, itself newly conceived, that deals with topical and local subject matter. The songs are generally lively, even when the texts are sad, since the Chopi help alleviate sorrow through communal dancing and singing as a means of catharsis.

To compose a Chopi suite, its creator first chooses words of the poem (the subject matter often consisting of several themes or events generally related only by free association) and develops them rhythmically. Since the Chopi language and dialects are tonal, the melodies arise naturally from the words. The poet, who is

tone language

also the composer, conductor, and performer, then begins to define the melody with a rubber-headed xylophone beater. When his right hand becomes accustomed to the new tune, the poet/composer begins to fill in harmonies and accompaniment figures with the left. The left-hand part then becomes the harmonic basis for the

melody and eventually the part performed by the full orchestra in the form of a harmonic ground (see Chapter 6). The orchestral performers partially improvise their parts according to context and the leader's indications. Finally, the composer calls upon friends and presents the composition to the dance leader, and together they choreograph the composition, called *ngomi* in the plural.

The Chopi dance suite usually consists of about nine to eleven separate movements:

dance suite movements

1–3	Orchestral introductions
4	Entry of Dancers *(Ngeniso)*
5	Call of the Dancers *(Mdano)*
6	Dance *(Joosinya, Doosinya, Cibudo,* etc.)
7	The Second Dance
8	Song *(Mzeno)*
9	Councillors *(Mabandla)*
10	Dancer's Finale
11	Orchestral Finale

These numbers are not fixed—there may be two Calls of Dancers and only one Dance, the number of the orchestral introductions is variable, and so forth. An analogous but less initially improvised flexibility can be found in the late Baroque suite in European music, which does not always follow the customary "PACSOG" format of Prelude, Allemande, Courante, Sarabande, Optional movement, and Gigue. (See the Glossary for more specific descriptions of these dances.)

African musical genius shows much of its strength in rhythmic vitality, as these examples demonstrate, but the remarkable variety and complexity of the continent's musical treasures can only be hinted at here.

KEY WORDS

mbira, pressure drum, timeline, interlocking rhythm, talking instrument, *dundun,* embellished sound, fuzz tone, interlocking rhythm, lamellaphone, linguaphone, *timbila*

SUGGESTED READING

Berliner, Paul F. *The Soul of Mbira: Music and Traditions of the Shona People of Zimbabwe.* Berkeley: University of California Press, 1978. (A detailed description of the instrument and its place in musical society. The book specifies the physical components of the *mbira,* an overview of its music, the role of the player, and the use of the instrument in spirit ritual.)

Butcher, Vada E., et al. *Development Materials for a One-Year Course in African Music for the General Undergraduate Student* (project in African music). Washington, D.C.: Office of Education, 1970.

Dietz, Elizabeth Hoffmann Warner and Michael Babatunde Olatunji. *Musical Instruments of Africa: Their Nature, Use, and Place in the Life of a Deeply Musical People.* New York: John Day, 1965.

Nketia, J. H. Kwabena. *The Music of Africa*. New York: Norton, 1974. (A thorough overview of music across the continent; included are sections on social and cultural background, musical instruments, musical structures, and the interaction of music and related arts.)

Stone, Ruth M. (ed.). *The Garland Encyclopedia of World Music, vol. 1: Africa*. New York: Routledge, 1997. (A reference book containing a variety of articles covering issues ranging from the traditional music of various African cultures to the contemporary music scene.)

Tracy, Andrew T. N. *How to Play the* Mbira (Dza Vadzimu). Roodeport: International Library of African Music, 1970.

SUGGESTED LISTENING

Africa: Shona Mbira *Music*, Nonesuch Explorer Series 72077
 <http://www.nonesuch.com>

"Nyamaropa yekutanga," *The Soul of* Mbira (chords, "fuzz tone"), Nonesuch Explorer Series 72054

"Conversations," *Bush Taxi from Bamako to Accra* (Kassoum Traoré, *djembé*, and Nii Ashitey Nsotse, *dundun*), Argile 09262)

Legacies—Hatyományok (*mbira,* with cabaça, double cowbell, marimba), Hungaroton Classic HCD 31813

"Song of Rejoicing After Returning From the Hunt." *Anthology of World Music: Africa: The Music of the Ba-Benzélé* (Ba-Benzele polyphony), Rounder 5107
 <www.rounder.com>

Musiques Dahoméenes, OCORA OCR 17

"Timi at Ede," *Duro Ladipo: Oba Koso,* Kaleidophone KS-2201.

International Library of African Music:
 <http://ilam.ru.ac.za>

HELPFUL VIEWING

Middle East and Africa—Music and Dance. Vol. 16—*Turkey*, vol. 18—*Chad and Cameroon.* The JVC & Smithsonian/Folkways Video Anthology of Music and Dance of Africa. Directed by Hiroshi Yamamoto. Victor Company, 1996 (3 volumes); included are clips of performances from various parts of the continent with no spoken commentary. Each volume comes with a booklet describing the performances and the instruments involved.

Africa Come Back: The Popular Music of West Africa (Repercussions series, program 7). Third Eye Productions, Ltd, for Channel 4 in association with RM Arts; prod. Penny Corke, dir. Dennis Marks. Imprint: Home Vision, © 1984. [63 minutes]

West African Heritage (From Jumpstreet series [4]). A WETA production; prod. & dir. by Robert Kaiser; host, Oscar Brown, Jr. Imprint: PBS Video, © 1980. [29 minutes]

SUPPLEMENTARY LISTENING

Herbie Hancock, "Watermelon Man" from *Headhunters,* Columbia (CK 65123), 1973 (use of *hindewhu* in an interesting and different context)

Charles Mingus, "Slop" from *Mingus Dynasty;* Columbia (CK 65513) 1959 (shouts of encouragement in jazz context)

Charles Mingus, "Far Wells, Mill Valley" from *Mingus Dynasty* (polyrhythm and hemiola in a jazz piece)

13
REVIEW SHEET

Short Answers

1. Name three African instruments.

2. List two characteristics of West African music.

3. Describe in your own words the music for a specific African social context.

Short Essays

1. Find in your own experience a social-musical context analogous to an African one. How are the two contexts similar? Different?

2. Explain how African instruments can "talk."

14

WOMEN IN MUSIC

Feminism and women's studies have encouraged a more rigorous assessment of the contributions of women composers, patrons, performers, and teachers of music. Historically, women were marginalized for many different reasons in various cultures and societies. An examination of women's involvement in music throughout Western history shows that, in general, women traditionally were forced to make music without the same benefits allotted men in training, encouragement, opportunity, status, and reward.

Women as Composers—by Suzanne Beicken

Since music played a primary role in divine worship during the Middle Ages, women had music in their convents and nunneries, as did men in their monasteries. The church demanded that trained musicians provide music for religious services, but music schools trained only male singers and composers. Though unable to attend these schools, women sang and composed in their convents and nunneries.

The first identifiable woman composer of stature is Hildegard von Bingen (1098–1179), a mystic, abbess, poet, natural historian, playwright, and musician. The tenth child of a noble family, Hildegard was dedicated to the church by the age of eight, as was the practice of the time. She was known to be outspoken on issues concerning the church, politics, and diplomacy, and her devotion to God, unrelenting adherence to the Gospel, and religious fervor made her a force to contend with in both secular and religious circles. Having had visions from childhood, Hildegard followed a divine calling and, in 1141, recorded her experiences of inspiration, producing spirited texts for her revelatory songs. These were later incorporated in her *Symphony of the Harmony of Heavenly Revelations*, a collection of over seventy texts with music that forms a liturgical cycle heard mainly on feast days. Even her short compositions have an unusually wide melodic range, sometimes covering more than two-and-a-half octaves. Her language (Latin), unmetered and unrhymed, is highly mystical and filled with visionary imagery.

Hildegard also wrote the earliest known morality play, *Ordo virtutum*, which consists of eighty-two melodies depicting a grand battle between the sixteen virtues and the devil over the soul, Anima. Since her music was restricted to her convent and community, it did not exert much influence. Today, after the rediscovery of her magnificent oeuvre, Hildegard has become one of the most popular representatives of the music of the medieval era.

In medieval secular life, both women and men composed and sang many kinds of songs, but above all, love songs. Women of the aristocracy often played and sang for their own enjoyment, while women of lower classes sometimes made a living as itinerant performers and household musicians. The Trobairitz, like their male counterparts, the troubadours, were part of a culture that emerged during the late-11th century in southern France. They were poet-composers who wrote in an early version of Provençal and are often identified with the concept of *fin'amors*, meaning fine (courtly) love. Not as much is known of the Trobairitz as of their male counterparts, but they, nonetheless, made significant contributions to the genre. The Trobairitz did not feel the need to use male pseudoynms or disguise the fact that they were women writing from the feminine perspective, unlike later generations of women writers. There are significant differences between the styles of verse written by troubadours and Trobairitz. The women tend to discuss more intimate feelings in their poems, while the men tend to create a more complex poetic vision. The verses by women, at times, display their frustrations with their restricted lifestyles.

Despite the limitations placed on women in the Middle Ages, Hildegard von Bingen and the Trobairitz show an ingenuity and a creativity that succeeded in bringing about works of lasting quality. Both social station and family, in particular the father-daughter relationships, were significant aspects in the training of women as musicians. Those born of nobility or well-to-do merchant families often had private musical instruction. Some women of the aristocracy became patrons of

Hildegard von Bingen

 Music from the Middle Ages is primarily without meter or rhyme and set to Latin text. This excerpt is one of 82 melodies from a medieval morality play.

 63 Ordo Virtutum "Castitas"

the Trobairitz
fin'amors

ingenuity and creativity

Hildegard receives a vision as a flash of light from heaven, and prepares to record the revelation on a wax tablet with a stylus. A monk waits to make a parchment copy.

Ordo virtutum excerpt

music. In general, however, neither men nor women of the nobility became professional musicians. Women from classes below the aristocracy had opportunity for musical training only if they themselves came from musical households. They had access to music in principally two ways: (1) when music was part of family entertainment and became part of a daughter's general education; and (2) when women grew up in families of professional musicians, in which case they were exposed to music making. They were usually encouraged and nurtured by a father whose support of the musical interest in his daughter led to sincere music instruction.

Francesca Caccini

Francesca Caccini (1587–ca 1640) was born into a musical family that encouraged her to perform and compose. She was the daughter of Giulio Caccini, a famous composer and musician in Florence. Her parents sang at the Court of the Medicis in Florence; in addition, her father was a member of the Florentine *camerata* (see Chapter 7). He also instructed her in composition, and with parental tutelage, she grew up singing and playing the lute, guitar, and harpsichord, and, in addition, wrote poetry and music. She became a singer, writing music for herself and other singers to perform at Court. She also set religious texts and short dramatic works to music. Francesca appears to be the first woman to write an opera, or *balletto,* as she called it. Her opera, *La Liberazione di Ruggiero da l'isola d'Alcina* was first performed in 1625. It is music in the style of the Florentine *camerata,* in which the voice is "set free" from the remainder of the texture. In a profession otherwise dominated by men, Francesca Caccini had a remarkable and successful career at the Court of Mantua. Aside from a supportive family and a prominent father as artistic mentor, Francesca Caccini found courtly sponsorship for a professional success few women enjoyed in the male-dominated world of the arts. Her development and career are not unlike those of Artemisia Gentileschi (1593–ca 1653), a famous painter who was initiated and trained by her father to become one of the few celebrated women artists of her time.

Élisabeth-Claude Jacquet de la Guerre

Another composer who wrote music in many styles and genres was Élisabeth-Claude Jacquet de la Guerre (1665–1729). She, too, was born into a musical household; her father was an organ builder and her mother was related to a well-known musical family in Paris. By the age of ten, Élisabeth had already established herself as a prodigy. The *Mercure galant* (a French gazette and literary journal currently operating under the title *Mercure de France*) in 1677 referred to her as a "wonder" in her sight-singing talents, her ability at the harpsichord, and her gifts as a composer. After being brought to the attention of Louis XIV, she was placed in the care of his mistress, Madame de Montespan. The King remained interested in her progress, gave her opportunities to perform for him, and encouraged her to dedicate publications to him. After the death of both her husband and her only child, Élisabeth continued giving public performances. Her compositions include harpsichord pieces, a ballet, an opera, various types of sonatas, and cantatas. She also wrote a *Te Deum* (a liturgical hymn of praise to God) for choir, which was performed in 1721 to celebrate the recovery of Louis XV; this work, unfortunately, has not survived. The famous 18th-century British music historian John Hawkins described her as "an excellent composer . . . [who] possessed such a degree of skill, as well in the science as [in] the practice of music, that but few of her sex have equaled her."

Anna Amalia, Princess of Prussia

Anna Amalia, Princess of Prussia (1723–87), enjoyed the opportunities in music afforded a noblewoman in the 18th century. Although her father, King Frederick William I, disliked music intensely, many of his children, among them Frederick the Great, became musicians. Anna Amalia received her earliest training from her brother, Frederick, studying the harpsichord, flute, and violin. Music thrived at her brother's court, and residing there, she even hired Johann Philipp Kirnberger (a student of J.S. Bach) as her music leader *(Kapellmeister)* and teacher (see Chapter 7). Obviously, a noblewoman of this stature had at her disposal some of the finest teachers and musicians of the time. Of her compositions, only a few pieces remain, perhaps because she was too self-critical to keep works that did not live up to her uncompromising standards. She is best known as a serious collector of music with over 600 volumes of significant works by J.S. Bach, Handel, Georg Philipp Telemann (1681–1767), who was the director of music for the five largest churches at

Hamburg, and Giovanni Pierluigi da Palestrina (ca 1525–94), the leader of the Julian Chapel Choir at the Vatican, perhaps best known for his beautiful Masses.

18th-century public concerts

The development of public concerts began to gain prominence in the 18th century, and these concerts gave women more chances to establish their own careers. In addition, some of the more enlightened musicians tried to help women become more established. Johann Adam Hiller, a leading figure in the musical life of Leipzig, founded a singing school in 1771, based on the Italian model, to help both sexes improve singing in Germany. With the rise of the middle classes, opportunities in music teaching also became more frequent as more people wanted to learn to play and make music in their own homes. Nonetheless, except in singing, women were still often considered outsiders among professional musicians. Although they joined the ranks of the new market economy and even became publishers and engravers, women remained on the margins of professional music making.

19th-century music schools

Beginning in the 19th century, educational opportunities for women in music increased even more, particularly the establishment of public music schools, some of which opened their doors to women. The Royal Academy of Music in London, for instance, allowed women to attend some classes. As instructional opportunities increased, women began to write works for larger ensembles, such as symphonies, concertos, and even grand operas.

A musician who came from one of the most important musical families in the 19th century, and who is at this time considered a significant artistic figure in her own right, is Fanny Mendelssohn Hensel (1805–47). Although her family was musical and intellectual, it was not an especially progressive one as far as attitudes towards women were concerned. Her father felt that a woman's main role was that of housewife, and he was unsupportive of her wish to perform in public. Even her devoted brother Felix, the well-known composer with whom she shared a deep passion for music, was opposed to her publishing her works. We may only ponder the reasons why Felix apparently did not support Fanny's going public with her works. Fortunately, her husband, Wilhelm Hensel, a Prussian Court painter, gave her the encouragement she needed. Fanny established her own salons and composed and performed frequently for gatherings of friends and family. Her works include more than 500 compositions, among them over 250 songs, numerous piano pieces (such as the Piano Trio, Opus 11), a string quartet, and a few large-scale dramatic works; many of these were never published and remain as manuscripts in private collections today. In spite of her intelligence and wit, as demonstrated in her letters and diaries, Fanny never gained sufficient confidence in her own composition, a fate shared with other women of the time.

Fanny Mendelssohn Hensel

Clara Wieck Schumann

In the 19th century, more women became proficient performers, first on the piano, then on other instruments. Clara Wieck Schumann (1819–96) is still recognized today as one of the finest pianists of all time. She, too, was born into a musical family; her mother was a singer and pianist, but it was really her father who, as her first teacher, established her musical background and prepared her for a career on the stage. He also rented, sold, and repaired pianos and taught private students. Clara made her formal debut in the *Gewandhaus* in Leipzig at the age of eleven, and after an appearance seven years later (1837) in Vienna, she was appointed Imperial Chamber Virtuosa in the Austrian capital. In 1840 she married Robert Schumann, very much against her father's wishes. Schumann had studied with her father from the time Clara was eight years old, and he was, at the time they married, a relatively unknown composer. Together they had eight children, yet Clara managed to concertize, compose, and teach. Robert had a congenital nervous condition, became mentally ill, and eventually died in 1856. Clara moved to Berlin and continued concertizing, playing throughout Europe. She championed works by Felix Mendelssohn, Chopin, her dear friend Johannes Brahms, and also performed works by the "old masters" she so loved, such as J. S. Bach and Beethoven. But she always devoted herself to playing works by her husband, by then a famous composer. In 1878 she was appointed Principal Teacher of Piano at the Hoch Conservatory in Frankfurt. She continued to perform until the age of seventy-two, five years before

Clara Wieck Schumann
Drawing courtesy of the Schumannhaus, Bonn

Lili Boulanger
Photograph courtesy of the Library of Congress

her death. Although her husband had been supportive of her efforts in composition, his needs had always taken precedence over hers. She had to fit her schedule into his, practicing and composing when it would not disturb him. Interestingly enough, she stopped composing after Robert's death, except for a piece written for a personal friend. Clara wrote many works for her own concerts, as was still the practice in the 19th century. Her works include numerous piano pieces, a Piano Concerto, Opus 7, many songs, and a Piano Trio, Opus 17, in addition to arrangements and transcriptions of works by her husband and by Brahms. Her piano music is often technically demanding, and her musical style in general is lyrical and flowing, with harmonic richness. She deserves to have her works become more integrated into the present-day repertory.

The 20th century saw enormous social changes which have, to some extent, allowed women to enter the music field more unhindered. Music as "accomplishment" for girls is still present (more families provide music lessons for their daughters than for their sons). As increased higher educational opportunities have become available to women, they have tried to achieve the professional goals that were unavailable to them in the past. Women performers have reached out to play a much wider variety of instruments, and they have even formed orchestras of their own.

International Alliance for Women in Music

Antonia Brico

Not until 1997 did the Vienna Philharmonic Orchestra offer a permanent contract to a woman, and then only after intense publicity generated by the International Alliance for Women in Music, an advocacy group of composers, scholars, teachers, and performers. Early in the century, women conductors such as Antonia Brico were forced to work only with women's orchestras and choruses. In many parts of the world a disparity still exists between how men and women are rewarded for their work, with women generally earning less overall, though new entrants into the profession are generally treated more equally.

Lili Boulanger
Nadia Boulanger

As composers, women have achieved success in all genres of music. A look at the Boulanger sisters (Lili and Nadia) points to the groundbreaking successes women can accomplish when given the opportunity. Lili (1893–1918) was the first woman

composer to win the coveted *Prix de Rome*, which she did at the age of twenty. As a composer, Lili was in the avant-garde of her generation. Though she was to live for only five more years, Lili proved to be among the best musicians of the early 20th century, owing to the profundity of her musical conceptions. Her older sister, Nadia (1887–1979), became one of the 20th century's most respected teachers of musical composition and is discussed in the section "Women as Teachers." Thus, no longer is the impetus of a musical family background and/or belonging to the upper class a prerequisite for becoming a musician. Amy Beach, Ruth Crawford Seeger, Elizabeth Lutyens, and Barbara Kolb are women composers who have been able to achieve attention if not fame for themselves, by themselves, as composers.

popular, jazz performers
In the arena of popular music and jazz, women have also been successful in accomplishing what would have been unthinkable in the 19th century (see Chapter 15). In every branch of music, folk, rock, and R&B, there are women who have become household names: Joan Baez, Joni Mitchell, Judy Collins, Laurie Anderson, Billie Holiday, Ella Fitzgerald, Whitney Houston, Diana Ross, Courtney Love, Reba McIntire, Lena Horne, Madonna, and the list continues. One can only hope, in the 21st century, that women will continue to cross the barriers which in the past have stood in the way of their entry into all kinds of musical careers.

Women as Patrons—by Bonnie Jo Dopp

Eleanor of Aquitaine
William, ninth Duke of Aquitaine and seventh Count of Poitou, is generally recognized as the first troubadour. His granddaughter, Eleanor of Aquitaine (ca 1122–1204), was one of the most enlightened personalities of the medieval world. Eleanor inherited both Aquitaine and Poitou in 1137 at fifteen, the same year she was married to Louis VII and crowned Queen of France. Eleanor transported her court, which may have included troubadours, from Aquitaine to Paris. With differences in language (old French) and some of the poetic forms, the northern French adopted the troubadour concept. These northern aristocrats were referred to as *trouvères*.

In March of 1152, Eleanor's marriage to Louis was annulled on grounds of consanguinity. Three weeks later she was married to Henri d'Anjou who, in 1154, became King Henry II of England. From 1155 to 1174, Queen Eleanor's courts encouraged the development of the 12th-century vernacular tradition. Poets and musicians from both Northern and Southern France gathered at her courts, and her famous Christmas court was held in a different location every year.

Eleanor's direct descendants also had far-reaching influences on medieval music. Marie and Alix, Eleanor's daughters from Louis, were influential patrons of lyric poetry and music. Marie's grandson, Thibaud IV of Champagne, was one of the most famous of the *trouvères*. Of Eleanor's eight children from Henry, music by two sons, Richard *Coeur de Lion* and Geoffrey of Brittany, survive. Yet it may have been Eleanor's and Henry's daughter, also named Eleanor, who had the most influence musically. The younger Eleanor was married to Alfonso VIII of Castile, and their court was a center of musical patronage in Spain. The younger Eleanor's great-grandson Alfonso the Wise, King of Castile and León from 1252 to 1284, supervised the compilation of a famous and important repertory of over 400
Cántigas de Santa María
monophonic songs in honor of the Virgin Mary, the so-called *Cántigas de Santa María*, intended primarily for secular performance.

Eleanor of Aquitaine was not only a survivor but also a cultural leader in the patriarchal and often harsh social structure of the Middle Ages. She is held in the highest esteem by historians for her noble and far-sighted ideals. Neither composer nor performer, Eleanor of Aquitaine nonetheless exercised a most profound and salutary influence on the history of both poetry and music.

Isabella de' Medici
Orsini

While the cultural constraints preventing women from full participation in composing and performing European art music are only now dissolving, the long history of musical patronage is filled with women's names. Female sponsorship of music has idealistic roots in Western European culture. The Greek Muses are female, and St. Cecilia has long been hailed as the patron saint of musicians. The first woman composer in Italy to seek publication of her works, Maddalena Casulana (*fl* 1566–83), publicly pursued the approval (and thereby, aid) of Isabella de' Medici Orsini (1542–76), also an active cultural patron. After the rise of republican states in the 18th and 19th centuries, patrons of music had to be found in the ranks of the general population.

The 20th-century English composer Benjamin Britten once wrote of a "holy trinity" fundamental to musical culture: composer, performer, audience. Only when all three elements are equally strong, he felt, can the deepest musical experiences occur. Patrons belong to the "audience" leg of the triangle, which is as active as the other two legs when musical culture thrives. Certainly many men have contributed importantly to musical patronage (a "masculine" term, after all!), and in a democratized society it is crucial that all be welcome to participate, for there is no royalty to bestow largesse upon starving musicians. In the 20th century, there were efforts of many women "behind the scenes" as money-raisers for musical groups. As people in whose names funds have been established to commission new music from living composers, women have been vital to the existence of many musical institutions and to the growth of artistic repertory.

Martha Baird
Rockefeller

Elizabeth Sprague
Coolidge

The Martha Baird Rockefeller Fund for Music and the Elizabeth Sprague Coolidge Foundation have been essential to the creation of many new scores by both men and women, including Aaron Copland's famous *Appalachian Spring*. The Elizabeth Sprague Coolidge Auditorium, given by Coolidge (1864–1953) to the Library of Congress in Washington, D.C., has hosted thousands of musical events for tens of thousands of happy concert-goers, all admission-free and often heard on national radio broadcasts.

Gertrude Clarke
Whittall

Many of these concerts have been performed on priceless Stradivari instruments purchased and maintained by a fund established by Gertrude Clarke Whittall (1867–1965). In musical patronage, women have frequently led the way.

Women as Performers—by April Nash Greenan

A discussion of the ways in which women of varying cultures and eras perform music would fill volumes, and an independent course of study could easily be devoted to the topic. Here, we are limited to a brief survey of the roles women have achieved as performers in selected contexts of the European art-music tradition and in the Balkan countries.

From the days of ancient Rome through the first half of the 20th century, the musician, specifically, one who performs music, was viewed at times with grave disapproval, occasionally with a degree of reserved social acceptance, and always with some ambivalence. Combined with the historically asymmetrical attitudes toward women in general, the perceptions of women as performers of music have been, in the Western world, largely negative.

Accounts from ancient Rome (300 B.C.E. to 250 B.C.E.) reveal that the performance of music by women was seen as undignified and even corrupting. Four centuries later, the attitude was deepened by the Christian church's adherence to Paul's instruction, "Let women keep silence in church." Nuns were allowed to perform the music of the liturgy in the seclusion of the convent, but women not of the cloth were not allowed to participate in the music of the Church.

Council of Trent

The above-mentioned policy, while inconsistently enforced, was reiterated officially in 1553 at the Catholic Church's Council of Trent. Similarly, for the hundreds of years that women generally were not allowed to perform music in the Church, social customs also restricted their performance of music in public settings. While the Trobairitz of the medieval era performed their own songs, their place in the upper echelon of society allowed such performance only in private, nonprofessional settings. Meanwhile, the professional, itinerant musicians, often referred to collectively as *jongleurs* or *jougleurs,* were of low social status and seen more as entertainers than musicians; their skills generally included juggling, acrobatics, dancing, magic tricks, and performing with trained monkeys or bears.

jongleuresses

Thus, the *jongleuresses* were often women of little formal education whose job was to entertain rather than perform music as an artistic expression; they remained largely anonymous. Reports from as late as the 19th century indicate that, while middle- and upper-class women were encouraged to learn to sing or play a musical instrument, they were strongly discouraged from pursuing careers as performers: their music should serve only to make them better candidates for marriage and to add grace to the home. Further involvement with music would somehow diminish their dignity and connect them with the disreputable tradition of the lower-classed entertainer. Although religious and social attitudes in the West have, until relatively recently, generally prohibited women from achieving recognition as excellent musicians, many women of extraordinary talent and determination have, over the centuries, refused to "keep silent."

Singers
Livia d'Arco
Anna·Guarini
Laura Peverara

In 1580, less than thirty years following the Council of Trent's decree that women "will abstain from singing either in choir or elsewhere" the polyphonic music of the day, the first professional ensemble of female musicians was formed at the court of Duke Alfonso II in Ferrara, Italy. The famous *concerto delle donne* (musical group of women) consisted initially of three magnificent singers—Livia d'Arco (d. 1611); Anna Guarini (d. 1598), daughter of the famous poet Giovanni Battista Guarini; and Laura Peverara (d. 1601). The three were joined later by Tarquinia Molza (1542–1617), whose abilities to sight-read, improvise, memorize, and perform music of extreme difficulty and virtuosity were praised throughout Europe. Compositions were commissioned expressly for performance by the *concerto delle donne,* and these women were paid excellent salaries. Nevertheless, because classification as professional musicians was not socially correct, the women were listed on the records of the court as ladies-in-waiting to the Duchess.

Singers
Faustina Bordoni
Pauline Garcia Viardot
Jenny Lind
Elly Ameling
Dawn Upshaw
Marian Anderson

Owing to the enormous success of Ferrara's *concerto delle donne* and other, similar ensembles, and following the performance of the first opera, Jacopo Peri's *Dafne,* in 1598, the thriving tradition of great female singers was established. Although professional female singers faced social resistance—the stringent actions taken by the Church during the Counter-Reformation included the advancement of *castrato* singers to allow the performance of high-voiced vocal music without employing women—they gradually secured a permanent place in musical performance. Great opera singers of the past include Faustina Bordoni (1700–81), who gained international fame and who, after marrying the noted composer Johann Adolph Hasse, was paid twice as much as her distinguished husband at the court of Dresden where they were both employed. Later, Pauline Garcia Viardot (1821–1910), in addition to becoming an international opera star, was also an excellent composer, concert pianist, actress, and graphic artist. The famed Jenny Lind (1820–87) sang opera but preferred the concert platform, a venue that has been favored by great singers of our own day, including Elly Ameling and Dawn Upshaw. The magnificent voices of Marian Anderson, Jessye Norman, and Kathleen Battle have not only perpetuated the tradition of superior female singers, but they have also leveled barriers faced by women of color.

Another performer, Anna Maria della Pietà (ca 1689–ca 1750), was hailed in 1734 as "the premier violinist in Europe" and was the first woman to achieve international fame as an instrumentalist. An orphan, Anna Maria was raised in the *Ospedale di Santa Maria della Pietà* (hence, her surname), one of Venice's centuries-old homes for abandoned children. All of the children at the Pietà received training in music, and Anna Maria's talent was soon recognized. By her 14th year, when she was in need of a superior violin teacher, the Pietà happened to hire a young priest and music teacher named Antonio Vivaldi (1678–1741; see Chapter 7). Vivaldi wrote twenty-eight violin concertos for Anna Maria to perform and, when she performed, her audiences regularly consisted of kings, emperors, princes, and dignitaries, from Bavaria to Denmark. Other important composers of the day, including Giuseppe Tartini, wrote demanding, virtuosic violin concertos for Anna Maria to perform, and one can only speculate on the degree to which her technique and suggestions influenced these compositions and, consequently, the development of the solo concerto (see Chapter 7).

Anna Maria's success is exceptional for, although women gained ground in the world of professional singing during the 17th and 18th centuries, they typically were not hired as orchestral musicians. The first women to play in orchestral ensembles were harpists, the harp being perceived as a "woman's instrument." Since women had not been admitted into the male orchestra, during the late 1800s, they formed their own orchestras and string quartets. From the 1920s through the 1940s, twenty-nine women's symphony orchestras flourished in the United States (the Detroit Women's Symphony Orchestra, however, was founded in 1947 and remained active through 1971). Concurrently, women began to demand—and acquire—the educational opportunities that had been reserved for men, and music conservatories gradually opened their doors to women.

Today, dozens of superior female instrumentalists are widely recognized, including the first-rate violinists Erica Morini, Sarah Chang, Anne-Sophie Mutter, and Midori; great cellists Raya Garbousova and Jacqueline DuPré; classical guitarist Sharon Isbin; and flutist Eugenia Zukerman.

For women it is, perhaps, fortunate that the piano was not developed until the 18th century: it is almost an equal opportunity instrument. While the earliest keyboards were sets of levers played by the entire hand and not the fingers, the keyboard familiar to us today has been in use since the early 15th century and has formed the basis of the clavichord, harpsichord, virginal, and organ. Educated, upper-class women of earlier centuries were expected to play a keyboard instrument, but only in an amateur, domestic capacity. The hammered system of the modern piano became solidified during the 18th century as women were acquiring greater access to professions as instrumentalists.

By the 19th century, several women had established themselves as concert pianists. Indeed, while the piano became a focal point of 19th-century compositional and performance techniques, one of the greatest pianists of the century was Clara Wieck Schumann (1819–96). A contemporary of the legendary Franz Liszt, Clara Schumann's style epitomized the Classical technique and formed a contrast to more popular, flamboyant playing. Schumann's career as a concert pianist spanned over sixty years, and her approach to concertizing transformed the recital: she was among the first pianists to play from memory and without assisting artists; she insisted on performing the works of only the greatest composers; and she elevated the piano recital to a polished, prepared performance, moving it away from the loosely organized collection of popular tunes and improvised pyrotechnics it had become.

Since Clara Schumann, many women have achieved international stardom as concert pianists. In Russia, Anna (Annette) Nicolayevna Essipova [Yesipova] (1851–1914) made a remarkable debut at age twenty-three in St. Petersburg and subsequently embarked on a most successful concert tour throughout Europe. In 1885, she was appointed pianist to the Russian Court and, from 1893 to 1908,

was Professor of Piano at the St. Petersburg Conservatory. Other great female pianists from the 20th century include Dame Myra Hess, Guiomar Novaës, Gina Bachauer, Rosina Lhévinne, Moura Lympany, Rena Kyriakou, Martha Argerich, Alicia de Larrocha, and Maria-João Pires. These women represented not only the exceptional achievements of female performers in the 20th century, but also, since their native countries include Russia, England, Brazil, Greece, Argentina, and Spain, the significantly broadened scope of cultural diversity in Western art music.

Balkan Women and Diaphony—by Robin Wildstein

A study of the differing roles women have as performers in various musics around the world could also easily occupy an independent series of courses. Therefore, we are limiting ourselves to music-making by Balkan women, mainly because a widely recognized texture, diaphony, is specifically associated with this region.

The Trobairitz had expressed feelings about women's place in society while remaining within the gender bounds set by that society. Similarly, in Greek villages today, women express themselves through song while staying within specified societal bounds. Greek women are the guardians of vocal forms, preserving and transmitting traditions. The options, however, are limited, and those that exist are mainly limited to commentary on their position in society.

In Greek villages, men are viewed as rational, women as emotional. Regarding death, women are obliged to embody the grief of the family. Villagers perceive music as an outward manifestation of inner states, and lamentations are considered a specifically female-dominated area. A woman who sings or dances frequently or particularly enthusiastically is frowned upon. Music as an expression of joy—singing, dancing, playing instruments—is specifically the domain of males.

Women in the other Balkan countries also support a strong vocal tradition. Singing while occupied with household tasks, they are unable to accompany themselves with instruments. The songs are often lyric poems, of varying lengths, that include lullabies and songs of mourning, love, weddings, and harvest. Young girls are taught domestic skills and songs by their mothers. Communal work parties bring girls and women together to bake, weave, and spin. The songs at these gatherings include references to village men and boys.

diaphonic song Diaphonic song is a style unique to the women of Bulgaria as well as of Macedonia and Serbia, and it is often performed at communal work parties. Diaphony is two-part singing in which the upper voice sings the melody while the accompanying voice maintains a syllabic drone on the tonic or subtonic (7th degree of the scale), and it often sounds like a vocal bagpipe. The intervals between parts can be a unison, a major or minor second, or less often, a third or fourth. Diaphonic song is usually performed at a slow tempo and loudly.

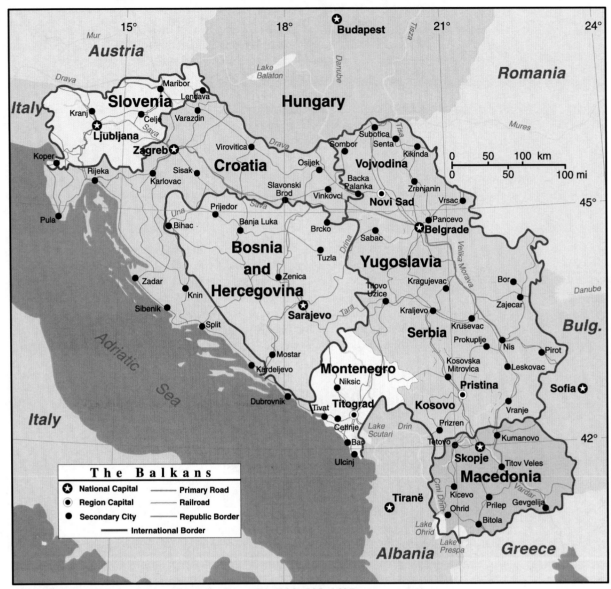

© MAGELLAN Geographix℠Santa Barbara, CA (800) 929-4627 www.maps.com

Names that appear on this map vary from the native forms generally approved by the US Board on Geographic names.

Variant Form	Native Form
Bosnia and Hercegovina*	Bosnia i Hercegovina
Croatia	Hrvatska
Macedonai	Makedonija
Montenegro	Crna Gora
Serbia	Srbija
Slovinia	Slovenija

*Kosovo and Vojvodina are autonomous provinces within the Republic of Serbia. The Republic of Serbia and the Republic of Montenegro now make up Yugoslavia. Due to the unsettled conditions in the Balkans, borders shown on this map are subject to potential change.

Women as Teachers—by April Nash Greenan

As teachers of music, women have made significant contributions to the musical traditions of the Western world. While they have not always been encouraged to be composers or performers, women have, through their teaching, influenced the performance practices of art music for centuries.

Naturally, nun-musicians were responsible for training their younger counterparts in the convent. The tradition of music instruction in the convent developed

such that by the 15th century several convents, especially in Italy, were known for their excellent music and concerts open to the public.

Marianne von Martinez
Maria Theresia von
Paradis

Many of the exceptional female performers who, contrary to social conventions, gained recognition for their artistry and skill, devoted much energy to teaching. Marianne von Martinez (1744–1812), a Viennese composer, singer, harpsichordist, and pianist, studied with Franz Joseph Haydn and was a colleague and friend of Mozart, with whom she often performed. On the heels of her successful career as a composer and performer, Martinez established a singing school in her home, where amateur and professional singers were trained. The remarkable Maria Theresia von Paradis (1759–1824) studied piano with the highly respected composer and keyboardist, Leopold Koželuh; she also studied singing and composition with Antonio Salieri, the contemporary of Mozart and teacher of Beethoven, Schubert, and Liszt. By the age of sixteen, Paradis had astonished the Viennese public with her piano playing and, after great success as a performer, she opened a music school that produced outstanding female pianists. Paradis had been blind since the age of three.

Marie Pleyel
Pauline Viardot

During the 19th century, when music conservatories began to accept female students, teaching opportunities for women dramatically increased. Following their successful careers as performers, the French pianist Marie Pleyel (1811–75) and French mezzo-soprano Pauline Viardot (1821–1910) joined the faculties of, respectively, the Brussels and Paris Conservatories. Composer and concert pianist Louise Farrenc (1804–75) taught at the Paris Conservatory throughout her 30-year professional career.

Anna Yesipova
Isabelle Vengerova

Among the pupils of Anna Yesipova (mentioned earlier as a performer), the famous Russian pianist who taught at the St. Petersburg Conservatory following her concert career, was composer Sergei Prokofiev and the astounding virtuoso, Simon Barere. Isabelle Vengerova (1877–1956) succeeded Yesipova at the St. Petersburg Conservatory and later joined the faculty of the Curtis Institute in

Anna Yesipova
Courtesy of International Piano Archives at Maryland

Adele Marcus
Courtesy of International Piano Archives at Maryland

Rosina Lhévinne
Courtesy of International Piano Archives at Maryland

Olga Samaroff
Courtesy of International Piano Archives at Maryland

Rosina Lhévinne

Olga Samaroff

Adele Marcus

Nadia Boulanger

Philadelphia. Vengerova's pupils included, besides Leonard Bernstein, composers Samuel Barber and Lukas Foss, as well as pianists Gary Graffman and Jacob Lateiner.

Russian-born pianist Rosina Lhévinne (1880–1976) studied at the Moscow Conservatory, winning the gold medal. In 1919, she and her husband settled in the United States and opened a music school in New York. Lhévinne also taught at the Juilliard School of Music, and her pupils included Van Cliburn, Misha Dichter, John Browning, and Garrick Ohlsson—four of the more successful pianists of our time.

American pianist Olga Samaroff (1882–1948) served on the faculties of the Philadelphia Conservatory and the Juilliard School. Her outstanding students included Rosalyn Tureck, William Kapell, and Alexis Weissenberg.

The celebrated American pianist Adele Marcus (1909–95) was the teacher of many excellent virtuosi, including Byron Janis, Thomas Schumacher, Horacio Gutiérrez, Tedd Joselson, and Santiago Rodriguez.

One of the most famous music teachers in the history of Western music was Nadia Boulanger (1887–1979). By the age of sixteen, Boulanger had won every prize in composition offered by the Paris Conservatory. She studied composition with Gabriel Fauré, Louis Vierne, and Charles Marie Widor, among others. During the 1930s she conducted the world's greatest orchestras, including the London Royal Philharmonic, the Boston Symphony Orchestra, the New York Philharmonic, and the Philadelphia Orchestra. She became legendary as the composition teacher of Aaron Copland, Roy Harris, Walter Piston, Virgil Thomson, and Louise Talma as well as Scottish composer Thea Musgrave, all of whom traveled to France to study with her. One of Boulanger's American pupils, Ned Rorem, has called her the most influential teacher since Socrates, so numerous and successful had her students been.

Isabelle Vengerova
Image courtesy of Curtis Institute of Music

Dorothy Delay

Some excellent women violinists have also built careers almost exclusively as pedagogues. The American violinist Dorothy Delay (1917–2002) was the teacher of Cho-Liang Lin, Midori, Shlomo Mintz, Itzhak Perlman, and Pinchas Zukerman, some of today's most respected violinists.

While many of the greatest musicians of the 20th century were taught by the women mentioned here, countless amateur musicians have been taught by their neighborhood or school music teacher, who is often a woman. Moreover, an infant's earliest exposure to music is often the soothing singing of his or her mother. Thus, throughout the world, the influence of women on the development of individual, nonprofessional music-making is immeasurable.

KEY WORDS

Trobairitz, *fin'amors*, Provençal, diaphony, troubadour, *trouvère*, *Cántigas de Santa María*

SUGGESTED READING

Auerbach, Susan. "From Singing to Lamenting: Women's Musical Role in a Greek Village," *Women and Music in Cross-Cultural Perspective*, ed. Ellen Koskoff. New York: Greenwood Press, 1987, 25–44.

Bernstein, Jane A. (ed.). *Women's Voices Across Musical Worlds*. Boston: Northeastern University Press, ©2004.

Bowers, Jane and Judith Tick (eds.). *Women Making Music: The Western Art Tradition, 1150–1950.* Chicago, University of Illinois Press, 1986.

Cook, Susan C. and Judy S. Tsou. "Bright Cecilia" [bibliographic essay], in *Cecilia Reclaimed: Feminist Perspectives on Gender and Music,* eds. Susan C. Cook and Judy S. Tsou. Urbana: University of Illinois Press, 1984, 1–14.

Dopp, Bonnie Jo. "Numerology and Cryptology in the Music of Lili Boulanger: The Hidden Program in *Clairières dans le ciel,*" *The Musical Quarterly,* v. 78, n. 3, Fall 1994, 556–83.

Ericson, Margaret D. *Women and Music: A Selected Annotated Bibliography on Women and Gender Issues in Music, 1987–1992.* New York: G. K. Hall, 1996.

Neuls-Bates, Carol (ed.). *Women in Music: An Anthology of Source Readings from the Middle Ages to the Present.* 2nd ed. Boston: Northeastern University Press, 1996.

Phan, Chantal. "The Comtessa de Dia and the Trobairitz," *Women Composers: Music Through the Ages, Vol. 1,* eds. Martha Furman Schleifer and Sylvia Glickman. New York: G. K. Hall, 1996, 61–68.

Reich, Nancy B. *Clara Schumann: The Artist and the Woman.* Ithaca: Cornell University Press, 2001. (Covers nearly all of the variegated aspects of Clara's life, including her interrelationships with other prominent figures such as Liszt and Brahms. The chapter entitled "Clara Schumann as Composer and Editor" is particularly interesting.)

Sadie, Julie Anne and Rhian Samuel (eds.). *The New Grove Dictionary of Women in Music.* New York: Macmillan Press Limited, 1994. (Organized in the same fashion as the *New Grove Dictionary of Music,* this book supplies detailed but concise articles on women composers, performers, educators and patrons.)

Shehan, Patricia K. "Balkan Women as Preservers of Traditional Music and Culture," *Women and Music in Cross-Cultural Perspective,* ed. Ellen Koskoff. New York: Greenwood Press, 1987, 45–54.

Tillard, Françoise. *Fanny Mendelssohn.* Trans. by Camille Naish. Portland: Amadeus Press, 1996. (A detailed biographical look at Fanny's life and relationships with her parents, brother, husband and friends, as well as a caring description of her music by a performer intimately familiar with it.)

SUGGESTED LISTENING

Hildegard von Bingen	*A Feather on the Breath of God; Sequences and Hymns by Hildegard of Bingen.* Hyperion A66039. *Ordo virtutum.* Deutsch Harmonia Mundi CDCB 49249.
Diaphonic song	*Two Girls Started to Sing: Bulgarian Village Singing.* Rounder ROUN 1055.
Fanny Mendelssohn Hensel	*Fanny Mendelssohn: Lieder & Trio.* Opus III OPS 30–71. *Chamber Works by Women Composers.* Vox Box SVBX 5112.
Clara Wieck Schumann	*Lieder.* Leonarda 107. *Piano Works by Women Composers.* Turnabout TV 34685.
Lili Boulanger	*Lili Boulanger (1893–1918).* Hyperion CDA66726. *In Memoriam Lili Boulanger.* Marco Polo 8.223636.

HELPFUL VIEWING

In the Symphony of the World: A Portrait of Hildegard of Bingen. Foreningen Casablanca and Flare Productions. Dirs. Jo Francis and John Fuegi; written by John Fuegi, Jo Francis, Niels Pagh Anderssen; prod. by John Fuegi & Morten Bruus. Imprint: Flare Productions, [1999]. [50 minutes]

14
REVIEW SHEET

Short Answer

1. Identify three ways in which gender affects the musical culture of which you are a part.

Short Essays

1. Name some professional difficulties Fanny Mendelssohn Hensel and Clara Wieck Schumann had. Do you think that both or either of them would have had similar difficulties if they had been born a century later? A century earlier? Explain your answers.

2. Comment on the importance of the audience in a musical culture. Describe the ways in which an audience supports the creation and performance of music.

15

AFRICAN-AMERICAN MUSIC

Early Genres

African-American music—jazz, the blues, ragtime, rhythm-and-blues, soul—has perhaps become more universally appreciated than any other music in history. A blending of African and European elements in the crucible of the Western hemisphere, African-American music has had both an immediate and a lasting approval.

African slaves rarely brought material goods across the Atlantic, but their cultural baggage was considerable. To varying degrees, language and folk tales, religion and dance, family relationships and music have been retained in Surinam, in northern Brazil, in Haiti, and in Cuba.

Afro-Cuban sects in the mountains of Cuba still use the Yoruba language of Africa in their rituals and distinctive African elements such as talking drums (see "Talking Drums" in Chapter 13). Waisted drums called *bata* differ little from their historical antecedents of the Yoruba people of Africa's Gold Coast. In the southeastern city of Santiago de Cuba, hearing an ensemble celebrating in the pre-Lenten *Carnaval* parade makes you think you are in Africa. Complex cross-rhythms from a thundering group of drums, a piercing timeline played on metallic brake drums, and a master drummer whose instrument floats above the din clearly lie closer to African roots than do many of the African music traits in North America.

Early African-American genres have survived in the United States today in greatly modified form. They include field hollers, shouts, moans, and cakewalks. Some of these are documented on recordings of old timers, made in the first part of the 20th century. Others are echoed in the published sheet music from minstrel shows and popular songs such as *Camptown Races.* In the following discussion, we will limit our topic to early African-American genres of Ragtime, Blues, Gospel, and Dixieland Jazz so that the connections between African-American and African music may be drawn most easily. The first African-American genre to find national acceptance was ragtime, a jaunty piano idiom.

Ragtime

Ragtime emerged from the popular music ferment in the United States at the turn of the 20th century: marches, polkas, waltzes, Spanish and other ethnic musics, and vaudeville songs. In its heyday, from the late 1890s to about 1915, ragtime sheet music and player-piano rolls flooded American parlors and dance halls. Scott Joplin, a black composer whose genius was the focal point of national interest, published his well-known *Maple Leaf Rag* and other pieces in Sedalia, Missouri. But while Joplin and other composers were marketing their fixed piano pieces to the general national audience, musicians like Eubie Blake in Baltimore and Jelly Roll Morton in New Orleans were improvising in bawdy-houses and "ragging" tunes: taking snatches and fragments of popular tunes and improvising on them in a well-defined, rhythmically syncopated, African-American style. The essence and genius of ragtime, as in other African-American genres, is not in fixed compositions but in what the performer does with them. The performer, not the composer, is the center of attention for the ragtime enthusiast.

Essentially a piano style, ragtime has characteristic rhythms built on an interplay between a steady 2/4 beat in the left hand and a syncopated melody in the right (see the discussion of syncopation and polyrhythm in Chapter 3).

Maple Leaf Rag The most popular of all published rags, Joplin's *Maple Leaf Rag* enjoyed sales numbering into the hundreds of thousands. The original edition was published in 1899, and Joplin himself "recorded" the *Maple Leaf Rag* by cutting a piano roll in 1916. Joplin viewed his music as classical, looking with some disdain on the attempts to make it "swing" (lively). We can appreciate this recording for its historical value and explore its non-variable elements. The tempo of the printed music is marked "Tempo di marcia" (march time), and the modular form also resembles marches of that time. Ignoring repetitions, we find that the form is *A B A C D* and easy to follow because each section is repeated.

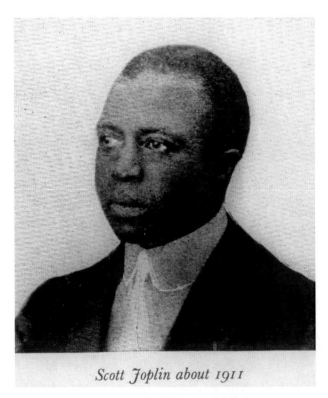

Scott Joplin about 1911

Rare photo of Scott Joplin.
Courtesy of the Institute of
Jazz Studies, Rutgers University.

Cover, Joplin's *Maple Leaf Rag*

James P. Johnson

Ragtime first saw the light of day in the bordellos of New Orleans, St. Louis, and Baltimore where they used to call the piano player "professor." But it was New York where the great virtuosos of ragtime assembled. In New York, James P. Johnson presented ragtime at the highest level, paving the way for great solo jazz pianists like Art Tatum and providing a basis for the solo style of modern jazz performers like Thelonious Monk, who used a transformed ragtime style when performing solo.

The ragtime music that the early masters played fused African vitality of rhythm with Euro-American popular instrumental forms. Despite the wide appeal of ragtime, it was probably the blues, an African-American vocal genre, that had the greatest impact on American music.

Blues

The blues is a feeling. It is also a musical form. In addition, it is a singing style with special intonation.

A powerful genre in its own right, the blues has also directly influenced jazz since the 1920s. From the blues came such popular genres as boogie-woogie, rhythm-and-blues, rock-'n'-roll, and soul. To Europeans, the blues is Americana. To Americans of all races, the blues is a national heritage. To African-Americans, it speaks to the soul.

As a vehicle, the blues transforms the touching personal experiences of life into artistic expression. It takes joy, sorrow, and love as themes, but art converts the ineffable personal feeling into shared communal experience. When Big Bill Broonzy leans back and sings:

Feelin' bad, sometimes I wanna cry
Feelin' bad, sometimes I wanna cry
Lawd, I lost all my money and the only gal I ever had

the well-worn motifs strike a sympathetic response in anyone who had that feeling and establish a common bond.

Familiar motifs, humor, and pathos make up only the verbal element in the blues. Non-verbal elements such as note-bending and affective use of rhetorical phrasing and rhythm communicate more than can words. Listen to the speech-like phrasing and rhythm of the blues, vocal or instrumental, and notice how they cut across and defy the 4/4 meter. Special expressive weight is carried by *blues notes*: scooping, sliding, gliding ambiguities of intonation on usually the third, seventh, and fifth degrees of the scale (see Chapter 4).

BLIND LEMON JEFFERSON "GOT THE BLUES"

Voice

SCOOPING ON THE 5th AND 3rd DEGREES

blues progression

The best-known blues form is a twelve-measure cycle based on a harmonic progression, called a chaconne in classical music. Compare this with the *mbira* piece *Nyamaropa* (see Chapter 13). In its classic form, the blues uses only three chords: I, IV, and V (see Chapter 5).

Howlin' Wolf

Howlin' Wolf (1910–76) was born into the Mississippi country blues tradition, with its strong beat and eerie vocal sounds. A younger bluesman, Johnny Shines, once said, "I was kind of afraid of Wolf . . . it wasn't his size, I mean the kind of sound he was giving off." In his recording of "Evil," Howlin' Wolf's gravelly voice recounts an old blues theme of sexual jealousy. The form of "Evil" provides an example of the classic twelve-bar progression:

harmonies	bars	text
I	1–4	Well, a long way from home can't sleep at all; You know another mule Is kickin' in your stall.
IV	5–6	That's evil,
I	7–8	evil is goin' on wrong;
V–IV	9–10	I have warnin' you brother,
I	11–12	you'd better watch your happy home.

blues progression

Many blues harmonic progressions do not conform to the "classic" structure outlined above. The twelve-bar I-IV-I-V/IV-I chord progression can reduce to only eight bars, expand to sixteen or sometimes ten. Like the idea of sonata-form in European classical music, the rules for the blues are written not on stone tablets but from the creative artist's heart.

boogie-woogie

In the 1920s and 30s, boogie-woogie developed as a faster, instrumental version of the blues (see the discussion of boogie-woogie in Chapter 5). Boogie-woogie kept the twelve-bar harmonic form of the blues, but with a strong rhythmic left hand in the piano and fast rhythmic figures in the right hand. Representative pieces in boogie-woogie include "Honky Tonk Train Blues" played by Meade Lux Lewis, "Mellow Blues" played by Jimmy Yancy, and "Pinetop's Boogie Woogie" played by Clarence "Pinetop" Smith, whose verbal interjections for his recording conjure up the atmosphere of a rent party:

Clarence "Pinetop" Smith

I want all of y'all to know Pinetop's Boogie-Woogie
I want everybody to dance 'em just like I tell ya.
Now when I say "hold yourself," I want all of ya to git ready to stop
And when I say "stop," don't move.

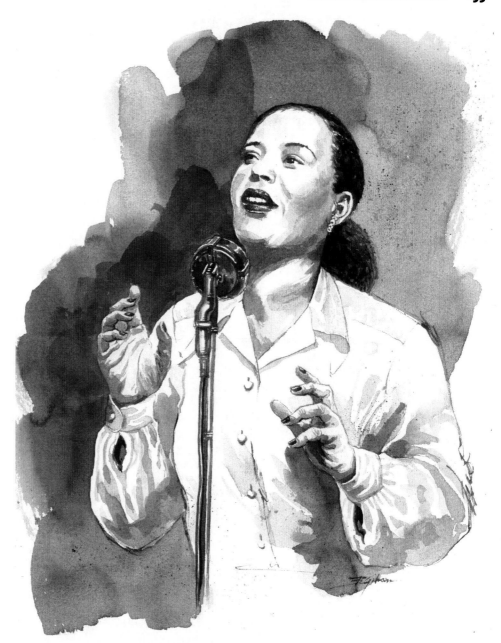

Billie Holiday, a leading blues interpreter
Drawing by Barbara L. Gibson

And when I say "git," I want all of y'all to do a Boogie Woogie
Hold it now . . . Stop . . . Boogie Woogie!
That's what I'm talking about.

The freedom of form available to blues has resulted in many developments. Some of the most expressive and typical examples of blues occur in such songs as Billie Holiday's "Billie's Blues" from the album *Billie Sings the Blues*. A fascinating development of the blues genre arose with the great instrumental blues of the 1940s bebop period. As in Charlie Parker's *Bloomdido* and *Billie's Bounce,* this type was often taken at a fast tempo, with the basic chord progression "spiced up" with substitutions that allowed the performers more freedom to improvise than the elemental I-IV-I-V/IV-I progression.

Compared to ragtime, the blues stands closer to the center of African-American music traditions. As a genre, the blues is vocal, word-oriented, highly variable beyond a basic structure, and bound to the black experience. The blues originated

in the 1890s, as did ragtime, but was acceptable only to black audiences until the 1930s and 1940s, when mainstream America discovered it.

The blues is the great secular wellspring from which African-American music has drawn. The religious counterpart to the blues is gospel.

Gospel

Gospel singer Bessie Griffin defined gospel in terms of what it expresses: "It can be funny, sad, or sexy. It's like the blues." Like the blues, gospel is deeply imbued with the African-American genius. Belief in Jesus and God is fervent and demonstrative; to "Make a joyful noise unto the Lord" is literally a major purpose of the service.

A most familiar staple of African style, call-and-response, permeates everything. The minister's passionate exhortations bring forth devout affirmations from the congregation:

Who washes away the sins of the world?
JESUS.

I say, who died for you and me?
JESUS.

And who will bring us everlasting life?
JESUS

Hymns sung by the entire congregation are initiated by the minister or by any member of the congregation, as the spirit moves. Participation goes far beyond singing and includes shouting, beating tambourines, jumping up and down, clapping, and joyous dancing (compare this with the *bira* ceremony of the Shona people in southeast Africa, Chapter 13).

A trained choir often performs set pieces in gospel style: call-and-response texture, rhythmic use of voices, and improvisation. The choir may also be accompanied by secular instruments such as acoustic or electric guitar, piano, organ, and drums. The musical and emotional high point of a choir performance comes when the choir repeats a short rhythmic figure, over which the soloist improvises in free rhythm.

Stevie Wonder, Ray Charles, Roberta Flack, Mahalia Jackson, and other successful popular singers got their early training in gospel. Gospel has influenced jazz instrumentalists as well, including Fats Waller and Thelonious Monk. But some devout believers draw a line between gospel for use in the church and gospel for profit and decry commercialization of any kind.

New Orleans
St. Louis
Kansas City
Chicago

The early history of gospel helps explain regional differences and the unique quality of gospel styles in the great cities of the Midwest. In New Orleans and other parts of the deep south, black musicians were not allowed to express gospel's many African influences—call-and-response, percussion, and group dancing. As the blacks moved north to St. Louis, Kansas City, and Chicago, the African traits in gospel surfaced and true gospel style was free to flourish. In Kansas City, African melodies are still used, as are large choirs, producing a style that exists in large scale there. Chicago-born Reverend James Cleveland (1931–91) was a leading figure in pre-1980s gospel, introducing complex harmonies and rhythms from jazz into his arrangements for mass choirs.

Many early traits of gospel seem to be preserved in the United States-influenced style of the Bahamas. Country church singing in the United States preserving pre-World War II styles has been recorded. Commercial gospel of the 1930s was featured by the Dixie Hummingbirds and the Golden Gate Quartet; this style is retained today in some churches.

The Little Wonders

In the town of Havre de Grace (population 9,000) in northeastern Maryland, The Little Wonders preserve the 1930s gospel style. In "Gospel Train," five singers, one with acoustic guitar, take a traditional image of American folksong, the train,

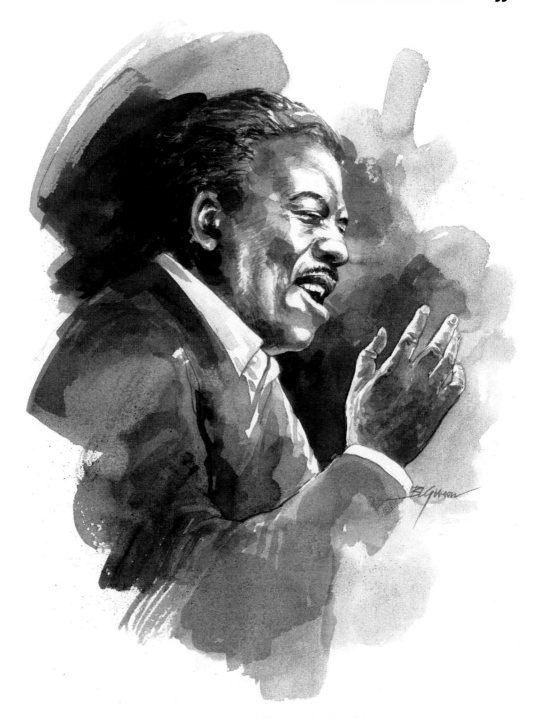

James Cleveland, a leading gospel interpreter
Drawing by Barbara L. Gibson

and borrow it in the service of the Lord. The performance is a compendium of African-American musical techniques, from the rhythmic use of voices ("bum, bum, bum, bumtebum") and bluesy melodic line, to the train imitations: "Wah, wah" (whistle); "Pssh, pssh" (steam); "Bing, bang" (bell); "All aboard!" and "Tickets, please!" The soloist, Granderson Jones, even imitates a mouth harp for one chorus.

Musicians who perform in gospel style today do not necessarily seal off that part of their life from all other musical experiences. The Little Wonders reflect a conservative, old-time style appropriate to their small-town Maryland congregation. Other churches, in the urban environment, absorb naturally soul, rock, jazz, and many other stylistic influences appropriate to their fellow believers.

Jazz

From roots in the black demimonde of Storyville in New Orleans to triumph in Carnegie Hall and universal acceptance, from Warsaw to Tokyo, from university curriculum to jukebox, jazz has conquered ever wider audiences. Like Eliza Doolittle, the lady has changed with her social status yet deep down, certain essential qualities such as improvisation, rhythmic freedom, "swing," and especially the primacy of the performer's art have remained constant.

Most of the jazz artists whom we call "genius" are black: Louis Armstrong, Duke Ellington, Charlie Parker, Miles Davis, Thelonious Monk, Billie Holiday. Outstanding white musicians such as Bix Beiderbecke and Bill Evans notwithstanding, jazz is fundamentally African-American in its origins, historically, stylistically, and by virtue of the sheer number of African-Americans who gave their talent to the art form. Like the blues, ragtime, and gospel, jazz synthesizes African with some European musical traditions in an American context.

Composers and arrangers have played a role, but jazz is in essence a performer's art. One is interested in what Billie Holiday can do with successive choruses of "He's Funny That Way," not who composed it or how closely she conforms to the composer's ostensible intentions. The unique sound quality, rhythmic inventiveness, and melodic and harmonic transformations that go into an individual performer's style are among the most important ingredients in jazz.

six pre-1980s style periods

Jazz has been documented, recorded, judged, and analyzed at least as much as, if not more than, any other popular art form in the world. Jazz historians since about 1990 have found it convenient to label about six style periods: New Orleans, sometimes called "Dixieland,"—1900s–1920s; Swing—1930s, early 1940s; Bebop—1940s; West Coast, Cool, Hard-Bop—1950s (a particularly creative decade that also witnessed unique innovations by Thelonious Monk); Free—1960s; and Fusion—1970s. (After the 1970s, jazz seems to have settled into a process of assimilation and synthesis.) One can find some justification for these labels, but it is important to note that all of these styles have continued up to the present and that individual musicians and their music have always been more complex than historical labels can express.

New Orleans

jazz: 1920s–40s formative years Armstrong

Louis "Satchmo" Armstrong (1900–1971), New Orleans trumpeter, strongly influenced jazz in its formative decades, from the 1920s through the 1940s. He excelled at interpreting New Orleans jazz, the blues, and swing. Armstrong's success over such a long period was only partly owing to his sheer musical talent. Among his other assets were flexibility and an ability to grow. When popular music changed, many performers formerly at the pinnacle of fame found themselves cast off. Not Armstrong; he led the way into the new styles of the 1920s and 1930s. As jazz evolved from a "folk" to a "classical" genre, Armstrong's formal training as a youth in the School for Waifs (orphans) also stood him in good stead. Other musicians, some untrained and unable to read music, were left behind.

New Orleans, the first jazz style to come to national attention, was Armstrong's springboard to national recognition as well. A rambunctious, polyphonic style, New Orleans jazz developed partly out of funeral-band processions. In these processions, the band instruments—trumpet or cornet, clarinet, trombone, banjo, Sousaphone, and drums—played slow, dirge-like hymns on the way to the cemetery. Returning from the cemetery, a trumpet or drum would give a special signal and the band would break into the joyous, carefree, improvising style we now call New Orleans style, and the mourners would begin to strut and dance, perhaps reflecting an African trait reaffirming the joyous attitude of the living. (See Chapter 13 and the discussion of the *Migodo* and the Chopi dance suite.) Good examples of this

"Dixieland"

kind of early New Orleans music may be heard on performances by the Preservation Hall Jazz Band and the Young Tuxedo Brass Band.

From about 1915, a group of white musicians calling themselves "The Original Dixieland Jazz Band" adopted the early New Orleans style. ODJB success after World War I led to other white groups copying their style. The term "Dixieland" often applies to these white groups, although some listeners use it to refer to any New Orleans-influenced style, including Armstrong's.

Young Armstrong played the blues on Bourbon Street, and he played in funeral bands and parades, and for dances. He picked and chose stylistic elements from the first pioneers of jazz: Bunk Johnson, Freddy Keppard, King Oliver, Buddy Bolden, and Jimmy Noone. At the School for Waifs, he had learned to read music and he had learned standard trumpet fingering. His reputation for creativity,

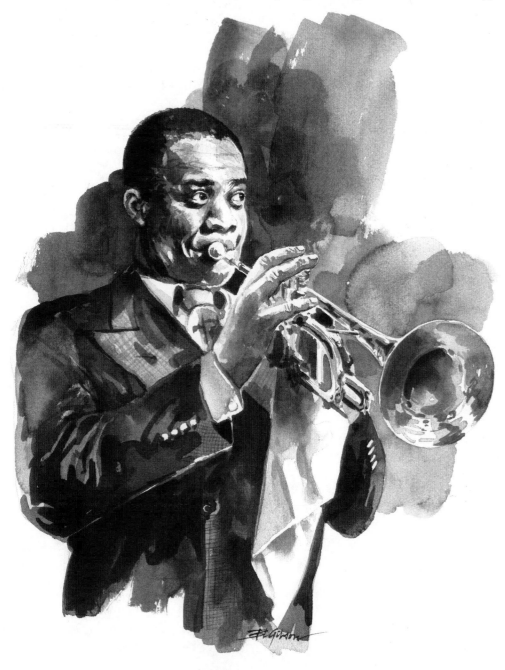

Louis "Satchmo" Armstrong, a leading jazz interpreter
Drawing by Barbara L. Gibson

Chicago

Fletcher Henderson

Armstrong as pioneer influenced by others, influence on others

 The history of jazz and its stylistic periods (Dixieland, Swing, Bebop, West Coast, Free, Fusion) has its origins in New Orleans at the turn of the 20th century. The texture is polyphonic with each instrument improvising melody, harmony, and rhythm according to its idiom.

 64 "Big Butter and Egg Man"

Armstrong: cultural ambassador

technique, and repertoire, of having that special quality of rhythmic "swing," brought Armstrong up the Mississippi River to Chicago in 1922 to join King Oliver's Creole Jazz Band.

The exuberant New Orleans style that became so popular in Chicago in the early 1920s (and that is still imitated today in some quarters) is well represented in "Dippermouth Blues," recorded in 1923. Despite the title's carrying Armstrong's nickname, he plays second "trumpet," that is, cornet. Oliver plays the muted cornet solo (compare the African "fuzz" tone; see Chapter 13), and the great Johnny Dodds plays the clarinet solo. The form of "Dippermouth Blues" is the classic twelve-bar blues chord progression mentioned earlier. The democratic equality of all the melody lines in the first chorus illustrates the typical New Orleans polyphonic texture. Each instrument improvises a melody, counter-melody, harmony, or rhythm part according to the idiom of that instrument in the New Orleans style. In the solos, we hear a tinge of blues expression in the clarinet and a strongly rhythmic cornet. The beat is a solid four-to-the-bar and the style is a toned-down, dressed-up Chicago version of what the Preservation Hall Jazz Band plays in New Orleans.

Within two years, Armstrong had outgrown Oliver's band and in 1924 began his career in New York with Fletcher Henderson's highly successful jazz band. Armstrong's ability to combine the best of the oral (old) tradition with the written (new) tradition is well demonstrated by his recording of "Big Butter and Egg Man," recorded in 1927. Using his own band of New Orleans musicians, The Hot Five, and recording in Chicago, Armstrong shows the sweeping influences of his new style. His cornet solos energize the performance with a combination of a lyrical, blues-like melodic line and an intricate rhythmic drive from the New Orleans instrumental style. He is now a star soloist, not merely another instrumentalist taking a solo turn. The influence on Armstrong of Don Redman's arrangements for the Henderson band are evident in the anticlimactic end of the piece. For a couple of cornet choruses, the downbeat disappears and the only accompaniment is the lone banjo on the offbeat. Contrast this with the now old-fashioned sounding solo by Dodds on clarinet accompanied by the New Orleans four-to-the-bar banjo strumming. Armstrong's forward-looking ideas also include motivic transformation of melodic ideas, which was to be an influence on later jazzmen such as Charlie Parker. Armstrong again became a leading influence during the swing era.

Armstrong went on in the 1930s and 1940s to fame and fortune, and rightfully so. In the 1950s, the United States Department of State sent him abroad as a cultural ambassador, and when jazz became a subject for historical study, Armstrong received credit for his profound influence on the course of jazz history. Even through the next generation of esotericism, Armstrong's name and reputation remained intact and revered. In the history of jazz, Armstrong is considered a true pioneer.

Music changes but human love for and need for music never changes. Seek the universals that bind us together and celebrate the diversity that makes us different.

KEY WORDS

Ragging, blue notes, standard blues form, mouth harp, call-and-response, New Orleans

SUGGESTED READING

Blesh, Rudi and Harriet Janis. *They All Played Ragtime: The True Story of an American Music.* New York: Oak Publications, 1971.

Heilbut, Tony. *The Gospel Sound: Good News and Bad Times.* New York: Simon & Schuster, 1971.

Jones, LeRoi. *Blues People: Negro Music in White America.* New York: W. Morrow, 1963.

Keil, Charles. *Urban Blues*. Chicago: University of Chicago Press, 1966.

Kingman, Daniel. *American Music: A Panorama*. New York: Schirmer, 1979.

Megill, Donald D. and Richard S. Demory. *Introduction to Jazz History*. Englewood Cliffs: Prentice Hall, 1989. (A good, if somewhat simplistic, description of the development of jazz and its roots; it includes separate chapters for the various blues traditions as well as pictures and analyses of tunes.)

Oliver, Paul. *The Story of Blues*. Philadelphia: Chilton, 1968.

——, Max Harrison and William Bolcom. *The New Grove Gospel, Blues and Jazz with Spiritual and Ragtime*. New York: Norton, 1986. (A most helpful starting point for a discussion of the topic. It includes entries on individuals and notes on recordings.)

Sales, Grover. *Jazz: America's Classical Music*. Englewood Cliffs, New Jersey: Prentice-Hall Press, 1988, ©1984. (Written by the famous jazz critic, this book is easy to read and contains many first-hand accounts of various instrumentalists and singers. Certain sections of the work provide excellent recommendations for purchasing recordings.)

Schuller, Gunther. *Early Jazz: Its Roots and Musical Development*, vol. 1 of *The History of Jazz*. New York: Oxford University Press, 1968.

Shapiro, Nat and Nat Hentoff (eds.). *Hear Me Talkin' to Ya: The Story of Jazz as Told by the Men Who Made It* (New York, 1955), rep. ed. New York: Dover, 1966.

Tirro, Frank. *Jazz, a History*. New York: Norton, 1977.

Williams, Martin. *Where's the Melody? A Listener's Introduction to Jazz*, rev. ed. New York: Pantheon, 1969.

——. *The Smithsonian Collection of Classic Jazz*, rev. version (booklet accompanying recordings). Washington, D.C.: Smithsonian Institution Press, 1987.

Zabor, Rafi. *The Bear Comes Home*. New York: Norton, 1997.

SUGGESTED LISTENING

The Smithsonian Collection of Classic Jazz. Smithsonian Collection of Records RC 033.

Howlin' Wolf, *Evil*, Chess CH 1540.

Marion Williams, *This Too Shall Pass*, Nashboro 7204.

The Little Wonders, Kaleidophone KS 801.

HELPFUL VIEWING

Videodisc. (Part of Yazoo Presents series.) Prod. Sherwin Dunner and Richard Nevins, ed. Dana Heinz. Imprint: Yazoo Video: 514, © 2000. [60 minutes]

General Background and Ragtime

Volume 3 of *The JVC & Smithsonian/Folkways Video Anthology of Music and Dance of the Americas* deals with the United States. A production of JVC/Multicultural Media, [1995].

West African Heritage

See Chapter 13 entry.

Blues

Bessie Smith and Friends, 1929–1941. Imprint: Jazz Classics: Distributed by Audiofidelity, ©1986. (Performances by Bessie Smith, Nina Mae McKinney, Nicholas Brothers, Eubie Blake, Lena Horne, Albert Ammons, Pete Johnson, Teddy Wilson, and others.) [39 minutes]

LADY DAY: *The Many Faces of Billie Holiday* (Masters of American Music series). A co-production of Toby Byron/Multiprises in Association with Taurus Film, Munich and

Video Arts. Prod. by Toby Byron and Richard Saylor; dir. Matthew Seig; written by Robert O'Meally. Imprint: KULTUR, 1991. [60 minutes]

Wild Women Don't Have the Blues. Calliope Films, Inc., prod. by Carole Doyle, Van Valkenburgh and Christine Dall; dir. Christine Dall; cinematographer, Steven Ascher; ed. Jeanne Jordan; narrator, Vinie Burrows; advisors, Chris Albertson [et al.] Imprint: California Newsreel, ©1989. [58 minutes]

Gospel

Gospel and Spirituals (From Jumpstreet series, [2]). A WETA production; prod. & dir. by Robert Kaiser, hosted by Oscar Brown, Jr. Imprint: PBS Video, ©1980. [29 minutes]

Too Close to Heaven: The Story of Gospel Music. A presentation of Films for the Humanities & Sciences; an IBT/CTVC production for Channel 4 in association with Jerusalem productions. (A videocassette release of the 1996 documentary film originally broadcast on British television.) Prod. Leo St. Clair; dir. Alan Lewens; narrator, Alphonsia Emmanuel. (Camera, Michael Callan; ed. Bruno Mansi.) Imprint: Films for the Humanities & Sciences, ©1997.

At the Jazz Band Ball: Early Hot Jazz, Song and Dance 1925–1933. Videodisc. (Part of Yazoo Presents series.) Prod. Sherwin Dunner and Richard Nevins, ed. Dana Heinz. Imprint: Yazoo Video: 514, © 2000. [60 minutes]

(New Orleans) Jazz

Let The Good Times Roll: A Celebration of New Orleans Music and Its Heritage Festival. Presented by Island Visual Arts, produced by Delilah Music Pictures. Prod. Stephanie Bennett; dir. Paul Justman. Imprint: PolyGram Video, ©1992. [90 minutes]

Louis Armstrong, the Gentle Giant of Jazz (American Lifestyle series). Hosted and narrated by Hugh Downs. Imprint: AIMS Media, 1994. [24 minutes]

Louis Armstrong: Satchmo in Stockholm, 1962 (Jazz and Video Collection series). "Made in the E.E.C." Imprint: Green Line Video, ©1992. [41 minutes]

Satchmo (Masters of American Music series, no. 2). Co-production of Toby Byron/Multiprises with CBS Music Video Enterprises, Taurus Film, Munich, and WNET/New York. Prod. by Toby Byron, written by Gary Giddins, dir. by Gary Giddins with Kendrick Simmons. Imprint: CMV Enterprises, ©1989. [87 minutes]

15
REVIEW SHEET

Short Answers

1. Name and describe two styles in the history of African-American music.

2. Name at least three elements which African-American music shares with African music.

Short Essays

1. Why is jazz a "performer's art"?

2. How did Louis Armstrong succeed in making transitions from one style to another?

3. How has African-American music influenced mainstream popular music?

Farewells and greetings—

Now that you have finished the text, it may be fun to apply some of its contents in your own musical experiences. While listening to your favorite rock song on your iPod, you may wish to trace its lineage to a "boogie-woogie" progression (Chapter 5) that became the basis for an early R&B work, which in turn became the parent of your present selection. Another suggestion: since many modern popular works make use of various media, you may find it possible to relate one of them to Wagner's idea of the *Gesamtkunstwerk* or find parallels in Beijing opera (Chapter 9) and come up with a surprising congruity, such as comparing a Wagner music drama with an elaborate production by a metal band that makes use of cinematic features. Still another possibility could be an "eclectic" approach in which a composer draws from many other sources, giving rise to a variety of questions. Bartók (Chapter 11) assimilated various ethnic folk traits in his "art" or "classical" music ("classical" in the general sense, not only that of Chapter 8), while heavy metal draws on the music of J. S. Bach (Chapter 7) and various "church modes," especially the Aeolian and Phrygian (Chapter 4 and Appendix III), as well as the traditional medieval interval of a tritone (three whole-steps, Chapter 11) with its satanic association. With eclecticism, it is sometimes difficult to separate "popular" or "folk" from "classical" music, especially since the "popular" music of one generation often becomes accepted into the rarefied classification of "art" or "classical" in the next. These topics always provide fascinating points to discuss.

Whatever your choice, whether any, all, none of the above—or, better yet, to create an analytical system of your own—the author and those of us who have contributed to this book wish to celebrate with you the many and diverse wonders abounding in the living world of music. To each and every one of you, best of luck and joyous listening.

Glossary

ABGESANG (AHB-geh-SAHNG; German) The *b* part of an old musico-poetic structure called *Bar* form: *aab.*

ABSOLUTE MUSIC Music written without any extra-musical association supplied by its composer.

ACADEMIES Semi-private concerts given at court (18th century).

ACCELERANDO (ah-CHELL-ehr-ON-doe) Gradually getting faster.

ACCIDENTAL A sharp, natural, or flat that is added to the music and is not part of the key signature.

ACCOMPAGNATO (ah-komm-pah-NYAH-toe) Accompanied; associated with a recitative having an accompaniment for several instruments.

ADDITIVE METER A system of unequal beats, involving ordinary note-values and dotted notes.

AEROPHONES Instruments through which air must be blown.

AFFECTIVE STYLE In the Baroque era, an expressive and sometimes quasi-declamatory vocal line (especially in the early 1600s), reflecting deeply felt emotions.

AGOGIC ACCENT A strong beat, in a metric pattern, that is emphasized rhythmically rather than by dynamics, being performed longer than written.

AIR Song or tune; in Italian, "aria."

AITAKE (eye-TOCK-ay) Japanese harmonic structures performed on the *shō* (mouth organ).

A-JAENG (AH-jeng; Korean) A bowed zither.

ĀLĀP (ah-LAHP; Indian) An improvisation section in free rhythm, introducing the fixed pulse section.

ALEATORY (AY-lee-ah-tor-ee) Used to describe the chance or indeterminate music of composers such as Pierre Boulez; from the Latin *alea,* a game of dice (or chance).

ALEXANDER I, CZAR OF RUSSIA (1777–1825) At the Congress of Vienna, the Czar's forces protected France from the vindictive demands of the Prussian King. Alexander was a driving force behind the signing of the Holy Alliance among the Great Powers of Europe in 1815. Like the Prussian King, Alexander subsequently became increasingly hard-line in his conservatism.

ALLA BREVE (AHL-lah BREV-eh) A tempo marking suggesting the flow of duple meter; indicated by ₵.

ALLEMANDE (ahl-läh-MAHND; French) One of the principal dances in the Baroque suite, in duple time and moderate tempo.

ALSO SPRACH ZARATHUSTRA (AHL-zo shprach tsara-TOOS-tra; German) "Thus Spake Zarathustra," a tone poem by Richard Strauss (1896), based freely on Friedrich Nietzsche's philosophical exposition of the same title (1883–85; Nietzsche subtitled his work "A Book for All and None").

AL'ŪD See *'ŪD* and *LUTE.*

ANDANTE (ahn-DAHN-tay) "Walking"; used as a tempo marking for a slow movement not as slow as *Adagio.*

ANHEMITONIC SCALE A scale with no half-steps, such as a whole-tone scale or the Javanese *slendro.*

ANTECEDENT A term meaning "preceding," often associated with the phrase grouping antecedent-consequent, a grouping that signifies "preceding" going to "following" (or "concluding"). Such a phrase grouping is also referred to as "question-answer."

APOLLONIAN (ah-pah-LOW-nee-un) Suggestive of classical grace, balance, objectivity, and control of the ancient Greek god, Apollo. Cf. DIONYSIAC.

ARCH FORM A one-movement or multi-movement form following a symmetrical design such as *ABCBA*.

ART TROUVÉ (ahr trew-VAY; French, "art found") OBJET TROUVÉ (ob-zhay trew-VAY; French, "object found") A concept stressing the discovery of art in a mundane object (a can of Campbell's Tomato Soup), as opposed to an artistically manufactured work (Michelangelo's *Pietà*).

AUFKLÄRUNG (owf-clair-rung) A German term for "enlightenment," often referring to the German "Age of Enlightenment."

AUTHENTIC CADENCE An ending that proceeds from a chord built on the fifth scale degree going to a chord on the first scale degree: a V-I ending.

ĀVARTA (Indian) A repeating rhythmic cycle.

BALLETS RUSSES (BAH-lay ROOSS; French) "Russian ballets" company in Paris 1909–29 conceived by the Russian impresario Sergei Diaghilev.

BALUNGAN (Javanese) The basic melody in a *gamĕlan.*

BAR FORM A medieval German poetic form, with the musical structure *aab* (two "*Stollen*" and an "*Abgesang*").

BAROCCO (bahr-ROKE-oh; Italian) Term used in the 18th century to describe a far-fetched syllogism, from which "Baroque" is partially derived.

BARROCO (bahr-ROKE-oh; Portuguese) Term used in the 18th century to describe an odd-shaped pearl, from which "Baroque" is partially derived.

BASSO CONTINUO (BAHS-so cawn-TEEN-oo-oh) The continuous, figured bass of the Baroque era; *Generalbass* in German, "thorough bass" in English.

BAUDELAIRE, CHARLES PIERRE (boad-LAIR, 1821–67) A French poet and critic whose *Les Fleurs du mal* (1857, 61) greatly influenced Stéphane Mallarmé and other Symbolist poets. Baudelaire, a great admirer of the American poet Edgar Allan Poe (whose works he translated into French), established symbolic correspondence among various sensory images, and his approach was embraced by later generations of poets and composers.

BHAIRAV (BYE-rahv, North Indian) Name of a melodic mode, or *rāga.*

BINARY FORM A two-part form in which the first part moves from the tonic key to a second key, and the second part moves from the second key back to the tonic.

BISMARCK, PRINCE OTTO EDUARD LEOPOLD VON (1815–98) The "Iron Chancellor," was the creator and first chancellor (1871–90) of the German Empire, following the conclusion of the Franco-Prussian War. Previous to 1871, "Germany" was actually a rather loose confederation of territories unified mainly through the German language and Germanic heritage.

BONANG (BOW-nahng; Javanese) A set of bronze inverted kettles of the Javanese *gamĕlan* orchestra.

BOUZOUKI (boo-ZOO-key; Greek) (1) A long-necked fretted lute; (2) a popular genre originating in the 1920s.

BOZUQ (BOOZE-uhk; Lebanese) A long-necked fretted lute, related to the Greek *bouzouki.*

BUFFA An Italian word associated with Italian "comic" opera, *opera buffa,* usually in two or, later, four acts.

BUKA (BOO-kah; Javanese) A solo introduction to a *gamĕlan* piece.

CABAÇA (kah-BAHSS-ah; African-Brazilian) A net rattle.

CADENCE (KAY-dense) The ending of a phrase, period, section, or movement in which a harmonic progression helps punctuate the musical line.

CADENZA (kah-DEN-za) An elaborate (originally improvised) soloist's passage at an important cadence.

CANCRIZANS CANON A "crab" canon: a type of canon in which a melody is performed forwards and backwards (by different voice parts) at the same time.

CANON A musical composition in which a melody is strictly imitated in one or more other voice parts. If the melody begins over again before the imitating voices conclude, the canon becomes a "round."

CANTATA A sung musical composition.

CASTLEREAGH, ROBERT STEWART, VISCOUNT CASTLEREAGH (KAHS-ul-ray, 1769–1822) An Anglo-Irish politician who was the United Kingdom's Foreign Secretary from 1812 to 1822 and represented Great Britain at the Congress of Vienna, where he was later replaced by Arthur Wellesley, first Duke of Wellington.

CASTRATO (kahs-TRAH-toe) A male singer whose testicles were surgically removed at puberty to preserve his high range.

CATHARSIS According to the ancient Greeks, a purifying discharge of psychic energy, a healing quality attributed to certain types of melodies.

CAVOUR, COUNT CAMILLO BENSO DI (1810–61) Italian Statesman and Premier of the Kingdom of Sardinia (1852–59) and a leader of the *Risorgimento* movement. In 1847, he founded the liberal daily *Il Risorgimento*.

CELESTA (chay-LESS-tah) A keyboard-chime instrument that projects soft, angelic sounds.

CEMBALO (CHEM-bah-low) The Italian word for harpsichord.

CENTONIZATION (SENT-uh-na-ZAY-shun) The process of patching together a melody from standardized melodic units.

ÇEVGÂN (chev-gyahn; Turkish) The Turkish crescent ("Jingling Johnny").

CHALUMEAU (SHAL-oo-MOE) (1) A 17th-century single-reed woodwind instrument with a cylindrical bore (in shape) and a possible forerunner of the modern clarinet; (2) The lowest register of the modern clarinet.

CHĚLĚMPUNG (cheh-LEM-pung; Javanese) A plucked zither of the Javanese court *gamĕlan* orchestra.

CHING CHÜ, CHING-HSI (Chinese) see JINGJÜ JINGXI.

CHITTARONE (KEY-tah-ROE-nay; Renaissance) A long-necked version of the theorbo (bass lute).

CHORALE (German: Choral) A congregational hymn of the German Protestant Church.

CHORD Three or more separate pitches combined.

CHORDAL TEXTURE A texture in which all parts move at the same pace (= chords). See HOMORHYTHM.

CHORDOPHONES Instruments whose sounds are created by vibrating strings, whether plucked, bowed, hammered, or air-blown.

CHOU (jow as in "show"; Chinese) A clown role in Beijing operas.

CHROMATIC MUSIC Music that stresses the use of many half-steps, resulting in the appearance of many accidentals (sharps, flats, and naturals not part of the key signatures).

CHURCH MODES A series of modes (originally eight) gleaned from traditional melody types in liturgical chant by medieval Frankish theorists, then further codified by Renaissance theorists.

CIMBALOM (SIM-ball-um) A Hungarian (Roma) instrument of the hammered dulcimer family.

CIMPOI (CHEEM-poy) A Romanian bagpipe.

CIOCIRLIA (CHYO kir-LEE-uh) A national folk dance ensemble of Romania.

CLARINO (Italian) (1) The upper range of a Baroque trumpet; (2) from the Middle Ages through the 18th century, name for a trumpet.

CLARION A type of trumpet of the Middle Ages and Renaissance.

CLASSIC (1) In music, the era of Haydn and Mozart (late-18th century); (2) an adjective referring to a musical style characterized by objectivity and an emphasis on the ultimate rather than the immediate, the Apollonian ideal as opposed to the Dionysiac; (3) as a noun or adjective, a high standard that serves as a model against which other styles are judged; (4) **classical,** as an adjective, is a reference to models and standards of Greek and Roman antiquity.

CLAVICHORD A small, portable keyboard of medieval origin, in which keys are attached to tangents that lightly strike the strings.

CLEF (Latin: *clavis*) A letter or sign used to establish the identity of pitches.

CLUSTER CHORD (HARMONY) Chords built on the intervals of major and minor 2nds.

COL LEGNO (koe-LAY-nyo; violin) To be played with the wood rather than hair of the bow.

COLLAGE (coe-LAZH) An art term, originally associated with Synthetic Cubism, describing a technique in which cutouts, often from newspapers and other objects from the everyday world, are pasted on a surface to create a new composition. In music, it implies a new organization of relatively familiar musical snippets.

COLOTOMIC CYCLE A periodic recurrence of timbres (and pitch levels) rather than that of a rhythmic or metric pattern.

COMPOUND FORM A form such as a symphony or suite that consists of more than one movement.

COMPOUND METER A meter in which the beats are dotted values and thus subdivisible by three.

CONCERTO (kon-CHAIR-toe) In the early Baroque, a sacred work that combines instruments and voices; in and after the late Baroque, a compound form for orchestra and one or more solo instruments, usually in three movements.

CONCERTO GROSSO (kon-CHAIR-toe GROW-sso) The grand concerto of the late Baroque, consisting of a solo group *(concertino)* and a tutti group *(ripieno)* appearing as contrasting sonorities.

CONSEQUENT Following as a result or conclusion. See ANTECEDENT.

CONSONANCE An interval or chord that is stable. Consonant intervals include the unison, octave, and fifth (all "perfect"), as well as the third and sixth (both "imperfect").

CONTRAFACTUM: A Latin term denoting a vocal piece featuring the substitution of one text for another with no change in music.

CORRENTE (kohr-REN-tay) A dance that became a standard movement of the Baroque suite; a fast Italian dance in triple time. See COURANTE.

COUNTERPOINT The existence of more than one voice-part in a texture.

COURANTE (kuhr-RAHNT) A French dance that became a standard movement of the Baroque suite; a moderate dance often in 6/4 time with hemiola shifts to 3/2. In origin, related to the *corrente.*

CROSS ACCENTS Conflicting accents resulting from different metric patterns performed simultaneously.

CSÁNGÓ (CHAHN-go) Hungarians formerly living in Romania.

CSÁRDÁS (CHAR-dahsh; Hungarian) A fast, duple-meter Hungarian ballroom dance with stylized folk elements.

DA CAPO ARIA A song movement found most often in Neapolitan operas of the late Baroque, with the musical form ABA, in which B provides contrast. On its repetition, A varies by improvised elaborations.

DAFF (Arabic) A frame drum.

DALANG (DAH-lahng; Javanese) A puppeteer of the shadow puppet drama *Wayang kulit*.

DAN (dahn; Chinese) A female role in Beijing operas.

DARB (Iranian) The generic term for a rhythmic mode, the equivalent of the Turkish usûl and Arabic iqa'ā.

DASTGAH (Iranian) The generic term for a melody type, the equivalent of the Arabic magām.

DAVUL (dah-ool; Turkish) A bass drum.

DEVELOPMENT The part of a fugue that follows its exposition. See also SONATA FORM.

DIAPHONY (die-YAH-fah-nee) An oblique-motion, two-part texture in which drone and melody are sung; in the Balkans, it is sung by women.

DIATONIC MUSIC Music that conforms to traditional heptatonic scales or modes (Ionian, Aeolian, etc.) without the addition of accidentals that lie outside the key signature.

DIES IRAE (DEE-ace EE-ray; Latin) "Day of Wrath"; a plainchant sequence from the Requiem Mass.

DIMINUTION The use of shorter note-values for a theme on its repetition.

DIONYSIAC (DIE-ah-NIZ-ee-ack) Referring to the cult honoring Dionysos, the ancient Greek god of wine and fertility; in the arts, characterized by Romantic freedom and spontaneous feeling. Cf. APOLLONIAN.

DJANGO (JOHNNG-go) The title of a jazz composition honoring gypsy guitarist Django Reinhardt.

DOINA (DOY-nah; Romanian) A blues-like lyrical song genre typical of Romania.

DOINA DE JALE (DOY-nah duh ZHA-lay; Romanian) A funeral doina.

DOMINANT The fifth degree of the scale (in solfège, it is *sol*).

DORIAN (mode or scale) A minor-related scale with the ascending pattern w-h-w-w-w-h-w.

DOTARA (Bengali) A four-string lute.

DULCIMER A hammered psaltery of medieval origin.

DÜM (doom; Turkish) A spoken syllable representing a low-pitched drum sound.

DUNDUN (doon-doon; African) A variable-pitched drum family of the Yoruba tribe of Nigeria.

DUTAR (DOU-tar, Turkish) Lute of central Asia.

DYNAMIC MARKINGS Markings that designate the relative loudness or softness of a given musical passage. Also referred to as "dynamics."

ECHIGO JISHI (EY-chee-go JEE-shee; Japanese) A lion dance.

EKPHRASIS (ECK-frah-sis; adj. ekphrastic; Greek) The transference of a visual representation into a verbal/written one, in which process of medium change ("transmedialization") the new presentation ("re-presentation") is transformed by the presence of an element or combination of elements absent from, or not apparent in, the original ("primary") representation. In musical ekphrasis, the original representation may be visual and (or) verbal/written before its musical transmutation.

ELECTRONIC (ELECTROACOUSTIC) MUSIC Taped music dating from the early 1950s, in which the initial impulse is electronically created to form the basis of a musical composition. Electroacoustic music can include *musique concrète* together with electronic music.

ENGELS, FRIEDRICH (1820–95) A German social theorist who co-authored, with Karl Marx, *The Communist Manifesto* of 1848.

EPISODE A musical passage where the main theme or subject is absent.

ETHOS An ancient Greek concept attributing to music the power to affect human character.

EXPOSITION (1) The first part of a fugue, in which the initial statement of the subject is presented (one at a time) in all the parts; (2) the first part of a sonata form (see SONATA FORM).

EXPRESSIONISM An early 20th-century movement in art in which inner feelings were often externally expressed through various types of distortion; the art created was often overtly emotional in nature.

FANTASIA (fahn-ta-ZEE-ah) A piece in relatively free form, often spontaneous-sounding, as if improvised or given to free flight of fancy.

FAUVES, LES (lay fove; French) "Wild Beasts"; a group of young painters exhibiting at Paris in 1905 and 1906.

FERMATA (fair-MAH-tah) A "pause," often appearing as the sign over ⌢ or under ⌣ a note, indicating the note be held longer.

FIGURED BASS A bass line that suggests chords above it through the use of numbers (or letters).

FIN'AMORS (FAN-uh-moor) An expression in medieval Provençal literature signifying the knightly concept of ideal love or "courtly love."

FIPPLE FLUTE A recorder.

FLAMENCO (fla-MENG-koe) An Andalusian song with guitar accompaniment and usually danced.

FLUIER (floo-YAIR; Romanian) A folk flute.

FLUTE (TRANVERSE) A flute held horizontally and blown from the side; of ancient origin.

FOLÍA (foe-LEE-yah) A stock bass melody of the late Renaissance and Baroque over which a set of continuous variations is built.

FREDERICK WILLIAM III, KING OF PRUSSIA (1770–1840) Reigning from 1797 to 1840, Frederick had lost all Polish territories in the Napoleonic wars, after which he became increasingly reactionary. Through his minister at the Congress of Vienna, Prince Karl August von Hardenberg, the King wished to impose heavy sanctions on France, which found a protector in Czar Alexander I of Russia.

FRISS (frish) The fast part of a Hungarian dance such as *verbunkos*.

FUGATO (fyoo-GAH-toe) Fugal section within a larger piece not a fugue.

FUGUE (fyoog) An imitative musical form that blossomed during the Baroque, in which a theme (subject) is developed contrapuntally.

FUNDAMENTAL The first partial; the pitch resulting from the condensations and rarefactions of the air molecules set in motion by the entire length of the vibrating body, whether string or air column.

GAGAKU (GAH-gah-koo; Japanese) The Imperial Court Orchestra.

GAMBANG (GAHM-bahng; Indonesian) A xylophone.

GAMĚLAN (GAH-meh-lahn) An Indonesian orchestra.

GANGSARAN (GAHN-sah-rahn; Javanese) A type of loud orchestra piece with much repetition of a single note.

GARIBALDI, GIUSEPPE (1807–82) General Garibaldi, "Founder of Modern Italy," was a leading and militant member of the *Risorgimento*. In 1850–51, he resided in Staten Island in the United States.

GAT (gaht; Indian) A musical work that features variations on a composed melody.

GAVOTTE (gah-VAUGHT) A 17th-century French dance (and optional movement in the Baroque suite) in 4/4 time and moderate tempo; its upbeat usually occurs on the second half-note of 2/2 time, or the third quarter in 4/4 time.

GAZEL (gah-ZELL; Turkish) An improvised vocal piece in free rhythm.

GĚNDER (guhn-dair; Javanese) A metallophone with thin keys, resonated by large bamboo-like tubes.

GENDING (gehh-DING; Javanese) A composition.

GERONGAN (gehh-RONG-ahn; Javanese) A male chorus.

GESAMTKUNSTWERK (geh-SAHMT-koonst-verk; German) Associated with the later operas of 19th-century composer Richard Wagner, the term is used to describe a work that integrates the arts, including music, poetry, and visual spectacle. By extension, the term can also be applied to ballets and other genres.

GIGUE (zheeg) A standard dance in Baroque suites, the Continental gigue shared a common ancestry with the English and Irish *Jig*, all stressing compound meter.

GOETHE (GUH-tuh) Johann Wolfgang von Goethe (1749–1832) was a German philosopher, novelist, dramatist, poet, humanist, and scientist, and, in addition, a Minister of State at Weimar (1775–85). Goethe's novella *The Sorrows of Young Werther* (1774) and the sometimes autobiographical novel *Wilhelm Meister's Apprenticeship* (1795–96) inspired many Romantic thinkers of the next generation, and his drama based on the Faust legend, especially *Faust,* Part 2 (1832), inspired many painters, musicians, and writers.

GONG AGĚNG (Ah-gung; Javanese) Great gong.

GONGAN (GONG'n; Javanese) A segment of a composition marked off by a gong.

GRAND OPERA A 19th-century form of serious opera popular in France and characterised by a large orchestra, spectacular staging, quasi-historical subject matter, and a grandiloquent, gestural style.

GREGORIAN CHANT The chant of the Roman Catholic Church, named after St. Gregory the Great, Pope from 590 to 604.

GUSLA (GOOSE-lah; Serbian, Croatian, Bulgarian) A one-string fiddle used by epic singers.

HAIDUKS (HIGH-dukes; Romania) A mountain people; outlaws.

HANE (Turkish) A section of an instrumental prelude or postlude.

HARDANGER FELE (HAR-dang'r FELL-a; Norwegian) A folk violin with sympathetic strings.

HARMONIC (noun) (1) An overtone produced on the violin; (2) See PARTIAL (noun).

HARMONIC RHYTHM The relative rate of harmonic change in a musical passage.

HARMONY Generally, the vertical (simultaneous) aspects of musical texture; specifically, a progression or succession of chords; a single chord.

HARP An ancient, plucked, open string instrument with a "body" that acts as a resonator, and a neck used for string tension.

HARPSICHORD A keyboard instrument in which strings are plucked by quills or bits of hard leather.

HASAPIKOS (hah-SOP-ee-kohss; Greek) A dance in fast 2/4.

HEMIOLA A rhythmic relationship stressing a 3:2 ratio; the superposition of a 3/2 accent pattern on a metrical pattern of 3/4 (or a 3/4 accent pattern on 6/8 meter).

HEMITONIC SCALE A scale that contains semitones (half-steps), such as a chromatic scale or any heptatonic scale.

HEPTATONIC SCALE A seven-note scale, such as any of the "church" modes, including the major and minor scales (= the "Ionian" and "Aeolian" modes; see APPENDIX III).

HETEROPHONY A texture in which two or more somewhat different versions of a melody (often vocal + instrumental) are presented simultaneously. It is frequently found in many cultures and is characterized by a melody line that appears to have "hazy" or "soft" edges.

HIDJAZ (he-JAZZ; Turkish) A mode that has an augmented 2nd interval between the 2nd and 3rd degrees. The equivalent of the Arabic *Hijaz.*

HINDEWHU (heen-de-hwoo; African) A hand-flute of one note used by Ba-Benzele people.

HOCKET In medieval and African polyphony, a style in which different voices alternate in succession performing a single pitch; while one part performs, the other has rests, creating a syncopation reminiscent of a hiccup.

HOFFMANN, ERNST THEODOR AMADEUS (Wilhelm) (1776–1822) An early Romantic composer, critic, caricaturist, jurist and writer of fantasy who changed his third given name from Wilhelm to "Amadeus" in 1813 as a tribute to Mozart. His writings inspired many later writers including Edgar Allan Poe, Franz Kafka, and others. His masterpiece is the two-volume fragment *Die Lebensansichten des Katers Murr* (The Life Views [Outlook] of Tomcat Murr, 1819–21) in which Hoffmann introduces the genius musician Johannes Kreisler (inspiring a work by Schumann). Jacques Offenbach's opera *The Tales of Hoffmann* and Tchaikovsky's ballet *The Nutcracker* are both based on works by Hoffmann.

HOMME ARMÉ, L' (LAWM ahr-MAY) A widely used anonymous secular song of the 15th century and the basis for many polyphonic settings of the Mass during the Early and High Renaissance.

HOMOPHONY (hoh-MAH-ph'n-ee) A musical texture consisting of melody and accompaniment.

HOMORHYTHM See CHORDAL TEXTURE.

HORA (HORE-ah; Israeli) A national folk dance of Israel.

HORNPIPE A medieval folk instrument, consisting of a cane reed fitted to a cow horn or shell; 16th century: English dance in triple meter; 18th century: English sailor dance in 4/4 meter.

HOSHO (HOE-show; African) A net rattle of the Shona people of Zimbabwe (Rhodesia).

HSIAO SHENG (h'see-ow shung) The role of a young man in traditional Beijing Opera.

HU-CHIN (WHO-chin; Chinese) A spike fiddle accompanying voice in Beijing Opera.

"HUNGARIAN" ("HUNGARIAN-MINOR," "ROMANI-MINOR") SCALE The Aeolian mode with raised fourth and an often raised seventh degree, thus creating augmented seconds between the third and fourth degrees, and the six and seventh degrees.

HURDY GURDY Also called "wheel fiddle"; the hurdy-gurdy dates from the Middle Ages and is a string instrument to which a keyboard is attached. Bowing action is replaced by a wheel crank at the side.

ICHING (EE-dzing) The Book of Changes from the Five Classics of Confucianism.

IDÉE FIXE (EE-DAY FEEKS) The fixed idea, a melody that is developed and recurs in later movements of a compound form, first used by Hector Berlioz (*Symphonie fantastique,* 1830).

IMITATIVE COUNTERPOINT A type of texture in which the various voice-parts have the same (or similar) melodic material with staggered entrances.

IMPRESSIONISTIC MUSIC A musical style, associated mainly with Achille-Claude Debussy and some of his followers, based on a term originally applied to the paintings of Claude Monet and some of his contemporaries in the 1870s. Impressionistic music is often characterized by an emphasis on "mood," "atmosphere," an imaginative use of timbre, a rich harmonic palette, and a generally low dynamics level. Debussy,

however, rejected the appellation with regard to his music, and he associated himself instead with the symbolist movement in poetry and drama.

INDETERMINACY Performer-associated creativity in Post-World War II avant-garde music, espoused by the American John Cage and his followers.

INTERVAL The distance between two pitches.

INVERSION A melody presented upside-down.

IQA'Ā (Pl IaA'ĀT; Arabic) The generic name for a rhythmic mode.

ISORHYTHM A repeating rhythmic pattern; in 14th-century polyphony, isorhythm passages were lengthy and structural; in today's usage, isorhythm refers to repeating melodic patterns as well.

IYA ILU (YA-loo; Yoruba) A generic term for a drum that "speaks."

JANIZARY MUSIC Music of the elite corps of soldiers who functioned as the personal guard of Turkish sultans from the 1300s to 1826; in 18th-century Vienna (Mozart, Haydn), music in the Turkish style *("alla turca")*.

JAW'S HARP Also, "jew's harp." A small instrument of medieval origin (or earlier) with a frame and metal tongue, the frame being held between the teeth while the metallic tongue is plucked by the finger; melody is produced by varying the shape of the mouth cavity.

JING (Chinese) A painted-face male role in Beijing operas.

JINGHU (jing-who; Chinese) A two-string spike fiddle used in Beijing operas.

JINGJÜ (JING-jue as in French "rue" and the German "ü" [curl your lips and say "eee"]; Chinese) The term for what is commonly referred to in English as "Beijing opera" or "Beijing theater style"; other spellings include *Ching-chü* and *Ching-hsi*, and, in pinyin, *Guójù* and *Jīngjù*.

JONGLEUR (zhong-luhr) A medieval traveling entertainer typically performing dance, music, and juggling.

JONGLEURESS A woman JONGLEUR.

JOR (JORR; Indian) *Ālāp* section where pulse becomes regular.

JOTA (KHO-tah) A fast Aragonese dance in triple time usually performed with castanets.

KABAKA (kah-BAHK-uh; East African) Uganda, king.

KABUKI (kah-BOUK-ee) Japanese opera.

KAMANJA (ka-MAN-zha; Arabic) An Arab and Persian spike fiddle used in a takht (ensemble).

KANUN (KAH-noon; Near East) A plucked zither.

KAPELLE MEISTER (kah-PELL'ah mice-tair; German; now Kapellmeister) The master of the chapel or band; the band leader or conductor. The term was used in Renaissance, Baroque, or Classic periods. Cf. Maestro di Cappella (Italian; my-EHS-trow dee cah-PELL-ah), Maître de Chappelle (French; METT'r duh shah-PELL).

KATHAK (COT-ock; Indian) A North Indian classical dance with strong rhythmic elements.

KAVAL (kah-VAHL; Romanian) A folk flute.

KĚMPUL (come POOL; Javanese) A small gong.

KĚNDANG (K'N dahng) A Javanese drum.

KĚNONG (kuh-NAWNG; Javanese) Large "inverted kettle" belonging to colotomic group.

KETAWANG (keh-TAH-wahng; Javanese) A composition form for Javanese *gamělan* orchestras.

KETCHAK (k'CHAHK; Balinese) A Balinese "monkey chant" vocal ensemble with strong rhythmic accents.

KETTLE DRUMS Of Arabic origin, an orchestral drum consisting of a hollow brass or copper kettle resting on a tripod, with a head stretched across the kettle by an iron ring; almost always found in pairs.

KĚTUK (kuh-TOOK; Javanese) A small "inverted kettle" of a *gamĕlan* orchestra.

KEY The tonal center, the feeling of "arriving home" in a scale, melody, or piece.

KHĀLI (KHAH-lee; Indian) An empty (unaccented) beat in a rhythmic cycle or *tāla*.

KHARJĀT (khahr-zhat; Arabic) The refrain-like closing lines of a *mūwashshah*.

KITHARA (KITH-are-uh) In ancient Greece, a large lyre (of Asian ancestry) used by professional poets to accompany epics.

KOBZA (KOHB-zuh; Romanian) A lute.

KÔS (Turkish) Giant timpani.

KOTO (KOH-TOH; Japanese) A plucked zither.

KOTO DANMONO (. . . dahn-moh-noh; Japanese) A purely instrumental form for koto.

KRITI (KREE-tee; South Indian) A composition.

KUJAWIAK (koo-YAH-vee-ahk) A Polish dance in the Mazurka family, relatively slow.

KULINTANG (COOL-in-tahng; Philippines) A Philippine ensemble similar to the Indonesian *gamĕlan*.

LANCHARAN (lahn-cha-rahn; Javanese) (1) An instrumental form; (2) fast tempo.

LANDRANG (LAHN-drahng; Javanese) An instrumental form.

LASSÚ (LAHSH-shoe; Hungarian) The slow part of a dance (Cf. FRISS).

LAYĀLI (LYE-a-lee; Arabic) An improvised song form.

LEDGER (LEGER) LINES Lines for individual pitches added above or below the regular lines of a staff.

LEGONG (LAY-gong) A Balinese genre of dance performed by professionals.

LEITMOTIV (LITE-moe-TEEF; German) Meaning "leading motive," a theme in a Wagner music drama that is specifically associated with a person, object, or element, and that undergoes musical change (register, instrumentation, dynamics, harmony, tempo) to blend with changes in the story.

LIED (pl. LIEDER; LEED, LEED'r) A German art song.

LITHOPHONE (African) A stone chime.

LUTE A Western descendant of and counterpart to the Arabic *'ūd*. The lute is a finger-plucked, fretted string instrument consisting of a deep piriform (pear-shaped) body and a long peg box at a right angle to the neck. (The *'ūd* is unfretted and played with a plectrum.) Both the lute and the *'ūd* have large families of related instruments.

LYDIAN (mode or scale) A major-related scale with the ascending pattern w-w-w-h-w-w-h.

LYRE (LIAR) An ancient stringed instrument, the body acting as soundboard, from which two curving arms rise and are joined by a crossbar from which strings are plucked with a plectrum.

MAKAM, MAQĀM (ma-KAHM; Turkish, Arabic) A system of melody types, akin in some ways to Western medieval modes.

MALLARMÉ, STÉPHANE (MAHL'-arh-MAY, stay-FAHN, 1842–98) A French poet and leader of the Symbolist movement in French poetry. His eclogue *L'Après-midi d'un faune* (published in 1876) was the basis for Debussy's famous *Prélude à L'Après-midi d'un faune* (1894), which Mallarmé deeply admired, as he did also the paintings of the American artist James Abbott McNeill Whistler.

MANYURA (mahn-YOU-rah; Javanese) The name of a Javanese melodic mode.

MAQĀMĀT (ma-kahm-AHT; Arabic) Plural of *maqam*.

MAQĀM HIJAZ (Arabic) A favored type of maqām using an interval that resembles an augmented second between the second and third degrees.

MARX, KARL (1818–83) A revolutionary German political philosopher and economist who co-authored *The Communist Manifesto* in 1848.

MĀTRĀ (-S)(MOTT-rah; Indian) The beat subdivisions in a rhythmic cycle.

MAWWÂL (Arabic) An introductory vocal improvisation.

MAZZINI, GIUSEPPE (modt-TSEE-nee, 1805–72) From early on a member of the Carbonari, a politically radical society, Mazzini founded in 1831 the liberal organization YOUNG ITALY while in exile and was a leading figure in the *Risorgimento*.

MBIRA ('m-BEER-uh; African) "Thumb piano" in Shona language of East Africa.

MBIRA DZA VADZIMU (. . . jah vah-JEE-moo; African) *Mbira* of the ancestors.

MEHTER (Turkish) The Turkish military band.

MEIJI (MAY-GEE) PERIOD (Japanese) 1868 to 1912, also referred to as the "Meiji Restoration," during which time Emperor Meiji opened Japan to the West culturally and commercially.

MEISTERSINGER VON NÜRNBERG, DIE (Dee MICE-tair-zinger faun NURR'N-behrk; German) The Mastersingers of Nuremberg. A music drama (opera) in three acts by Wagner (1868), to his own libretto, based on Goethe, E. T. A. Hoffmann, and others. The setting: Nuremberg, 1500s.

MELISMATIC A vocal style in which many notes are sung to a single syllable.

METALLOPHONE Any percussion instrument that consists of a row of tuned metal bars, generally struck with a mallet, such as a vibraphone.

METER In music, a system of beats organized by regularly recurring stresses, analogous to lines of poetic feet in versification.

METTERNICH, PRINCE KLEMENS LOTHAR WENZEL VON (MET-ahr-nik [nikh], 1773–1859) Austrian Statesman and from 1809 Foreign Minister, subsequently President of the Congress of Vienna (1814–15). Metternich personified political conservatism and dominated politics from 1814 to 1848.

MICROTONAL MUSIC Music that uses intervals smaller than semitones (half-steps).

MIGODO (African; plural of *Ngodo*) Dance pieces of the Chopi people in Mozambique.

MINIMALISM ("ABC Art," "Primary Structures") A movement dating from the 1950s and named in the late 1960s that arose in reaction to the subjective approach of the Abstract Expressionists and emphasized impersonal statement characterized by sculptures with flat colors and the interaction of geometric planes, or paintings with subject matter restricted to repetition of geometric shapes. In music, where varied repetitions of simple and sometimes random rhythmic or melodic patterns occur, as in the works of La Monte Young, Terry Riley, Steve Reich, Philip Glass, and John Adams.

MIXOLYDIAN (mode or scale) A major-related scale with the ascending pattern w-w-h-w-w-h-w.

MODE Narrowly defined, a scale; more broadly, a melody type with mood association. Rhythmic modes are repeating patterns.

MODULAR FORM The smallest musical form that is complete in itself, but capable of expansion through repetition or variation.

MODULATION The change from one key center (or tonic pitch) to another within a piece.

MONODY (1) Monophony; (2) a type of early Baroque solo song consisting of a vocal line written in affective style, accompanied by one or more instruments supplying the BASSO CONTINUO.

MONOPHONY Music that features a single melodic line performed at the unison or octave.

MONOTHEMATIC MUSIC A musical work based on one melody or theme.

MONTESQUIEU Charles-Louis de Secondat, Baron de La Brède et de (MAWNT-uh-skew´; 1689–1755) A brilliant and witty political philosopher and jurist of the French Enlightenment whose advocacy regarding the separation of powers involving the executive, legislative, and judicial branches of a government provided a most significant source of inspiration for the framers of the Constitution of the United States of America.

MOTIVE The shortest complete and recognizable melodic figure, often used as a formal building block.

MUSIQUE CONCRÈTE (mew-ZEEK kohnng-KRET; French) A technique, dating from 1948, in which sounds from the outside world are recorded on tapes that are manipulated to form a musical composition. Cf. ELECTRONIC MUSIC.

NAI (n'EYE, Arabic) A vertical flute.

NAKKARE (Turkish) Small timpani-like pair of drums.

NĀTYA-ŚĀSTRA (NOT-ee-ah SAHSS-tra; Sanskrit) A comprehensive Sanskrit treatise on dramaturgy, believed to be by Bharata, which dates from about the 5th century and contains discussions of music, dance, and dramaturgy as constituents of Sanskrit theater.

NAY (NIGH; Romanian) Panpipes.

NEM (n'm; Javanese) The name of a melodic mode.

NEOCLASSICAL MUSIC A musical style that uses forms and/or idioms of 18th-century music; in the 20th century, a trend of objectivity and balanced formal designs exemplified in the music of Erik Satie and Igor Stravinsky, among others.

NETORI (NEH-toe-ree; Japanese) The prelude to a *Gagaku* piece.

NEUMES (NOOMS) Notational signs for melodic motion used in medieval chant, 8th–14th centuries.

NEY (NAY; Turkish) A Turkish rim-blown, obliquely held flute.

NONIMITATIVE COUNTERPOINT A type of texture in which the various voice-parts have different melodic material.

NOTES INÉGALES (an-ay-GAHL) A Baroque practice in which music notated in equal values was performed in unequal values; the expression also refers to any systematic rhythmic deviation from notated values.

OBLIQUE MOTION A type of polyphony that combines a freely moving melody with a drone.

OCTATONIC SCALE An eight-note scale (within an octave) that alternates whole-steps with half-steps, such as D, E, F, G, A-flat, B-flat, C-flat, D-flat.

OPERA A type of theater performance, dating from slightly before 1600, in which music is combined with sung dramatic action.

OPERETTA A theater genre lighter and more popular than opera, containing spoken dialogue.

ORATORIO From the "Oratory," or chapel, where the first Oratorios, sung in Latin, took place in the early Baroque. A lengthy stage composition without staging and costuming for voices and orchestra, generally on a biblical or mythical subject, in which a (sung) part for narration and lengthy choruses are prominent.

ORGAN A keyboard instrument with pipes and wind supplied a bellows; also called "pipe organ."

ORPHEUS A legendary Thracian poet-musician whose love for his wife Eurydice has been the subject of many operas and, in the 20th century, a ballet (1948) by the Russian composer, Igor Stravinsky.

OVERTONE One of a series of tones, of higher frequency than the fundamental, produced by a vibrating air column, string, or surface.

PAIAN (PEA'n); (PAEAN or PEAN) In ancient Greece, a song or hymn of praise to Apollo and considered to have healing properties; eventually, a general hymn of praise.

PAN KU (PAHN-koo; Chinese) A membranophone (drum) used in Beijing opera.

PANPIPES An ancient and geographically widely found instrument consisting of a series of stopped, end-blown reed pipes bound together like a raft; the basis for the earliest organs.

P'ANSORI (PAHN-sore-ee; Korean) A highly developed South Korean art form combining declamation, song, heightened speech, and pantomime.

PARALLEL MOTION Music in which the various musical lines move in the same direction at the same time and also by similar or identical intervals.

PARALLELISM A type of texture in which chords move in parallel motion.

PARLANDO STYLE A metrically free style of music that imitates or approximates speech rhythmically.

PARTIAL (noun) One of a series of tones, either the fundamental or any of its overtones, produced by a vibrating air column, string, or surface. Synonymous with harmonic (as a noun). See HARMONIC.

PATET (PAH-tet; Javanese) A melodic mode.

PELOG (PEH-log; Javanese) One of two tuning systems.

PENTATONIC A scale of five tones to the octave (such as the black keys on the piano).

PERCUSSION The vast family of instruments that are struck.

PERIOD A formal unit consisting of two or more complementary phrases, typically in an antecedent-consequent relationship. See PHRASE.

PERMUTATIONS Tranformations associated with twelve-tone (dodecaphonic) music, in which a tone row may be presented upside-down ("inverted"), backwards ("retrograde"), and backwards and upside-down ("retrograde inversion").

PESHREV (PESH-REF; Turkish) An instrumental prelude form.

PESINDEN (peh-SIN-den; Javanese) A female vocal soloist.

PHRASE A musical unit, often four measures, that typically forms part of a larger unit called a period. When a phrase requires a response from another phrase to form a period, the phrases together form an antecedent-consequent ("question and answer") relationship. In each period, there can be two or more antecedent phrases for each consequent phrase. In texted music, the musical phrase often corresponds to a clause of text.

PITCH The relative "highness" or "lowness" of a musical sound, measured by the frequency (cycles per second, or Hertz) of a vibrating air column, string, or surface.

PIYASA (pee-AHS-uh; Turkish) "Commercial" or nightclub music.

PLAGAL CADENCE A type of cadence in which a chord of the fourth degree of the scale goes to a tonic chord, IV-I.

PLAINCHANT Medieval liturgical monophony.

PLECTRUM A tool for striking or plucking a chordophone.

POINTILLISM A term borrowed from art, describing a technique the painter Georges Pierre Seurat (1859–91) used, and sometimes applied to the subtle textural shadings of the composer Anton von Webern (1883–1945).

POLYPHONY A type of texture in which the voice-parts have different melodic material sung with staggered entrances and/or at different pitch levels.

POLYRHYTHM Two or more different meters performed simultaneously.

PROGRAM MUSIC (1) Instrumental music that is written for concert-hall performance and that has an extramusical association specified by the composer; (2) any music that specifies an extramusical association. It is often contrasted to "Absolute music."

PROVENÇAL, PROVENÇAU (pro-vaughn-sahl) A dialect of the Occitan language spoken mainly, but not only, in medieval southern France; it is also an old version of a language (langue d'oc) used by troubadours in medieval literature.

PSALTERY (SALT'r-ee) A medieval zither plucked by the fingers of both hands or by two plectra.

PUSPOWARNO (poos-pa-WAHR-naw; Javanese) The title of a *gamělan* composition.

QANUN (ka-Noon, Arabic) A plucked zitter in a talent.

QUADRIVIUM (kwod-REE-vee-um) According to the 6th-century Roman patricians Boethius and Cassiodorus, the last four of the seven liberal arts; the quadrivium consists of arithmetic, geometry, music, and astronomy. The first three liberal arts, the *trivium*, are grammar, rhetoric, and logic.

QUADRUPLE METER Meter in which there are four beats per measure.

QUARTAL HARMONY Chords based on intervals of fourths rather than thirds or seconds.

QÜPAI (chue-pie; Chinese) Pre-existent tunes used in Beijing operas.

RAG (verb) To make a syncopated version of a musical selection.

RAG (TIME) An African-American piano genre in duple meter characterized by syncopation.

RĀGA, RĀG (RAHG-ah, RAHG; Indian) A melodic mode.

RĔBAB or RĀBAB (reh-BOB; Javanese) A spike fiddle.

RECAPITULATION The restatement in a sonata form (see SONATA FORM).

RECITATIVO (RAY-chee-tah-TEE-voe) In oratorios and Italian operas, a musical style in which the text is declaimed in speech rhythm but heightened by added melodic nuance.

RECITATIVO SECCO (RAY-chee-tah-TEE-voe SECK-koh) A type of recitative ("dry") usually performed with only harpsichord accompaniment and often consisting of fast-moving text.

RECORDER A member of the fipple-flute family, blown from the end with a whistle mouthpiece; of medieval origin.

RETROGRADE Backwards; often applied to a theme written or performed backwards; also referred to as "cancrizans" (crab).

RHAPSODY A musical piece, free in style, often with changing moods and tempos that sound spontaneous.

RHYTHM (1) In general the concept that deals with temporal aspects of music; (2) in particular, patterns of musical durations and accents, whether irregular in make-up (as in "free" rhythm) or (more often) operating in association with regularly emphasized beats (meter).

RIMBAUD (JEAN-NICHOLAS-) ARTHUR (1854–91) A precocious French Symbolist poet who died tragically young and whose interesting biography has recently appeared in the movie *Total Eclipse* starring Leonardo DiCaprio as Rimbaud.

RING DES NIBELUNGEN, DER (dair RING dehss NEE-bel-ung-en; German: The Ring of the Nibelung) A cycle of four music dramas (1853–74) by Wagner, based on the Nibelungenlied and the Scandinavian Edda: *Das Rheingold* (Dahss RINE-golt); *Die Walküre* (dee VAHL-kewr'h); *Siegfried* (ZEEG-freed) and *Götterdämmerung* (GUHT-tair-DEM-er-ung). The libretto, first conceived in the summer of 1848, is by Wagner.

RIQQ (rick, with a rolled "r," Arabic) The tambourine in a takht ensemble.

RISORGIMENTO (ree-ZORGE-ee-MEN-to; Italian: Reawakening) The nationalistic movement in Italy begun in 1750, intensified in 1848, and concluded with the unification of Italy in 1870.

RITARDANDO Getting slower by degrees.

RITORNELLO (REE-tor-NEHL-low) In Baroque operas and cantatas, recurring instrumental preludes and postludes (and also, occasionally, interludes) to sung arias.

ROCOCO (English, roh-KOE-koe; French, rah-kah-kah) An early to mid-18th-century trend in art that emphasized a delicate and ornate style that was decorative. Used principally with architecture and interior design, the term is sometimes applied to music of the early Classic period.

ROMANTIC (1) The emotional, expressive style associated with 19th-century music; (2) music that focuses on the excitement of the moment.

RONDO A refrain structure that alternates refrain statements with freer passages called "episodes." Originally associated with poetic texts and dance, it became an instrumental genre in the 17th, 18th, and 19th centuries.

ROTA (Latin: wheel) A circular canon, a round.

ROUNDED BINARY FORM A binary form in which the opening theme returns at the end of the second section.

RUAN (rwahn; Chinese) A four-string round lute with twenty-four frets, used in Beijing operas.

RUBATO (rue-BAH-toe) Freedom of beat; from the Italian "rubare," to rob (the beat).

SACKBUT Renaissance brass instrument and forerunner of the trombone, which has a more narrow bore and less flaring bell than the modern trombone.

SA'IDI (Arabic) A popular rhythmic mode from Southern Egypt.

SAM (Sum; Indian) The principal beat that marks the beginning of each statement of a cycle.

SAMPAK (SAHM-pahk; Javanese) An instrumental form for fight scenes in the shadow-puppet drama.

SANGA (SAWN-gaw; Javanese) The name of a Javanese melodic mode.

SANJO (SAHN-joe; Korean) A quasi-improvised Korean instrumental form.

SANTUR (santūr, santour, santoor, santir [Arabic]) A Persian zither (or dulcimer) of trapezoidal shape with thirty-six strings grouped by twos and struck with two light mallets. Related versions of the santur also exist in Turkey and Iraq.

SARABANDE (SAHR-ah-BAHND) A movement of the Baroque suite; the sarabande is a slow dance in triple meter with a stressed second beat; it had appeared in Spain in the 16th century and probably came from Mexico.

SĀRANGĪ (seh-RAHN-gee [hard G]) A Northern Indian bowed instrument with a large body carved from a single piece of wood and with a wide fingerboard of three to four melody strings and numerous sympathetic strings.

SĀROD (seh-RODE; Indian) Fretless, skin-faced, plucked lute.

SARON (SAH-rahn; Javanese) A metallophone with eight heavy bronze keys over a box resonator.

SAÙNG (SOWNG; Burmese) Harp.

SAZ (SAHZ; Turkish) A long-necked fretted lute.

SCALE A series of tones going up or down (usually in an octave) according to a fixed plan of intervals; in traditional Western scales, these intervals usually consist of whole steps and occasional half-steps.

SCHERZANDO (scare-TSAHN-doe) Playful.

SCHILLER, Johann Christoph FRIEDRICH von (1759–1805) German poet, dramatist, historian, and philosopher. His poem *An die Freude* ("Ode to Joy"), conceived in 1785, was set to music by Beethoven in the latter's Ninth Symphony. After serving as Professor of History and Philosophy at Jena beginning in 1789, Schiller returned to Weimar in 1799 (his second visit there) and together with Goethe founded the Weimar Theater, which became the leading theater among the German territories.

"SCOTCH" SNAP A syncopated first beat that begins short and accented.

SEGAH (say-GAH; Turkish) Name of a melodic mode.

SEQUENCE (1) A melodic segment or short harmonic progression that is repeated at different pitch levels on successive statements; (2) a chant that follows the Alleluia in the Roman Catholic (medieval) Mass.

SERIA An Italian word associated with Italian "serious" opera, *opera seria,* usually in three acts; during the second half of the 18th century, this type of opera became increasingly superseded by other operatic types, including the Italian *opera buffa* and the German *Singspiel.*

SHAKUHACHI (shah-koo-HAH-chee; Japanese) A rim-blown vertical bamboo flute.

SHAMAN (SHAH-men, SHAY-men) Among certain peoples and tribes in Asia and elsewhere, a wise person, often a combination of priest and doctor, who has links to the spiritual world and is capable of healing and divination through sorcery.

SHAWM A double-reed, conical-bore woodwind instrument made from a single piece of wood; used from the 13th through 17th centuries, its soprano version was the ancestor of the modern oboe. Related types exist in different parts of the world and as folk instruments in parts of Europe; it has a loud and aggressive sound.

SHEHNAI (sh'n-EYE; Indian) A double-reed conical, outdoor wind instrument.

SHÊNG (shung; Chinese) Bamboo mouth organ. (SHENG) A male lead role in Beijing operas.

SHÎNAWI (she-NAH-we; Korean) Improvised instrumental ensemble piece related to shamanistic music.

SHŌ (Japanese) A mouth organ.

SHŌ AITAKE (EYE-tock-ay; Japanese) Clusters of tones; harmony played by the *shō* mouth organ in the *Gagaku* Court Orchestra.

SHONA (SHOH-na; African) An East African people living mostly in Zimbabwe (Rhodesia).

SIDE DRUM Also known as the snare drum, this is the most commonly used drum in symphonic bands.

SIMPLE METER A meter in which the beats are of ordinary (not dotted) values, hence each is divisible by two.

SINGSPIEL (ZING-SHPEEL) A type of comic opera from the late 18th century, sung in German with spoken dialogue often replacing recitatives.

SITĀR (SIT-are; North Indian) A long-necked fretted lute.

SLENDRO (SLEHN-droh; Javanese) A tuning system.

SLĔNTĔM (SLEHN-t'm; Javanese) The largest metallophone in the *gamĕlan* orchestra.

SONATA (so-NAH-tah) A compound form of the Baroque and Classic eras, specifically for instruments.

SONATA FORM A formal design usually found in first movements of classic sonatas and related genres (symphonies, quartets, etc.) consisting of Exposition (modulating from the tonic to a second-key), Development (an area of modulation), and Recapitulation (all in tonic).

SONG A musical composition intended for vocal (sung) performance.

SPIKE FIDDLE A vertically held bowed string instrument with a round handle that pierces its body and lower end, forming a cello-like spike that rests on the ground.

SPINET An uneven, six-sided harpsichord, with the longest side containing the keyboard and strings running diagonally or parallel to the keyboard.

SPRECHSTIMME (SHPREKH-SHTIM-meh; German) A vocal style between speech and song.

SREPEGAN (SREP-uh-gahn; Javanese) An instrumental form.

STACCATO NOTES Notes that are sharply detached from their neighbors, indicated by a dot (over or under the notehead), a vertical stroke, or a solid black wedge.

STAFF NOTATION Any notation that uses lines and spaces to indicate particular pitches.

STRETTO In a fugue, the piling up of subject statements in close succession, usually appearing near the end.

STROPHIC FORM In vocal settings of poetic texts, the same music repeated for successive stanzas of the text (all the same size and with the same rhythmic structure).

SUBJECTS and ANSWERS (fugue) The successive statements of the main theme in the exposition of a fugue. The odd-numbered entrances are statements of the "subject," the even-numbered entrances are the "answers."

SULING (soo-LING; Javanese) A duct flute of bamboo.

SUM (some; Indian) Focal point of the rhythmic pattern in a *tāla*.

SYMBOLIST POETRY A late-19th and early 20th-century movement in France and Russia that stressed sound and imagery over linear logic in poetic expression.

SYMBOLISTES (sam-boe-LEESTS) A group of late 19th-century poets, including Mallarmé, Verlaine, Rimbaud, and the Belgian dramatist Maeterlinck, who stressed sound, synaesthesia, Asian mysticism, symbolism, feeling, and abstract concepts rather than literal meaning in their poetry.

SYMPHONIC POEM A 19th-century genre developed and designated by Franz Liszt, often a one-movement orchestral work, with programmatic associations and thematic transformation.

SYMPHONY A compound form, usually of three or four movements, for orchestra, in which the first movement is typically in sonata form.

SYNAESTHESIA (SIN-es-THEE-zha) A circumstance in which one type of stimulation elicits the sensation of another, as when the hearing of a sound evokes the sensing of a color.

SYNCOPATION A temporary interruption of the basic meter, often created by the suppression of an expected strong beat, especially the downbeat.

SYNERGISM The strong over-all effect resulting from the successful combining of various component parts. In the arts, synergism results from the combining of various disciplines such as poetry, dance, and music and is best exemplified in the powerful impact of ancient Greek drama.

SYRINX (SEAR-inks) Ancient Greek panpipes.

TABLĀ (TAW-blah, Arabic) (1) A set of North Indian drums for classical music; (2) the drum on the player's right.

TABLATURE Any notation which, by means of numbers, letters, or other symbols, tells the player which finger to use, at a particular place on an instrument.

TAKHT (Arabic) The representative music ensemble of Arab music.

TAKSIM (TOCK-seam; Turkish) Instrumental improvisation.

TĀL North Indian pronunciation of *tāla*.

TĀLA (TAHL-uh; Indian) Rhythmic cycle or mode.

TALLEYRAND, CHARLES MAURICE DE TALLEYRAND-PÉRIGORD (tah-leh-RAHNH-pay-ree-GOHR, 1754–1838): A witty, brilliant, and cynical diplomat who had a chameleon-like genius for adapting to and dominating different and opposing political positions: he rose to prominence during the Revolution, curried favor with Napoleon, represented French interests during the Congress of Vienna where he promulgated the sacred *(derrière-garde)* Principle of "Legitimacy" (restoring pre-Revolutionary status to the old European ruling families), gained favor with the post-Napoleonic reigning French monarchs (first Louis XVIII, then Charles X), and finally helped Louis Philippe (the "Citizen King") to power.

TAMBAL (TSOM-bahl; Romanian) A hammered dulcimer.

TĀNPŪRA The North Indian version of the South Indian *tāmbūra,* a long-necked lute used for a drone in Indian classical music.

TAQSIM (Arabic) An improvisatory opening with no set tempo, performed on an instrument.

TARAB (Arabic) The enchantment that a musician is able to involve in an audience.

TARAGOT (tar-a-GOAT; Romanian) A single-reed, keyed wind instrument descended from a shawm.

TAVERNA (tah-VAIR-nuh; Greek) A Greek nightclub.

TAXIM (TOCK-seam; Greek) An instrumental improvisation.

TEK (teck; Turkish) Syllable representing high-pitched drum sound.

TEMPO. The speed of the musical pulse.

TEMPO GIUSTO (TEM-po JUICE-toe; Italian) A steady pulse; the opposite of free rhythm.

TERRIARY FORM A three-part form in which each of the three parts ends on the tonic key and in which the third is a repetition or slightly modified repetition of the first, resulting in an overall ABA design.

TERTIAN HARMONY A system of harmony in which the chords are built on superposed intervals of thirds.

TESLIM (tess-LEAM; Turkish) The refrain in instrumental pieces.

THEMATIC TRANSFORMATION The process wherein a motive or melody undergoes changes (in key, and/or register, mode, tempo, dynamics, and if orchestral, in timbre), but where the rhythmic pattern and melodic contour remain relatively constant.

THOROUGH BASS English reference for BASSO CONTINUO. In German, the *basso continuo* or "thorough bass" is designated *Generalbass.*

TIHAI (TEE-HIGH) (North Indian) A three-fold rhythmic figure used to enhance the return(s)-of a *sam (sum)* in a *tāla.*

TIMBILA (tim-BEAL-uh; African) A xylophone orchestra of the Chopi people of Mozambique.

TIMBRE The quality of sound that distinguishes one instrument (or voice) from another.

TIME SIGNATURE The numerical indication at the beginning of a piece that establishes the meter of the music.

TIMPANI Two or more kettledrums; the singular form is timpano.

TINTĀL (TEEN-tahl; Indian) A *tāla* or rhythmic mode consisting of sixteen beats.

TOCCATA In Baroque music, a keyboard piece written in idiomatic style, with chords alternating with running passages, sometimes with imitative (fugal) sections. From "toccare," to strike or touch (a keyboard).

TONALITY The existence of a key center or keynote (tonic).

TONE POEM A term used by the late-19th and 20th-century composer Richard Strauss to describe his symphonic poems, which stress literal description through musical means.

TRANSPOSITION The shifting of an entire composition to a different key, such as raising a piece a whole tone from F to G.

TRIAD A chord that, in its basic position, consists of three pitches, each a third apart, such as C-E-G.

TRISTAN UND ISOLDE A three-act music drama (opera) by Richard Wagner, completed in 1859 and freely adapted from the old Tristram and Iseult legend (Wagner's libretto is based on G. von Strassburg).

TRITONE The interval of three whole steps; also referred to as "the devil in music."

TROBAIRITZ (tro-bear-EETS; Provençal, plural form) Female troubadours.

TROUBADOUR A southern French medieval poet/musician performing in the language of langue d'oc.

TROUVÈRE (true-VAIR) A northern French form of "troubadour," spoken in langue d'oil, the medieval language of northern France.

TUBA The lowest brass instrument of the symphony orchestra.

TUKUNG (two-kung; Javanese) The title of a *gamĕlan* composition.

TUTTI (Italian: all, full) Used to designate orchestral statements in concertos. In the Baroque concerto grosso, synonymous with *ripieno*.

TYMPANON (pl. TYMPANA; Greek) An ancient Greek hand drum, common to all antiquity.

'ŪD (ood; Arabic) An unfretted, short-necked, deep-bowled present-day ancestor of the lute, played with a plectrum.

UILLEANN (ILL'n; Irish) (Union) bagpipes.

USTAD (oos-TAHD; North Indian) A master musician's title.

USÛL (oo-SOOL; Turkish) A generic name for rhythmic modes.

UZBEKI (OOZE-BECKY) Adjective: of or pertaining to a Turkic people, the Yuzbeks, of Central Asia.

VERBUNKOS (VEHR-boonk-oash) An 18th- and early 19th-century Hungarian soldier's dance used to recruit young men into the Austrian army.

VIBHĀGA -S (Indian) The main beats of a *tāla* (rhythmic cycle).

VĪNĀ (VEE-nah; South Indian) A long-necked, fretted lute.

VIOL A Renaissance bowed string instrument differing from the violin family by having a fretted fingerboard, six strings, and differently shaped body.

VIOLA D'AMORE (vee-OH-la deh-MOH-ray) A European viol with sympathetic strings.

VIOLIN A bowed chordophone with four strings tuned in fifths and an unfretted fingerboard. With ancient roots, the violin did not assume its modern, independent identity and structure until the Baroque period. The violin family (violin, viola, cello, double bass) is often contrasted to the older viol family.

VIOLONE (vee-oh-LOW-nay) A low-pitched, fretted, six-string bowed chordophone of the Renaissance and Baroque eras that complemented the viol family; an ancestor of the modern double bass.

VOCALISE A vocal part sung without words.

VOUDUN (voo-DA(N); Haitian) Cult ceremony "voodoo."

WAYANG (WYE-ahng or WAHNG; Javanese) A shadow puppet play.

WHOLE-TONE SCALE A six-note (hexatonic) scale, made up completely of whole steps (and no half-step, and therefore anhemitonic); C, D, E, F-sharp, G-sharp, A-sharp (C) or D-flat, E-flat, F, G, A, B (D-flat).

WINTERREISE (VIN-ter-RISE-uh; German: Winter Journey) A cycle, in two parts, of twenty-four songs (1827) by Schubert to poems by Wilhelm Müller.

XYLOPHONE An ancient instrument, consisting of a row of flat wooden bars fastened horizontally to a frame, tuned to all the notes of the scale, and struck with two mallets.

YANG (Yahng) One of two poles in ancient Chinese concepts, represents qualities of sun, maleness, openness, etc., opposite of *yin*.

YIN One of the two opposing concepts in ancient Chinese thought, representing night, moon, female, secretiveness, etc., opposite of *yang*.

ZARBI FETIH (ZAR-bee FEHT-ee; Turkish) A rhythmic mode of exceptional length.

ZEIBEKIKOS (zay-BEK-ee-kohs; Greek) A dance in 9/4 meter.

ZEYBEK (ZAY-bek; Turkish) A folk dance in 9/4 meter.

ZIL (Turkish) Cymbals.

ZITHER A chordophone with lengthwise strings and a resonating body; the archetypal chordophone.

ZURNA (ZOOR-nuh; Turkish) A type of double-reed, conical outdoor wind instrument. See SHAWM.

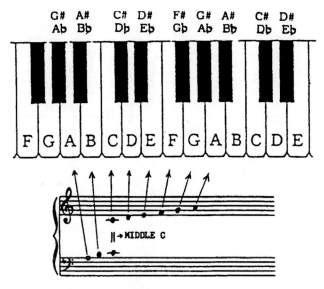

Appendix I: Pitches and Durations (Note-Values)

Pitches

sharps and flats

The first seven alphabet letters, A to G, identify pitches corresponding to the white keys on the piano. The sharp (#) "raises" a note a "half-step, or semitone (movement to the right to the nearest piano key), and the flat (♭) "lowers" it a "half-step" or semitone (movement to the left). When sharps or flats are added within a piece of music, sharps usually appear when the melody goes up, from left to right on the keyboard, and flats usually are seen when the melody goes down, right to left. In musical notation (on the staff), sharps and flats appear to the left of the note to which they belong, while in letter reference, as directly below, they appear to the right.

ledger (leger) lines

Pitches above or below the staff employ ledger (or leger) lines (middle C in the example above).

The "scale" of any given melody is simply the set of tones used in that melody, arranged in a logical, stepwise progression:

There are many scales and each has its own flavor, as may be seen by the detailed discussion in Chapter 4. Each culture produces its own scales from among the many possibilities. Recent research in the psychology of music demonstrates that the scale of "scalar" basis for a melody is the prerequisite for learning that melody.

tonic

The pitches within a scale usually have a hierarchy in which some seem to be more important than others. The "key" of a scale is the pitch that makes us feel we are home, that we have finally arrived. Sing "Joy to the World!/the Lord is . . ." If

you leave out the note for the last word, you will feel something is missing, that everything is left hanging. When you finally add that note, you feel that you have arrived "home." This home is the key note, or "tonic." The tonic is considered the first degree of the scale. If something is in F, it will often begin and usually close on F. Thus, the tonic is the tone of prime importance, it is with relation to the tonic that all other tones of the scale assume a role in the movement of a melodic progression. An F-major scale is placed in the F octave (from one F to the next F), a G-major scale in the G octave, and so forth.

Durations (Note-Values)

The modern system of rhythmic notation can be traced as far back as the early 13th century and has not changed substantially since the late 15th century. Even before 1200, a notational system using specific durations evolved as shapes became associated with specific durations. In the late-13th century, the basis for modern notation appeared with note-values that could be measured against one another.

The relative lengths of notes, called note-values, of Western musical notation are now familiar symbols to many of us, even if we have not yet studied them. See the accompanying illustration.

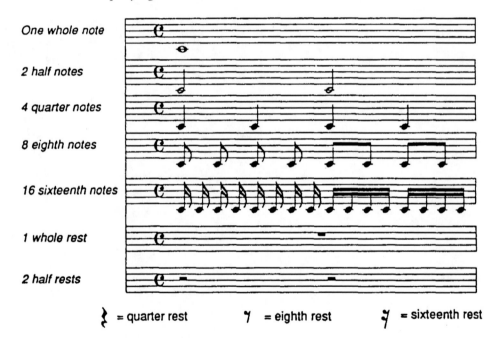

Dot (·), over or under a note indicates staccato.

After a note (or rest) it lengthens the preceding note (or rest) by one-half the time-value of the note (or rest)

Appendix II: Key Signatures

In West European classical music, the two most important modes in the period 1650 to 1900 are the major and minor. Changes from one key to another, modulations, have frequently involved change of mode as well. Modulations often involve parallel or relative relationships.

What is a relative relationship? When a major and minor pair of scales share the same basic notes—the same key signature—they have a relative relationship. C major and A minor each have no sharps or flats in their key signature: C major is the relative major of A minor, and A minor is the relative minor of C major. F major and D minor have the same relationship to each other, as do G major and E minor. Notice that the minor key is always a minor third below the major.

When you stay in the same key but change modes, such as from C major to C minor, a *parallel* relationship occurs. In a parallel major-minor pairing, the major key signature is always three to the sharp side (or the minor is three to the flat side): A minor has no sharps or flats, A major has three sharps; C major has no sharps or flats, C minor has three flats; D minor has one flat, D major has two sharps (1 flat + 2 sharps is here the equivalent of 3 sharps);

The Major Mode

"Sharp" keys

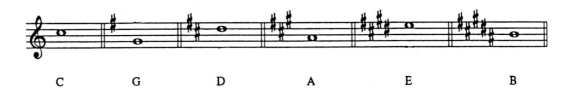

C　　　G　　　D　　　A　　　E　　　B

"Flat" keys

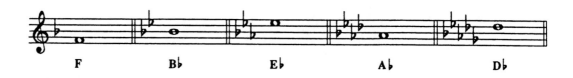

F　　　Bb　　　Eb　　　Ab　　　Db

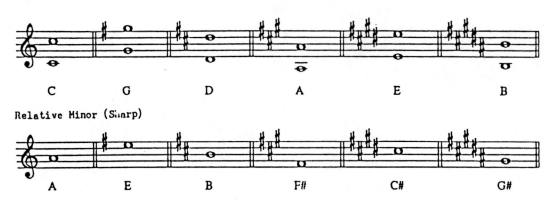

C G D A E B

Relative Minor (Sharp)

A E B F# C# G#

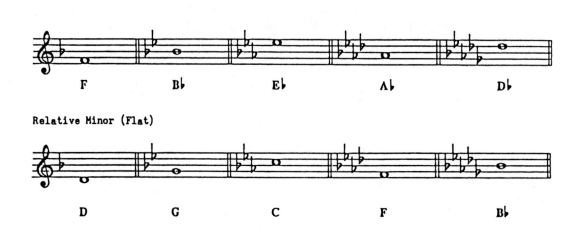

F B♭ E♭ A♭ D♭

Relative Minor (Flat)

D G C F B♭

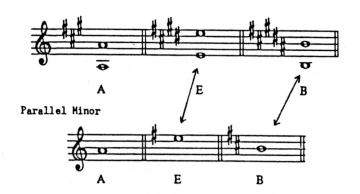

Parallel Minor

Appendix III: "Church" Modes and Solmization

The "Church" Modes

Major (-Related) Modes

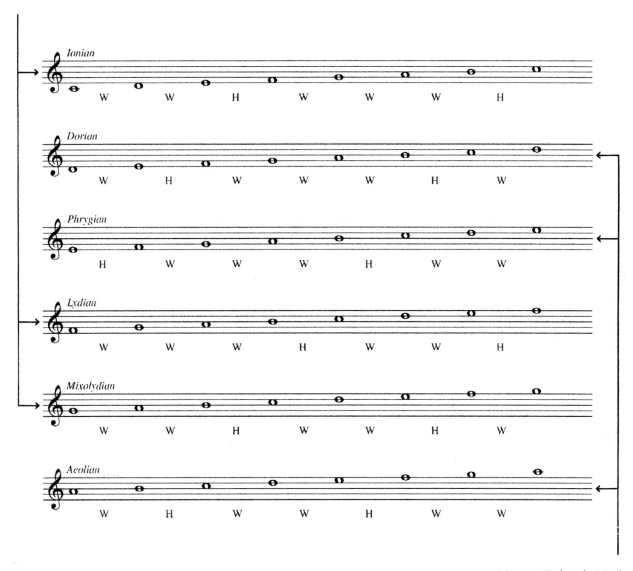

Minor (-Related) Modes

The major and major-related modes have two whole-steps (two W's) between the first and third degrees; the minor and minor-related modes have a whole-step and a half-step (a W and an H or an H and a W) between the first and third degrees.

Solmization ("Solfège")

There are two techniques in using *sol-fa* syllables. With "fixed" *do, do* stands for the actual pitch of C, *re* is D, *mi* is E, and so forth. More familiar in the United States is "movable" *do,* in which do is the first tone of the scale no matter what that pitch may be, *re* the second tone, *mi* the third tone, and so on. With "movable" *do, do* is F in an F-major scale, G in a G-major scale, and so forth.

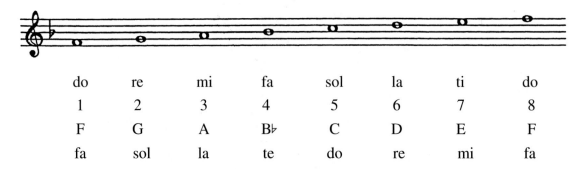

do	re	mi	fa	sol	la	ti	do
1	2	3	4	5	6	7	8
F	G	A	B♭	C	D	E	F
fa	sol	la	te	do	re	mi	fa

For pitch names in the chromatic scale, the vowel sounds are changed to i (as in "marine") when going up, and to e (sound of ay as in "may") when going down, except for the second degree, which becomes a (as in "ah"):

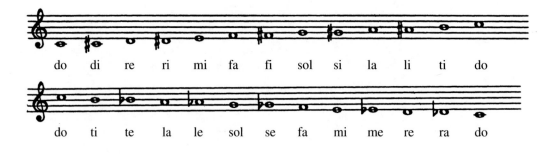

do di re ri mi fa fi sol si la li ti do

do ti te la le sol se fa mi me re ra do

UP:

C	C-sharp	D	D-sharp	E	F	F-sharp	G	G-sharp	A	A-sharp	B	C
do	*di*	*re*	*ri*	*mi*	*fa*	*fi*	*sol*	*si*	*la*	*li*	*ti*	*do*

DOWN:

C	B	B-flat	A	A-flat	G	G-flat	F	E	E-flat	D	D-flat	C
do	*ti*	*te*	*la*	*le*	*sol*	*se*	*fa*	*mi*	*me*	*re*	*ra*	*do*

In most pedagogical systems, solmization is based on the major mode. To use the *sol-fa* system in the minor mode, the syllable found in the relative major is used for any given pitch. Thus, in A minor, the pitch A is *la,* as it is in C major, the pitch B is *ti,* and so forth.

Appendix IV: The Overtone Series and Intervals

The Overtone Series

When someone plays a single pitch on a violin or oboe, what we hear are the air molecules set in motion by the vibrating string or air column. The vibrations progress outward in expanding circles, like those produced by a stone thrown into a pond. The vibrating body starts the molecules in a regular series of condensations and rarefactions that we perceive as a musical sound. (Music, sound itself, cannot be heard in a vacuum.) The pitch we hear, the relative "high-ness" or "low-ness" of a sound, is determined by the length of string or air column: the longer the string, the lower the pitch; the shorter the string, the higher the pitch.

Vibrating bodies, such as strings and air columns, vibrate spontaneously not only as a whole but also in parts: halves, thirds, fourths, fifths, sixths and so on. The whole vibrating body produces the *fundamental,* heard as pitch. The smaller, partial vibrations create *overtones,* each pitched higher than the preceding. Since they are typically much softer than the fundamental, we hear them not as pitches but as aspects of tone quality or timbre. The violin, clarinet, dulcimer, cello, piano, harpsichord, and guitar each stresses different groupings of overtones; this is largely why each instrument sounds different from the others.

If the whole vibrating string, the fundamental, proceeds at 110 cps (cycles per second) or Hz (after Heinrich R. Hertz, a German physicist), the overtones will be 220 Hz (half the length = twice as fast), 330 Hz (a third the length = 3 times as fast), 440 Hz, 550 Hz, 660 Hz . . . producing the following overtone series:

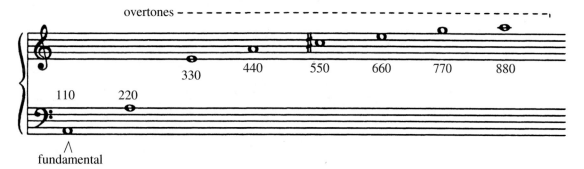

Dividing by 110, we see the progression 1, 2, 3, 4, 5, 6, 7, 8 The higher in the overtone series, the closer together the pitches.

On many instruments, such as the piano and violin, the overtones or *harmonics* can be made to sound alone by means of special techniques. On other instruments it is actually more natural to play the overtones than to play the fundamental. On open pipes made up of very long and thin tubes, that is, of relatively narrow bore, the first overtone rather than the fundamental acts as the natural tone of the instrument. Many of the standard "brass" instruments fit this category: trumpets, horns, bugles, and trombones. (Not so the tuba, which has a wide bore.) All the familiar military signals on the bugle *(Taps, Reveille)* are produced by playing overtones of a single fundamental. The process of producing these overtones is called *overblowing.*

291

Intervals: The Perfect and Major/Minor Systems

An interval may be one of five types: major, minor, perfect, augmented, or diminished. These types form two systems:

1. The intervals of the unison, 4th, 5th, and octave (8ve) are considered *perfect*. Perfect intervals may be made smaller (diminished) or larger (augmented) by a chromatic alteration of one of the notes by a half-step.

2. The intervals of the 2nd, 3rd, 6th, and 7th are considered *major*. Major intervals may be made smaller by a half-step (minor), and the minor interval still smaller by a half-step (diminished). If the major interval is enlarged by a half-step, it is augmented. A perfect interval can never be major or minor, just as a major or minor interval can never be perfect.

Intervals are usually measured from the lower tone up, as in the following chart:

Abbreviations				larger
Perfect = P			Augmented	
Major = M		Perfect		Major
Minor = m				Minor
			Diminished	
				smaller

(Perfect) unison = 0 half-steps
Major 2nd = 2 half-steps
Major 3rd = 4 half-steps
Perfect 4th = 5 half-steps
Perfect 5th = 7 half-steps
Major 6th = 9 half-steps
Major 7th = 11 half-steps
(Perfect) 8ve = 12 half-steps

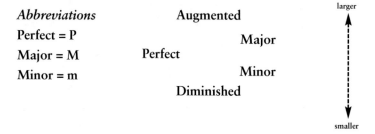

major mode

minor mode

Appendix V: Dynamics

In musical contexts, the term "dynamics" refers to how "loud" (or "soft") the music seems to us. Loudness and softness are kinds of emphasis. In traditional Western music, the Italian terms *piano* (quiet), or *p*, and *forte* (loud), or *f*, form the nucleus from which other levels of dynamics are graded. Thus, *fortissimo*, or *ff*, means "very loud," and *pianissimo*, or *pp*, means "very soft." *Crescendo*, or ⟨, means gradually getting louder, and *diminuendo*, or ⟩, means gradually getting softer. The modern keyboard instrument called "piano" was in the 18th century referred to as a *"fortepiano"* (ancestor of today's "pianoforte"), meaning it could produce loud and soft dynamics, in contrast to the harpsichord, the dynamic level of which, on any given pitch, is fixed and cannot be controlled by the performer.

Range of dynamics in the later 18th century and early 19th century (Beethoven):

pp = pianissimo : very soft

p = piano : soft

mp = mezzo piano : moderately soft

mf = mezzo forte : moderately loud

f = forte : loud

ff = fortissimo : very loud

sf or *sfz = sforzando* or *sforzato* : forced, loud, often in comparison to the immediately preceding and following music (thus essentially synonymous with "accent")

Range of dynamics in the later nineteenth century (Tchaikovsky):

from *ppppp* [5] to *ffff* [4]

"Tree of Life"
Javanese shadowpuppet

293

Compact Disc Tracks

CD Track	Chapter	Selection	Concept
1–6	1 Society	Beethoven–*Symphony 6*	program music
7	2 Timbre	Rumanian Folk Song	panpipes
8	2	Sibelius–*Swan of Tuonela*	English horn
9	2	Indian *rāg'*	*sārangī*
10	2	Japanese song	koto
11	2	Turkish *taksim*	Turkish *ud*
12	2	Indonesian court orchestra	*gamĕlan*
13	3 Time	Hungarian dance	accelerando
14	3	Beethoven–*Symphony 7*, II	simple duple meter
15	3	Strauss–*At the Beautiful Blue Danube*	simple triple meter
16	3	Beethoven–*Symphony 6*, V	compound duple meter
17	3	Bach–*Jesus bleibet meine Freude*	compound triple meter
18	3	Holst–*The Planets:* "Mars"	additive meter
19	3	Joplin–*The Easy Winners*	syncopation
20	3	Bernstein–"America"	hemiola
21	3	Joplin–*Pine Apple Rag*	polyrhythm
22	4 Melody	Mason–*Joy to the World*	major scale
23	4	Bessie Smith–*Poor Man's Blues*	blues scale
24	4	Gottschalk–*The Banjo*	pentatonic scale
25	4	Debussy– "Voiles"	whole-tone scale
26	4	Saint-Saëns–"Bacchanal"	augmented-second scale
27	5 Texture	Houston–*Amazing Grace*	monophony
28	5	Bagpipes–*The Brown Thorn*	oblique motion
29	5	Mozart–*Piano Concerto 21*, II	homophony
30	5 Harmony	Beethoven–*Symphony 5*, IV	authentic cadence
31	5	Handel–"Hallelujah Chorus"	plagal cadence
32	5	Chopin–*Prelude in C minor*	fast harmonic rhythm
33	5	Bessie Smith–*St. Louis Blues*	blues chord progression
34	6 Form	Bach–*Wachet auf*	German *Bar* form
35	6	Pachelbel–*Canon in D*	continuous variation

Index

Thanks to Qualiton Imports, LTD and their distributed labels for the music on this CD: 7/8 MUSIC 079803, ARGILE 09262, HUGAROTON CLASSIC HCD 31813, NAVRAS NRCD 0154, SOW 90116, BIS 1015, NAVRAS 5507, COL LEGNO 20057, WORLD ARBITER 2001, HUNGAROTON HCD 18244, ELYSIUM GRK 712, I LOVE CLASSICS 165.509-2, IDIS 332, SUPRAPHON 3317, AMSC 582, AVID CLASSIC MASTERS, PAVANE 7317, THOROFON 2448, PAVANE ADW 7317, BIS 533, GOLDIES GLD 25394-2, CENTAUR 2549, BIS CD 371, BIS-CD-555, GOLDIES GLD 25417-2, SAYDISC 416, BIS 205, ELYSIUM 712, CLASSICO 300-1, CLASSICAL DIAMONDS HCD 4001, IDIS 332, BAYER 100116, JAZZTERDAYS JTD 102416, PAVANE 7264, GOLDIES GLD 25394-1, SUPRAHON FL 3317, GOLDEN STARS 5326, BIS 439/40 CD-440, SUPRAPHON BG 3565, GOLDEN STARS GSS 5326 CD 2, CLASSICO 300/1 CD 1, IDI 6388, GALA 501, HUNGAROTON 31748, BIS CD 1105, HUNGAROTON CLASSIC 12631, HUNGAROTON CLASSIC HCD 18191, NAVRAS 0154, HUNGAROTON 31813, ARGILE 9262, PANDA 79803.

www.qualiton.com